FASHION APPAREL AND ACCESSORIES

FASHION APPAREL AND ACCESSORIES

JAY DIAMOND
NASSAU COMMUNITY COLLEGE

ELLEN DIAMOND
NASSAU COMMUNITY COLLEGE

Delmar Publishers Inc.™
I T P

NOTICE TO THE READER

Publisher does not warrant or guarantee any of the products described herein or perform any independent analysis in connection with any of the product information contained herein. Publisher does not assume, and expressly disclaims, any obligation to obtain and include information other than that provided to it by the manufacturer.

The reader is expressly warned to consider and adopt all safety precautions that might be indicated by the activities described herein and to avoid all potential hazards. By following the instructions contained herein, the reader willingly assumes all risks in connection with such instructions.

The publisher makes no representations or warranties of any kind, including but not limited to, the warranties of fitness for particular purpose or merchantability, nor are any such representations implied with respect to the material set forth herein, and the publisher takes no responsibility with respect to such material. The publisher shall not be liable for any special, consequential or exemplary damages resulting, in whole or in part, from the readers' use of, or reliance upon, this material.

Cover credits (left to right, top to bottom): Men's Fashion Association, Health Tex, Ellen Diamond, MFA, American Textile Manufacturers, MFA, Maryesta Carr International, Inc., Ellen Diamond, Ellen Diamond, Leather Apparel Association, Ellen Diamond, and Valentino.

Delmar staff:
Acquisitions Editor: Mary McGarry
Project Editor: Theresa M. Bobear
Production Coordination: Sandra Woods
Art & Design Coordinator: Karen Kunz Kemp

For information, address Delmar Publishers Inc.
3 Columbia Circle, Box 15-015
Albany, NY 12212-9985

Printed in the United States of America
Published simultaneously in Canada
by Nelson Canada,
a division of The Thomson Corporation

1 2 3 4 5 6 7 8 9 10 XXX 00 99 98 97 96 95 94

·Library of Congress Cataloging-in-Publication Data

Diamond, Jay.
 Fashion apparel and accessories / Jay Diamond, Ellen Diamond.
 p. cm.
 Includes index.
 ISBN 0-8273-5624-2
 1. Clothing trade. 2. Clothing and dress. 3. Dress accessories.
 I. Diamond, Ellen. II. Title
 TT497.D48 1993
 687—dc20 93-31762
 CIP

CONTENTS

P R E F A C E

A walk through the pages of fashion reveals a world that is filled with a cast of legendary characters. Many, even though no longer living, continue to dominate design through their creativity and the influences they inspired in those who followed their lead. The talents of Fortuny, Christian Dior, Cristobal Balenciaga, Andre Courre'ges, and Coco Chanel impacted the fashion scene with impeccable tailoring, spectacular pleating, inventive shaping and silhouettes, and fabulous accessories that enhanced the apparel. These designs seem to reappear again and again in collections at every price point. Many of the reigning architects of fashion have equally distinguished themselves and indelibly etched their names in fashion's illustrious history. The Yves Saint Laurent trapeze, Mary McFadden's artistry with pleats, Christian Lacroix's pouf skirts, Claude Montana's ingenious leathers, and Georgio Armani's unstructured jackets are just some styles that have changed the course of design.

Although fashion transcends other fields such as home furnishings, the scope of this writing will be limited to apparel and accessories and the roles played by the industry's components in their marketing strategies.

The text is multifaceted and is divided into five separate sections, each exploring a different aspect of the apparel and accessories world. INTRODUCTION TO THE INDUSTRY provides a capsulized overview of the field as well as the exciting careers that await those who enter it. The INDUSTRY'S MAJOR COMPONENTS, producers and processors, manufacturers and designers, retailers and promoters of fashion, are examined in terms of their contributions. Textiles, leather, furs, metals, and stones, THE MATERIALS OF FASHION APPAREL AND ACCESSORIES, are addressed in terms of their development, functions, and uses by those who create fashion. The APPAREL CLASSIFICATIONS closely examines men's, women's, and children's clothing, emphasizing the specific characteristics of each. A detailed discussion on the products that augment apparel are presented as ACCESSORIES AND ENHANCEMENTS and run the gamut from footwear to jewelry.

The textual material is significantly underscored with many photographs that enable the reader to visualize what has been discussed. Some are in full color and feature professionally prepared pieces of artwork that represent the industry's most important designers and their

collections. Detailed drawings accompany some of the styles, silhouettes, and product details to facilitate their comprehension.

In addition to the traditional pedagogical embellishments of the book, such as the use of learning objectives to give the reader a sense of what knowledge may be acquired in each chapter, review questions that serve as a means of recalling what was read, and exercises that enable the students to personally explore the pertinent areas of fashion, supplementary materials are also available. An Instructor's Guide features both answers to all of the questions in the text and a test bank for each chapter.

A video cassette package complements the text. Produced in full color, the student is shown every aspect of the apparel and accessories market, including the development of the raw materials of fashion, the design of merchandise and its production, how the industry promotes its wares, and the highlights of fashion collections, past and present.

Fashion Apparel and Accessories is a product of the extensive careers of its authors as educators and practitioners in the field. Along with information culled from their own experiences, they have incorporated data from the field's most esteemed professionals.

ACKNOWLEDGMENTS

The authors are grateful for the helpful comments received from the following educators who reviewed the manuscript:

Ruth Glock
Iowa State University
Ames, Iowa

Kay King
Houston Community College
Houston, Texas

Cheryle Brockman
Central Piedmont Community College
Charlotte, North Carolina

Barbara DeNatale
FIDM
Los Angeles, CA

Mercy Buttdorf
Skyline High School
Salt Lake City, Utah

Kathy Tamblyn
Waubonsie Valley High School
Aurora, IL

ABOUT THE AUTHORS

Jay Diamond is professor of Marketing, Retailing and Fashion at Nassau Community College in Garden City, New York where he teaches a variety of fashion and retailing subjects.

After graduation from Baruch College of City University of New York where he majored in retailing, he became a partner in a small clothing chain, *Helen Diamond*. There, he put his education to work as a buyer and merchandiser of women's fashions. After several years as a full time retailer, he left the industry to attend New York University where he received a Master's Degree in Business Education. Upon graduation he became a full-time educator at Nassau Community College, where he served in a variety of capacities that included: Department Chairman of the Marketing, Retailing and Fashion Department, Dean of Business, and Special Assistant to the President. He has been recognized several times as an outstanding educator with such honors as Distinguished Professor of the State University of New York, and the first Distinguished Achievement Award Recipient at Nassau Community College.

In addition to participating in the fashion world and education, he has authored numerous textbooks including, *Retailing, Principles of Marketing, Retail Buying, Professional Selling, The World of Fashion* and *Contemporary Visual Merchandising*. He is also the co-creator and writer of a five-part *Fashion Retailing Video Series*. At the present time he is finishing work on a new text, *Fashion Advertising and Promotion.*

Ellen Diamond is an adjunct member of the Marketing, Retailing and Fashion Department at Nassau Community College in Garden City, New York where she teaches fashion subjects.

After graduation from New York University, where she majored in art, she became a partner in a small women's clothing chain, *Helen Diamond,* where she utilized her art background as director of visual merchandising and assisted in the purchasing of fashion merchandise. Although she remained a retailer for more than fifteen years, she never lost her love for the art world. She regularly produced paintings and limited edition lithographs which are featured in galleries across the United States. Her distinctive art ability was formally recognized when she was asked to become a member of the National Association for Women Artists.

Coupled with a wealth of experience in art, retailing and education, was her desire to write. She is the co-author of two fashion-related texts, *The World of Fashion* and *Contemporary Visual Merchandising.* Her first solo effort was titled *Fashion Retailing.* In addition to her endeavors as an author, she recently co-created and wrote a five volume video series on *Fashion Retailing.* Her next project will be as co-author of a textbook, *Fashion Advertising and Promotion,* which will feature her drawings and photography.

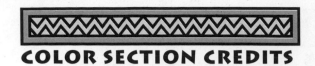

COLOR SECTION CREDITS

FIRST COLOR SECTION CREDITS

A-1-1	Color Wheel adapted from the Color Compass, © 1972, M. Grumbacher, Inc. All rights reserved. Used with permission.
A-2-2	Photo taken by Ellen Diamond at Criscione
A-2-3	Photo taken by Ellen Diamond at Macy's
A-3-4	Photo taken by Ellen Diamond at St. Laurie, Ltd.
A-3-5	MFA
A-4-6A	Photo taken by Ellen Diamond at Frank Olive
A-4-6B	Photo taken by Ellen Diamond at Lola
A-5-7	Photo taken by Ellen Diamond at Seidel Tanning
A-5-8	Photo taken by Ellen Diamond at Allen Edmonds
A-5-9	MFA
A-6-10	Mikimoto (America) Company, Ltd.
A-6-11	Mikimoto (America) Company, Ltd.
A-6-12	Mikimoto (America) Company, Ltd.
A-7-13	Mikimoto (America) Company, Ltd.
A-7-14	Mikimoto (America) Company, Ltd.
A-8-15	Ellen Diamond
A-8-16	Ellen Diamond
A-8-17	International Linen Promotion Commission

SECOND COLOR SECTION CREDIT

Photos by Ellen Diamond; taken at the Tickle Me! factory and showroom in New York.

SECTION 1

INTRODUCTION TO THE INDUSTRY

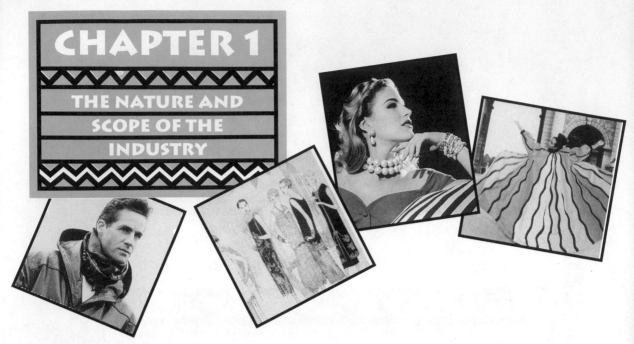

CHAPTER 1

THE NATURE AND SCOPE OF THE INDUSTRY

LEARNING OBJECTIVES

After reading this chapter, the student should be able to:

1. Discuss the major influences of wearable fashion for the twentieth century.
2. Explain the roles played by the various components involved in apparel and accessories.
3. List the major fashion capitals in the world and their importance to the field.
4. Use the language that the industry's professionals utilize when discussing wearable fashions.
5. Describe the stages of the fashion cycle.

INTRODUCTION

From runways in Paris, where architects of haute couture unveil their collections, to street corners, where vendors hawk counterfeit copies of handbags, jewelry, and other accessories that bear the same designer labels of the French originals, consumers are able to purchase wearable fashions that suit their personal preferences.

In upscale fashion salons, conventional and specialized department stores, specialty chains, boutiques, and flea markets, fashion abounds at every conceivable price point. Customers can purchase anything from the latest fashion innovations to the conservative styles that are traditionally acceptable

year after year. The offerings are so enormous that every man, woman, and child can find an abundance of products quickly and conveniently.

The industry is one in which a network of specialists interface perfectly so that styles can be brought to the public in a timely fashion. Beginning with the mills that create fibers and fabrics, tanners who manipulate leather into supple, attractive materials, fur processors who transform pelts into workable materials, lapidaries who enhance stones with masterful cuts, and metal workers who alloy and shape the raw materials into pliable products, the stage is set for designers to create styles that will motivate consumer purchasing. Based on fashions of yesteryear, historical inspiration, emergence of new fibers, the present political climate, new waves of theater and film, ethnic cultures, and a host of other inspirational resources, designers formulate their ideas of apparel, footwear, handbags, belts, jewelry, watches, gloves, hats, hosiery, scarves, cosmetics, and fragrances.

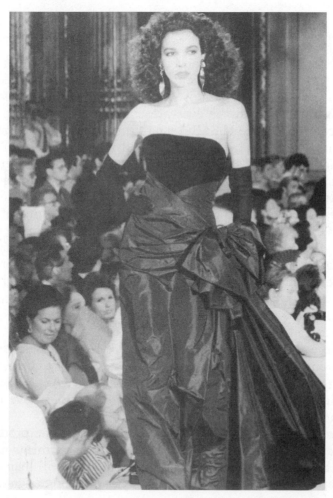

Figure 1-1 Yves Saint Laurent ballgown modeled on Paris runway. (Courtesy of Yves Saint Laurent)

Once the stage has been set with the finished product, it must be distributed to retailers who use their expertise to motivate the public to purchase.

In markets around the globe, from the traditional fashion capitals to the unlikely shores of Third World nations, businesses are eager to meet the competitive challenges of this complex industry. Where America was once the world's leading producer of apparel and accessories, it struggles now to retain that position of leadership. With lower wages a primary consideration for the proliferation of off-shore producers, domestic manufacturers often find competition difficult.

This chapter will serve as an introduction to the material presented throughout the text. It will introduce the reader to the language commonly used in the trade, a historical overview of the twentieth century's fashion innovations, the domestic and international fashion capitals, the roles played by the industry's major components, and the cycle that fashion follows in the reintroduction of styles.

THE SCOPE OF THE INDUSTRY

As a whole, fashion apparel and accessories is a multibillion dollar industry. In America, where the field is constantly being plagued by the competitive forces of other nations, the numbers of those employed continue to decline. Even with the ever-present decreases, fashion is a business that, according to the U.S. Bureau of the Census, ranks fourth in manufacturing, after steel, electronics, and motor vehicles. Apparel alone accounts for annual sales of more than $20 billion and employs over 1 million people, with women's and children's products accounting for more than 400,000, and men's and boys', 335,000. Hat workers number 16,000; furs, 2000; and other accessories employ a total of 41,000.

America's fascination with designer names has made an impact on the manufacturing industry. Of the producers who once used their company names on the apparel and accessories they made, many now opt for designer signatures to enhance their products. Through *licensing*, an agreement in which individuals and businesses give other companies permission to use their names on products for a fee, well-known designer labels now adorn everything from apparel to eyewear.

The early licensing leader was Pierre Cardin, who today has such agreements with hundreds of producers of every conceivable type of fashion product. Others such as Liz Claiborne, Anne Klein, Bill Blass, Yves Saint Laurent, Donna Karan and Perry Ellis have capitalized on these arrangements.

Some designers require complete control over the products that bear their names and demand the right of refusal for garments and accessories that do not fulfill their requirements. Other merely "sell" their names for a fee or commission without getting personally involved in design or production.

The fashion retailing component continues to grow in the United States. The major players in today's market are the chain operations, with companies such as The Limited dominating the field. Women's wear alone accounts for more than 80,000 stores; men's wear, 19,000; shoes, 43,000; and jewelry, 50,000. Department stores have taken a back seat to these ventures, with many forecasters predicting that the roles they play in fashion retailing will continue to erode.

Direct marketing has become a major method in the distribution of fashion apparel and accessories to the consumer. With the ever-increasing number of women employed outside of the home, catalog shopping has become a way of life for those without time to shop in stores. Traditional retailers and catalog companies continue to expand their offerings, via the mail, and are achieving greater sales volumes each year.

Today, the home shopping networks are becoming dominant forces in fashion merchandise. Where 24-hour broadcasts of programs such as QVC features bargain-type accessories and apparel, the new wave of merchandise selling on television is beginning to rival the assortments offered at prestigious stores. At this writing, Saks Fifth Avenue, Nordstrom, and Macy's have initiated plans to sell their upscale collections on home shopping networks.

Figure 1-2 Arnold Scaasi design for Mohl Fur Company. (Courtesy of MFA)

THE LANGUAGE OF FASHION

Each industry or profession has its own language. Fashion, as with the others, uses specific terminology to describe its many facets. To be a successful participant in the field, it is necessary to understand the practices and procedures used in its daily routines.

The terminology offered here is that which is typically spoken in the apparel and accessories industry and is used throughout the text. More technically oriented terms, for example, those used in the textiles field, will be discussed in specific, relevant chapters.

Style　The characteristics that distinguish one apparel or accessories design from another. Styles do not change, although their acceptance by consumers changes all the time. For example, bell-bottoms is a style that features pant legs that flair at the bottom. The style does not change, but its popularity does.

Fashion　The style that is popular or prevails at the time. Miniskirts, platforms shoes, princess-line dresses, and capes are all styles, but their acceptance by consumers changes periodically.

Figure 1-3 The six-button double-breasted jacket is a fashion favorite. (Courtesy of MFA)

Silhouette The shape or outline of a garment. There are primarily three basic shapes or silhouettes in fashion, the others being variations of these. They are the tubular that falls in a straight line, the bustle that features interest to the back of the garment, and the bouffant that characteristically flares out in fullness.

Fad A fashion that is short-lived. When a style gains quick acceptance from the public but disappears almost as quickly, it is called a fad. Probably one of the most famous fads of the fashion world was the collarless "Nehru" jacket of the 1960s that had immediate fashion recognition but faced a rapid demise.

Classic A style that is a basic, integral part of a wardrobe. A strand of pearls, blazer jacket, button-down-collar shirt, and a pair of loafers are considered to be classics.

Collection A designer's merchandise offering for a particular season is called a collection. It is usually used when describing the complete work of an upscale designer. For popular-priced merchandise, the term *line* is often used in place of collection.

Couturier A French term used to describe male designers. Although it may be used for all designers, only the most original creators of fashion are referred to as couturiers.

Couturiere The female counterpart of couturier.

Haute couture The fashion houses of Paris such as Yves Saint Laurent and Chanel that belong to the Chambre Syndicale de la Couture Parisienne, the organization that regulates fashion in Paris.

Prêt-à-porter A French term used to define ready-to-wear apparel.

Confinement The sale of merchandise on an exclusive basis to a specific trading area. It might be a designer collection that is "confined" to one store in an area or a fabric that is for the exclusive use of one manufacturer.

Knock-off A copy of a higher priced design.

Custom made Merchandise that is specifically tailored to fit a customer's measurements.

Resource A term that is used by retailers to describe the manufacturers or wholesalers from whom they purchase.

Fashion cycle The stage through which fashion passes from introduction to decline.

Trend The direction in which fashion is moving.

Hot item A best selling item that is reordered again and again.

Trunk show A method of showing a collection of apparel, by designers or their representatives, in stores.

Target market The group of consumers to whom a line of merchandise is directed.

Showroom The place in which vendors show their lines of merchandise to prospective buyers.

Seventh Avenue The entire wholesale district of New York City's garment center.

Price point A specific price at which a line is offered for sale.

Off-price A price that is lower than the original wholesale price.

Jobber A term that is synonymous with wholesaler.

Licensing When manufacturers or designers give other producers the rights to their names for a fee or commission.

Off-shore production When a manufacturer creates a line in one country and has it produced in another.

Market week The period of time when the store buyers come to the wholesale markets to place their orders for the next season.

THE FASHION CYCLE

When a particular style embraced by the consumer is worn for at least one season, it is called a fashion. When the period of acceptance is extremely brief, it is called a fad. There is no specific period of time necessary to be called one or the other. Styles pass through four different phases from their inception to their demise, better known as the fashion cycle. In the early 1990s, platform shoes completed its cycle in a few seasons, whereas in the late 1950s, the "chemise" dress lasted a few years.

The cycle begins with the introduction stage, moves into a growth period, on to a maturity stage, and falls from favor in a period of decline.

INTRODUCTION STAGE

Generally, when a style is introduced into the marketplace, it is at the highest price points. It might be a new silhouette featured in a French couturier's collection or one that is part of a distinctive manufacturer's line. At this point, there is no way of knowing if the style will be popular with the store buyers and consumer public. Thus, the introduction stage is costly to the producer who has spent considerable money on fabrics, trim, and creation of the items. This being the case, the newest styles are usually expensive to purchase. If the garments or accessories are successful sellers, the knock-offs are readied for distribution at lower price points.

GROWTH STAGE

If the style is generally accepted, a variety of adaptations, at many different prices, are in the marketplace. When the "pouf" skirt was introduced by Christian LaCroix in Paris, it was the rage of the season. In a short time, the copies were everywhere. Fashion consumers bought the originals for thousands of dollars, whereas others were busy buying adaptations for under $100.

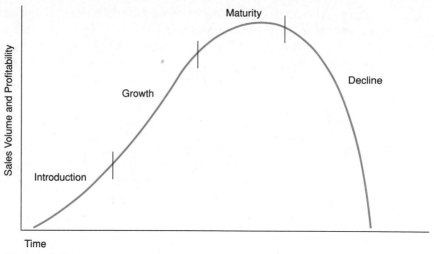

Figure 1-4 The stages of the fashion cycle.

MATURITY STAGE

At this point, the style achieves its greatest sales volume. The time of maturity might be one season or many. Although the industry tries to motivate the consumer to buy at least one item in the style, the purchase of many gives the style a longer life. In the case of designer jeans, in the early 1970s, consumers were so taken with the fashion that wardrobes all over the country featured numerous pairs. The difficulty with this period for manufacturers and retailers is their ability to determine when the popularity will decrease. All too often, the decline comes quickly, leaving the industry with merchandise that is no longer considered fashionable by the public.

DECLINE STAGE

At the point when it appears that the style is losing popularity, the original designer or manufacturer has long abandoned the item, readying something new for the customer. During this period, left-over pieces are drastically reduced to prices that will sell quickly. It is urgent to rid the inventory of such items before they are no longer desired at any price.

Many manufacturers have opened their own stores in outlet centers from coast to coast so that they may dispose of the merchandise heading for decline. Others use off-price merchants, who buy at prices that are far below the original wholesale, for disposal.

THE WORLD'S FASHION CAPITALS

Unlike years past when the domestic fashion scene was dominated by New York City's Seventh Avenue and Paris was the major European home of high-fashion apparel, other centers have entered the market-

place. Although both New York and Paris are still dominant forces in the production of clothing and accessories, cities abroad such as Milan, London, Tokyo, and Hong Kong, and American cities such as Los Angeles, San Francisco, and Chicago have gained international reputations as major players in the field of fashion.

NEW YORK CITY

The undisputed headquarters for fashion apparel and accessories is New York City's Garment Center. It is made up of streets on Seventh Avenue (often used interchangeably with Garment Center) and Broadway, that run from 34th to 41st Streets and include all of the side streets in the area. In these few blocks, a wealth of men's, women's, and children's clothing and accessories are designed and manufactured for distribution all over the world.

From the upscale collections of Calvin Klein, Donna Karan, and Bill Blass to the popular-priced offerings of producers who do not benefit from recognizable names, every fashion style and price point is available in these quarters.

Figure 1-5 New York City's Garment Center, the leading American fashion apparel and accessories market.

At one time, the vast majority of the designs developed on Seventh Avenue were also manufactured there. Today, however, with the increasing production expenses, many have opted for domestic cities to make the goods, where the expense of doing business is less than in New York City, or for off-shore centers, where production costs are even lower. Although some sewing and assembling still takes place in the garment center, the majority of the fashion businesses merely maintain design studios and showrooms where the buyers can come to see and purchase the merchandise.

DOMESTIC REGIONAL MARKETS

Known as regional markets, several cities across the United States are home to apparel and accessories companies.

California, known for its casual lifestyle, has been the birthplace for less formal types of items. From swimsuits to dresses, California towns offer their own views on fashion. Both the Fashion Center in San Francisco and the CaliforniaMart in Los Angeles house hundreds of permanent showrooms that feature the wares of the West Coast.

Florida has also become an important entry in fashion merchandise. Not only do Miami's producers design and produce extensive lines of apparel and accessories there, but the Miami Merchandise Mart has become the home to southern manufacturers who use this Florida city as their major wholesale outlet. Buyers from every part of the south regularly convene during market weeks to eye and buy the lines of that region's producers.

Many consider Milwaukee to be the leather center of America. With numerous tanners turning hides into workable skins and shoe manufacturers producing many shoes for the nation, buyers from all over the country flock there for their leather needs. In addition to this merchandise segment, the area has also been home to many famous domestic lines such as JH Collectibles.

THE EUROPEAN FASHION CAPITALS

Most of the great original designers of haute couture still choose Paris for their headquarters. Karl Lagerfeld, Christian LaCroix, Yves Saint Laurent, and others run empires that invent fashion apparel and accessories for the rest of the world to simulate. The greatest designers are members of Chambre Syndicale de la Couture Parisienne, the world's best known fashion trade association, which restricts membership to only a few companies.

Although couture still plays a major role in Paris fashion, with stores and private customers eager to purchase the fashions at the highest price points, many designers have added less expensive prêt-à-porter collections aimed at a wider segment of the international market.

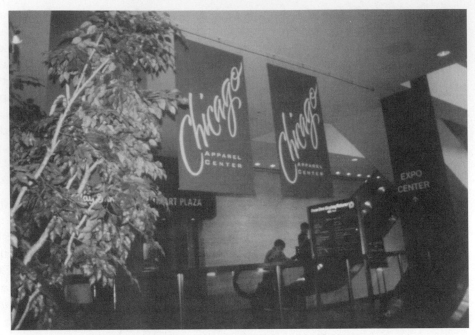

Figure 1-6 The Chicago Apparel Center is the Midwest's major wholesale market for fashion merchandise.

When the lights dim on the runway shows at a season's opening, all of the fashion world has its eyes on Paris for a glimpse of what the rest of the world will ultimately produce as adaptations of the originals.

From the days when Chanel, Balenciaga, and Dior introduced innovative design to customers all over the world to today's collections of Laurent, LaCroix, and Lagerfeld, Paris still reigns as king.

Milan has come of age in the past 20 years as a fashion leader. For many years, it produced the textiles and leathers that influenced designers all over the world. Today, although this is still the case, Milan has its own stable of fashion architects who have gained international renown. Giorgio Armani, Gianni Versace, and Gianfranco Ferre are but a few who have captivated audiences with their fashion genius. Armani, in fact, has come to be known by customers of many different classes through lines that range from the upscale couture bearing the Giorgio Armani label to the lower price points featured by Armani A/X stores throughout the world.

When one thinks of "mod" clothing of the 1960s, London and Mary Quant immediately come to mind. With a freshness not shown before to Great Britain's audiences and, later, to Americans, Quant's minis and hot pants put London on the map as an international capital of fashion merchandise. Today, Zandra Rhodes, Maxfield Parrish, Betty Jackson, and others have continued on the road opened by Mary Quant. In addi-

tion to the fashion innovators, London has maintained its reputation for fine, tailored men's wear. Home to Burberry, Turnbull & Asser, and Henry Poole, the British continue to uphold their reputation as the leading creators of fine men's wear.

Other European countries contribute fashion to the world. Although they are not in the same league as Paris or London, for example, more and more of the merchandise they produce is being exported to America and other nations.

Spain, for example, has been a leader in leather products. Spanish apparel, handbags, and shoes have been mainstays in many American shops. Finland's Marimekko has long distributed ready-to-wear across the seas, and Sweden has made its mark with youth-oriented, moderate-priced apparel.

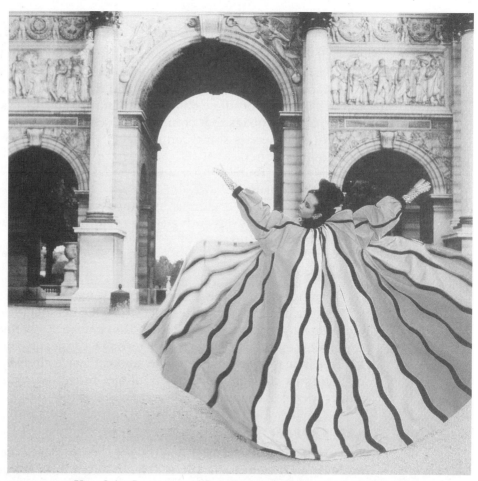

Figure 1-7 Yves Saint Laurent model at the Arc de Triomphe in Paris, major European fashion capital. (Courtesy of Yves Saint Laurent)

THE FAR EAST

Original design and licensing also make the Far East a fashion leader. Tokyo has been the home to famous designers such as Hanae Mori and Rei Kawakubo, who have achieved international recognition for their innovative creations, and its leading manufacturer, Renown, who produces much of America's design labels through licensing agreements. Although originality is not the mainstay of Hong Kong, it is that region that produces much merchandise for designers such as Giorgio Armani and Calvin Klein. With the high cost of production in these designer's native countries, off-shore production has helped them cut expenses. The combination of lower wages and expert tailoring has made Hong Kong a leader in fashion production. South Korea, similar to Hong Kong, concentrates on production for other country's designers rather than on creating original designs.

CLASSIFICATIONS OF APPAREL AND ACCESSORIES

The fashion apparel and accessories industry is segmented into two distinct classifications. The apparel market concentrates on the design and creation of clothing for men, women, and children. The accessories component's task is to produce adornments and enhancements such as shoes, jewelry, and handbags that complete the wearer's outfits.

Although there is some commonality among the various categories, each has a uniqueness of its own in terms of production techniques, methods of distribution, promotional endeavors, and the benefits it provides to the consumer.

The following is a glimpse of the various segments of the fashion apparel and accessories industry. A more detailed account of each is offered later in the text.

WOMEN'S WEAR

The largest section of the fashion industry, women's wear is divided into product classifications and size ranges. The former include dresses, sportswear, active sportswear, suits and coats, knitwear, swimwear, rainwear, pants, blouses, intimate apparel, maternity wear, jeans, and bridal wear.

To eliminate the need for costly and extensive alterations, the industry tailors its clothing in a variety of size ranges. They include misses, juniors, petites, women's, half sizes, and tall sizes.

MEN'S WEAR

As with the women's market, men's wear is also segmented according to products and size classifications. The different lines include clothing, or tailored clothing as it is sometimes called, sportswear, active sportswear, formal attire, outerwear, shirts and furnishings, and raingear.

The size ranges for clothing, (coats, suits, sportcoats) are regular, short, long, extra long, portly, stout, extra large, and athletic cut. Each is targeted toward a specific height and weight and eliminates the need for extensive tailoring.

Dress shirts come in neck size and sleeve length, with the casual types produced in small, medium, large, and extra large.

CHILDREN'S WEAR

The major merchandise classifications are jeans, outerwear, swimwear, sleepwear, underwear, sweaters, shirts, blouses, and dresses. They come in a variety of sizes that are based on chronological age. Included are infants, toddlers, children's, girls', boys', preteen, and youth sizes.

ACCESSORIES

Serving both fashion as well as function needs, there are numerous types that complete the wearers' wardrobes.

Footwear, handbags, belts, jewelry, watches, gloves, hats, hosiery, and scarves come in a variety of styles, each designed to complement particular clothing.

Trimmings such as beads and bows are used to enhance apparel and accessories, whereas findings such as zippers and buttons are often more functional in purpose.

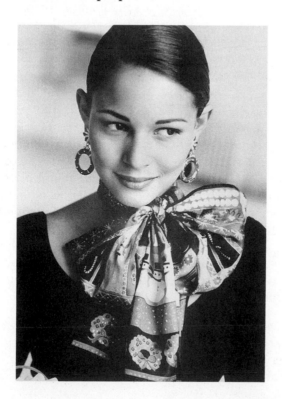

Figure 1-8 This bow-tied silk scarf adds color and excitement to the outfit. (Courtesy of the Vera Companies.)

APPAREL AND ACCESSORIES OF THE TWENTIETH CENTURY

The styles that we see featured as today's fashions are not really new. They have all been seen and worn over and over again since clothing and accessories were first created. Although contemporary designs have been translated to fit our present needs, the shapes and silhouettes are the same that have made fashion history throughout the decades.

Yesterday's geniuses such as Chanel, Balenciaga, Dior, Schiaparelli, Patou, Norell, and Mainbocher regularly used their creative talents to capture the attention of fashion-conscious consumers all over the world by expanding on the basic shapes. Today's fashion stars such as LaCroix, Lauren, Armani, Kamali, and Lagerfeld do the same. With the exaggeration of a hemline or neckline, the use of a bold, vibrant pattern, or the interpretation of something from the past, their designs make fashion headlines.

THE TURN OF THE CENTURY

Formality still reigned for men and women as Americans entered the twentieth century. Women wore waist-fitted dresses that required tight-fitting undergarments. Fabrics were chiffons or other sheers augmented with laces. The lengths were to the floor. The costumes were completed with large hats that sported feathers and bows, and gloves were part of every outfit, no matter the season.

Frock coats for formal wear and suits for less formal occasions were the order of the day for men. Footwear was primarily of the laced-up boot variety. Hats were required for every function. For more casual attire, knickers topped by tweed blazers were acceptable. Shoes, rather than boots, were part of the outfit.

The children's wardrobes mimicked those of their parents.

THE 1910S

Gone were the mandatory petticoats that fit snuggly under the corseted, full-skirted silhouettes. Straighter, simpler lines were the order of the day. For the first time, women revealed their legs in hobble skirts that had front slits. Because shoes were now more visible with the new styles, shoes and hosiery took on new importance. Hats were still considered necessities, but their shapes were smaller than during the decade before. Small handbags and parasols were accessory enhancements.

Men's dress became less structured with the introduction of the unpadded natural shoulder line and straight-legged trousers. Only the very special occasion warranted use of formal attire.

THE 1920S

Unlike any period in time that preceded it, this decade ushered in a new-found freedom for women. Wild parties, jazz, and illegal speakeasies

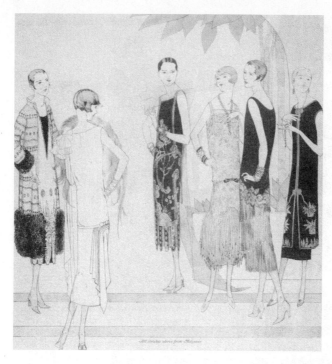

Figure 1-9 The flapper look of the 1920s.

made it a time for fashion innovation. Instead of the floor-length styles, dresses became shorter and shorter, with the new flapper look seen everywhere. Ruffled flounces adorned the long torso silhouettes, and layers of chains were the newest fashion accessory. Short hair was covered with cloches (close-fitting hats). Dresses laden with heavy beading and multilayered fringes were typical of evening wear. Fur shawls and wraps were the chosen coverings for evening. For fashionable women, the daytime featured a wealth of knickers and culottes that were topped with blazers.

Stylish men shed the straight-legged trousers in favor of bell-bottoms and flared models. Fitted jackets replaced the looser styles, and knickers were used extensively. The polo shirt was introduced for a more casual look.

THE 1930S

As the frivolity of the 1920s passed into the economically depressed 1930s, outrageous dress also lost its place in fashion. At the beginning of the decade, women made do with what they had and many altered their old clothes to give them a new look. A few years into the period, a more elegant and regal atmosphere prevailed for those who could afford it. The new order of the day called for mid-calf lengths for casual attire, and full-length dresses for evening. The bias cut was considered chic, with back-detailing and trains featured on gowns. Heavily padded-shouldered suits also were popular for daytime wear, with basic colored, soft fabrics enjoying popularity.

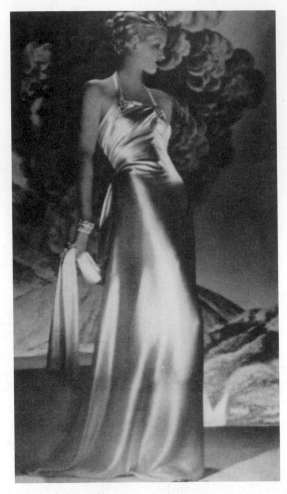

Figure 1-10 Bias-cut evening gown of the 1930s.

As did their female counterparts, men wore suits with padded shoulders and straight-legged cuffed pants that were augmented with pleats. It was a time when the double-breasted model became prominent.

Leisure wear was the latest in fashion news with tweeds for men and navy blazers and white pleated skirts for women. Pants emerged as women's apparel for casual wear.

THE 1940S

Fashion came to a sudden halt at the beginning of the decade when World War II took the world's attention. The couturiers of Paris closed their shops, and the world had to wait for another time to enjoy the pleasures of fashion merchandise.

With natural materials such as leather in short supply, synthetics had be used for shoes; nylon stockings were hard to come by because the fiber was mainly being used for parachute production. The government began

to restrict certain excesses such as more than one pocket on a blouse, and the number of buttons for closures were limited.

The look at the beginning of the decade was more functional than fashionable, except for the wealthy. Padding was used even more aggressively than in the 1930s, and silhouettes were straight and simple. Man-tailored suits were the hot items for women.

At the close of the war, Paris once again responded with innovative creations. Fashion producers all over the world took their cues from Dior who introduced very full-skirted dresses that were accentuated by tiny waistlines. The skirts grew longer and were topped by short, fitted jackets.

The youth of America chose flared skirts topped with oversized sweaters that were called "Sloppy Joes" as their most important costume.

It was a time when the new generation of "separates" was born, with American designers such as Bonnie Cashin and Claire McCardell making their marks as fashion innovators.

Men discarded their double-breasted suits for single-breasted models with narrow lapels. The less structured approach to men's wear caught fire with sportscoats and contrasting trousers.

THE 1950S

The highlight of the decade was Chanel's introduction of the chemise. Hemlines were raised and dropped and raised once more throughout the period. The strapless dress made an impact on evening wear, but sportswear was the major story of the time. Pants, pedal pushers, and shorts of all lengths were favorites for women. The mix-and-match concept became popular with consumers who purchased many different tops and bottoms that they could wear in many combinations. The natural fibers were joined by a wealth of man-mades.

At the middle of the decade, the "beatnik" look was stylish, with leotards and form-fitting pants topped by oversized shirts. A large segment of the younger generation chose the fullest skirts ever shown and wore them over stiffened petticoats to make them look fuller. Skirts made of felt and embellished with "poodle" appliques were the fad of that time.

Men preferred the "Ivy League" look that featured narrow lapels and natural shoulders in charcoal-grey flannel. The pants were simple and narrow and many sported "buckle" ornamentation at the back. The white shirt was no longer the only suitable color for appropriate dress. Pale pinks and blues were quickly added to shirt wardrobes.

Leather jackets became popular when Elvis Presley first sported his on television.

THE 1960S

The youthful look was the keynote of fashion as the decade began. The Beatles were credited with the new "mod" look. Although this was a style

that would catch on, it was the skirt length that caused the greatest controversy. At the beginning of the period, knee-lengths were most important until Mary Quant styles dictated the tiniest minis ever seen. Hot pants by Quant in London and Courrèges in Paris captured the minds and hearts of women all over the world. The boot quickly replaced the shoe as the desired footwear, and complete wardrobes of boots became commonplace.

With hats taking a back seat for many years, the millinery industry was excited when Jackie Kennedy, wife of the President, chose a pillbox style to accompany her favorite Chanel suits. Women all across the country soon wore copies of both the suits and the hats.

The chemise, previously popularized by Chanel in an earlier decade, was resurrected by Yves Saint Laurent. His version featured the bold geometric shapes of the artwork seen in Mondrian paintings. Many women preferred pantsuits for day wear, and every major manufacturer satisfied them with versions in flannels and tweeds.

Swimwear also saw a major change. Rudi Gernreich gave women a newfound freedom with unconstructed styles. To underscore his preference for this new look, he presented a topless version in his runway show. This was not the accepted style; however, it did signal a new look for decades to come.

Men also took to new fashion directions. Extra-wide lapels on jackets that topped bell-bottoms and flared pants were everywhere. Boots were

Figure 1-11 The pantsuit was a favorite during the 1970s. (Courtesy of Yves Saint Laurent)

also worn in place of conventional shoes. For the first time, jewelry became an important accessory for men in the form of chains.

The youth of the world found a fondness for the ragged look. Torn jeans, T-shirts, and army boots were typical uniforms.

As mentioned earlier, skirt length was ever-changing in the 1960s. By the close of the decade, the floor-length maxis made their debut.

THE 1970S

At the beginning of the decade, women, for the first time, soundly rejected the dictates of the fashion designers. The midi, introduced at the close of the 1960s, was a disaster! At this point, the world of fashion began to recognize the necessity of addressing the wants and needs of consumers instead of telling them what they must wear.

Pants were favorites as both separate garments and in suits. For evening wear, the pants, in luxury fabrics, were a favorite. So successful were the pants outfits that renowned designers such as Yves Saint

Figure 1-12 The pouf design, popularized by LaCroix in the 1980s, became the basis for future couture and ready-to-wear creations. (Courtesy of Yves Saint Laurent)

Laurent joined the bandwagon with his own versions. Minis and hot pants were the preference of the younger set, who wore them with sky-high platform shoes.

Men chose suits that featured suppressed waists and fully padded shoulders. The pantleg was flared. It was a time when men began to consider fashion important for themselves.

Denim resurfaced, this time emerging as a designer creation. Led by Calvin Klein, the fashion world produced flares, bell-bottoms, and straight-legged models that bore the designers signature on the back pocket. No longer was denim relegated to heavy-duty work; it was worn for almost all casual occasions.

The 1970s closed with a feeling of less formality. Casual attire was considered appropriate for most situations, and even when evening wear was called for, it was less dressy.

THE 1980S

During this decade, two major styles reappeared. Bored with the casualness of the late 1970s, designers tried to tempt their customers with a

Figure 1-13 Denim apparel was popular in the 1980s. (Courtesy of MFA)

revival of more exciting dress. LaCroix excited the fashion world with his pouf creations that echoed the full-skirted, 1940s designs of Dior. The bouffant silhouette was copied at every price point. Another return was the mini, popularized during the 1960s. First embraced by the young, it soon captured the attention of older women.

Designer labels were featured on an abundance of apparel and accessories. Through licensing agreements, names like Cardin and Dior embellished popular-priced garments. Signature status was dominant in the handbag industry, with fashionable women collecting many different models, each bearing a designer's name or logo.

For daytime wear, jeans continued to dominate, along with a host of other leisure-type outfits. This time, the denim pants were of the Levi type, with the designer models falling from favor. Warm-up suits became the rage, both on the tennis court and off, and sneakers replaced the sport shoe as appropriate footwear for many situations.

With more women returning to careers outside the home, a wealth of executive-type business suits became popular.

The hottest accessory at the close of the decade was the faux pearl necklace, popularized by Barbara Bush. It was worn with every outfit and was available at every price point.

Figure 1-14 The faux pearl necklace, popularized by Barbara Bush, was the late 1980s hottest accessory. This is an oversize version of the Bush necklace. (Courtesy of Henri Bendel)

For men, the "peacock" designs of Cardin that boasted accentuated shoulders and pant legs disappeared and, in their place, more classic suits were chosen for business. Both single- and double-breasted models were featured. After a day at the office and for leisure-time activities, the choice was sweatsuits, jogging outfits, and denims, each worn with sneakers.

THE 1990S

As the final decade of the twentieth century began, there was an air of individuality in dress. No longer was a specific style considered the only appropriate one. Skirt lengths were, at first, short but, at the time of this writing, midis were seen everywhere. The bell-bottom trouser was again being touted as the latest fashion, but it did not catch on as it did in the 1960s. Platform shoes were also tried again; they, too, did not reach the sales quotas demanded of a trend-setting fashion.

Men continued to wear the styles of the1980s for both business and daytime wear.

REVIEW QUESTIONS

Because the decade is not yet complete, it is anyone's guess where fashion will turn.

1. Which segment of the fashion industry employs the greatest number of workers? Which is second?
2. Where does the fashion apparel and accessories industry rank in comparison with the other leading industries in America?
3. Describe how licensing has increased the customer's awareness of designer names.
4. Which segment of the retail fashion business accounts for the greatest number of outlets?
5. Discuss the change in the fashion merchandise assortment now offered on the home shopping networks.
6. Differentiate between the terms *style* and *fashion*.
7. What is the difference between *fashion* and *fad*?
8. Define the term *off-shore production*.
9. List and briefly explain the four stages of the fashion cycle.
10. Why have many manufacturers who are based on New York's Seventh Avenue opting for production in other places?
11. To which organization do the great couturiers of Paris belong?
12. What is the difference between couture merchandise and pret-a-porter?

13. How has Hong Kong made its mark in fashion without any great numbers of original designers housed there?

14. For what major purpose does the women's apparel industry offer a great number of different size ranges.

15. How do the children's wear companies size their apparel products?

16. Describe the important styles that became fashionable during the "roaring twenties."

17. Why did fashion come to a sudden halt during the beginning of the 1940s?

18. What major silhouette did Chanel introduce in the 1950s that caught the fancy of women?

19. Who was the first designer responsible for the "mod" look of the 1960s, and what were the major "mod" styles?

20. During which era was denim resurrected to become a fashion item, and how did it accomplish its success?

EXERCISES

1. Using photographs from today's fashion magazines, look for styles of apparel and accessories that were once popular during another decade. Select five illustrations and mount each on a foamboard. Each should indicate the name of the style and the period in which it was considered to be a fashion item.

2. Prepare a report on the current status of the fashion apparel and accessories industry. Include statistical information showing the size of each segment in terms of dollar volume and numbers employed.

 Current information may be obtained through use of The Statistical Abstract of the United States or by writing to the Bureau of the Census in Washington, D.C.

3. Select a major wholesale market and investigate it in terms of the fashion products it sells to retailers, the number of companies in the market, and the areas the market serves.

 The information might be obtained by writing to a fashion trade paper in the area. In California, for example, the major regional periodical is the *California Apparel News*, and in New York City, it is Fairchild's *WWD* for women's clothing, and *DNR* for men's wear.

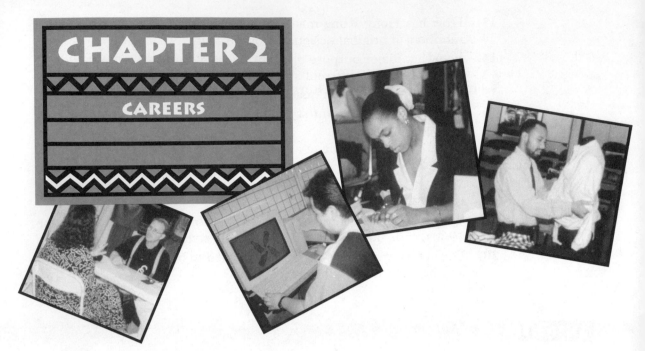

CHAPTER 2
CAREERS

LEARNING OBJECTIVES

After reading this chapter, the student should be able to:

1. Discuss the career opportunities available in all of the segments of the field of fashion.

2. Explain the many ways in which to discover employment opportunities in the industry.

3. Prepare the necessary instruments and aids that will be useful for the career search.

4. Plan for the actual interview.

5. Select wearing apparel that would be suitable for the interview.

6. Write a follow-up letter to a prospective employer, showing continued interest in the company and appreciation for the time spent during the interview.

INTRODUCTION

As Jhane Barnes lunched with a friend in a coffee shop adjacent to the college she was attending, little did she know that this would be the time and place where her illustrious career as a fashion designer would be launched. As the two were engaged in conversation, a passerby stopped and asked Jhane's male companion where he bought the trousers he was wearing. He responded that he did not buy them, they were the creation

of the friend with whom he was sitting. After a few words, the passerby, who identified himself as a buyer, offered to purchase several dozen pair if Jhane could have them quickly produced. She hurried to school to meet with a professor who was able to make a contact for her with a contractor. The rest is history! She is one of today's most creative designers, with her collections regularly featured in prestigious stores like Bloomingdale's and Neiman Marcus.

Although this was an unusual and exciting entrance to a career, it is not typical in the field of fashion. No matter how talented and well prepared one might be, there are standard procedures that should be followed to assure easier accessibility into the industry.

Fashion careers that are specifically apparel- and accessories-oriented provide excitement, unlimited challenges and substantial monetary rewards, and are available in many different industrial segments. A person with a special creative ability might choose to pursue a career in clothing design or in visual merchandising, designing display settings that enhance a store's merchandise. If merchandising is the area of interest, a career as buyer, market consultant, or fashion forecaster could be the right choice. Those with communication skills might opt for a position as a fashion writer or commentator.

No matter what the initial or ultimate goal, the apparel and accessories field is one that has no geographical boundaries, as is the case in

Figure 2-1 Apparel designer examining details and trimming. (Courtesy of Criscione)

some other industries. Although fashion is one of the largest industries in the United States, opportunities are available in most corners of the world. From the fashion runways of the European capitals such as Paris, London, and Milan to the textile mills in the farthest reaches of the Orient in Hong Kong and South Korea, manufacturers, importers and exporters, retailers, market consulting organizations, fashion forecasters, publishers, visual merchandising companies, and wholesalers are always ready to use the services of individuals who are properly trained and motivated to develop careers. A quick look at the industry's trade papers immediately reveals a host of these available, global opportunities.

As in any initial career search, it is the better prepared individual who has the advantage over those with whom he or she is competing. Understanding the "rules of the game," which is explored in this chapter, will provide that necessary edge.

DISCOVERING THE OPPORTUNITIES

Whether the goal is to become a production patternmaker, international sales service representative, design room coordinator, or any other professional in the field, one must first learn where the available positions are. There are several ways in which to learn about the industry's needs.

TRADE PERIODICALS

Most companies run classified advertisements in trade papers such as *Women's Wear Daily*, *The Daily News Record*, and *California Apparel News* to announce openings. The first two feature potential employment opportunities all over the world because they are internationally distributed. The latter, a regional publication, uses a more regional approach because its pages are earmarked for the California market.

In addition to providing the career hopeful with company ads, individuals may also place their own requests in these papers in the positions-wanted section, notifying the industry of their availability.

CONSUMER NEWSPAPERS

Newspapers such as the New York *Times*, *Los Angeles Times*, and others that are based in cities where segments of the fashion industry are located, regularly feature classified advertisements that announce job openings. In addition to the specific company's ads, employment agencies that specialize in the fashion industry also place ads listing their areas of expertise.

JOB PLACEMENT CENTERS

Most colleges and universities have centers that assist graduates with career placement. Those such as the Fashion Institute of Technology in

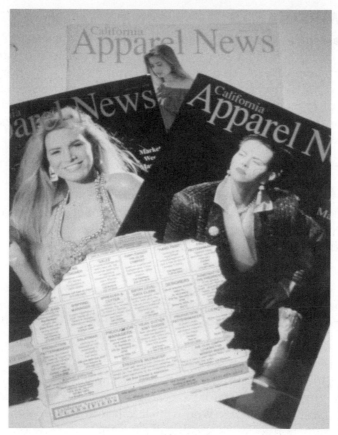

Figure 2-2 Trade paper classified ads for the fashion industry.

New York City and others that offer a host of fashion-oriented programs are regularly notified by the industry about specific career opportunities. Not only do these centers provide up-to-date information, but they also have materials such as "How to Write A Resume" and "How to Prepare For An Interview" available to help the job candidate become better prepared to find employment.

NETWORKING

One of the better ways to get one's foot in the door is through recommendations from people already in a company's employ. Each of us has friends and relatives who might work in the fashion field or might be aware of someone who does. By calling on this network of people, it is possible to learn about potential employment and how one might go about gaining an interview.

All too often, resumes that are sent to a company get lost among the many that are received by the people in positions of hiring. When a resume is hand delivered, it is more likely to be read.

INDUSTRY COMPONENTS

The fashion apparel and accessories industry transcends many different levels from those that provide the raw materials to those that sell to the ultimate consumer. Textile mills, manufacturers, market consultants, retailers, advertisers, and other industrial components employ a wide range of specialists who perform a host of fashion-oriented jobs.

Some of the more typical career classifications will be examined within specific industry components.

MATERIALS PRODUCERS

Apparel and accessory products are manufactured from a vast assortment of materials that include textiles, leather, and furs. Each of these industry segments provides opportunity for employment.

The Textile Industry. The field of textiles is made up of those with the creative talents who produce the designs, technically oriented individuals who participate in the transformation of the designs into fabrics, and those who market the products to the garments and accessories manufacturers.

Designer. Textile designers have the responsibility to create patterns on paper that will ultimately become fabrics. The patterns must be presented as repeats, indicating how they will appear on the finished product. Major companies often use two categories of designers, those who develop the pattern and those who translate it into the repeat format.

Designers may work specifically for one company or might freelance and work, by contract, for many textile mills.

Colorist. Although the designer is responsible for the pattern creation, the color combinations in which they are produced are often numerous. Large companies generally prefer to use colorists who specialize in creating color harmonies that enhance the details of the design. Although there are certain theoretical standards in terms of color combination selection, often it is the unusual, rather than the typical, that attracts attention and makes the patterns more salable.

Converter. Under this general classification, which involves transforming unfinished or gray goods into usable fabrics, dyers, printers, and finishing specialists play significant roles. The tasks performed are technically rather than artistically oriented. A complete understanding of dyeing and printing techniques, coloring agents, and finishing applications is necessary to work as a converter.

Grapher. In the knitwear segment of the textile industry, graphers are employed to transfer the designer's original pattern onto graphs, which are used to reproduce the patterns. To work as a grapher, it is necessary

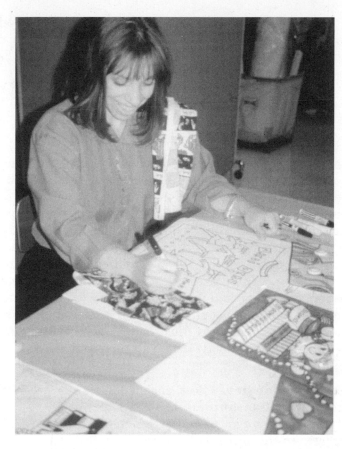

Figure 2-3 Colorist selecting appropriate color harmonies for the design. (Courtesy of Tickle Me)

to understand the various knitting construction techniques and how the design will take to the specific materials.

Stylist. The large textile mills usually employ a stylist who is responsible for determining the image that the next season's line will feature. He or she investigates color trends, yarn innovation, and fashion forecasts and passes them on to the company's colorists and designers. Armed with the stylist's suggestions, they are better able to prepare the new line.

Fabric Supervisor. When there is a substantial amount of yardage being produced, a fabric supervisor is needed to oversee many of the areas of production, with much of the attention focused on quality control. If a print is off-center or improperly aligned on the fabric, it will end up as a "second," resulting in company losses. If damages to the fabrics appear in abundance, the entire run will have to be sacrificed at low prices. The fabric supervisor has these and other responsibilities to make certain that the final product will come off the production line as it was intended. To perform in this capacity, the individual must be knowledgeable of all processes used in producing textiles.

Production Manager. As with the fabric supervisor, the production manager must also have the technical expertise necessary to run the plant operations. The job primarily involves the coordination of each area such as weaving, printing, dyeing, finishing, and quality control and making certain that all properly interface with one another. With time being of the essence in textile plants so that orders can be delivered when specified by the company's accounts, he or she must keep the assembly-line operations moving at a steady pace.

Salesperson. The textile industry may sell directly to the apparel and accessories companies or to wholesalers who, in turn, sell to these outlets. To properly service both of these users, the seller must have a complete understanding of every aspect of the textile industry. The areas of expertise must include fiber composition, weaving and knitting techniques, the manner in which the fabrics have been colored and printed, the coloring agents used, the finishes utilized and how they will enhance the fabrics, the potential uses of each fabric and how it may be used by the product designers, and the care necessary to extend the fabric's life.

Although salespeople in many industries gain their knowledge on the job, those in the textile field must have a technically oriented fiber and fabrics education to properly deal with the problems that such a complicated industry faces every day.

The Leather Industry. Those engaged in leather production are more concerned with transforming the hides and skins of the animal into usable materials than in the actual design of garments. The creative uses are relegated to the apparel and accessories designers.

Tanner. The people who are involved in the tanning process are responsible for converting the raw collagen fibers of the hides and skins into stable products that are not susceptible to rotting.

Today's tanners are particularly versed in "chrome tannage" and must be technically educated to handle the procedure, which involves the application of the appropriate chemicals in the proper amounts to produce a quality material.

Dyer. Although those involved in textile coloration must be properly trained, the leather dyeing process requires an even greater understanding of coloring. Because the hides and skins are nature's products, each piece has individual, inherent characteristics that must be addressed during the dyeing process. To skins with areas of pigmentation, the dyer must be able to apply the appropriate amount of color that will render the entire piece one color. Certain leathers require combination dyes to assure in-depth penetration, a problem with which the dyer must also deal. How much time the dye needs for perfect absorption, the type of coloring agent that provides the best results, and which dyes perform best are just some of the problems he or she will regularly face.

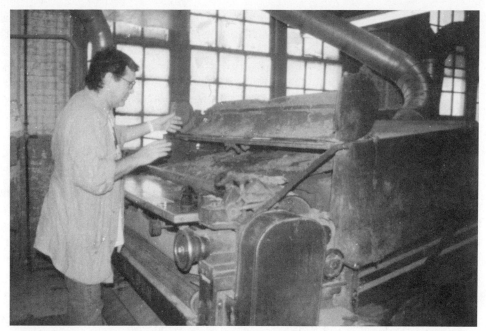

Figure 2-4 Finisher at machine that applies a functional finish to leather. (Courtesy of Seidel Tanning)

Finisher. After the dyer has completed the coloring task, the finisher is called on to further enhance the leather's beauty and make it more functional. People in this phase of the operation must have a complete knowledge of the sophisticated materials that do such things as make the dyed leather more opaque and render them resistant to abrasion and staining.

The Fur Industry. The fur industry, as with the other two material-producing industries already explored in terms of employment, provides career opportunities that require complete technical knowledge.

Purchasing Agent. The purchase of pelts is unlike that of most other materials. It is a situation in which the products are sold in bundles at auction. Purchasers are not given a specific price for each bundle of pelts but must make an offer through a bidding process in the presence of other purchasing agents. To make certain that an appropriate bid is being offered, the agent must have a complete understanding of how to value each lot of merchandise. Being able to judge quality in terms of fur density, uniformity of color, skin matching, and other characteristics is imperative because each contributes to the ultimate price that will be paid.

Colorists. Although many pelts are used in their natural colors, dyeing and bleaching are often used to either enhance the original colors or radically change them. Because the furs are so fragile, special attention must be paid during these color-altering periods.

When a bundle of skins is examined, it might reveal that some do not have the exact shading of the others. The expert dyer, in this case, must be able to enhance the color of the ones that do not match to bring uniformity to the entire bundle. This takes a great deal of expertise.

In the fashion world, bright colors might be the order of the day instead of the natural color of the skins. The colorists must first apply bleaches before the new colors are added. Only a complete understanding of the different dyes and bleaches will assure that the furs will not be damaged.

Because pelts are often expensive, errors will be costly for the company.

Cutter. Only the skilled worker may be used in cutting the pelts. Some techniques, such as "letting out," which will be described in the chapter on furs, requires hundreds of ⅛-inch cuts to be made on each skin. Each cut is done by hand, and the slightest error could prevent the skin from being used in the garment. The cutter must be able to work quickly and accurately.

Salesperson. Once the garment has been constructed, it is either sold directly to the consumer at the fur manufacturer's facility or to retailers. In either case, a complete understanding of the product is necessary to accomplish the sale. Sellers must be knowledgeable in terms of construction, coloring techniques, characteristics of each fur family, benefits to the customer, and care of the product.

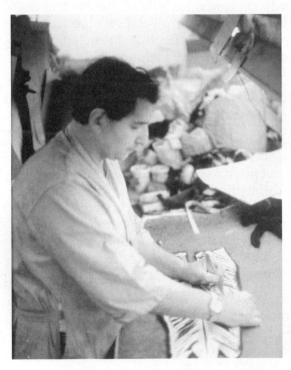

Figure 2-5 Fur cutter "letting out" a pelt.

MANUFACTURERS

Whether the production is apparel- or accessories-oriented, the manufacturing industry offers numerous careers ranging from those that involve design and production to the ones that are involved in distribution.

Designer. Large companies employ a creative team that is directed by a head designer and might include a variety of assistants with varying responsibilities. In the smaller companies, the design task is generally the responsibility of one individual who wears many different hats.

To participate on a design team, the individuals must be technically trained, with the best coming from special educational institutions such as Parsons School of Design or Pratt Institute. There they have learned all about design theory and have mastered sketching, draping, pattern making, and sewing, all necessary for employment in the field.

In addition to their technical competency, the professional designer must possess significant artistic ability, which is at the core of every design. They must be able to translate their inspirations, which might come from any number of sources such as travel to a foreign country, a new movie, a famous period in art, or a popular ethnic culture, into salable clothing or accessories. The comprehension of color and how to best use it to enhance the designs are also musts for success in the field.

Although the creative abilities are of paramount importance, the able designer must also have a sense of the market being served so that the

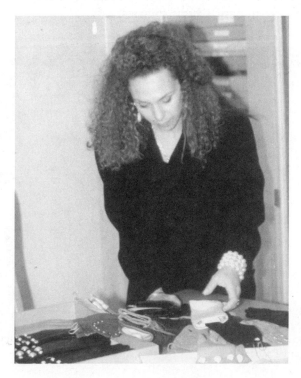

Figure 2-6 Glove designer, Carolina Amato, examining her line. (Courtesy of Carolina Amato Inc.)

designs will serve specific needs. Being able to produce exciting products with viable sales potential is imperative to the success of any company.

A look at many fashion advertisements and promotions quickly reveals the importance of the designer to the company. Many designer names and company names are one and the same and it is that name that captures the attention of the consumer. A great many such as Bill Blass, Donna Karan, and Ralph Lauren are principals of their companies and have significant influence over many of their organization's operations.

Designer assistants perform many of the same duties as the head designers. They are, in fact, often responsible for the creation of specific styles that are shown to the designer for approval. In some companies such as Liz Claiborne, a large team of assistants actually produces all of the styles. Assistant designers get little recognition from the outside world for their efforts, with the attention focused on the designer of record.

It is the designer, be it the head or assistant, who provides the lifeblood to the company through his or her ability to create appealing products.

Patternmaker. The unsung hero of the back room is the patternmaker. He or she must take the original designs and transform them into patterns that will be used in the production of the merchandise. A complete knowledge of sewing, production techniques, cutting, fabric use, and grading is necessary to perform this job. With the attention generally focused on design, merchandising, and sales in the fashion industry, there always seems to be a shortage of these technically trained people who command significantly high salaries.

Figure 2-7 Patternmaker translates the designer's creation into production patterns. (Courtesy of Saint Laurie)

Product Manager. Working closely with the design team, the product manager's role is a coupling of creativity and merchandising skills. The specific tasks performed include handling purchase orders for materials and trim, costing each style, planning for the necessary yardage for each product, determining the minimum number of individual items needed to be sold before a style goes into production, distribution scheduling, and assisting with presentations to major retail accounts.

Those best suited for such positions should possess experience in merchandising, operations, sales, and retailing as well as the ability to communicate both verbally and in writing. Formal education in marketing, manufacturing, or merchandising is generally required of those seeking careers as product managers.

Merchandiser. For the designer's creations to become salable items, there must be a sense of which market the line will serve, how many different styles will comprise the collection, which types of fabrics will best enhance the projected styles in terms of fiber, construction, and cost, which mills will best provide these materials, and how much the final product will cost.

In some small companies, especially those that specialize in adaptations or "knock-offs" of popular styles, the merchandiser also takes on the task of designer. He or she must, in addition to performing all of the typical merchandising tasks mentioned earlier, scan the market for higher priced items that can be translated into styles that would have a life at his or her company. Often, this merchandiser selects components such as silhouettes, sleeves, and necklines from various styles and reassembles them into new models.

Merchandisers for the major companies command high salaries, with those who perform as product developers being paid even more.

Stylist. Some companies use stylists exclusively instead of designers for the creation of their product lines. Where designers have the technical and artistic ability to create original models, the stylist is an individual with good taste who can recognize the various components that make up a good style, line, or collection.

By visiting textile mills, trimmings companies, fashion forecasters, market consultants, and retailers, the stylist is able to determine the needs of the market for the next season and to assemble lines that will satisfy the customer's needs.

The job is research oriented and may take the individual anywhere in the world where fashion is at its forefront. Places such as Hong Kong, London, and Milan are typical stops where the stylist may research the elements that will be needed for his or her company's line.

In companies that do employ designers, a stylist might work as a design assistant, providing the information gathered from researching the market.

Production Manager. To make certain that the manufacturing process is carried out in a timely manner that addresses such areas as the actual production, delivery of materials and trimmings, and quality control, it is necessary for a skilled production manager to be in charge.

The manufacturing process may be vertically integrated, that is, all of the operations are performed in house by the company or approached by using outside companies, known as contractors, for some of the operations. In this case, the production manager must coordinate the efforts of his or her own factory with the outside agency. To further complicate matters, many businesses are using off-shore plants to perform some of the manufacturing processes, requiring the production manager to make trips to these foreign shores.

The individual concerned with the management of the production must have a full understanding of the technicalities of cutting and assembling, the workings of the equipment used in the procedures, the abilities of the people in the plants, the complexity of the different materials used, and anything else that might impede production. Although the designer's styles or models might be considered to be the backbone of the company, poor quality production can seriously affect the company's profitability. Production managers are therefore among the highest paid performers in the fashion industry.

Samplemaker. After the original design has been drawn or draped on a mannequin, a number of samples must be completed. One might be used for pattern making and others for production purposes and use in the

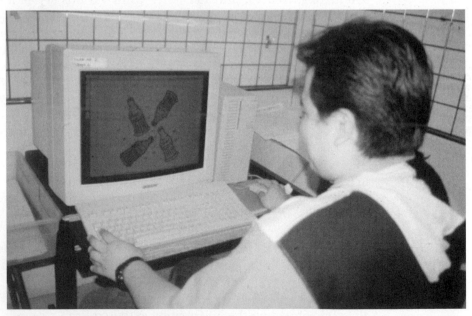

Figure 2-8 Samplemaker using computer and design system. (Courtesy of Tickle Me)

company's showrooms where the lines are offered to the buyers. Specialists in this field must be capable of hand and machine sewing and be competent in the translation of the designer's work into models.

Purchasing Agent. The materials used in the production of apparel and accessories include textiles, leather, furs, metals, stones, plastics, lucite, and vinyls as well as a variety of trimmings and findings (functional trim such as zippers). In the small companies, a jack-of-all-trades performs the purchasing duties, whereas in the larger companies, the chores may be split among a few people. Whatever the situation, those responsible for buying the materials must have knowledge of the various materials' resources, the products and their characteristics, and how they will serve the designers' creations.

They are also concerned with production schedules, price points, and any role that the materials will play in the development of the line. To satisfactorily plan the purchases, the agents must be both proficient in mathematics so that yardage can be assessed and sufficiently competent to negotiate the terms and write the orders.

Quality Controller. With the enormous amount of competition in the apparel and accessories markets, each company must be concerned with quality. Not only will such attention bring greater profits to the company but it will encourage repeat business from the retailers, season after season.

The individual who is responsible for keeping the quality at a level prescribed by management must be aware of production at every point and be able to catch the manufacturing errors. Whether it is ill-matching buttons, zippers that have been poorly sewn, or stripes that do not properly align themselves, any error, no matter how slight, must be corrected. He or she should be an individual who is meticulously responsible and capable of recognizing potential problems during production. It is a position that requires continuous presence on the job, regularly examining the products for flaws. When little attention is paid to quality control, merchandise returns and cancellations are possible, each reducing the company's ability to make a profit.

Customer Servicer. More and more fashion manufacturers are making certain that customer satisfaction is guaranteed. Not only do these people interface with the retailers, but many have hotlines for customers to call to air their complaints or merely obtain information about product care. By doing so, they are making repeat business more likely.

People in customer service must be both knowledgeable about the company's lines and willing to help correct any problems associated with purchases. It might be an irate consumer whose swimsuit ran during use in a pool or whose garment shrunk after laundering or a retail buyer complaining about shoddy construction. Whatever the situation or level from

Figure 2-9 Salesman selling his line at the International Boutique Show. (Courtesy of Larkin)

which the complaint originates, it is the responsibility of those in customer service to be cordial and to help make any necessary adjustments.

Those best suited for this career must have excellent communications skills, a pleasant attitude, and the ability to solve problems.

Salesperson. It is the seller, more than most others in the industry, whose competency determines whether or not the company's products will reach the retailer. Those who work for apparel and accessories manufacturers are among the highest paid in the industry. With monetary rewards based on commission, straight salary, or a combination of both, they are capable of substantial incomes.

Selling for the manufacturer involves two different groups of purchasers, those who work as retail buyers and those who are representatives of resident buying offices who often act as agents for the stores. Whether it is the small fashion operation, major department or chain organization, or resident office, the job calls for the same involvement.

The professional seller must be able to generate business for the company by establishing positive rapport with the customer. Once a trust has been established and the recommended items of the past season sold, the seller's job is simplified and repeat business is easier to come by. Those who sell fashion, and have established a regular clientele, often find that customers follow them even if they move on to new companies.

It is the seller who not only must have good verbal skills but must be able to take the customer through the various stages of the sales presentation. Helping the buyers with their merchandising plans, promotional

endeavors, and visual presentations are just some of the other duties they perform. The skills may be acquired in college-level sales courses and refined on the job.

Manufacturers also provide a host of other fashion careers as fit models, those who are at the designer's service to make certain that the original sample is appropriately crafted; cutters; sewers; finishers; inventory expediters, those responsible for distribution of the finished goods; and order processors.

RETAILERS

Through a vast network of department stores, specialty chains, boutiques, mail-order houses, and other retailing operations, those who wish to serve the ultimate consumer's needs with apparel and accessories may establish careers in management, merchandising, and store operations. With employment opportunities available all over the world, participants need only to find the geographic location in which they would like to live and begin to practice what they have learned about the field.

Retailing, more than any other industry component, offers formal training for those interested in pursuing management-level careers. Through executive training or executive development programs, qualified individuals, primarily college graduates, set out on a path that will eventually lead to the career for which they were best suited. The goal might be that of buying fashion apparel or accessories, working as a fashion director, or managing a unit of a chain organization. Most companies that offer such programs combine classroom instruction with on-the-job training. In this way, theoretical practices can be learned and applied to in-store situations.

Those who prove themselves with their initial retailing assignments generally find that upward mobility is easy to achieve. Assistant buyers become buyers, and department managers usually are offered the reins as group or store managers. Although initial salaries in the field are often considered low in comparison with other industries, those who reach the higher levels of employment easily catch up to the rest. This, coupled with the excitement generated by the ever-changing fashion business, makes retailing a great place to use one's abilities.

Merchandise Managers. Those who make the ultimate decisions concerning buying and merchandising practices in the retail environment are the merchandisers. They are among the highest paid individuals in the store. Most organizations use a plan that employs both a general and several divisional merchandise managers.

General Merchandise Manager. The ultimate decision maker in the merchandising division has the responsibility to determine the store's merchandising budget, to set sales goals, determine the quality level and

Figure 2-10 The general merchandise manager is the ranking member of the store's merchandising team. (Courtesy of Saint Laurie)

price points for the goods to be carried, establish markup targets and potential profitability, and direct the store's merchandise philosophy.

Retailers use only one general merchandise manager in their companies, therefore making it a career goal that is difficult to achieve. Only the best candidate from the ranks of the subordinate divisional merchandise managers successfully climbs the ladder to this position. He or she is one of the highest paid individuals in the company, perhaps earning more than anyone but the store's chief executive officer.

Today's G.M.M., as it is referred to in the trade, is somewhat different from yesterday's counterpart. Where experience was once the primary factor that led to this position, giving the less formally educated person the chance to achieve this level, those with potential for success today usually have completed a minimum of four years of college and have mastered the mathematical and decision-making processes. Where good merchandising sense and fashion savvy was once the only prerequisite for the job, more formally based educational competency is now considered essential.

Divisional Merchandise Manager. Immediately under the jurisdiction of the merchandising team is the divisional merchandise manager. This individual is responsible for only one segment of the store's merchandising offerings such as men's wear or women's wear. With most department stores emphasizing fashion merchandise and the leading chains across the United States dominated by fashion-oriented merchandise mixes, those who wish to become D.M.M.s in apparel or accessories divisions have much more opportunity than those interested in hardgoods.

With the fast-paced environment of fashion merchandising, and the seasonal and perishable nature of the the goods, the divisional managers in these merchandise classifications must constantly keep abreast of the changes taking place in the field. They must know the wholesale markets, evaluate fashion trends, research new lines, assess markups necessary to

bring profits to the store, assist and supervise their buyers, and interface with those executives who have responsibility for advertising, promotion, management, and operations.

Because the fashion aspect of retailing is so volatile, those D.M.M.s responsible for such merchandise are generally paid more than those empowered to oversee the other product lines. Typically, they come from the ranks of the store's buyers or from other retailing organizations in which they have been purchasers or divisional merchandisers.

Buyers. As in the case of merchandising, retailers usually employ two levels of buyers, the head buyer, known as the buyer, and the assistants. The former usually requires a number of years experience as an assistant, with the latter assuming his or her position directly from an executive training program. Most people interested in apparel- or accessories-oriented retail careers choose buying as their goal.

Head Buyer. The individual responsible for the actual purchase of the merchandise is the buyer. Decisions in terms of resourcing, merchandise selection, terms of the purchase, merchandise mix development, markups, merchandise placement, and markdowns are just a few items that fall within the realm of the buyer's decision making.

With the enormous expansion of the wholesale markets, the buyer can no longer quickly cover the merchandise sources. Travel, both domestic and foreign, is extremely extensive. Because of this, many of the duties that typically made up the buyer's daily routine are no longer within his or her domain.

Buyers are primarily concerned with the management of the buying function and the tasks that maximize profits for their particular department or store. Among the responsibilities undertaken are the planning of purchases, determining markups, taking markdowns, calculating the "open-to-buy," assessing each manufacturer's product line, and evaluating the individual items in the inventory for reorder potential.

To carry out the numerous tasks, today's buyer must be mathematically trained, computer literate, able to communicate both verbally and in writing, capable of selecting the right merchandise and negotiating favorable terms, and responsible as a decision maker.

The position is generally one that takes about four years as an assistant buyer to achieve and rewards the successful practitioners with high salaries and the opportunity to move to the merchandising level.

Assistant Buyer. The road to becoming a buyer takes many different turns. Most often, one must first learn his or her trade by being an assistant. In most major retail organizations, the assistant buyer is chosen from an executive training pool, rewarding those who have shown the most skills in terms of merchandising with the opportunity to establish a career as a buyer.

Typically, the assistant buyer is there to help the buyer with resource and merchandise selection, following up orders, interfacing with the

Figure 2-11 The buyer and her assistant check the fashion resource directory in a garment center building.

management and sales staff to learn about customers' wants and needs, and, during peak sales periods, is often found on the selling floor.

Although the salaries are generally low, the position does provide the opportunity for a future, lucrative career as a buyer.

Managers. Depending on the size of the company, management positions may be limited to one for a small store to significant numbers as in department stores. Those in the fashion segment of retailing may either serve as a department manager, group manager, or store manager.

Department Manager. In large businesses, retailers generally have individual managers for each department. The men's wear, women's wear, shoes, handbags, and children's wear departments would each have someone at its head. These individuals are middle managers, carrying out the policies that have been established by the store's executive team. Working within specific guidelines, they may hire salespeople, prepare work schedules, handle customer complaints, act as liaison with the buyer to relay customer requests, physically rearrange merchandise displays, and sell on the floor.

Department managers either come from the ranks of the executive trainees or, often, are promoted from the selling floor. Although the salaries are comparatively low in terms of the long work week involved, they do have the opportunity to advance to the positions of group or store manager.

Group Manager. In many large stores with numerous departments, there is sometimes the need to have supervisory personnel who are responsible for several departments in an area, in addition to individual supervisors for each department. The group managers make certain that the department managers are carrying out their tasks; they plan staff needs, screen

and hire department managers, and make recommendations, where appropriate, to each manager.

Successful department managers have the opportunity to advance to this position, which provides greater monetary rewards.

Store Manager. The potential to assume managerial responsibility for a particular retail unit is excellent. Although appointments to this level of management is difficult at department store flagships, the numerous branches offer opportunity. Chains, however, offer the greatest number of positions as store managers. Companies like The Gap, Limited, and Merry Go Round, with units totaling several thousand, are always in need of well-trained individuals.

After successful stints at lower management levels, those with the greatest potential may climb the ladder to the top management positions. Among the duties and responsibilities involved here are hiring, scheduling, determining product placement on the selling floor, managing the store's visual merchandising activities, and overseeing the sales force.

Store managers usually are paid straight salaries with bonuses based on overall sales as an incentive for greater earnings.

Fashion Director. Primarily serving in an advisory capacity, the fashion director or coordinator is the person who provides fashion information to the store's buyers and merchandisers before they make their purchases. Not only do they supply the individual buyers with specific fashion information for their individual departments, but they provide an overview of the market so that each buyer's purchases will coordinate and blend with those of the other buyers in the store. For example, if the dress buyer is alerted to red as the season's "hot" color by the fashion director, the same color shoes could be bought by the shoe buyer, enabling the consumer to satisfy both needs. Without such forecasting assistance, each purchaser would act independently, resulting in the lack of unifying elements in the store's merchandise mix.

Aside from the advisory function, most fashion directors assist the store's product developers who create private label goods of the market's designer trends, which might inspire them in their merchandise development. Other duties involve fashion show production and direction, interfacing with the visual merchandising department to suggest displays that might enhance certain merchandise, travelling to the mills to learn about fabric trends, visiting to fashion forecasters, and keeping top management informed of potential changes in the industry's direction for apparel and accessories.

Not only does the job provide the individual with a role for developing the store's fashion image, but it has monetary rewards as well as exciting environments in which to work.

Visual Merchandiser. Those whose responsibility centers on the presentation of the merchandise on the selling floors and the displays in the

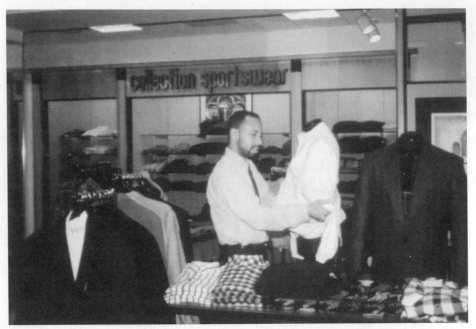

Figure 2-12 Visual merchandiser making interior display change. (Courtesy of Bloomingdale's, Chicago)

store's windows are collectively known as visual merchandisers. The level of visual involvement is dependent on the size of the store, the manner in which business is conducted, and the dollar investment management is willing to make.

Typically, it is the department store that provides the vast majority of careers in visual merchandising. With a traditional dedication to featuring interesting, eye-appealing displays, this retail segment spends more in this area than any other type of retailer. The majors such as Lord & Taylor, Macy's, Bloomingdale's, and Marshall Field have large staffs that make up their departments. Individuals in these stores perform such duties as background construction, signmaking, trimming, and so forth.

At the head of the visual team is a director or, to indicate the importance of the position to the company, a vice president who manages a team that includes background and theme designers, lighting experts, installers, signmakers, and carpenters.

Many branches use a small nucleus of visual merchandisers who work at the store's headquarters and develop displays and other visual concepts that are used in the various units. Some companies employ teams of trimmers who rotate through the stores and install the displays. Small retailers often use independent freelancers who work either on contract or by individual installation, providing everything from the background materials to the actual trim.

Whatever level of visual merchandising one enters into, it is an area that demands artistic training and excellence. A great number of these people have studied visual merchandising at colleges and universities or have art degrees. Although the beginning salaries are generally low in the entry-level positions at department stores and chain organizations, the higher levels of director offer significant salaries. If one is determined to work as a freelancer, an hourly rate of better than $100 is not unusual.

Special Events Director. The major department stores regularly feature special events that focus on designers, collections from foreign countries, fashion shows, and other programs that emphasize their position as fashion leaders and innovators. Personal appearances by such luminaries as Karl Lagerfeld, Donna Karan, Pierre Cardin, and Ralph Lauren are commonplace.

It is the special events director who develops the concepts and is responsible for bringing them to fruition. Those with special creative talents are best suited for the job. With the sameness found in today's department store arena, in terms of merchandise offerings and services, it is the special events directors who must design programs that will separate their companies from the competition.

To carry out these events successfully, the director must be someone both capable of long-range planning and who can effectively communicate with the outside sources necessary for such endeavors.

Those who have successfully climbed the ladder in this area have come from diverse backgrounds, including advertising, promotion, business, and communication.

Public Relations Director. For any retailer to be successful, as many customers as possible must be attracted to the store. One of the ways in which this is accomplished is through the use of positive public relations. By informing the public of programs and events that might motivate them to visit the store, the retailer can expect sales to rise.

It is one thing for a store to run a special event, it is another to sufficiently capture customers' attention to make them participate. The public relations director is charged with the responsibility of interfacing with the media in the hope that they will provide coverage in their newspapers or news broadcasts that will feature the store's positions. When, for example, Elizabeth Taylor is promoting her new fragrance and making personal appearances, the store benefits if it is featured in the television spots on local television. In this way, the store's name is mentioned along with the personality appearance, often stimulating the consumer to attend.

The public relations director must first and foremost have excellent communications skills. He or she is required to regularly write concise press releases that are earmarked for the media's attention and eventual placement in print or on the air. Often, if the piece is well written, it will be used as it was written by the public relations specialist.

Those best suited for such positions have majored in English or communications and may have had advertising experience.

Advertising Manager. One look at any newspaper immediately reveals the significant role played by advertising in attempting to bring the shopper to the store. With the enormity of the advertising expenditure and the highly competitive nature of the retail environment, it is necessary to develop a program that will uniquely present each store to the public.

With creative expertise, advertising directors are able to provide a particular look or image to their programs. By developing a certain character in their ads through such devices as stylized fashion figures, the customer can quickly differentiate one store's advertising from the other.

Those interested in such careers should have formal educational backgrounds in advertising and be capable of writing copy, preparing artwork, creating layouts, selecting type styles, and so forth. Those who work for stores that specialize in apparel and accessories would also benefit from taking courses that would familiarize them with the different products and materials used in their production. They must also be competent in terms of managing their staffs and making certain that each individual's efforts are carefully coordinated with the others in the department.

Other careers that center on apparel and accessories include comparison shoppers, those who check inventories and prices in competitor's stores, personal shoppers, individuals who help customers with their purchases by preselecting merchandise for them to try or assist them through the store, and product developers who create the private label collections for their company's exclusive use.

Market Consultants. The chances for success for retailers, designers, or manufacturers are greatly enhanced when an outside organization is used to provide information that will help with merchandise planning. In the fashion industry, there are several different types of companies that provide the information and skills needed for those businesses to be successful. They are the resident buying offices, fashion forecasters, and reporting services, who, for fees or commissions, are ready to serve their client's needs.

RESIDENT BUYING OFFICES

An excellent place for those interested in careers in fashion apparel and accessories is the resident buying office. These teams of market consultants service the retailer by providing information ranging from the discovery of new resources to trends in the market and will make purchases according to the directions of the store's buyers. There are numerous positions in these companies, with the vast majority centered on merchandise acquisition.

Employment at this level is appealing for many because the work week is less demanding than that of the retailers they serve. Typically, the

offices operate on a 9-to-5 basis and are closed on weekends and holidays. Those wishing for merchandising careers and cannot endure the demands of retail hours may find this a better place for employment. It should be noted, however, that the salaries offered are well below those paid by retailers. A store buyer, for example, may earn as much as 25 percent or even more than his or her resident office counterpart.

Buyer. Serving in a position that is more advisory than decision making, the resident buyer's responsibilities are servicing the needs of the retail clients. They research the market each day to discover new resources, learn about hot items, follow up the status of orders that have been placed, purchase merchandise according to the directions set forth by the store's buyers, and investigate new trends that might affect future purchases. Because their companies are located within the wholesale markets, they can easily feel their vibrations and pass any uncovered pertinent information along to the stores.

The formal educational requirements are less stringent for those seeking careers as resident buyers than they are for store purchasers. Typically, a two-year degree in retailing or fashion merchandising will suffice.

Once an individual has successfully served two or three years as an assistant buyer, the opportunity may arise to become a buyer.

Assistant Buyer. Those who possess associate's degrees and are interested in careers that are apparel- and accessories-oriented, will find the resident buying office a good place to begin a career as an assistant buyer. The initial responsibility is primarily that of following up orders to check

Figure 2-13 Resident buyer services the store buyer by finding resources and recommending items. (Courtesy of Henry Doneger)

their status. Assistants also help the buyers with the evaluation of new lines and sometimes prescreen items before the buyer sees them.

Although the monetary rewards are low, it does serve as a means for a career enthusiast to enter the field and gain the experience necessary for employment in other fashion occupations.

Merchandise managers, who oversee the buying function, product developers who create private label merchandise under the resident office label, and fashion coordinators, who assess the various markets and merchandise classifications for the buyers, are some other positions available in this field.

FASHION FORECASTERS

In the ever changing field of fashion where style acceptance comes and goes rapidly, retailers, manufacturers, and designers generally try to investigate fashion products and their potential popularity. The forecaster helps those responsible for making fashion decisions by researching market trends through visits to materials producers and design capitals all over the world.

The primary function of those who work as forecasters is to provide such information as color trends, fabric uses, silhouette preferences, and price points as early as one year before the information is needed to make manufacturing and purchasing decisions.

An understanding of the fashion industry, the ability to assess trends and perform other research, a knowledge of apparel and accessories construction and the materials such as textiles and leather, and the skills necessary to communicate this information to clients is necessary for those wishing to enter the field.

REPORTING SERVICES

Some companies provide information to their customers on the status of the market through written and videotaped informational reports. Unlike the resident office, which also makes purchases, this type of organization is solely one that offers information to the retailer.

Competency in writing plus a complete understanding of the fashion industry are essential for success in this field.

FASHION COMMUNICATIONS

Trade periodicals, consumer newspapers, fashion magazines, and television networks offer employment to photographers, writers, illustrators, and commentators. Some of the media hire people for full-time positions in these areas, whereas others use the services of freelancers. Whichever the case, all of these people must be highly skilled, having received their training from appropriate educational institutions.

PREPARATION FOR THE CAREER SEARCH

Once the candidate has carefully examined the industry in terms of career opportunities through the inspection of the classified advertisements in trade periodicals and consumer newspapers and has sufficiently networked with friends and relatives, preparation must begin before an offer to interview may be granted. Resumes and cover letters are essential tools for everyone and, in some cases, a portfolio of the candidate's work is appropriate.

THE RESUME

Because those with the responsibility for hiring have busy schedules, it is impossible and impractical for them to grant interviews to everyone who asks. To screen candidates for employment, a resume, featuring the

```
                         JENNIFER WELLS
                       1412 Wrightway Drive
                     Milwaukee, Wisconsin 53217
                          (414)332-1943

EDUCATION:   FASHION INSTITUTE                   NEW YORK, NY
             AAS-Fashion Design, June 1990
             Honors: Dean's List

EXPERIENCE:
May 1992-    CANDEE TOGS, INC.                   CHICAGO, IL
Present         Designer
                . Designs children's wear collection.
                . Travels to Far East to purchase materials.
                . Sketches and drapes individual designs.
                . Creates first sample.
June 1991-   ADORABLE ADDITIONS                  NEW YORK, NY
April 1992   Designer
                . Designed accessories that included handbags,
                  school bags, belts and hats for girls.
                . Sketched designs for each style.
                . Chose materials to be used for each product.
                . Selected trimmings and findings for products.
                . Traveled to off-shore manufacturing facility to
                  assess product control.
July 1990-   DRESSES ON PARADE                   NEW YORK, NY
May 1991     Assistant Designer
                . Worked with head designer on little girl's
                  line of moderately priced dresses.
                . Draped designs based upon head designer's
                  sketches.
                . Chose trim for dresses.
                . Assisted in the selection of textiles.

INTERESTS:   Travel, music, art, dance, aerobics.

REFERENCES:  Will be furnished upon request.
```

Figure 2-14
Resume for fashion designer applicant.

applicant's qualifications, educational background, work experience, and other credentials, should be prepared.

Preparation may be accomplished either by the candidates themselves or by professionals. If the former route is chosen, it is best to become familiar with standard resume forms that are available in books on resume writing or from local governmental agencies that deal with job training and placement. Because the resume is often the only way in which the potential employer can assess your credentials, it might be best to seek the services of a professional. For a modest fee, the document will be prepared and ready to be directed to human resources managers.

The resume on page 51 is typical of those used for employment in the fashion industry.

```
                                        1412 Wrightway Drive
                                        Milwaukee, WI 53217
                                        July 16, 199X

Mr. Howard Tracey
Matthew Michaels, Inc.
112 West 34 Street
New York, NY 10008

Dear Mr. Tracey:

Your advertisement in the July 14 edition of Women's Wear Daily
for a children's dress designer has motivated me to apply for the
position.

In addition to my formal educational training, which taught me
every aspect of clothing and accessories design, my professional
experience has given me the background necessary for your
advertised position.

I would appreciate an opportunity to meet with you and show you a
sample portfolio of some of my original designs.  At the same
time, I would be available to answer any questions you might have
about me and my training.

I'm looking forward to hearing from you so that we might further
discuss my potential employment with Matthew Michaels, Inc.

Sincerely,

Jennifer Wells
Jennifer Wells
```

Figure 2-15
Cover letter
to accompany resume.

THE COVER LETTER

The resume should be accompanied by a cover letter that briefly describes the applicant's desire to work for the company. It should be carefully written, using information that might motivate the employer to consider an interview.

The information on the resume should not be repeated in the letter but should emphasize other factors such as one's knowledge of the company, a friend on the staff who suggested applying for the job, availability for the interview, and so forth. Brevity is important because lengthy letters are often quickly passed over by busy executives.

It is better to find out the name of the individual to whom the letter should be sent than to use the "Dear Sir" format. If one is uncertain about the person's name, a call to the company can quickly reveal it.

Finally, the letter should be carefully typed and screened for grammatical and spelling errors on paper that matches the one used for the resume.

A typical cover letter is shown on page 52.

THE PORTFOLIO

For positions that require visual inspection of a candidate's body of work, it is essential that a portfolio featuring representative pieces be prepared. When the individual is embarking on a career in design, visual merchandising, or fashion illustration, for example, photographs would certainly enhance the opportunity for employment.

Professional pictures of clothing designs, displays, drawings, or whatever best underscores the person's ability should be mounted in a portfolio for use during the interview. No matter how articulate one might be, assessment of the work is more simply achieved with this format.

PREPARATION FOR THE INTERVIEW

Resume, cover letter, and portfolio preparation are just the beginning of the road that hopefully leads to the acquisition of a job and the beginning of a career. Make certain that when one is invited to come in for an interview, sufficient time will be spent planning for the event.

The most successful job applicants prepare themselves in any number of ways with such endeavors as researching the company, role playing, and appearance refinement.

COMPANY RESEARCH

Knowing about the company not only enables the candidate to feel confident, it provides information that might be needed to address certain interview questions. A simple "I don't know" in regard to questions about the organization might be reason enough for the interviewer to come to an unfavorable decision.

Figure 2-16 Sales trainee and trainer participating in role playing. (Courtesy of Barbara Blumberg and Rona Casciola)

Company knowledge might be acquired from any number of sources such as annual reports, available for the asking from company headquarters, a visit to the premises of a retailer to assess the facility, its merchandise, and the people who work there, reports written for periodicals such as *Stores Magazine*, *Visual Merchandising and Store Design*, and *Women's Wear Daily*, from talks with people knowledgeable about the industry, and from informational packages that some major businesses prepare about themselves.

ROLE PLAYING

There is no better way to handle potential questioning than through the use of role playing. With a friend or relative who is familiar with the field acting as the interviewer, many different areas of the real interview can be examined. One of the most beneficial approaches used to augment the practice interview is videotaping. A record of the mock interview enables the career applicant to examine his or her strengths and weaknesses and correct those that need improvement.

After numerous attempts at role playing, the actual interview will be easier to handle.

APPEARANCE

The first impression one makes as he or she enters the office of the interviewer is of great significance. It may immediately give a positive or negative impression. Without having spoken a single word, the properly dressed candidate may score points.

Proper dressing and grooming is simple to accomplish. It should not necessarily be the individual's own preference in terms of taste, but should be appropriate for the particular position. Retailers, for example, have required dress codes for their employees that immediately convey the store's image to the customer. By dressing for the interview in the way that the store deems proper, the candidate will make a positive impression.

Learning about appropriate dress and grooming may be accomplished by reading books on the topic, speaking with experts who specialize in proper business appearance, or by visiting the company to assess the styles that are being worn by their employees.

It is a simple task to accomplish and one that will help to set a positive tone for the interview.

INTERVIEW FOLLOW-UP

When the interview has been completed, a letter should be sent immediately to the company to show appreciation for the time given and to reinforce interest in the position.

The letter should be brief and written in enthusiastic terms. It should also indicate when and where the candidate might be reached for any further information.

REVIEW QUESTIONS

1. Briefly describe the industry segments that provide apparel- and accessories-oriented career opportunities.
2. Why is a fashion career one that is suitable for people in most geographic locations?
3. How might opportunities for employment be found by someone interested in fashion?
4. Describe the benefits of networking.
5. Differentiate between the jobs performed by store buyers and those by resident office buyers.
6. In what way does the retailer's fashion director serve the buyer's needs?
7. Discuss the differences in the roles played in the industry by resident buying offices and reporting services.
8. What resources are available for those wishing to prepare their own resumes?
9. How important is a portfolio of work for fashion career placement?
10. Describe the best technique to prepare oneself for the interviewer's questions.

1. Prepare a resume, using the sample in the text or any found in resume books, for an apparel or accessories career.

2. Write a cover letter to accompany the resume prepared for exercise one and a follow-up letter of appreciation.

3. Select one segment of the fashion industry such as retailing or manufacturing and research it in terms of career possibilities. The information might come from such sources as trade papers, newspapers, or discussions with those already employed in the field. From the available positions, select one that interests you most, and prepare a report that addresses the following:

 a. The level of formal education needed for entry.

 b. The duties and responsibilities of the job.

 c. The general range of salaries for such work.

SECTION 2

THE INDUSTRY'S MAJOR COMPONENTS

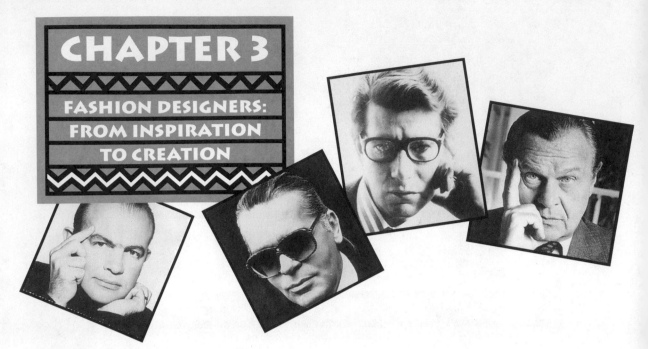

CHAPTER 3
FASHION DESIGNERS: FROM INSPIRATION TO CREATION

LEARNING OBJECTIVES

After reading this chapter, the student should be able to:

1. Distinguish between the notion of original design and adaptation.

2. Explain the color wheel and how the designer uses it in the creation of a garment or accessory.

3. Describe the various elements of design and their relationships to each other.

4. Discuss the principles of design and how they must be addressed to assure that the outcome will be a totally harmonious product.

5. List the stages of development of a sample.

INTRODUCTION

As the runway stages of the fashion world are made ready to present the collections of renowned designers, the audiences, replete with buyers, merchandisers, fashion directors, and publicists, get ready to critically assess what they are there to see. Whether it is Paris, Milan, London, or New York, models dressed in imaginative and innovative creations strut to upbeat music and are recorded by the flashing cameras as the design team eagerly awaits the attendees' reactions. Patternmakers, sample-hands, trimmers, and apprentices, all hidden in the wings, hold their breaths as they wait to learn if their efforts have been appreciated.

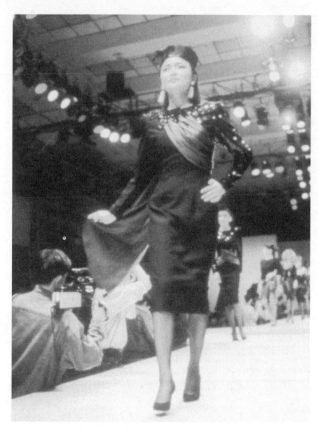

Figure 3-1 A runway in a Hong Kong show introduces fashions for the new season. (Courtesy of the Hong Kong Tourist Association)

Rousing applause or obligatory, polite response when the designer accompanies the models in the show's finale indicates whether or not the line will be enthusiastically purchased.

A world apart, in terms of presentation and excitement, a different class of designer is waiting to learn if his or her efforts are to be recognized. In off-the-beaten-path locations, in garment centers across this and other nations, lesser known talents are showing their latest fashion accomplishments. No photographers are here for these occasions, but, nonetheless, the moment of truth has arrived for these designers to have their work assessed.

Other situations requiring various levels of design comprehension and execution are part of the fashion scene. Product developers who work for specific retailers, turning out garments that are to become part of their private label collections, are often merely possessors of good taste and can recognize which "necklines, sleeves and silhouettes," when properly coordinated, will result in a salable garment. Through the manipulation of these various elements, they often come up with styles that could be targeted for their own clientele. Finally, there is the designer who is merely a good merchandiser and recognizes fashion that will sell and

Figure 3-2 A designer creating a fashion collection. (Courtesy of Criscione)

makes exact copies of higher priced items for inclusion in his or her line. The term *designer* is loosely applied to this individual because originality is not a part of the creative process.

No matter which level of fashion is being addressed, from the haute couture to the lower ends of the price-point scale, it is the designer who has the initial responsibility to bring attention to the company by way of the merchandise he or she has created.

To mount a *line*, a designer must be capable of translating his or her *inspirations* into creations that will be accepted by the customer the company serves. With an understanding of the marketplace, coupled with design principles, color comprehension, and the fundamentals of garment construction, he or she is ready to tackle the creation of new models, the adaptation of an existing style that has been introduced at another level, or design something unique that will hopefully capture the fancy of the buyers.

This chapter addresses the various types of designers, ranging from the masters of originality to the "copycats" whose specialty is the knock-off, the principles and elements of design, and the methods used in development of the samples.

DEVELOPMENT OF THE CONCEPT OF THE LINE

Although the designer is the one responsible for the specific styles, fabric selection, color choices, and trimmings, he or she does not work in a vacuum. The ultimate size of the line, price points, and other important aspects of merchandising are often a team effort. Using his or her individual expertise, each person contributes something that will eventually be translated by the designer into garments or accessories that may be successfully marketed.

THE BREADTH OF THE OFFERING

Some companies are prepared to market a product package that has many different elements. In women's wear, for example, there might be several groups within the offering such as dresses, coordinates, suits, and sportswear. There might be a central theme that runs through the entire line, or several themes for each classification.

Other companies might opt for a more specialized approach. Their forte might be sweaters, and thus the line would be restricted to that merchandise group.

The designers of haute couture often create a broad range of products that is featured in a collection. When the merchandise is introduced in a runway show, not only does the apparel bear the designer's signature, but so do the accessories that enhance the garments. Shoes, belts, gloves, scarves, hats, and any other items that will complete the outfits are part of the collection. Thus, a collection is not merely a line of dresses or suits but an overall design statement that shows off the designer's talents.

PRICE POINTS

Each company establishes a price range or price point for its merchandise based on the retailers to whom it would like to sell and the ultimate consumer to whom it would like to appeal. There are numerous traditional levels of fashion that are based on price. They begin at the top with the haute couture, where price is rarely a major consideration. The designs featured help establish the individual as a creative design force so that future revenue will come from ready-to-wear collections mounted by the same company or through franchising arrangements. Most renowned designers franchise their names and make significant profits from them. Names like Yves Saint Laurent, Karl Lagerfeld, Christian LaCroix, Georgio Armani, and Gianfranco Ferre have distinguished themselves at the haute-couture level and have ventured into profitable ready-to-wear collections as well as franchised agreements.

One step below haute couture is the designer merchandise, whose price points are top scale, but within the reaches of more people. Bill Blass, Donna Karan, Ralph Lauren, and Carolina Herrara are just a few who successfully market such upscale collections. Many, like their haute-

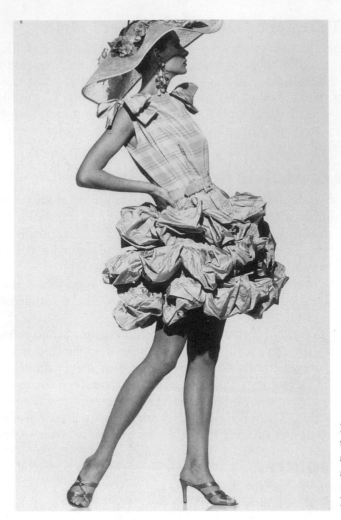

Figure 3-3 Haute couture collections feature accessories created by the apparel designer. (Courtesy of Yves Saint Laurent)

couture counterparts, create less costly collections that bear trademarks associated with their higher priced merchandise. Donna Karan does it with DKNY and Anne Klein with Anne Klein II.

To offer a price point that falls between the designer collections and the better sportswear lines, bridge lines were developed. Names like Adrienne Vittadini and Ellen Tracy bridge the gap and feature designer merchandise that is more easily consumed by wider audiences.

Just below this level is the one often referred to as better sportswear. Liz Claiborne captivated a vast market when she introduced her now-famous better sportswear lines. Working women quickly embraced her offerings because they were fashionably correct and affordable. Few "names" grace these lines; their recognition occurs mainly from the company rather than a particular designer.

Figure 3-4 Donna Karan markets a collection well below haute couture using the DKNY label. (Courtesy of Macy's, New York)

The remainder of the merchandise is priced significantly lower all the way down to the budget classifications. They are generally known by or sought after because of their cost, not their designer influence.

No matter what the level, the merchandisers must address the costs of the garments and accessories in terms of fabric, trim and construction, and the available outlets for their placement.

SEASONS

Each industry, as we examine later in the text as they are specifically explored, has a traditional number of seasons for which it must prepare. Ranging from the typical two for children's wear to five or more for women's wear, the designer must be ready to produce a new line for each. This is another decision that is not the designer's but is based on the specific merchandise classifications, their price points, and the markets they serve.

INSPIRATIONS

After all of the guidelines and parameters for production have been established, the creative forces take over to produce a collection or line that will fit both the company's needs and those of their retail clients.

Designer inspiration may take many routes, depending on the goals of the company. In the case of the internationally renowned designers,

Figure 3-5 Yves Saint Laurent's fascination with historic Russian costume influenced his 1976-1977 collection. (Courtesy of Yves Saint Laurent)

originality is the key ingredient, and inspiration for their new collections may come from a host of situations or events. A visit to a particular country or study of a specific culture might influence their thinking, the result being a line that has an ethnic orientation. Mary Quant's fascination with Britain's "hippy" subculture of the 1960s inspired a *mod* look that catapulted her to fame. The current wave of films could serve as the basis for the designer's next effort. The film masterpiece *Dr. Zhivago* brought a wave of Russian influences to many apparel and accessories collections. A painter's body of work might influence the colors or patterns that the designer would incorporate into his fashions. The fabrics of the Spring/Summer collection of Yves Saint Laurent was highlighted by the geometrics of Mondrian paintings, the result being one of his most successful offerings. An exciting entertainer might also influence not only one designer's approach but a whole spectrum of design. In the 1980s, Madonna's enthusiastic reception was not only for her performing talents but for the costumes she wore during her appearances. Scantily clad in lacey and racy garments, a host of designers embraced her approach and impacted the fashion world with all types of apparel and accessories that bore the Madonna signature.

As we left the 1980s and entered the 1990s, another format gave designers the impetus for new creativity. MTV captured the attention of a market as few others had in the past. A younger generation, not often motivated by the traditional entertainment media, was quickly drawn to watching the antics and gyrations of favorite performers. Although the music was the primary ingredient in these presentations, the visual effects included a departure from conventional dress that audiences soon demanded. A new generation of designs quickly made the transition from the television screen to the stores. Devotees of the various rock groups found those stores and purchased adaptations of the garments and accessories worn by their favorite performers.

The more typical approaches taken are through visits to the fabric mills, materials processors, color and fabric libraries, discussions with fashion forecasters and market representatives, meetings with influential clients who regularly interface with their customers, and through the study of the social and economic climates of the time.

The sources that motivate the designer are everywhere. Successful designers have the ability to recognize specific "inspirations" as being sufficiently unique so that they can be translated into exciting fashions.

DESIGN ELEMENTS

Inherent in every good design is a complement of ingredients that work together. The designer is the one who selects these elements and blends them into a garment or accessory that will be fashionable and functional. In fashion design, the basic elements are color, materials, silhouette,

details, and trim. Each plays a vital role in the creation, with one usually serving as a dominant force.

COLOR

Rarely does one of the other elements rival the initial impact made by color on the potential customers. It is the first thing that we see when we take an overview of a particular department in a store or, in some cases, the store itself. Many retailers have improved their sales volume through the exciting use of color in their visual merchandising approaches. The Gap initiated a concept that was quickly followed by others. When a shopper enters the store, he or she is greeted by a variety of items that are carefully presented in color arrangements. The eye quickly concentrates on the color, drawing the shopper to the display for closer inspection. The Liz Claiborne First Issue stores adapted the same technique and present every product group in segmented color arrangements. There, too, the eye focuses quickly on the colors.

To generate enthusiasm for a collection or a group of related items within a line, designers and manufacturers often present them in one striking color. Just as the ultimate consumer is inspired by the presentation to examine further other elements of the designs, so do the professionals who are there to purchase them for their inventories.

Color plays this dominant role throughout fashion, and it is the designers in each of the industry's components who must both understand the force and power of color and know how to maximize its use.

Color Theory and Selection. There are rules to address and rules to ignore, the decision coming from the individual responsible for charting the company's design philosophy and eventual rendering of product styles. Some designers are sufficiently gifted to rely on their instincts to come up with color combinations that defy all the rules of the game. Others are more traditionally oriented to acceptable theories that give them variations that are endless and technically correct. After considerable time spent using these standard practices of color theory, most designers fill their minds with the concepts and freely learn to draw from them and sometimes adjust them to fit their needs, without the need for the constant referral to the schemes for use in their designs.

The Color Wheel, as shown in the color insert, is a system that the majority of the designers use to test their ideas and make certain that they are technically correct. It was developed by David Brewster and uses the three primary colors, yellow, blue, and red, to achieve all other colors. By mixing two of the primaries, the secondary colors, orange, purple, and green, are achieved. These colors are arranged on a wheel in an order that enables anyone with simple understanding of the concept to come up with an infinite number of color arrangements. When augmented or enhanced by the neutrals, black and white, any array will be possible.

Designers and their staffs always discuss color by using certain terms. "This hue would be great," "Another value or intensity would be even better," "Perhaps a tint or shade of the color would even be more striking." The comprehension of such terminology makes everyone who interfaces with the designer, such as the merchandiser or product developer, more capable of endorsing the decisions made for the various lines.

Hue The technical name by which the color is known. Purples, blues, greens, and reds are just a few of the hundreds of different hues.

Value The lightness or darkness of the color is known as its value. When colors are made lighter, they are done so with the addition of white, the result being a tint. If a darker value is needed, black is added, producing a shade.

Intensity The brightness or dullness of the color is referred to as its intensity. To dull the color, gray is added. In some cases, the color to be dulled is done so through the use of that color's complement, a term that is described in the discussion of color combinations.

With the use of the color wheel, the various relationships may be easily examined. There are many different combinations that can be quickly pulled from the color wheel. Some of them are:

Monochromatic The simplest of the schemes is the one in which a single, basic color is used. Variations may be achieved by the use of different values or intensities and by using black and white, the neutrals.

Analogous Colors that occupy adjacent places on the wheel are said to be analogous to each other, and are the basis for such a combination. Red and red-purple or yellow and yellow-green, for example, are analogous color schemes. They too could be altered through the additions of the neutrals.

Complementary When two colors are opposite each other on the wheel they are known as complements. Orange and blue and yellow and purple, for example, are two sets of complementary colors. If the goal of the designer is to intensify the colors in a combination, the use of complements, next to each other, will achieve the effect. If you have ever noticed the intensity of the traditional Christmas color scheme of red and green, you have experienced the effect of a complementary color scheme.

Split complementaries The use of one color on the wheel, in combination with two colors that flank the initial color, produces a split complementary scheme. It allows for greater freedom than does that afforded by the other arrangements.

Double complementaries In multi-colored prints that call for a great deal of intensity, the use of four colors might be appropriate. One arrangement that produces intensity of four colors is the double complementary scheme. It involves two sets of complements on the wheel.

Triads Three colors on the wheel, each being equidistant from the other two, are the basis of such a combination. Yellow, red, and blue constitute such a plan. See the color insert for illustrations of the six common color relationships.

Aside from the technical correctness of the chosen color arrangements, a number of psychological factors must be addressed before any final color decisions should be made.

Sometimes, for example, a warm or cool feeling is necessary to come from a particular color scheme. Although no single color actually produces heat or cold, each imparts a psychological feeling of warmth or coolness. In color theory, warmth is impacted with the use of orange, red, and yellow, and coolness with blue, green, and purple.

In addition to their warmth and coolness, each color has "earned" a reputation to impart a set of feelings or dimensions.

Red More than any other color, red is associated with romance and love and gives greater intensity to designs used for products marketed for those purposes. It is warm as well as stimulating.

Yellow Sunny and cheerful are words suggested for yellow. Many use it to achieve a "friendly" image for their designs.

Orange It is a color that imparts a warm, sunny feeling.

Blue Whenever people are asked for their favorite color, blue is the most commonly given answer. It is restful and quiet and provides a refreshing coolness to any garment.

Green Refreshing and peaceful is the effect given by green. It is cool and quiet and provides subtlety.

Purple Long known as the color for royalty, it lends itself to fashion that demands the dramatic.

Although colors are technically known by such names as blue and green or red-orange and yellow-green, referring to them as such is often too mundane in the fashion world. Major companies use colorists or stylists who "coin" color names that lend excitement to their fashions. Although it might seem unnecessary to take such steps, the newly "fashioned" color designates often inspire the buyers to use them in their promotions, thus giving the particular lines another dimension of individuality. "Sea foam" might impact better than pale, blue-green and "hyacinth" better than violet.

MATERIALS

There is no required order to the choice and use of the elements that constitute a design. The inspiration might come from the colors that dominate a land that the designer has visited or the silhouettes of a culture that

Figure 3-6 Re-embroidered lace was the inspiration for this festive dress. (Courtesy of Bill Blass)

dominate a popular film. It is often the materials that designers find in their travels that motivate them to take a specific direction.

The term *materials* should not only mean fabrics but anything that the designer might use for his or her product line. Apparel and accessories, although using textiles more than any other materials, significantly make use of leather, furs, plastics, glass, and wood in their designs.

The feel or the "hand" of the fiber, its visual effect or function, may entice its use. The gossamer sheerness of organza might inspire the creation of a ball gown that tends to float. The heavily textured jutes and ramies might motivate the creation of a line of handbags that serves both fashion and functional needs.

The softest kidskin, with its drapability characteristic, could be the basis for its use as a sophisticated evening dress, whereas the stiffer cowhide might be the inspiration for a sturdy handbag that makes the transition from the office to an evening event.

A stenciled fur that enhances the conventional use of the skin could motivate the creation of a product used for fun and leisure.

Before any final decisions are made in terms of the material's use, there should be extensive reviews of everything that the markets have to offer. Designers search all over the world, sometimes uncovering goods that they find sufficiently enticing to use as the central ingredients in their

designs. Suppliers routinely call on them, alerting them to anything new in the marketplace. Other sources of fabrication come from the industry's experts at places such as the fashion forecasting houses.

With price a considerable factor in costing out the final products, they must be carefully assessed to make certain that they fit into the company's price points. Once the combination of price, type, and quality has been satisfied, most designers secure sample cuts of fabrics and any other materials and study them before choosing the ones needed. With these materials in hand, the designer is ready to begin the process of creating the line.

All of these materials, as well as others, are discussed in individual chapters that examine their characteristics, properties, and uses in more detail.

SILHOUETTES

The garment's shape or outline is known as its silhouette. Although these do not change over the years, their acceptance as fashion changes con-

Figure 3-7 The European silhouette utilizes a fitted, double-breasted design. (Courtesy of MFA)

siderably. What might be fashionable one year might be unacceptable another. Silhouette usage often runs in cycles that last for varying periods of time. It might be the beltless, semifitting chemise or an empire-inspired fit that accentuates the bustline that is the rage for women's wear. For her male counterpart, the suit that reigns might be a snugly fitted "European" jacket complemented by straight tailored trousers or an unconstructed design worn with loose, baggy pants.

The actual finished style could be a modification of something that was in favor a decade before, returning in this collection as the updated version. It is the designer who must carefully "read" the customer's preferences and execute the silhouettes that fit their needs.

The various styles and shapes are examined, later in the book, in specific apparel and accessories classifications.

DETAILS

The different types of pleating or tucking, pockets, collars, and button-holes are known as the details. The same-shaped garments may project totally different images when different detailing is used. A successful silhouette may be repeated over and over again in the same line, using different details to differentiate each model. By doing so, the company capitalizes on a successful idea and, hopefully, finds other items that are salable. The wealth of details found in each merchandise category will also be explored within those specific chapters.

TRIMMINGS

Although the basic elements such as color, materials, silhouette, and details comprise the product's basic design, it is the trim that often distinguishes one model from another. Decorative adornments to any design are known as trimmings, whereas those that are functionally oriented such as zippers are called findings.

Trimmings may be produced in a variety forms. Some of the more typical types include *braid*, achieved through the interlacing of three or more strips of fabric, until a narrow trim is produced; *appliques*, small individual pieces of fabric that are either manufactured to a particular size or shape or are cut into from larger pieces of fabric, as in the case of lace; *embroidery*, motifs produced by hand or machine that use a variety of threads that are sewn into the fabric; *beading*, *sequins*, and *piping*, narrow strips of fabric that are used to outline and accentuate details; *artificial flowers*, *bows*, *ribbons*, and *belts* that are part of a garment.

DESIGN PRINCIPLES

Having selected all of the elements that constitute the final product, attention focuses on the manner in which they are assembled. A relation-

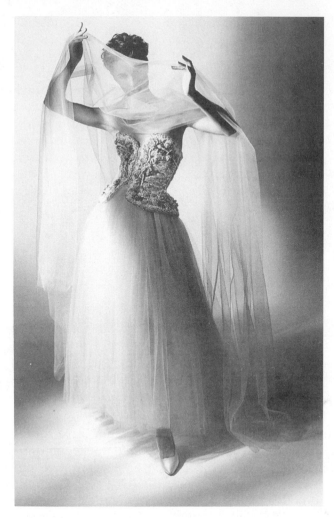

Figure 3-8 Bodice encrusted with sequins, beads, stones, and metallic cording enhances the simplicity of tulle. (Courtesy of Bill Blass)

ship of all of the parts must be considered and placed in a manner that is based on the principles of design. They are balance, proportion, emphasis, rhythm, and harmony.

BALANCE

To understand balance, it is best to think of a scale that has two equal objects on either of its sides. The sameness of the two pieces allows the scale on which they sit to be balanced. When designers speak of balance it is more as a "visual" distribution. The concept of balance is twofold, symmetrical and asymmetrical. Symmetrical balance approaches the design by placing two elements on either side of a central point. Using buttons down the front of a dress as the central point, with patch pockets on each side, for example, would make the garment one that uses symmetrical or formal balance. Although this approach is certainly correct

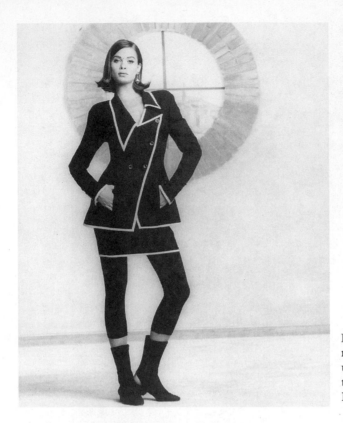

Figure 3-9 An asymmetrical design features unusual collar and closing treatments. (Courtesy of Karl Lagerfeld)

and appropriate for many styles, it does not leave room for more inventive design. With the use of one oversized pocket on one side, and another, differently shaped object such as a decorative pin or flower, the construction has used asymmetrical balance to capture attention. It should be noted that both approaches stay within the rules of balance, except that the former is formal and the latter informal.

PROPORTION

When the various parts are properly scaled to complement each other in the design, they are said to be in proportion. The use of an oversized lamp on a small table would create an unpleasing visual effect; the eye would not accept it being appropriately proportioned. The same principle is used in apparel and accessories design. An enormous bow on a delicate, sleeveless, snug-fitting blouse renders it unattractive and overpowering. The body of the garment would be lost to the proportion of the trim.

A design must have a sufficient amount of unadulterated and unadorned space so that the details and trim can proportionally enhance it.

The term *fashion*, however, denotes experimentation, and strict reliance on the rules tends to produce a boring garment. Designers con-

tinuously experiment with proportion and try to make their creations more exciting. The elongated jacket teamed with a very short skirt, for example, might seem disproportional. When the fabric for both parts are the same and provide the overall impression as one piece, the proportion is not only correct but more exciting.

RHYTHM

When a sense of movement moves the eye from one of the design's elements to the next, rhythm has been achieved. It may be accomplished by one or more of many means. Repetition, for example, provides rhythm by placing a number of the same shapes or details in the design. A row of pleats, for example, would be indicative of repetition. Continuous line is exemplified by the use of a linear connection. A "path" of vertically placed tucks on a blouse moves the eye throughout the entire garment. Progression involves the gradual increase or decrease of one of the design's elements. When a color pattern uses a hue in its purest form and then features a variety of lighter tints of that color in "bands," the feeling of rhythm has been accomplished. In rhythmic radiation, the movement generates from a central point. A "sunburst" pattern may achieve this type of rhythm. Alternation is simply accomplished when two different elements, usually color, are used. In a yellow and orange striped motif, the two colors serve as the alternating forces that create rhythm.

EMPHASIS

Every good design has a central point on which attention is focused. It is the place in the design to which the eye is initially drawn. If this place of emphasis has been carefully considered, the rest of the garment will then become the beneficiary of this featured aspect of the design. It may be achieved in any number of ways. Yves Saint Laurent's use of ostrich feathers on a collection of elegant gowns drew immediate attention. Emphasis may be achieved through the use of imaginative trim or detail, the introduction of a striking color to an overall subtle color scheme, or with the use of an unexpected material as in the case of leather ornamentation on a denim jacket.

HARMONY

When all of the elements of the design work together and the eye witnesses a unified effect, harmony has been accomplished. The end product should underscore the intention of the design. Where the goal is subtlety, the principles used should quietly blend together, producing something that is "low-key." If, however, drama is the desired effect, the principles should be handled in a manner that accentuates those elements, such as color or trim, that impart excitement.

A delicate evening bag, for example, would be considered a success in terms of the principles of design if it has been appropriately sized to com-

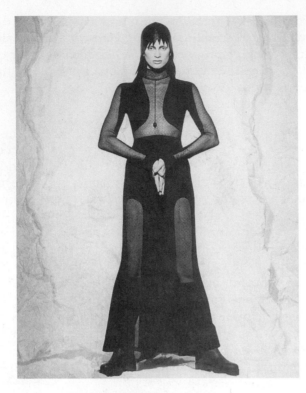

Figure 3-10 This black viscose dress with transparent tulle inserts is an example of symmetrical balance. (Courtesy of Karl Lagerfeld)

plement the apparel for which it is being crafted, balanced either formally or informally with the use of properly placed detail, achieved some sort of movement with the addition of a long chain for wearing on the shoulder, an example of continuous line rhythm, enhanced by a large faux jewel that serves as its point of emphasis or focal point to which the eye is first drawn, and harmonized because all of the parts work well together.

EXECUTION OF THE SAMPLE GARMENT

The complexity of the task of turning out samples varies from situation to situation. The most rigorous occasions are those when a totally new collection is being readied. With the final number of pieces having been determined by the staff's merchandisers, it is the company's design component that must now provide the various styles. It should be understood that there is always a greater number of samples completed than the number needed for the overall line. In fact, as much as 50 percent or more of the finished samples may be eliminated before the buyers get their chance to purchase. A visit to most garment centers will reveal a tremendous number of sample sales, at which time those garments that are not destined for the production line are sold, piece by piece, at their wholesale cost or below.

THE SKETCH

The chore begins with a preliminary sketch by the designer. The look or feel of a special fabric might quickly inspire a specific silhouette that would be appropriate. This first sketch might be nothing more than a rendering that addresses the silhouette and, perhaps, some detailing. It must, however, be sufficiently drawn to be understood by those who are going to develop the patterns. Today, computer programs that feature shapes and details are readily available and add clarity to the designer's sketches. There is even computer software that translates the sketch into the pattern that will be used to cut the pieces of the proposed design.

THE PATTERN

The pattern is composed of the various parts of the design such as the body of the garment, the sleeves, collar, and pockets. It is used in the transition from the designer's rendering to the creation of the sample-size garment. The sizes used are generally those that best show off the products. In men's wear, a size-38 suit is typical and in women's wear, juniors usually are sampled in size 7 and missy styles in size 8.

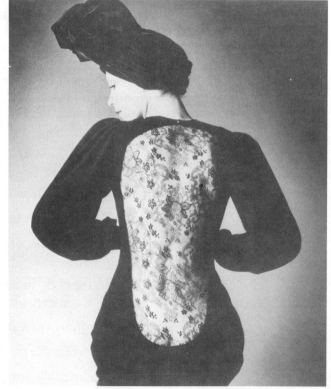

Figure 3-11 The designer's sketch is translated into a dress that uses unusual back treatment. (Courtesy of Yves Saint Laurent)

The pattern may be achieved either through a means of draping in which a "muslin" is created by cutting the various pieces of the design on a form or through the use of the flat pattern technique, accomplished on a table, where draping is less desirable. The decision for one of these approaches, or a combination of the two, is determined by the specific design.

After the pattern is made, it is placed on the fabric to be cut by the individual who is responsible for making the sample. Some designers use their assistants for this purpose, whereas others use cutters.

SAMPLE CONSTRUCTION

The sample maker assembles all of the pieces that complete the garment. The stitches and methods used must be appropriate for those that will be used in regular production. Often, the sample is so carefully sewn that the finished products that reach the stores pale by comparison. If this is the case, the goods that reach the selling floors might be returned to the vendor. Care must be exercised to make certain that both the sample and the production pieces are of similar quality.

Although the garment's appearance is of significant importance to its sale, its fit is equally important. To assure proper fit, the garment should be tried on a live model after the kinks have been corrected on the stationary form. As the model walks and sits, the garment's ability to satisfy the figure's formation can be assessed.

Too often, when this stage of development is lightly passed over, the products are sent back to the manufacturer.

When the design team has completed its tasks, the line is readied for selling and production is about to begin.

REVIEW QUESTIONS

1. Define the term *knock-off*.

2. Describe the breadth of the typical haute couture collection.

3. In what way does designer merchandise differ from haute couture?

4. Discuss some of the areas of inspiration from which a designer creates a line.

5. What "color system" do most designers use when they are assessing the various color combinations?

6. Define the terms *hue, value* and *intensity*.

7. Differentiate between the terms *tint* and *shade*.

8. Which color scheme relies on just one color, and how does this color limitation avoid monotony?

9. To create the illusion of intensified color, which color scheme is used?

10. Why do colorists and stylists "invent" new color names rather than using the hue's traditional name?

11. What is the term used to describe the shape or outline of a garment?

12. Discuss the difference between symmetrical and asymmetrical balance.

13. Describe three types of rhythm that designers use to give movement to their creations.

14. How does the designer achieve a harmonious effect on each of his or her designs?

15. Discuss the three stages used in the execution of the sample.

16. What is a pattern?

17. Differentiate draping from flat patternmaking.

18. Why is it important for the final garment to be judged on a live model instead of on a regular dress form?

EXERCISES

1. Choose an apparel or accessories classification for the purpose of evaluating its designs. After scanning a number of fashion periodicals such as *Elle, Gentlemen's Quarterly, Vogue, Harper's Bazaar,* and *Esquire,* select five items that attract your attention. Mount each on a piece of foam or construction board and, next to them, indicate the following:

 a. The specific elements used.
 b. The garment's or accessory's silhouette.
 c. The details used in each design.
 d. The trim used to enhance the product.
 e. The principles used.

 Each item should then be carefully critiqued in terms of how you believe it will fare in the marketplace.

2. Bring to class tubes of acrylic paint of the three primary colors and black and white. Using the "blank" color wheel provided by your instructor, mix the appropriate primaries to achieve the secondary colors. When that is complete, mix the paints to produce the tertiary colors, those found as a result of mixing a primary and a secondary. With the addition of black and white, create tints and shades of each of the primary, secondary, and tertiary colors.

CHAPTER 4

FASHION MANUFACTURERS: FROM PRODUCTION TO DISTRIBUTION

LEARNING OBJECTIVES

After reading this chapter, the student should be able to:

1. Determine the costs involved in the production of apparel and accessories.
2. Differentiate between inside shop production and contracting.
3. Contrast the advantages and disadvantages between off-shore and domestic production.
4. Explain the basic stages of production for fashion merchandise.
5. Discuss the various aspects of merchandise distribution by manufacturers.

INTRODUCTION

As the lights dim in the numerous arenas where the seasons's latest collections have previewed, another fashion environment is ready to spring to life. Garment centers all over the world are eagerly awaiting the signal for production to begin. Although the designer has struggled to create a line that he or she believes will entice the retailers to buy, only a small percentage of the items will make the transition from the original samples to mass production. After the lines have been carefully "edited," those that have met the production quotas will be manufactured for distribution to the stores.

Garment centers such as New York City's Seventh Avenue are filled with the various industrial components that contribute to the finished

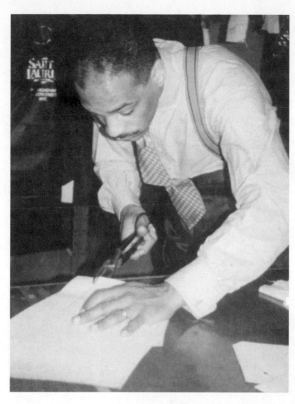

Figure 4-1 Designer Avery Lucas creating an item that will hopefully become part of the line. (Courtesy of Saint Laurie)

products as well as to the places in which the purchasers may make their selections. Fabric outlets, trimmings supply houses, manufacturer showrooms, and production facilities perform their specialized functions in getting the merchandise from the production point to the consumption point. Fastidiously dressed buyers armed with record-laden attachés artfully dodge the "trolley-filled carts" of bolts of fabrics, garment sections that are being moved from cutters to assemblers, and finished apparel and accessories that are headed for the nation's retailers. The noisy horns from the truckers trying to maneuver the crowded streets and make their deliveries add the "music" to the environment.

Although all of this hustle and bustle provides peripheral excitement, extreme care must be exercised by the manufacturing community to make certain that their efforts render profits. Numerous decisions must be made before any production may begin. How much will materials, trimmings, and labor cost? Should the entire garment be constructed by the manufacturer or will it be more beneficial for some of the operations to be undertaken by outside contractors? Would "off-shore" production be more suitable or might a domestic plant better serve the company's needs? How will quotas and tariffs affect the manufacturer?

These and some other functions of fashion manufacturing are addressed in the chapter.

Figure 4-2 Garment center "trolley" filled with fabrics headed for production.

ESTABLISHING THE COST OF THE PRODUCT

Long before materials and trimmings are purchased and production schedules set, the costs of every component of the finished product must be determined. If not carefully approached, a best-selling garment or accessory might not bring a profit to the company. Up until this time, an approximate set of costs has been established based on the designer's original model or sample. After the signal has been given to go ahead with production, these estimates must be transformed into actual costs. Along with the materials and trimmings, the expenses incurred in manufacturing and distribution must also be determined. Only an exact calculation will show the manufacturer how much to charge the retailers.

MATERIALS

Whether it is the fabric for a suit, leather for a pair of shoes, or the "setting" for a piece of fashion jewelry, the exact amount needed for each unit must be determined. In cases where more than one material is used, each must be individually assessed and figured into the total materials cost. In the case of handbags, for example, the frames on which the styles

Figure 4-3 Materials are the garment's basic ingredient. (Courtesy of Tickle Me)

are constructed are individually priced and easy to assign a specific cost. The fabric or leather coverings, however, are sold by the yard, requiring specific yardage determination that must be multiplied by the cost per yard. Assuming the following materials were needed for the aforementioned handbag, the cost analysis would break down this way:

frame ..$ 6.00

1/8 yard matelasse ($32 per yard)$ 4.00

1/32 yard leather gusset ($48 per yard)$ 1.50

1/8 yard rayon lining ($4 per yard)............$.50

Total materials cost....................$12.00

TRIMMINGS

The trimmings or enhancements to apparel or accessories are generally individually priced as in the case of buttons, bows, zippers, ornamental pins, and flowers. Some, however, such as piping and handbag straps come as yardage. They too must be determined and figured into the product's cost.

Figure 4-4 Operator applying trim to the sample garment. (Courtesy of Tickle Me)

Using the preceding handbag example, trimmings cost would be shown this way:

leather handle...$3.25

3/4 yard shoulder strap ($4 per yard)$3.00

tassel...$1.85

Total trimmings cost......................$8.10

PRODUCTION LABOR

Production labor costs include the making of the patterns, grading, marking, cutting, and assembling. Although the first three are easy to determine because those who perform the operations generally work for the company on an hourly or weekly structure and figures can be generated for their specific tasks, cutting and assembling may be provided in a number of ways. Few manufacturers produce an entire product from start to finish. The majority perform one of the major operations such as cutting or sewing, leaving the other(s) to outside contractors. Some companies go the "outside route" entirely and are only responsible for design, materials purchases, and sales.

In the cases where all of the production takes place in an "inside shop" that is company owned, the time it takes for each operation can be costed in terms of the employee's wages. If one or more of the operations is performed by a contractor in an "outside shop," the total assembling cost, for

Figure 4-5 Sewing is a major cost of production. (Courtesy of Saint Laurie)

example, is set by an individual contract for a specific number of garments. The total cost is then divided by the number of pieces to be sewn, giving the company the actual cost per unit. This cost is then added to the labor costs of the manufacturer who has done his or her own cutting.

Using as an example, the production of a dress that combines inside and contracted operations, the labor costs, per unit, would look like this:

inside cutting ($22 per hour) ¼ hour...............$ 5.50

contracted assembly (1000 pieces, $7500)$ 7.50

finishing ($25 per hour) ⅛ hour$ 3.12

Total production labor$16.12

In some situations, the workers are paid on a "piece" basis and are paid a set amount for each finished product. This system significantly simplifies the costing of labor.

TRANSPORTATION

The cost of freight must be also considered for each unit. In-house production eliminates the need for and expenses incurred in moving the gar-

ment from one production point to another. In today's fashion production, however, this is the exception rather than the rule.

Most products are transported by truck from one destination to the next until the finished product comes back to the manufacturer. Contracts are established with freight companies that address the amount of units that will be handled. The cost of the contract must then be broken down to each specific unit so that it can be included in the product's final cost. Although domestic shipping costs are significant, they pale in comparison with the expenses incurred when overseas production is used. If time is of the essence, air freight, the costliest means of transportation, will need to be used. Although transporting by ship is considerably less costly, the time it takes to receive the merchandise might be too restrictive for the manufacturer's needs.

The company must carefully address all of the advantages and disadvantages of each shipping situation and determine which provides the best in terms of ultimate cost.

DISTRIBUTION EXPENSES

The sale of the goods by the manufacturer to the retailer involves considerable expense. There are two major methods used in selling the goods to the retailer; one involves the manufacturer's own sales staff, the other involves the manufacturer's representatives. In both situations, the expense of selling each unit must be considered before the cost of each individual item is finalized.

In a later section in this chapter, the different distribution choices are discussed, including the costs of each.

DETERMINING THE WHOLESALE PRICE

After all of the costs directly related to the specific product have been determined, the manufacturer must decide on a markup that will cover any additional expenses of doing business and bring a profit to the company. The markup is the difference between the cost and the wholesale price as indicated in the following example:

$$\text{wholesale} - \text{cost} = \text{markup}$$

$$\$40 - \$30 = \$10$$

The markup is then expressed on a percent, using the wholesale price as the base. Using the above numbers, the markup would be 25.

The markup percent must consider such fixed expenses as rent, heating and ventilation, electricity, telephone, and insurance. Salaries for executives, sales personnel, and the design team must also be included, along with the costs attributed to the promotion of the merchandise, which include cooperative advertising allowances for retailers and promotional

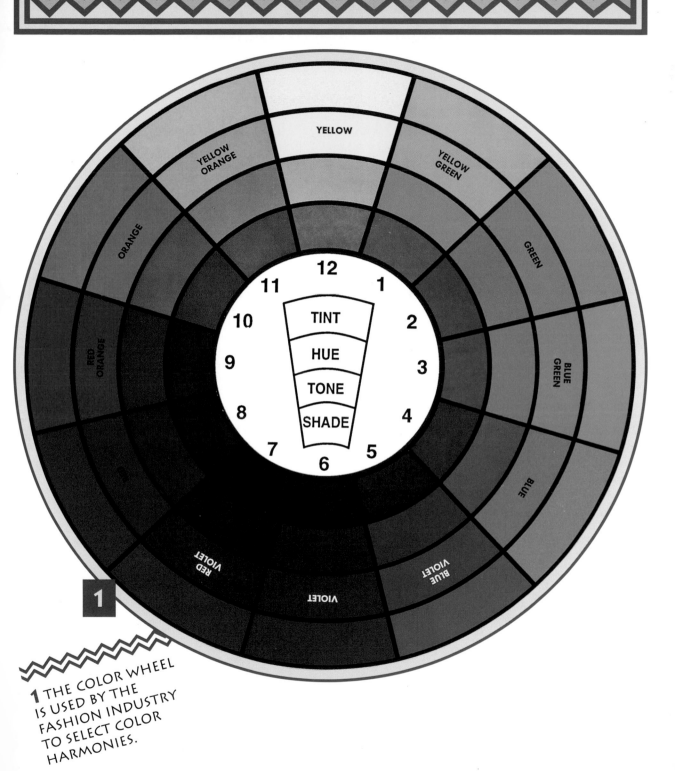

1 THE COLOR WHEEL IS USED BY THE FASHION INDUSTRY TO SELECT COLOR HARMONIES.

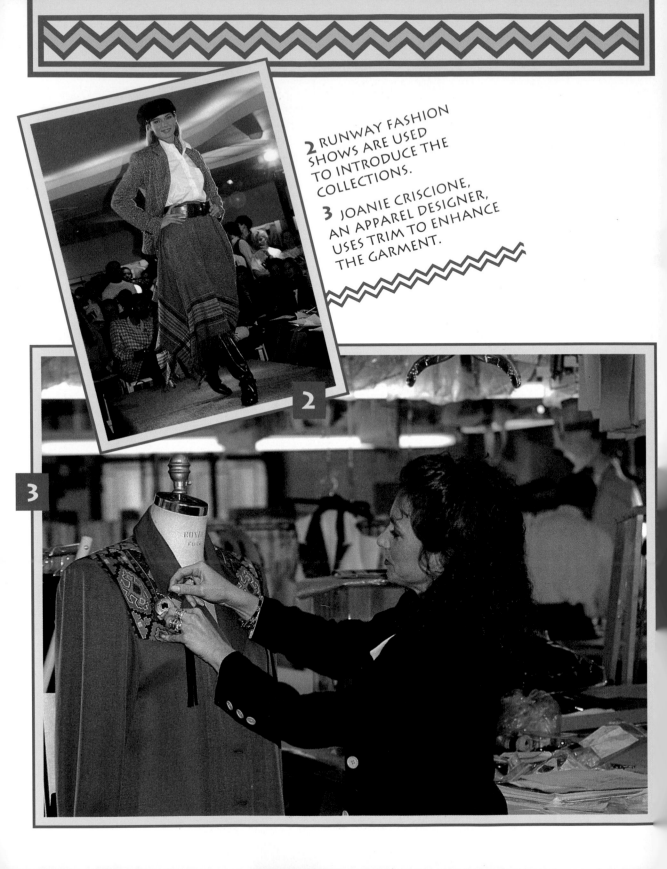

2 RUNWAY FASHION SHOWS ARE USED TO INTRODUCE THE COLLECTIONS.

3 JOANIE CRISCIONE, AN APPAREL DESIGNER, USES TRIM TO ENHANCE THE GARMENT.

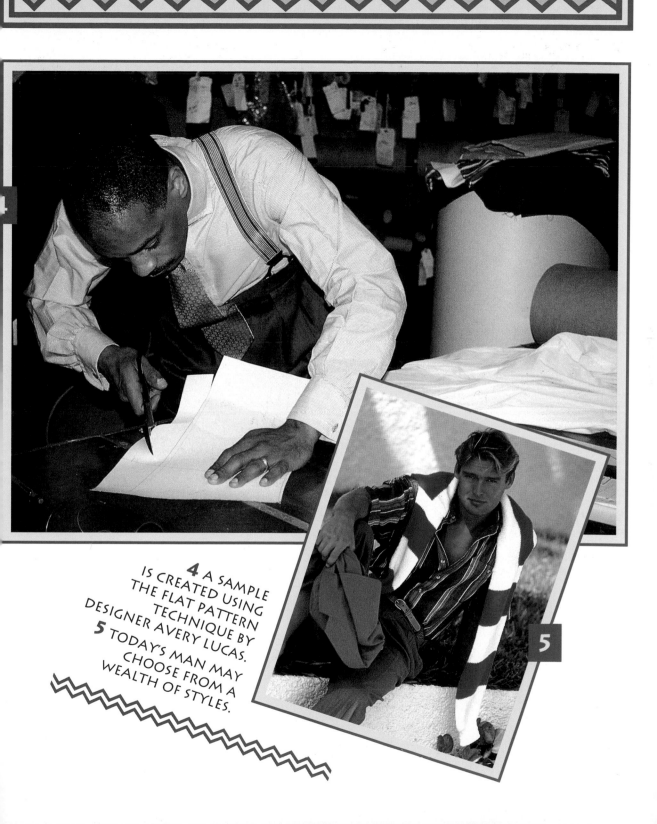

4 A SAMPLE IS CREATED USING THE FLAT PATTERN TECHNIQUE BY DESIGNER AVERY LUCAS.

5 TODAY'S MAN MAY CHOOSE FROM A WEALTH OF STYLES.

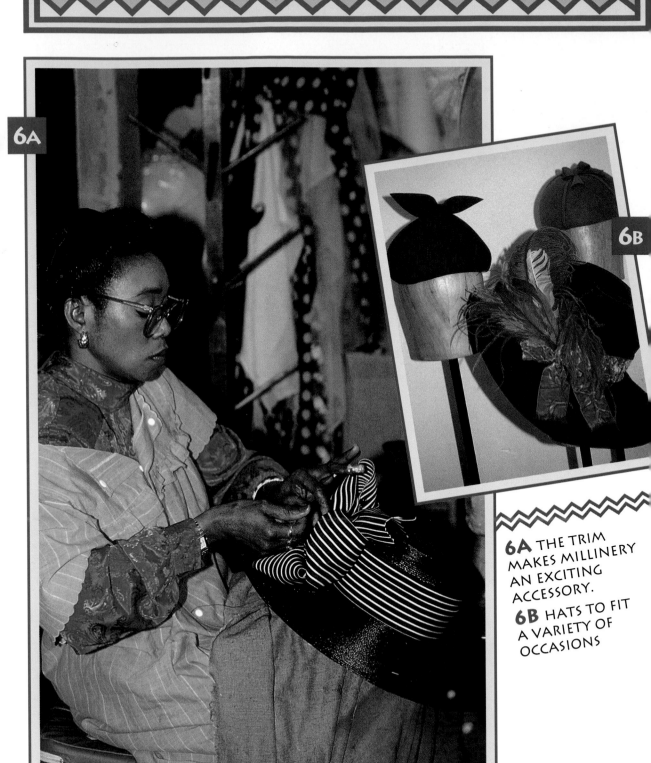

6A THE TRIM MAKES MILLINERY AN EXCITING ACCESSORY.

6B HATS TO FIT A VARIETY OF OCCASIONS

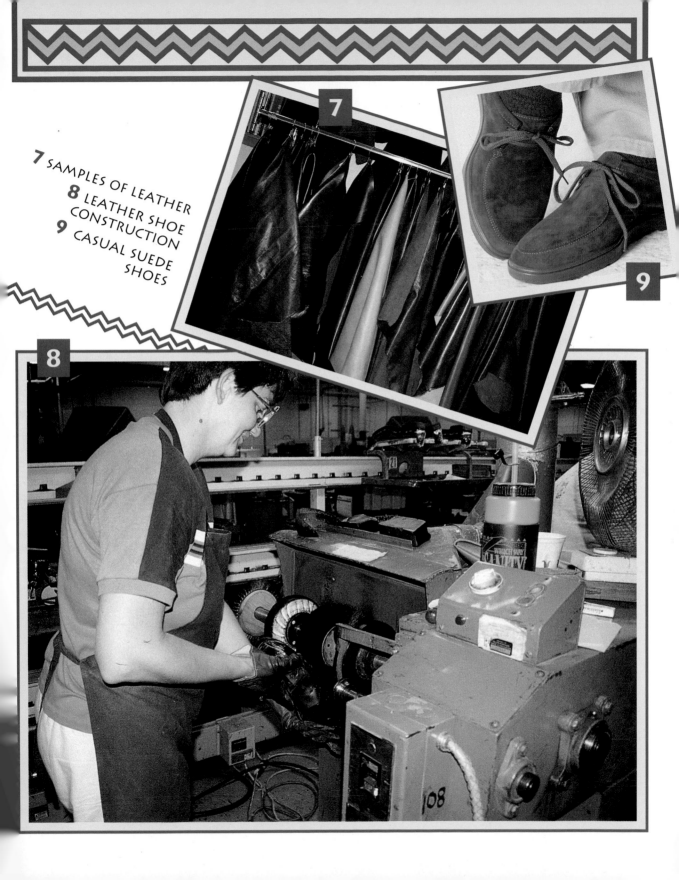

7 SAMPLES OF LEATHER
8 LEATHER SHOE CONSTRUCTION
9 CASUAL SUEDE SHOES

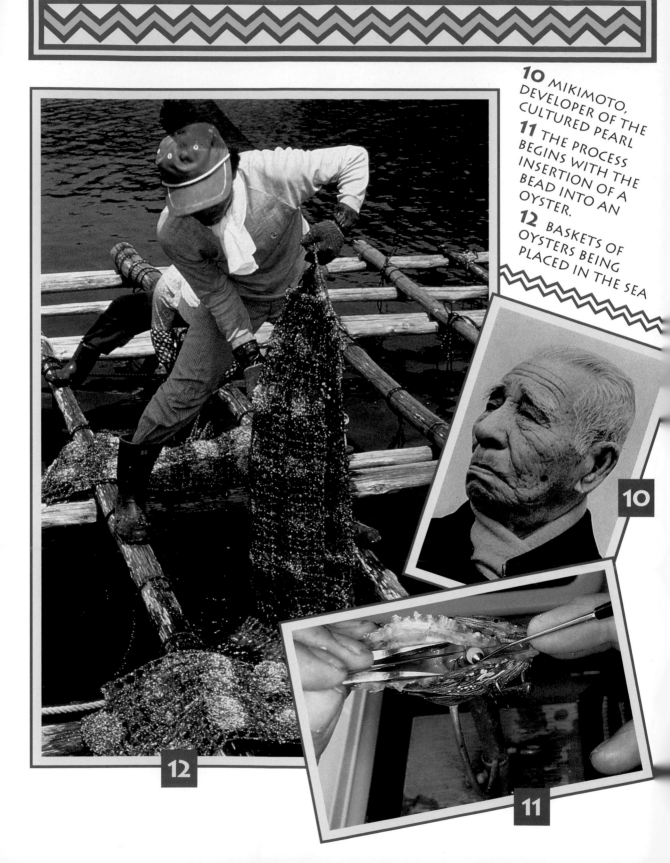

12

10

11

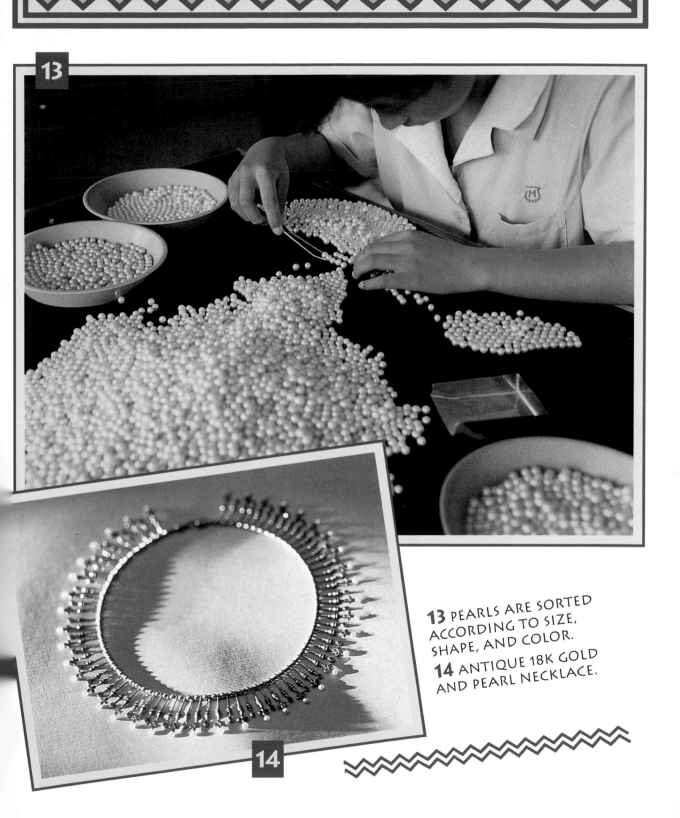

13 PEARLS ARE SORTED ACCORDING TO SIZE, SHAPE, AND COLOR.
14 ANTIQUE 18K GOLD AND PEARL NECKLACE.

15

16

1

events such as fashion show production and press kits that are used to notify the industry of the season's newest efforts. Any potential losses such as those attributable to goods that must be disposed of at lower than anticipated prices and unpaid retailer invoices must also be considered.

The actual markup in the fashion apparel and accessories industries varies from company to company and product to product. Some lines command higher than the typical markups because of a particular designer's appeal, a limited production volume, or the originality or newness of the designs. High-volume companies, on the other hand, might opt for a significantly lower markup than others in the industry because their enormous sales potential brings them greater overall profits.

Sometimes a manufacturer will use a promotional price policy that reduces the markup in the hope that the lower price will bring greater sales volume and, in turn, more profit. Other companies establish specific markups for their regular lines and lower markups for lines that they produce for slower selling periods.

There are no hard, fast rules to follow, except that the fashion business is highly competitive, and each manufacturer must carefully assess his or her position in the industry to make certain that the company's pricing structure is appropriate to maximize sales.

PURCHASE OF MATERIALS

After the decision has been made in terms of which styles will be produced and in what quantities, the next step is to purchase the materials. The yardage or component parts necessary for each style to be produced is based on a preestablished *cutting ticket,* a term used to indicate the minimum number of pieces ordered to insure profitability. If, for example, the cutting ticket for style 848 is 400 pieces, it will be manufactured only if that number of pieces has been ordered by the retailers.

The size and potential volume of each manufacturer determines the manner in which the materials will be purchased. Large companies buy their fabrics directly from the major textile mills because it is there that they can avail themselves of the best prices. Smaller companies are often restricted to smaller textile producers or wholesale fabric suppliers because they may be unable to meet the minimum requirements necessary for purchasing from the industry's giants. The sources for other materials such as leather, metals, and stones are also determined by the size of the purchase.

As we will learn in Section III, The Materials of Fashion Apparel and Accessories, materials are available from resources throughout the world. The purchasers of these products must know the various markets and the advantages and disadvantages of buying from each. Price, delivery time, and reliability of supply are a few of the factors that must be considered before any orders are placed.

Figure 4-6 Determining yardage needs for a style. (Courtesy of Saint Laurie)

Each major materials classification, textiles, leather, furs, metals, and stones, are individually addressed in separate chapters that underscore their specific roles in the manufacture of apparel and accessories.

PRODUCTION ALTERNATIVES

The term *manufacturer,* as it is used in the fashion industry, is somewhat misleading. In many cases, the manufacturer does not participate in any of the production functions but merely is responsible for the lines' creation and sales. The actual production comes at the hands of outside contractors.

INSIDE SHOPS

Company-owned production facilities are known as *inside shops*. Except for some of the giants in the industry such as VF Corporation, makers of Jantzen and Lee, few manufacturers produce the entire garment. The major advantages of the inside shop are both the better control over all of the operations, which contributes to better quality, and the shorter time frame for manufacturing because the goods need not be moved from one facility to another. Although these are certainly advantageous, the negatives center around financing such operations. The initial outlay for

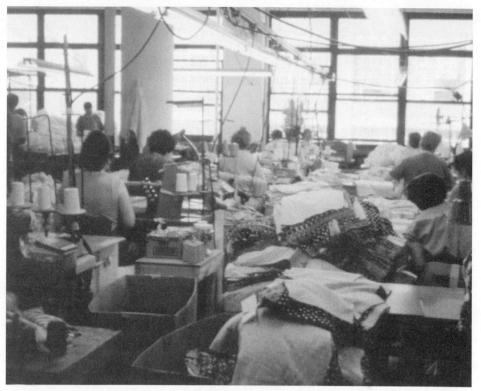

Figure 4-7 Tickle Me manufactures its line in its own production facility. (Courtesy of Tickle Me)

equipment is significant and, during slow periods, labor and overhead costs continue, although there may be less demand for the goods.

OUTSIDE CONTRACTORS

The majority of the fashion manufacturers use outside shops for some or all of their production. A company might cut the garments and ship them to sewing contractors for assembling or have outside shops provide the cutting while they sew their own goods. More and more companies are relinquishing production, using their own staffs only for design and sales.

Outside contracting affords the manufacturer the advantage of paying only for the services needed. During peak periods, more than one contractor could be employed, which significantly speeds production time and makes delivery to the store faster. In the fashion industry, with "perishability" a factor, saving a few days can be meaningful. With manufacturing left to others, the company can better direct its efforts to the creative and distribution functions. Finally, the business need not make the heavy capital investment necessary for equipment and can more easily weather the slow periods. Although the advantages are certainly con-

siderable, there are disadvantages with which a company must deal. Because the operations take place away from the company's premises, there is little, if any, control over production. Contractors might be late in their deliveries, quality might be less than expected, and in cases where more than one contractor is used, extra expense could be involved in moving the goods from one to the other.

OFF-SHORE PRODUCTION

When the cost of manufacturing spiraled upward, many American apparel and accessories manufacturers sought alternatives to domestic production. Some headed to outlying, underdeveloped areas of the United States where municipalities gave tax advantages to industry to set up shop and costly union labor was not a requirement. Others searched for overseas operations in countries where the costs of production were far below those of the United States.

Countries such as Hong Kong, South Korea, and the Philippines quickly became attractive centers for the production of American goods. The popularity of off-shore production can be immediately understood by the quick examination of the merchandise labels that are affixed to the apparel and accessories inventories in America's retailers. More than 50

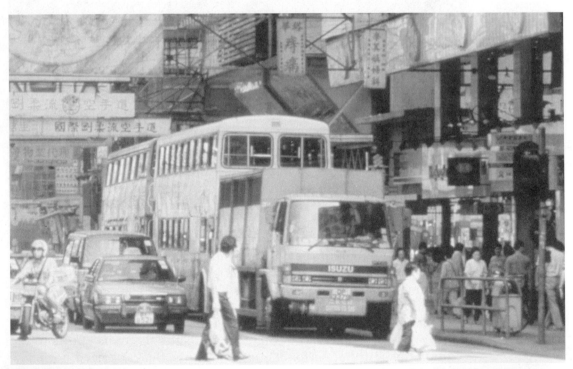

Figure 4-8 Hong Kong is a major off-shore fashion producer. (Courtesy of the Hong Kong Tourist Association)

percent of the fashion merchandise bearing American company names comes from countries other than the United States.

There are three basic ways in which a company might use off-shore production for the manufacturer of their products. By setting up a wholly owned facility, which the company totally finances and operates, they have the benefit of complete control in terms of personnel selection, manufacturing techniques, and so forth. Some choose the joint-venture option, which involves a partnership between themselves and a contractor who will perform the production function. This arrangement affords the company some control, whereas the costs of the operation are shared. The outside contractor is also used in foreign countries and requires payment only for services rendered.

Although cost savings are the primary consideration for going one of these routes, there are several factors that must be considered before any of these manufacturing approaches are taken.

Import Tariffs. When an American producer or a manufacturer in any country produces merchandise domestically, costs for labor, materials, promotion, and overhead are the only considerations for determining the wholesale price. When a company based in one country wishes to have its merchandise produced elsewhere, a number of restrictions and expenses are imposed that ultimately contribute to higher costs.

Duty or tariffs, which are additional amounts levied on merchandise that comes from abroad, are imposed by the government of the importer. The purpose of this additional charge is to give domestically produced goods a more competitive price. For example, if an American-made shirt costs the manufacturer $12 and its foreign counterpart can be imported for $6, the result would be unfair competition and a lesser demand for the higher priced item. The government establishes a tariff schedule that clearly lists every conceivable type of product and the percent of duty for each. The $6 shirt might be dutiable at 50 percent, increasing the price an additional $3, bringing it to $9 and closer to the American price.

The rates of the duty are based on a percentage of the product's appraised value and vary from one merchandise classification to another. The country of origin is also a factor in the rates applied, with imports from one country costing twice as much as the identical import from another. Countries that enjoy "most favored nation" status have their goods valued at considerably lower tariffs than those classified as "nonpreferential" countries. The difference can be as much as 250 percent! For example, a recent tariff schedule of the United States listed men's shirts at 2.5 percent for preferred countries and 10 percent, 4 times the amount, for the nonpreferred countries.

Sometimes the American government, wishing to assist a foreign country with its economic problems, provides for a duty-free program. The Caribbean Basin Initiative, for example, enables goods imported

Heading/ Subheading	Stat. Suf. & cd	Article Description	Units of Quantity	Rates of Duty		
				1		2
				General	Special	
6103		Men's or boys' suits, ensembles, suit-type jackets, blazers, trousers, bib and brace overalls, breeches and shorts (other than swimwear), knitted or crocheted:				
		Suits:				
6103.11.00	00 0	Of wool or fine animal hair.........(443)	No.....v kg	77.2¢/kg + 20%	7.7¢/kg + 2% (IL) 46.3¢/kg + 12% (CA)	77.2¢/kg + 54.5%
6103.12		Of synthetic fibers:				
6103.12.10	00 7	Containing 23 percent or more by weight of wool or fine animal hair...........(443)	No.....v kg	77.2¢/kg + 20%	7.7¢/kg + 2% (IL) 46.3¢/kg + 12% (CA)	77.2¢/kg + 54.5%
6103.12.20	00 5	Other.........................(643)	No.....v kg	30%	3% (IL) 18% (CA)	72%
6103.19		Of other textile materials:				
		Of artificial fibers:				
6103.19.10	00 0	Containing 23 percent or more by weight of wool or fine animal hair..............(443)	No.....v kg	77.2¢/kg + 20%	7.7¢/kg + 2% (IL) 46.3¢/kg + 12% (CA)	77.2¢/kg + 54.5%
6103.19.15	00 5	Other....................(643)	No.....v kg	30%	2.4% (IL) 18% (CA)	72%
6103.19.20		Of cotton...........................	18.7%	0.5% (IL) 11.2% (CA)	90%
	10 6	Jackets imported as parts of suits.................(333)	doz. v kg			
	15 1	Trousers, breeches and shorts, imported as parts of suits...................(347)	doz. v kg			
	30 2	Waistcoats imported as parts of suits.................(359)	doz. v kg			
6103.19.40		Other...........................	6%	Free (E*,IL,J*) 3.6% (CA)	45%
		Subject to cotton restraints:				
	10 2	Jackets imported as parts of suits.......(333)	doz. v kg			
	20 0	Trousers, breeches, and shorts imported as parts of suits.............(347)	doz. v kg			
	30 8	Waistcoats imported as parts of suits.......(359)	doz. v kg			
	40 6	Subject to wool restraints...............(443)	No. v kg			
	50 3	Subject to man-made fiber restraints...............(643)	No. v kg			
		Other:				
		Of silk:				
	60 1	Containing 70 percent or more by weight of silk or silk waste................	No. v kg			
	70 9	Other..........(843)	No. v kg			
	80 7	Other...............(843)	No. v kg			

Figure 4-9 A U.S. tariff schedule.

from such countries as Jamaica, Haiti, and Barbados to come in without any added tariff.

The manufacturers wishing to participate in these off-shore production programs first investigate the tariff schedules and select the countries that will be most favorable to their needs.

Quotas. Another significant factor to consider before overseas arrangements are made involves quotas. A *quota* is the amount of merchandise

that a country's government will allow to be imported. The amounts are generally established in numbers of units rather than dollars. As with the duties imposed, these restrictions are designed to eliminate unfair competition for the importing country. In countries in which production costs are comparable with the importer's country, no quotas are established. The United States does not impose any quota restrictions on merchandise from any area other than the Far East, where the labor costs are significantly lower. Thus, merchandise from France may be imported in any quantities. Merchandise from Hong Kong and South Korea, however, may be ordered only in specific amounts.

The quota arrangement often hampers the importer who has developed a "hot item" and is inundated with large orders that cannot be satisfied. In some cases, quotas may be purchased from quota holders who have not exercised their rights to import all of their allocation.

The quota system requires a careful study by the manufacturer regarding alternatives such as using domestic production or choosing those countries that are quota free.

Quality Control. Although there are many benefits to off-shore production, quality control is an important factor to consider before any such arrangement is made.

Goods that are produced far from the manufacturer's headquarters are difficult to scrutinize and sometimes arrive in less than desirable conditions. The sewing might not reflect the original sample, the trim might

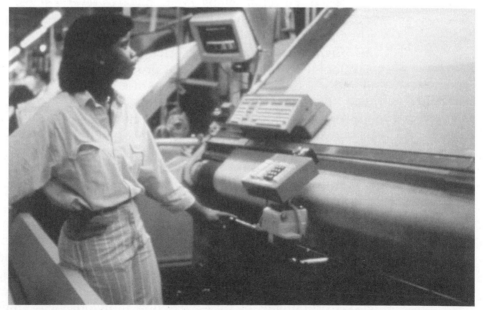

Figure 4-10 Quality controller inspecting fabric for imperfections. (Courtesy of American Textile Manufacturers)

not be color matched, and other minor imperfections could cause problems. To overcome such obstacles, the larger companies use quality-control managers to oversee their foreign production on either a full-time or a visiting basis.

Reorders. Often, the styles that are selected for production and distribution do not sell in the stores as successfully as initially expected. Thus, the profitability that comes from reorders is not realized. Manufacturers thrive on runners, numbers that reorder over and over again. The hot items, as they are called, must be delivered quickly, because with the perishability factor of fashion merchandise, every day that is lost to slow delivery reduces the time in which the item may sell.

Delivery problems, although possible with domestically produced goods, seem to escalate when off-shore manufacturing is used. Not only does it take longer for the goods to arrive at their destination points, but sometimes materials used for the garments come from one area and must be shipped to another area for manufacturing and the problem becomes compounded. Many vendors and retail buyers do not reorder foreign-produced goods because of these potentially dangerous situations. Too many late deliveries result in store cancellations, with the manufacturer finding it necessary to dispose of the unwanted goods at greatly reduced prices.

THE MANUFACTURING PROCESS

The process of transforming the designer's work into merchandise that will reach the retail selling floors involves several steps, beginning with making the production pattern for each style and concluding with the finished product.

Each apparel and accessories classification has its own stages of development. Some are general procedures that cut across most merchandise products, whereas others are specific to a particular product type. The manufacturing process addressed in this section is generally appropriate to men's, women's, and children's apparel and some fashion accessories. Furs, textiles, shoes, gloves, and jewelry, which are atypical of these stages, are separately discussed in chapters that examine the industries in which they are produced.

THE PRODUCTION PATTERN

As previously mentioned, the original pattern is created by the designer or designer's assistant and is accomplished either by draping or flat patternmaking. In some companies, the patterns that will be used to produce the actual garments are mere adjustments or corrections to the designer's creation. When the sample need not address exact sizes and could be tailored to fit a particular individual who might be used to model the style in the manufacturer's showroom, the actual production, in terms of fit, must be appropriate for the consumer markets served by

the company. The importance of this stage might be best understood with a specific example. Italian crafted shoes are generally more narrowly constructed than American shoes because the native Italian's foot tends to be narrower. When shoes made in Italy are produced with the patterns or "lasts" for their own country's consumption, those shoes that might be exported to America are often inappropriate for the wider American foot. Thus, different patterns for the same style must be developed to better serve different wearer needs.

The production patternmaker, who might serve a dual role by also making designer patterns, uses the same methods discussed in the previous chapter. Strict adherence to the company's size standardization is perhaps the most important detail to which attention must be paid. Any consumer who tries on a variety of styles of different vendors quickly recognizes that size-standard sizing is not part of the fashion industry. When a carpenter orders "2 X 4" lumber or 6d nails, every piece will be identical no matter where the merchandise is produced. The dimensions of a size-12 dress, however, from one manufacturer might be totally different than from another. Often, a retailer sales associate will say, "try a smaller size because this manufacturer makes a fuller cut." The specifications must be established by the company and carried out by the patternmaker.

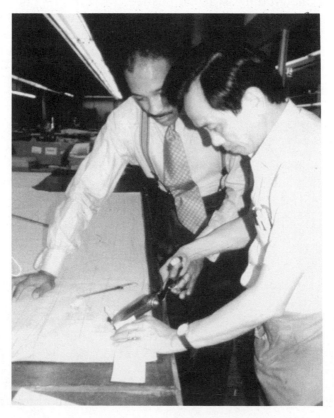

Figure 4-11 Designer overseeing production patternmaker at work. (Courtesy of Saint Laurie)

GRADING AND MARKING

After the pattern is completed, it must be graded to fit the different sizes in the range that will be produced. Designer samples and patterns in men's clothing generally are made in a size-40 regular, but the complement of sizes might range from 38 to 44, with shorts and longs needed in addition to the regulars.

The grading may be achieved by manual or computerized means. In the former, traditional procedure, the operator uses the sample pattern as a guide and creates the other sizes by increasing or decreasing the other patterns, using amounts that have been predetermined. In manual preparation, the grader must possess specific skills because it is the hand and not the machine that does the actual calculation necessary for each size. More and more companies are using computerized systems for pattern grading. The operator who uses these sophisticated systems must take the initial pattern and mark the key points with a computerized "digitizer" that automatically upgrades or downgrades the pattern. Once the key points of each pattern are set into the computer's memory, a pattern for each size is automatically printed. Not only does the computer provide for more accuracy in grading, it accomplishes the procedure in a fraction of the time that it takes for an operator to perform the functions.

After the grading is accomplished, markers, or pattern layouts, are constructed that measure the same width as the material to be used for the product. The markers are made of paper and traced from the pattern boards for each of the garment's components. Each part is then set out to fit as closely as possible to the next to eliminate fabric waste. As with grading, markers can be accomplished by computer.

Figure 4-12 Computerized system for pattern grading. (Courtesy of Saint Laurie)

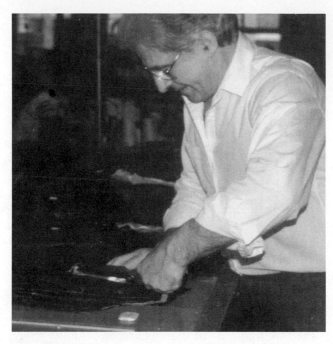

Figure 4-13 Fine garment sections are cut by hand. (Courtesy of Saint Laurie)

CUTTING

After the patterns and markers are generated, the fabric is spread on the cutting table in layers over which the markers are placed. The number of layers depends on the density of the fabric, with as many as 500 for the sheered materials.

The cutter expertly follows the markers and guides a vibrating blade around their edges. The vertical blade is better than the circular type because it is more accurate when following the curves of some designs. The fineness or coarseness of the blade depends on the thickness and density of the material.

Although traditional hand cutting is still very much in use, more and more computer utilization is found in the cutting room. Not only does it provide speed, but its accuracy is unrivaled. In some sophisticated manufacturing plants, the laser beam is used in conjunction with the computer to perform the cutting function.

In cases in which a style is repeated over and over again, making it a staple in a line, die cutting might be used. The process resembles that of a cookie cutter. A die is developed that has sharp edges that, when pressed against the layers of material, easily cuts through. Inexpensive gloves that have year-to-year usefulness often use die cutting in the factory.

The vast majority of apparel and accessories are mass produced, warranting cost-cutting savings that are found in cutting many pieces at one time. In the couture houses, however, individual garments are still being cut one at time.

Figure 4-14
Assemblers involved in "piece work" production. (Courtesy of Tickle Me)

ASSEMBLING

The number of different sewing steps can range upward of 150 for fine shoes and more than 200 for quality men's wear. The work may be accomplished by hand, as in the case of fine quality merchandise, or, for the most part, by machine.

Sometimes, an individual worker may assemble the entire garment or, in the majority of cases, the final product is a team effort of assembly-line production. Individuals are trained to perform one function, passing their work to the next in the line who furnishes the next sewing effort, and so on to the last in the line. The factories using this approach place individuals performing the same operation in one section. After they complete their particular task, the batch of work is moved on to the next section for the next production step, and so on.

Although hand sewing is sometimes used, it is only the most expensive garments and accessories that are totally hand sewn. The majority of the assembling is done by a number of power machines, with handwork, if used, left for decoration or trim.

There are several types of machines, including the lock-stitch that sews a straight seam, the chain-stitch that produces a looped effect, an overlock that sews one seam over another and enhances the appearance of some designs, the blind-stitcher that is used for hemming, and the buttonhole machine that effortlessly and automatically sews the buttonholes.

More and more automated sewing is being introduced in the factories as a means of reducing labor costs. By using computer-driven machines, inexpensive garments are being totally assembled, thus eliminating the need for the number of operators employed for traditional sewing.

Some assembling involves fusing where two pieces are "bonded" together. In the men's wear industry, lesser quality garments fuse together the facing and visible fabric of a lapel, thus eliminating the need for costly sewing.

FINISHING

After the garment or accessory is assembled, it moves on to finishers who sew the buttons or provide some decorative touch. Beads may be sewn on the garment at this stage as might ornamentation such as appliques and fringe. Decorative hand stitching may also be added at this point. Although some of the finishing is done by hand, much of it is accomplished by means of special machines.

Some of the finishes are functional rather than decorative. Pressing, for example, is important because it usually straightens a poorly sewn garment and renders it appropriate for selling. Another, in the hat industry, is blocking, which helps with shape retention. The special finishes used in the production of fashion apparel and accessories are discussed in their respective chapters.

LABELING

Any number of labels are affixed to each product. One identifies the manufacturer or designer. These are extremely important to a large segment of the consumer market because of the messages they deliver. A consumer might be aware of a particular brand's quality, and the visibility of the label helps make the sale. Another might be motivated by the status of a particular designer and his or her name on the garment could spell a quicker sale. Throughout the decades, in fact, many designer and manufacturer labels sewn on the outside of the garment have helped to increase sales. Calvin Klein's name on the outside of the pocket brought enormous sales to the company during the designer-jean era.

Instructions for care are also found on labels, which enable the consumer not only to learn how to clean the garment but also cuts down on returns due to improper laundering. Foreign-made merchandise, by law, must list country of origin, and this accounts for a third label that must be affixed to the garment.

DISTRIBUTION OF THE FINISHED PRODUCT

After the manufacturing process is completed, the products are ready to be delivered to the retailer. Manufacturers, whether they perform all of the production procedures themselves or have them performed by contractors, are generally responsible for shipping the goods to their customers.

The merchandise is sorted according to style and is broken down into the orders that have been placed. Some manufacturers produce only the total quantities that have been ordered, leaving nothing for future shipments. Most, however, cut more than the ordered amounts, hoping that reorders will be forthcoming and that they will be able to act quickly in responding to those purchase requests.

The goods are packed and delivered according to the instructions the buyer has indicated on the purchase order. Such directions include the

Figure 4-15 Garments on hangers headed for the stores.

means of transportation preferred by the customer as well as how the goods will be packed. Some stores specify that garments must be delivered on hangers to facilitate handling at the store, whereas others are satisfied with flat, packed boxes. Whatever the case, the shipping clerks must pay attention to the store's requests.

After the orders have been picked, a packing slip, which indicates style numbers and quantities, is inserted into the package, informing the store's receiving department as to what is inside. The receivers can then quickly compare the packing slip with the purchase order and make certain that the delivery is correct before any unpacking takes place.

It is now up to consumers to decide if the manufacturer has created the fashions that will motivate them to buy.

REVIEW QUESTIONS

1. What are the major components of a fashion product that must be considered in its pricing?
2. If production labor costs are based on hourly or weekly wages, how can they be adjusted to determine what one unit costs in terms of labor?
3. In determining the wholesale price, what is the first formula that must be addressed?
4. Why might one manufacturer work on a higher markup than another?
5. What is meant by the term *cutting ticket*?
6. Describe an *inside shop* and the advantages it affords the manufacturer.

7. Does the use of an outside contractor provide any advantage to the manufacturer?

8. Differentiate between the terms *wholly owned facility* and *joint venture*.

9. Why do governments levy tariffs or duty on merchandise that is brought in from foreign countries?

10. Does the importing of merchandise from countries with "most favored nation" status provide any advantage to the manufacturer?

11. In what way might the quota systems hamper the efforts of the manufacturer?

12. How can a manufacturer who has used the allocated quota import extra merchandise?

13. Why is it difficult to reorder off-shore produced merchandise?

14. In what way does the production pattern differ from the designer's pattern?

15. Describe the two techniques used in pattern grading.

16. When is die cutting used?

17. Although hand cutting is extremely costly, what types of fashion merchandise use this method?

18. What types of labels do manufacturers affix to their products?

EXERCISES

1. Select a shirt, dress, pair of trousers, or some other garment from your wardrobe that you are ready to discard. Carefully disassemble the various parts of the design and staple them onto a foam board. Any functional or ornamental trim should also be affixed to the board.

 To estimate the approximate materials costs of the garment, measure the total yardage used and the number and types of different trim elements. After this preliminary work has been completed, visit a fabric and trimmings store to determine the costs of the same or similar types of materials found in your garment.

 A list should then be prepared to indicate exactly how much it would cost for the materials needed to produce a copy of your garment.

2. Make arrangements for a personal or telephone interview with two garment manufacturers to discuss their production procedures. One should be an inside shop for production, the other outside contracting. The interview should focus on the reasons for each manufacturer's decision for his or her type of production. Prepare an oral report citing the advantages of each type of production procedure as outlined by the two companies.

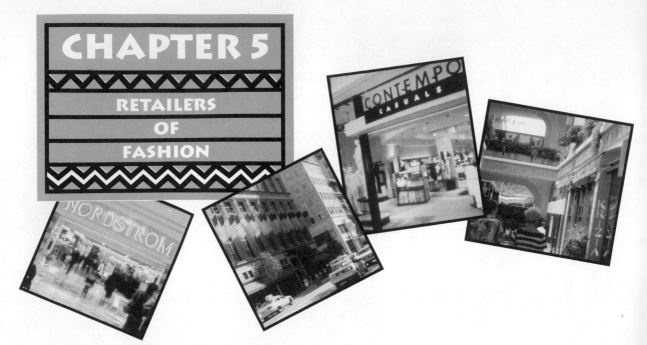

CHAPTER 5
RETAILERS OF FASHION

LEARNING OBJECTIVES

After reading this chapter, the student should be able to:

1. Classify the various types of retailers that feature fashion apparel and accessories.
2. Evaluate the different retailing centers available to fashion retailers and the functions they serve.
3. Discuss the manner in which designers and manufacturers of fashion merchandise have improved their own destinies in the disposal of slower moving items.
4. Describe the manner in which fashion buyers and merchandisers plan their merchandise assortments.
5. Identify some of the different types of ancillary services with which retailers interface for direction in fashion buying and merchandising.

INTRODUCTION

Whether one walks down the world's most fashionable streets such as Worth Avenue in Palm Beach, Florida, or avenue Montaigne in Paris, France, and visits the exquisite boutiques of international fame, strolls through the aisles of department stores and specialty shops such as Macy's and The Limited, or joins the hustle and bustle of flea markets that dot the maps of the world, fashion apparel and accessories are readily available in a host of styles, designs, and price points.

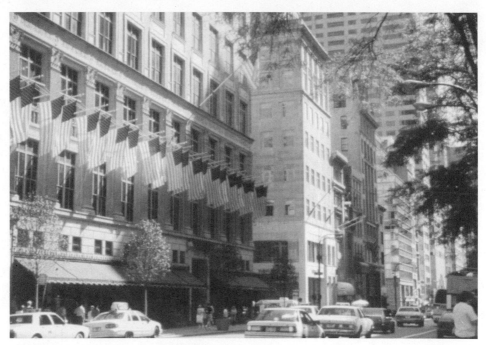

Figure 5-1 New York City's fashionable Fifth Avenue.

The retailers of fashion represent the link between the producers of apparel and accessories and the consumer. The consumer market is so diverse in its appetites and needs of fashion merchandise that the retailers of the world must carve out a niche for themselves to attract customers to their companies.

Not long ago, retailers of apparel and accessories had much easier ways to gain the shoppers' attention. Inventive visual presentation, unique services, and personal attention enhanced the store's merchandise assortment and helped motivate purchasing. Merchandise was "traditionally priced" and customer loyalty was the order of the day. Although some fashion retailers such as Loehmann's made their marks with selling below the "regular price," they were the exception rather than the rule.

Today, although the traditional retailers still dominate the fashion scene, more and more discounters and "off-pricers" such as T.J. Maxx, Clothestime, Marshalls, Syms, Today's Man, and Burlington Coat Factory have significantly changed the nature of fashion retailing. No longer is the shopper in search of a Ralph Lauren garment restricted to buying at a boutique or high-fashion specialty shop and paying the "original or suggested" price. Desirable fashions are easily obtainable at the lower priced outlets. Perhaps their availability is a little later in the season, but many consumers are willing to wait for the bargains.

The late 1980s saw the emergence of still another retailing format that has impacted on the conventional retailers of fashion. Direct marketers in ever-increasing numbers are successfully competing for customer dollars with a host of catalogs and selling via cable T.V.

The world of retailing in the final decade of the twentieth century is very different from other times. The keen competition has caused many merchants whose names and reputations were once synonymous with fashion to close their doors. Garfinkel's, Bonwit Teller, and B. Altman are a few who have succumbed to the industry's highly competitive environment. Although there is certainly no shortage of fashion apparel and accessories for shoppers to purchase, the retailing scene is one in which mundane offerings and routine merchandising practices are no longer acceptable.

In this chapter, attention is focused on the various classifications of fashion retailers of apparel and accessories, the major retail venues in the United States and abroad, how traditional retailers are confronting the off-pricers, the manner in which buyers and merchandisers plan their purchases, and the outside assistance retailers seek before heading to the wholesale marketplace.

CLASSIFICATION OF RETAILERS

Retailers of all sizes and specializations are in the business of selling fashion apparel and accessories. They operate all over the world in a variety of shopping districts and sell merchandise in every price line or price range. Some offer a host of impeccable services as a means of attracting and maintaining customer relationships, whereas others opt for making bargain prices their forte to capture a share of the consumer market. It is the shopper who decides what motivates purchasing and, ultimately, selects the company that meets his or her needs.

Those who sell these fashion items are classified as department stores, specialty shops, boutiques, direct marketers, flea markets, warehouse outlets, franchises, and licenses.

DEPARTMENT STORES

The department store is either a traditional operation that features a wide assortment of both hard and soft goods or a specialized company that restricts its selection to one classification of goods. Macy's, Dillard's, Famous Barr, Bloomingdale's, and Woodward & Lothrop are typical of the former, and Neiman Marcus, Saks Fifth Avenue, and Nordstrom are examples of the latter. Those who operate as full-line department stores generally emphasize fashion apparel and accessories in their total product mixes. Many of these companies, in fact, present fashion merchandise as 90 percent of their offerings. The reasons for this off-balance mix is that fashion-oriented items provide the stores with the greatest markups and

Figure 5-2 Nordstrom at Tyson's Corner, McLean, Virginia. (Courtesy of L & B Group)

potential for profit. Their commitment to carrying other lines enables them to satisfy their customers' needs for such goods as electronics and furniture under one roof. Stores such as J.C. Penney and Sears, in fact, once leaders in hard goods, have now opted to eliminate or deemphasize hard goods and have repositioned themselves as fashion operations.

Whatever the emphasis, department stores are either one-unit businesses or large organizations with numerous units. Those with multiunit companies use flagships or main stores for their management planning and merchandising and expand via the branch store to reach people in various locations. The flagship is the largest facility housing the company's most complete assortment. Buyers, merchandisers, and other decision makers usually have their offices in these headquarter stores, with the branches serving only as sales outlets. The assortments in the branches are similar to those found in the flagships, except that the quantities are smaller and sometimes merchandise is eliminated from specific branches if the need does not seem appropriate. For example, if one branch is located in a less affluent area than the other stores in the organization, it might be deemed inappropriate for that branch to carry higher priced boutique items.

The store is divided into separate areas or departments that specialize in specific product classifications. Some merchandise classifications

are further segmented according to price lines. A store, for example, might have three separate shoe departments, each with a special character and range of prices. In this way, different customer services could be used that best address the individual department's needs. Many department stores pay close attention to the location of their fashion departments and their proximity to compatible areas. Shoes, for example, would be most appropriately placed near handbags and hosiery to offer the customer an opportunity to buy coordinated items and therefore increase the amount of the purchase.

During the late 1980s and early 1990s, some fashion-oriented department stores have expanded via the twig or spinoff route. Unlike the branches that feature a condensed version of the assortment available in the main store, the spinoff is actually a specialty store within the department store organization that concentrates on one classification of merchandise that has proven successful for the company. Macy's, for example, is a proponent of the spinoff concept. In cases in which specific lines of merchandise have been profitable for the company, separate units have been opened to merchandise these collections. Names like Aeropostale, fashions for the younger set; and Charter Club, sportswear similar in styling to Ralph Lauren; all departments within Macy's stores, have been spinoffs as separate entities. In this way, the department store has been able to challenge the specialty store for a share of that market. With the number of women now employed in full-time positions and the time available for shopping diminished, these new units provide the department store with vehicles that permit quicker and easier purchasing.

SPECIALTY STORES

By definition, a specialty store or limited-line store, as it is sometimes addressed, is one that restricts its selection to a specific merchandise classification. The merchandise assortment can be broad and include a host of related items. The Gap, Banana Republic, and Wallachs are such stores, with each featuring clothing and accessories for men and women. Others such as AnnTaylor sell merchandise exclusively to outfit the woman, and Structure caters specifically to the man. The key to the specialty store designation is that the merchandise lines are all compatible in the store. By contrast, the department store features a more general classification of goods.

A trend toward a further narrowing of merchandise assortments has begun to develop in some stores throughout the world. These organizations restrict their product lines to an even more restrictive base and are usually known as the subspecialty stores. They merchandise items such as ties or socks exclusively, and do not mix these products. With the availability of numerous lines of merchandise, the fast pace with which

Figure 5-3 Contempo Casuals is a specialty chain. (Courtesy of SDI)

customers might make their selections, the limited amount of space in many high-traffic environments, and the often prohibitive costs to lease large amounts of space, the subspecialty concept has started to take hold. The Sock Shops, retailers of socks, originated in Great Britain and quickly became known in the United States. Stores that carry only sneakers, rather than the full complement of shoes, or Indian jewelry, rather than the complete line of jewelry and other accessories, technically fall within this subspecialty classification.

It should be noted that specialty stores are either individual units or chains that range in size from two stores to more than a thousand.

BOUTIQUES

An excellent arena for featuring merchandise that is either exclusively crafted or available in limited numbers is often the fashion boutique. They are generally small units, individually owned and managed and rarely parts of large chains, that feature the unique and unusual at upper-level price points. The key to the success of these operations is exclusivity. A customer who frequents such shops expects to see one or, perhaps, two pieces of an item rather than a full complement of sizes and colors as is predominant in typical department and specialty stores. Both custom-made clothing and accessories are generally available, with the presence of a couturier or dressmaker who is ready and capable of executing specific customers requests. An attractive street-length dress could be adapted perhaps as a

floor-length design for evening wear; in many of the boutiques, where customer service is their forte, such a request could easily be satisfied. Jewelry, belts, handbags, and scarves that coordinate with the apparel are usually available, providing the customer with a total outfit.

Customers who frequent the boutiques expect the best and are willing to pay for it.

DIRECT MARKETERS

The retail environment of today is unlike that of yesteryear. The day of the male-dominated work force has long passed, with women taking their rightful places at every level of employment. The woman's time for shopping has been preempted by newfound careers, resulting in fewer hours for shopping. This phenomenon has created a market for women who now have greater disposable incomes than ever before together with the need for different and larger purchases. Many in our society have expanded their workdays to coincide with the demands of the workplace and find they, too, have less time to satisfy their needs.

Not many years ago, the field was rather limited to such giants as Spiegel and Sears where fashion merchandise at many price points and taste levels appealed to the market that shopped from their homes. To capture the attention of this time-restricted segment of the population, direct marketers in ever-increasing numbers have joined the bandwagon, hoping to provide merchandise to this expanding group.

Figure 5-4 Catalogs of direct marketers fill America's mailboxes.

The primary route the direct marketers for fashion apparel and accessories have taken is via the merchandise catalog. Stores that once limited their catalog offerings to peak selling periods such as Christmas and some sales events, have now expanded their operations to the point of home delivering sales booklets as many as 30 times a year. It might be the opening of each season, a special store event, or promotions.

Joining the traditionalist department stores who have always flirted with the customer at home, specialty chains are also in the game. Although the store is their usual arena for customer shopping, their catalogs have made their way into the home. Victoria's Secret not only mails a catalog that features its store assortment but includes additional items that are not available in the store. Recognizing that the female shopper often has a male partner, the catalogs also feature items for him. AnnTaylor continues to expand its catalog and features much of the items merchandised in the store.

Other specialty merchants in the fashion direct-marketing game with a traditional in-store retail base are companies like Eddie Bauer, Lands End, and Coach.

Some companies, that are primarily catalog focused, continue to enter the scene with highly specialized catalogs targeted for narrow market segments. Patagonia, which features "functional" clothing for the family in stores throughout the United States, now reaches an in-home population that is aware of its lines but have little time to shop in stores. A reading of the catalog indicates its significant investment to gain this customer's attention. Others include The Nature Company Catalog, featuring items with the environment and its natural beauty as inspirations, and Garnet Hill, which sells original natural fiber fashions exclusively. The scores of mailings that reach households almost every week of the year, with an ever-increasing variety of catalogs, indicates that the future will witness increased sales for both fashion-oriented and other goods by these means.

FLEA MARKET VENDORS

Instead of visiting department stores, specialty shops, and boutiques for their fashion purchases, more and more shoppers are heading for flea markets or swap meets, as they are often called, to satisfy their needs. Although elegant surroundings and fastidious services are absent from these arenas, wide assortments and lower prices more than make up for the lack of the esoteric environments. The entrepreneurs who operate these stands or stalls have the lowest possible retail expenses, paying only for the days the markets are in operation and offering little to the customer except value. In the earlier days of the flea market operations, fashion apparel and accessories were in short supply and those that were available were rarely first quality or name-brand items. Today, however, these mer-

Figure 5-5　The flea market offers fashion merchandise at low prices.

chants offer fashion merchandise easily recognized by their famous labels. Designer apparel, jewelry, handbags, shoes, scarves, and so forth, sport such names as Calvin Klein, Pierre Cardin, Perry Ellis, and others. Lesser known brands as well as unbranded items are also available.

OFF-PRICERS AND DISCOUNTERS

Those who sell merchandise to the public at prices that are below the established retail amounts are called *off-price merchants* or *discounters*. The two classifications are related via the lower price policy, but that is where the similarity ends. Off-pricers buy manufacturer closeouts later in the season than do their traditional retail counterparts and, by doing so, are able to purchase the merchandise for less or off-price. Therefore, they can pass the savings onto the consumer. The discounter, on the other hand, purchases at the original wholesale price but sells it at discounted prices.

While traditional discounting has been on the wane in fashion retailing, with most of it being done by smaller stores with less costly operational expenses, the off-price market is booming. Companies like Marshalls, Hit or Miss, T.J. Maxx, Loehmann's, Burlington Coat Factory, Syms, Today's Man, and others have stores from coast to coast. Some such as Marshall's, Syms, and the Burlington Coat Factory sell complete lines on men's, women's, and children's fashion, whereas others such as Today's Man specialize in male apparel and accessories.

Figure 5-6 Syms, is an off-price chain that features men's, women's, and children's apparel and accessories.

All of the offerings at these stores were originally value purchases made from such designer names as Liz Claiborne, Perry Ellis, Adrienne Vittadini, Pierre Cardin, Ralph Lauren, and others and passed on to the consumer at prices that were well below the traditional retail. Today, many of these emporiums mix their designer labels with private label merchandise that they have created for their own stores. These items cannot be comparison shopped as can the well-known lines because the merchandise is sold in these off-pricers' own shops. However, the private label goods are comparably priced to branded merchandise of similar quality.

MANUFACTURER'S WAREHOUSE OUTLETS

In an effort to compete with the off-pricers to whom they sell their leftover items, many designers and manufacturers have joined the warehouse outlet bandwagon. Setting up shop to service retail customers in spaces that are adjacent to their wholesale plants or in areas that are away from the traditional downtown shopping centers and malls, more and more of these companies are entering the retail arena.

In addition to reaping profits from these operations, the manufacturers may better control their product's distribution than they do by selling to the off-pricers. They may quickly dispose of unwanted goods by ship-

Figure 5-7 This J. Crew Factory Store is an outlet where the retailer disposes of slow-selling goods.

ping them to their own outlets without having to wait for the hungry off-pricers who often demand prices lower than they would like to offer.

In a variety of locations, discussed separately in the section on "Retailing Venues," designers and manufacturers such as Liz Claiborne, Jones New York, Evan Picone, Coach, Dooney & Burke, Joan & David, Tahari, and Vanity Fair have set up shop. They sell only their own brands at prices well below those that are available in the regular, traditional department and specialty stores. Because the outlets are away from the usual retail environments and the merchandise is generally slow selling or from a past season, they are able to maintain their conventional methods of distribution to conventional retailers while participating in their own warehouse outlets.

FRANCHISES AND LICENSES

These two retail classifications share many similarities. They are both established by manufacturers who wish to sell their offerings exclusively through controlled outlets and they make a great many of the decisions by which their member stores must operate. The better known of these operations are in the fast-food field, with McDonald's leading the pack, but many companies have entered fashion retailing. Franchises and licenses

differ in that the former requires a "start-up fee" for participation and financing of the specific location, whereas the latter requires only a written contract in addition to the cost of establishing the particular store.

The best known of these arrangements is Benetton. The company manufactures men's, women's, and children's apparel for distribution in licensed outlets throughout the world. Ralph Lauren, in addition to operating some of his own stores in his fashion empire, is involved in numerous franchised retail outlets.

By using this format, manufacturers are both better able to control the manner in which their products are sold to the consumer and to avoid the natural competition of numerous lines in a single store. When a customer shops in a franchised or licensed store, only that company's merchandise is available for purchasing.

MISCELLANEOUS RETAILERS

Although the aforementioned provide for the lion's share of retailing, there are others that participate in retail sales. Kiosks are very popular in heavily traveled areas. In malls, major office structures, and airport terminals, a host of these free-standing structures feature any number of fashion products from jewelry to handbags. Street vendors are often found on major downtown shopping streets hawking everything from sunglasses and jewelry to watches and scarves. They operate out of small carts or suitcases, whichever the merchandise requires. Some are licensed by the municipalities in which they operate, whereas others are unlicensed and constantly move to avoid the authorities. Some major airline terminals and busy office complexes feature vending operations that are totally different from the cigarette and soda machines. They feature catalogs of fashion merchandise that are augmented by exciting photography and ready order forms for shoppers. With the targeted shopper being one who has only minimum time to shop, these machines provide a needed service.

RETAILING CENTERS

Fashion retailers, as well as all of the others, are found in many different types of settings. They range from the typical downtown shopping district to the newest phenomenon, the outlet center. Between these are such places as the strip centers, power centers, and free-standing locations, among others.

DOWNTOWN SHOPPING DISTRICTS

Most cities have "downtown" areas that are tenanted by businesses, entertainment centers, restaurants, and places where a large part of the population works and plays. These districts have served as natural locations for retailers because they have what is often referred to as "captive

audiences." The majority of department stores began their operations in these districts to capitalize on the numbers of people who visited them daily for their work or pleasure. New York witnessed the beginning of the Macy's and Bloomingdale's dynasties, Chicago played host to Carson Pirie Scott and Marshall Field, Arkansas to Dillard's, and Washington, D.C., boasted Woodward & Lothrop.

Today, many of these same companies have spread their wings and expanded via the branch route, opening units in surrounding areas. Some such as Macy's and Bloomingdale's have opted for coast-to-coast expansion and have stores dotting the map all across the United States.

The question of whether or not the downtown central district is still a viable choice for department stores and other retail operations is debatable. Some of these locations have suffered because of migration to the suburbs, leaving the central district in less than desirable conditions. Some retailers followed their customers to the suburbs and have abandoned the once-heralded downtown location. The major fashion department stores, for the most part, have maintained their headquarters in the downtown facilities and continued to use these facilities as places where management resides and decisions are made. Many of those who held to these locations have found the downtown areas are once again gaining the attention of new inhabitants whose needs must be served. Marshall Field has just completed a multimillion dollar facelift of its State Street flagship in Chicago, as has Macy's in New York City.

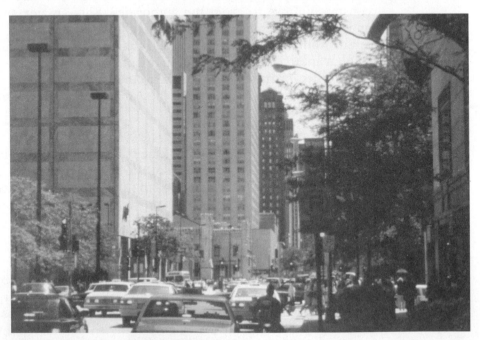

Figure 5-8 Chicago's fashionable downtown, Michigan Avenue.

With space becoming increasingly costly and limited in the downtown areas, more and more vertical malls are being erected to address the needs of the stores that find these locations desirable. Chicago has been a leader in the field with its innovative Water Tower that features branches of Lord & Taylor and Marshall Field as well as a host of upscale specialty apparel and accessories retailers. Following their lead, Bloomingdale's Chicago flagship shares a vertical facility with Henri Bendel and numerous other fashion merchants. The latest addition to this type of configuration in Chicago is one that features Saks Fifth Avenue and numerous fashionable specialty shops. Baltimore's downtown Galleria is another vertical venture that makes fashionable shopping available downtown in a limited amount of space.

HIGH FASHION AVENUES

In some parts of the country where the more affluent reside or visit, merchants have established specific areas to house the most fashionable shops in the world. They may be found in the middle of a major city or in a suburban area. Wherever the location, these shopping districts are home to the nation's most elite sellers of fashion apparel and accessories. Some of the better known are Rodeo Drive in Beverly Hills, California, Worth Avenue in Palm Beach, Florida, and Madison Avenue in New York City.

Figure 5-9 The Esplanade on Worth Avenue, Palm Beach, Florida.

Designer labels such as Chanel, Yves Saint Laurent, Gucci, Sonia Rykiel, Giorgio Armani, Givenchy, and Ungaro are featured in shops all over the world that bear their names.

The key to such merchandising is exceptional customer service. Customers may have their cars valet parked on Rodeo Drive, may have goods delivered to their homes accompanied by fitters, enjoy a snack while shopping, or anything else to make their shopping experience memorable.

Although these environments are not commonplace on the American shopping scene, they are extremely profitable in the few places in which they exist.

REGIONAL MALLS

When many Americans left the inner cities and migrated to the suburbs in the 1950s, major retailers moved in the same direction. The larger department stores started to open branches in places that were innovative for the time. These locations were malls that housed a variety of stores with the department stores serving as the anchors. One of the earliest entries into this type of location was at Roosevelt Field on Long Island, New York, part of a former air base facility used in World War II. The mall was an immediate success, serving the people in that area with branches and units of stores with which they were familiar.

The malls offered the consumer the convenience of one-stop shopping and sufficient parking facilities to accommodate the suburban shopper. Stores were placed on one horizontal level in an open-air environment. To limit competition, the developers subscribed to the controlled shopping center philosophy by limiting a predetermined number of each type of store to the facility.

Today, major malls all over the country have expanded on the original concept and are considered to be one of the more successful of the types of available shopping districts. Although the format is loosely based on the early prototypes, the newer entries are significantly larger, fully enclosed to make shopping comfortable every season of the year, and feature a wide variety of other attractions such as dining courts and entertainment centers. Many have also expanded to two or three stories to provide sufficient space for more stores in less acreage.

Where the older malls were anchored by two major department stores that aided in drawing shoppers to the facility, today's regional malls boast as many as six anchors. Tysons Corner Center in McLean, Virginia, has at its core Bloomingdale's, Nordstrom, Hecht's, Woodward & Lothrop, and Lord & Taylor to augment the numerous smaller specialty units.

Although the United States is still the leader in the regional mall concept, Canada boasts the largest in the world in West Edmonton, Alberta, where 800 shops are segmented into theme areas that feature attractions such as an indoor pool complete with waves. At one point, the mall was

Figure 5-10 The Fashion Center in Plantation, Florida. (Courtesy of Melvin Simon & Associates, Inc.)

earmarked for middle-income markets. Today, however, such names as Neiman-Marcus, Tiffany, Saks Fifth Avenue, and other upscale, prestigious companies are gracing malls along with the less pricey stores. In such cases, where many price lines are featured under one enclosure, the stores are often grouped accordingly. That is, the higher priced shops are assembled together, and so forth. In this way, the consumer can save time and head for that part of the mall that is most appropriate to his or her needs.

The merchandise emphasis at most malls is fashion apparel and accessories. Although the assortment features other product lines, these two general classifications account for the bulk of the business.

POWER CENTERS

At the end of the 1980s, the power center emerged as an excellent facility to sell merchandise at bargain prices. Unlike the regional malls with the department store anchors and customer services, the power center is a small configuration of stores that exudes a no-frills atmosphere. At the very nucleus of these centers are promotional stores like Marshalls and T.J. Maxx that feature lower prices and, therefore, attract large crowds of

shoppers. One major power center is Colonial Commons in Harrisburg, Pennsylvania. It boasts 10 anchors that include Montgomery Ward, T.J. Maxx, and Clothworld in the bounds of 428,500 square feet. Off-pricers and discounters of numerous merchandise lines round out the remainder of the sites in centers like this one. As is the case with most of today's other retailing centers, this classification is also fashion oriented. Apparel and accessories are in abundance and serve as the draw.

To draw large crowds to the power centers, they are usually strategically located adjacent or convenient to major highways and travel arteries. The giant interstates along the east coast from Florida to Maine, for example, feature power centers of approximately 30 to 40 stores and incorporate manufacturer's outlets along with the other retail operations.

MANUFACTURER'S OUTLET CENTERS

The primary function of designers and manufactures is to develop collections of merchandise and sell them to retailers who, in turn, sell the goods to the consumer. Although this is the optimum target of these producers, often the merchandise they create does not meet their expectations. The economy might be sluggish with the expected sales unrealized or, as is sometimes the case, some styles simply do not attract the consumer's fancy. Because the merchandise has been produced, it is often necessary to dispose of it through means other than selling to the traditional users. Some designers and manufacturers choose to entice their regular accounts to purchase some of the items below the typical whole-

Figure 5-11 Potomac Mills, an outlet center in Virginia. (Courtesy of Western Development Corporation)

sale price, thus enabling the stores to dispose of them at reduced rates. Others use the off-price route and sell their leftovers to those giants in the field. Still others wish to control more carefully the disposal of their closeouts and opt for a more direct approach to the consumer market. Those who wish to do so open their own outlets, as discussed in the previous section, in places that specialize in such endeavors.

Throughout the United States, numerous manufacturer's outlet centers are in operation for the disposal of goods by manufacturers. Some of the major centers are found in North Conway, New Hampshire; Freeport and Kittery, Maine; Secaucus, New Jersey; and Reading, Pennsylvania. Store after store bearing such names as Ralph Lauren, Liz Claiborne, Calvin Klein, Boston Trader, Leslie Fay, J.G. Hook, and others line the streets. These are owned and operated by the producers.

In the late 1980s, centers that rival the traditional malls in terms of comfort and convenience have been developed that feature manufacturer's outlets. In enclosed environments, augmented by food courts and enormous parking facilities, fashion companies like Tahari, Nine West, Geoffrey Beene, Benetton, Joan & David, and Dexter are are selling their goods at reduced prices. The largest of these indoor outlet centers is Sawgrass Mills in Ft. Lauderdale, Florida, where two miles of shops feature designer product lines at less than traditional prices.

NEIGHBORHOOD CLUSTERS AND STRIP CENTERS

In small towns, stores typically dot the area's main streets or are grouped in small centers that are along the sides of main roads. These stores are rarely occupied by major retailers, except, perhaps, for small branches of chains. The bulk of these operations are individual proprietorships that serve the community's needs. They might feature shoe stores, boutiques, accessory shops, and so forth. Although more and more of these locations have fallen on hard times because of the close proximity of the regional malls in most geographic locations, some continue to thrive.

MULTIFUNCTION CENTERS

In an effort to capture the attention and pocketbooks of people while they are in their business environments, a trend has developed that integrates the workplace with shopping facilities. In New York's Financial Center, numerous fashion retail outlets are incorporated into the building's structure. Hoping to capitalize on the captive audience that is made up of financiers, high-priced, upscale fashion retailers have set up shop. World renowned Barney's, one of the nation's largest and most exclusive men's retailers, features a branch in the center and sells to the executive who is too busy to visit the company's other units.

The locations also feature restaurants and occasional entertainment in center courts as an inducement for those who work there to spend

their limited free time there during the work day. The shops are usually small and feature individual customer service, so that a business person in a hurry can make selections quickly and easily.

RECLAIMED LANDMARKS

When Quincy Market was built around Faneuil Hall in Boston in the 1970s, the United States saw the dawn of a new type of retail location. Abandoned for many years, the area was refurbished to underscore its history and to serve as a place where retailers could sell their wares. Fashion merchants and others quickly stumbled on a profit-producing environment.

Today, the concept has taken hold in other parts of the country. The once-dilapidated Union Station in Washington, D.C., is resplendent with numerous shops as is the once-abandoned Union Station in St. Louis. South Street Seaport in New York City, once a place where fisherman traded their wares, has been modernized with a shopping facility that features stores such as Banana Republic, The Gap, Limited, and others. Jacksonville, Florida, has revitalized its waterfront with the Jacksonville Landing, as has Baltimore, Maryland, with its Inner Harbor.

The retailers enjoy success in these locations because they are surrounded by places of historical interest that draw the crowds. Little need for advertising is necessary because the primary focus is the area itself. Shopping is a natural complement for the tourist.

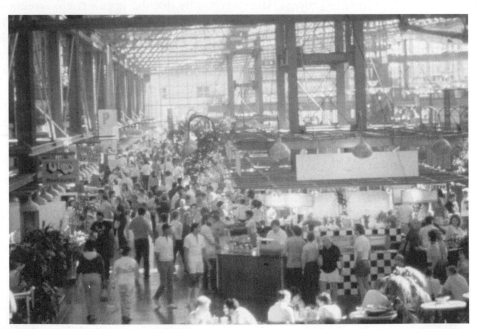

Figure 5-12 Union Station in St. Louis, a reclaimed landmark. (Courtesy of Rouse Corporation)

PREPARATION FOR FASHION PURCHASES

The wealth of fashion apparel and accessories available from all over the world makes their purchase a challenge even for the most seasoned buyers. Whether the company is a small independent operation or one that is a major department store or specialty chain, the selections they ultimately choose must be appropriate for their potential customers.

Merchandise is available at virtually every price point and quality and ranges from the conventional or conservative to the highest of haute couture fashion. To plan their purchases, buyers follow a rigorous procedure to make certain that their needs are properly assessed. The buyer who purchases "by whim" without the essential planning is playing a dangerous game. Buying plans must include budgeted allocations, customer preferences, the store's image, price points that have been established, and so forth.

Small retailers and their large counterparts use similar approaches to the procurement of their inventories. The major difference between the two is the size of the inventory and the number of people involved in making the final decisions. Fashion entrepreneurs usually develop buying plans using the "one-person concept." That is, all of the preliminary work is handled by the individual called the buyer. In large companies, the buyers are usually part of a merchandising team that is headed by a merchandising manager who both establishes budgets and the fashion direction the store wishes to follow. The buyers are also aided by fashion coordinators and directors who provide insights into the marketplace and assistants who help them with their purchases.

Planning involves the development of a model stock. This is a basic assortment that addresses inventories in such areas as style, quantities, quality levels, and price points. The model stock is developed based on input from a number of sources, the most important of which is the store's

Figure 5-13 The IBM System 4680 helps retailers keep track of merchandise. (Courtesy of IBM)

past sales records. By scrutinizing this information, the buyer can evaluate the resources from which past purchases were made, customers preference in terms of style and price, and anything else that would impact on future purchases. With the advent of such point of sales computer systems as the IBM 4680 and ACI's RETAIL EXPRESS software package, merchants can quickly examine the store's past merchandising history.

In addition to these in-store specialists who advise the buyers, many outside services are used by fashion retailers to augment their in-house research. These are discussed in the next section.

The model stock, once developed, then assists the buyers in making determinations on both quantities and qualities needed. Unlike the purchasers of hardgoods and non-fashion items, fashion merchandise procurement is always in a state of flux. Colors change, seasons come and go, customer preferences may be affected by the state of the economy, and so forth.

Buyers of fashion merchandise are always working on two seasons, the one that is represented by the calendar and features current merchandise in the store and the upcoming one or more that may be as far off as nine months. The role played by the buyer is imperative to the store's success, and many companies survive or fail because of their buyer's ability to read the marketplace.

ANCILLARY SERVICING OF THE FASHION RETAILER

Although those involved in the running of the store operations are in the best positions to assess the needs of their customers, it is advisable to use as many outside sources as possible to make certain that the right approach to merchandising is being undertaken. Although most fashion retailers have seasoned professionals making the decisions, out-of-store services provide information about the state of the marketplace, specific trends in terms of style, color, and silhouette, new resources, hot designers, and so forth. Among those available to the fashion retailers are resident buying offices, reporting services, fashion forecasters, fashion periodicals, and public relations organizations.

RESIDENT BUYING OFFICES

These companies, sometimes referred to as market consultants, provide an enormous amount of fashion information to retailers. For a fee, which varies according to the specific role the office plays for the store, buyers, merchandisers and fashion directors can feel the pulse of their respective markets.

The offices are located in the major wholesale fashion markets in the United States, with some operating branches in the significant overseas apparel and accessories centers. Each office has a staff of buyers who constantly scan their markets so that they can disseminate newsworthy fashion information to their members. Thus, retailers who are unable to

Figure 5-14 Henry Doneger Associates, a resident buying office, communicates with retail clients. (Courtesy of Henry Doneger Associates)

visit the market regularly because of time or distance limitations are kept abreast of the scene through this service.

With the constant change taking place in such a fast-paced industry, day-to-day knowledge of the highlights are imperative to fashion retailer decision making.

In addition to providing current status reports via such means as pamphlets, brochures, "hot items" bulletins, more and more resident buying offices are providing their customers with videotapes that represent the marketplace.

Although these market consultants generate a steady stream of informative documents, that is not the only manner by which they serve their clients. Most offices prepare for the store buyers' visits to the marketplace at periods called "market week." These weeks are times when each industry segment introduces its new collections for the following season. Because the buyers are in town for such a short period, it is imperative that a great deal of preliminary planning is accomplished to make the visit most productive. To this end, resident offices play a vital role. The staff assesses the market prior to the store buyers' arrival in terms of fashion trends, "what is in and what is out," "who is hot and who is not," fabrication and color influences, price adjustments, and so forth. All of this information is assembled and presented to the buyers when they come to

market. This preplanned service saves the buyers time and capsulizes what they can expect to find on their visits.

In addition to providing such information, most resident buying offices hold group and individual meetings with their clients and often accompany them to the various resources for on-the-spot assistance in collection evaluation.

The market consultants represent the giants in the industry as well as the smallest shops.

REPORTING SERVICES

Scouting the market via direct visits or constant perusal of fashion periodicals and notifying their subscribers about the state of the market is the role of the reporting service. Its function is less sophisticated and personalized than the resident offices because communication is strictly through the delivery of news reports via written communication. The Retail News Bureau is one of the larger fashion reporting services that interfaces with the fashion industry. They send weekly reports to their clients that concentrate on reorders being placed by major stores, predictions of the coming season, and anything else that would guide the stores in their buying and merchandising endeavors.

FASHION FORECASTERS

Many fashion retailers, primarily those with upscale clientele and inventory sourcing that often necessitates purchasing from international design regions, regard preplanning as a vital ingredient, necessary to their success. Although most retailers preplan their acquisitions, except for, perhaps, the off-pricers who operate on spur-of-the-moment acquisitions, the study of trends often takes place as much as one year ahead of the season. Numerous fashion forecasters such as Colour & Trends, Promostyl, Nigel French, Here & There, and Design Intelligence have scouts placed all over the world to assess the textile mills, major influential designers, color trends, and anything that is likely to show up in the designs of the apparel and accessories that will eventually surface at the retail level.

For a fee, fashion retailers receive volumes of materials that summarize the far-off season, are able to meet with the forecasters to discuss possible trends, use textile libraries that house vast collections of fabric swatches, and see filmed presentations that explore the near future of fashion.

Stores that prepare major fashion promotions often do so at least one year in advance of the event and, to properly develop their plans, the fashion forecasting service is one that is invaluable.

FASHION PERIODICALS

The wealth of published materials that is available to the fashion retailer is enormous. It falls into two categories. One deals with the trade and provides subscribers with the latest industry innovations and happenings.

Publications such as *Women's Wear Daily* and *DNR*, both Fairchild products, are the "bibles" to their respective industries. Numerous regional papers are also available, such as the *California Apparel News*, which pinpoint specific markets. Numerous others such as *"M"* and *"W," Gap, Visual Merchandising and Store Design*, and *Fashion Showcase* are also available and they provide fashion merchants with other points of view.

Fashion consumer publications also provide the retailer with invaluable information. These periodicals reveal to the buyers all of the "news" that is being fed to the consumer and, therefore, can adapt their inventories to include those shapes, silhouettes, colors, and so forth that are being extolled by the fashion editors.

PUBLIC RELATIONS ORGANIZATIONS

Some fashion industry segments maintain public relations groups that present an overview of the next season's offerings to the retailers. They examine the collections of the leaders of the field and invite the manufacturers and designers to have specific styles photographed for inclusion in a press kit earmarked for retailers and fashion publications. Each item is carefully reproduced in photo and slide formats and sent to the "trade" with appropriate "copy." These materials help steer buyers to specific producers for possible purchases and for use in store advertising and promotion.

With the world of fashion always in a changing mode, it is the professional retailers who know how to reach out to the marketplace and avail themselves of the invaluable resources that exist to make their decisions less risky. Given the enormity of competitive retailing, such indulgence is certain to make business more profitable.

REVIEW QUESTIONS

1. How does the specialized department store differ from the one that takes the more traditional approach?

2. In what way is the department store's branches unlike that of its flagship?

3. Are the department store's twigs or spinoffs, as they are often called, different from the company's branches?

4. How do specialty stores and subspecialty stores differ in terms of merchandise assortment?

5. Describe some of the unique features of fashion boutique product mixes.

6. Who are the major direct marketers in retailing and by what means do they continue to reach their potential customers?

7. Are flea markets merely arenas for low-end merchandise? Defend your answer with knowledgeable reasoning.

8. Differentiate between off-pricers and discounters and discuss which is having the greater impact on fashion merchandise.

9. Why have numerous fashion designers and manufacturers of apparel and accessories expanded via the warehouse outlet route?

10. In what way are franchises and licenses similar?

11. Is the downtown shopping district still a viable retail location?

12. Why are the high-fashion avenues of the United States found in such limited numbers?

13. Which fashion industry segment is the major operator within the outlet centers?

14. What is a power center and what role, if any, does it play in the marketing of fashion apparel and accessories?

15. Define the term *model stock* and describe how the retail buyer develops it.

16. Why are past sales records so imperative to the successful planning of next season's merchandise assortment?

17. What advantage does the large retailer have for fashion merchandise planning that the smaller counterpart does not?

18. Are resident buying offices equally important for small and large retail organizations?

19. Differentiate between the resident buying office and the fashion forecaster.

20. Discuss the benefits of regular examination of trade and consumer periodicals for fashion retailers.

EXERCISES

1. From the following pairings, select one and choose two specific retailers who fit into those categories. Make an appointment with a representative from each company to discuss their merchandise offerings, images and special appeal to customers:

 department store and specialty store
 specialty store and boutique
 flea market vendors and warehouse outlets

 After the information has been obtained, prepare a detailed report contrasting the differences between the two stores you have studied.

2. Visit a regional mall to study the complement of stores it houses. Categorize the various stores into specific merchandise classifications. For example, list all of the department stores, shoe stores, jewelry stores, etc. Prepare a report indicating the percentage of each store classification in the mall and the reasons for its prominence.

CHAPTER 6
FASHION ADVERTISERS AND PROMOTERS

LEARNING OBJECTIVES

After reading this chapter, the student should be able to:

1. Discuss the importance of advertising and promotion to fashion industry.

2. Describe some of the promotional campaign and advertising participation of fashion's material producers.

3. Explain the various techniques used by designers and manufacturers of apparel and accessories to introduce their merchandise collections.

4. Discuss how the fashion retailer advertises and promotes fashion to the consumer.

5. Describe how trade associations help their respective industries with product promotion.

INTRODUCTION

When DuPont perfected its soft and silky Micromattique, a fiber that held the promise of rivalry for silk, or Donna Karan wanted the world to know about her newly created DKNY collection or Calvin Klein launched his Eternity fragrance, it was creative advertising and promotion that captured the attention of the fashion-minded consumer. Although knowledgeable participants in the fashion industry know the value of effective campaigns as well as the costs associated with them, it

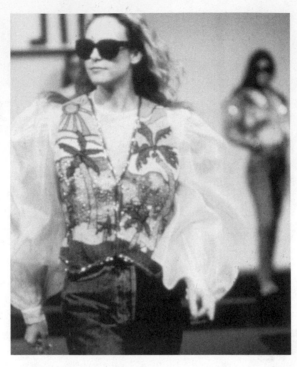

Figure 6-1 Runway shows are often used to promote a new collection. (Courtesy AETEC)

is the selection of the right vehicles that can lift the product from obscurity to the center of attention. The wealth of promotional tools available is significant to the industry's various components. Designers of international renown often use the runway show to introduce their latest collections. When a revolutionary, new fiber is being introduced to the fashion world, the textile company might opt for a full-blown fashion production that requires the creative talents of composers, lighting professionals, directors, scenic designers, and actors to underscore the magnitude of the new product. Retailers might host an in-store dinner for the introduction of a new private label, with the proceeds of the event earmarked for a specific charity.

Whatever the occasion, it is the goal of designers, manufacturers, and retailers to get their fashion message across to their markets. In doing so, the dollar commitments often reach extraordinary levels. It has been estimated, for example, that the Calvin Klein launches of the Eternity and Obsession fragrances cost more than $20 million each. Although these figures might seem excessive, the investment paid off when these same products delivered sales that made them the industry's top two sellers.

In this chapter, each of the industry's components such as the material's producers and processors, apparel and accessories designers and manufacturers, fashion retailers, and trade associations is represented in terms of the various techniques of advertising and promotion that they use in their businesses.

THE PRODUCERS AND PROCESSORS OF FASHION MATERIALS

The producers of the various materials that are used in the manufacture of apparel and accessories must appeal to three specific groups to guarantee the success of their products. Those who manufacture or process textiles, leather, furs, metals, stones, and other materials must initially convince those who manufacture clothing and accessories that their fabricating materials are better than the competition. Next to be addressed is the retail market. Buyers and merchandisers must be made aware of the benefits that their materials afford and that they are the ones that the consumer is apt to look for in dresses, sportswear, shoes, jewelry, and the host of fashion items sought by the consumer. Finally, by focusing on the ultimate consumer, the materials producers help presell the goods they produce; that is, if a favorable impression is achieved through the use of the print and broadcast media, the shopper is likely to seek products made of those specific materials.

The materials components of the industry use a variety of advertising and promotional endeavors to achieve their goals. It might be the use of press kits or press releases that get their messages across to the industry's professionals, fashion shows that illustrate the types of garments that might benefit from using certain fibers, or print ads, directed at the ultimate consumer, that feature the designs of famous clothing manufacturers that are made of the company's materials.

In addition to each raw materials producer's own promotional campaigns, there are trade associations or industrial public relations organizations that have the task of spreading the word about their industry's attributes.

THE TEXTILE INDUSTRY

More textiles are used than any other material in the production of fashion apparel. Within this industrial sector, it is the fiber-producing giants such as DuPont and Monsanto who spend millions of dollars annually to gain their market share. They use fashion shows, direct mail, and print and broadcast advertising that not only feature their own products, but cooperative layouts that combine specific fabrications with well-known apparel designer fashions.

Fashion Shows. The size and scope of the *fashion show* depends on the importance of the message the company needs to deliver. For new color palettes of existing fibers, the show might involve informal modelling in the showroom of garments constructed of the already familiar fibers or an in-house runway presentation in which models show off the fiber's garments in a more structured setting. For major launches of new fibers, the choice might be more extravagant. To accommodate large audiences of press, apparel manufacturers and designers, and retail merchandisers

and buyers, the giant fiber companies usually choose off-premises arenas such as theaters or hotel ballrooms for their presentations. Often, they invest in fully staged musical shows. Central to these themes, which usually involve specially written scripts that are augmented with original music and lyrics and are performed by professional actors, are clothing designs that feature the company's new fiber. Attendees are usually treated to food and beverages that range from simple breakfasts to more elaborate offerings that feature hors d'oeuvres and complete meals.

Today, the shows are videorecorded for distribution to any industry professional who was unable to attend the performance. Sometimes, these tapes are used by retailers as part of their in-store video promotions to familiarize the shoppers with the fibers they are likely to see in apparel and accessories designs.

Advertising. The wealth of *advertising* used by the textile industry is accomplished through campaigns in both the print and broadcast media. The target audiences are those involved in the field who are the textile's users such as designers and manufacturers, retailers, and the consuming public. By appealing to these specific groups, the industry tries to motivate them to seek out finished products that use the advertised fibers and fabrics.

The *industrial users* are approached primarily through the use of trade publication advertisements and direct mail. Nationally read periodicals

Figure 6-2 Direct mail advertising brochure used to promote new fiber. (Courtesy of DuPont)

Figure 6-3 DuPont's *Lycra Magazine,* a direct mail publication. (Courtesy of DuPont)

such as *Women's Wear Daily* and *DNR* regularly feature advertisements that spell out the virtues of fibers and fabrics to the professionals in the field, with regional entries such as the *California Apparel News* running ads that focus on materials that are appropriate to specific area use.

One of the most effective methods used to bring textiles news to manufacturers and retailers is through direct advertising. The major materials producers regularly target industrial users through a host of brochures, pamphlets, and flyers. Some of the direct mail offerings are grand-scale publications such as DuPont's *Lycra Magazine.* Produced semiannually, it features the latest news about the fiber, innovative uses, designer creations utilizing Lycra, and a host of articles about the fiber. In a format that rivals the most elegant consumer fashion magazines, it immediately catches the attention of the professionals who receive it through the mail.

The *consumer market* is also heavily targeted with textile advertising campaigns. The major producers such as DuPont and Milliken regularly use fashion magazines such as *Harper's Bazaar, Elle,* and *Vogue* in two distinct ways. One focuses on a specific fiber and tells the reader about its benefits. The other uses the cooperative format in which the fabric is featured in well-known designer fashions. In this way, the reader who favors a particular designer's merchandise also learns about the material producer's fibers and fabrics.

THE FUR INDUSTRY

At a time when the fur industry is undergoing a great deal of negative press because of animal rights activists, the processors of the pelts have escalated their advertising campaigns to stem any further erosion of sales.

Although the materials producers use ongoing promotions such as the one that bears the Blackglama trademark in a campaign titled "What Makes A Legend Most?" and features famous entertainers in furs, the thrust usually centers on institutional messages. Full-page ads in newspapers and magazines often concentrate on the industry's concern with animal safety and how it uses painless technology to remove the animal's pelts.

Many of the processors also take the direct mail route of advertising. Brochures and pamphlets, primarily concentrating on efforts that address careful pelt removal, are sent to fur manufacturers and retailers so that they can dispel any unpleasant notions that their customers might have about improper removal of skins from animals.

As far as the actual garments are concerned, their promotions are generally undertaken by fur designers and manufacturers and the retailers who sell to the public.

THE LEATHER INDUSTRY

Tanners and processors of leather primarily promote their products to those who turn the raw material into apparel and accessories. Occasionally, they address the consumer market with magazine advertisements that present the virtues of leather over the man-made imitators.

To capture the attention of those who transform the material into wearable garments, they use either industrial periodicals such as *Women's Wear Daily* or trade shows such as Leather World, held in New York City, and the Wolburn Show in Boston.

In the periodicals, they feature the latest color trends for the upcoming season, new processes that give leather additional benefits, and new ways in which to market leather products.

At the trade shows, the tanners appeal to leather garment and accessories manufacturers with their latest innovations and to the retailers by showing how leather products can increase sales.

An extensive amount of leather promotion comes at the hands of the industry's trade associations, which is discussed later in this chapter along with the fashion world's other trade organizations.

THE METALS AND STONES INDUSTRY

The bulk of the advertising that features metals and stones is undertaken by the designers and manufacturers of jewelry, watches, and other accessories that use these materials in their production.

There is a limited amount of consumer-directed advertising for these raw materials. DeBeers, for example, a leading diamond processor, occa-

sionally runs magazine advertisements that concentrate on the stones and their beauty rather than on specific jewelry designs.

APPAREL AND ACCESSORIES DESIGNERS AND MANUFACTURERS

Those who take the available materials and transform them into wearable apparel and accessories are in a highly competitive business. The designers and manufacturers must motivate their customers, the retailers, to buy their wares and, at the same time, play a role in informing the consumer about their specific lines and collections.

There is a wealth of advertising and promotional devices used by these creative forces to make an impact on their potential markets. They use a variety of techniques, which includes advertising, personal appearances, runway presentations, press kits, and cooperative promotions with the retail organizations.

The degree of involvement depends on the nature of the products offered for sale. Designers of upscale, pricey collections are always near the top of the spenders on promotion. Cosmetics and fragrance manufacturers are usually the winners when it comes to the launching of new products. At the bottom of the ladder, in terms of dollar investment for advertising and promotion, are the lesser known businesses.

DESIGNERS OF HIGH-FASHION COLLECTIONS

When internationally recognized designers like Karl Lagerfeld, Ralph Lauren, Donna Karan, and Christian LaCroix are ready to treat the world to a glimpse of their latest collections, a number of promotional techniques are used: included are the press kits, runway shows, charity-sponsored events, and advertising.

Press Kits Most major designers hire publicists who are responsible for getting the names of the designer mentioned wherever possible, without paying for the publicity. The major method of communication with the media, who hopefully will give editorial coverage to the designer and his or her newest collection, is by preparing a press kit. Each season, a promotion package, complete with an overview of the designer's fashion history, a synopsis of the line, and photographs of the designer and some of the key elements of what will be featured, is prepared for transmittal to trade paper publicists, fashion magazine editors, consumer newspaper special events writers, and television shows and news broadcasts.

Because this vehicle is commonplace in the industry, it is imperative that the public relations specialists are both capable of preparing press kits that motivate examination and sufficiently familiar with those in the communication outlets to know where their clients will achieve the desired exposure.

Figure 6-4 Press kit for Christian LaCroix collection. (Courtesy of Christian LaCroix)

If a national or local news program features 60 seconds or so on a particular designer, the exposure is enormous. When a particular designer is singled out for fashion innovation at the opening of a new collection in Paris, the press kit has more than served its purpose.

Sometimes, specific programs such as "Entertainment Tonight" highlights a fashion designer or public television's Adam Smith's "Money World" focuses on a creative talent. The initial interest is often spawned by an interesting press kit. Adam Smith once featured the Benetton family and its designs on his "Money World" program, and the coverage gave the company invaluable national recognition.

Runway Fashion Shows The obligatory, runway show is commonplace with those that present the better known, fashion-forward collections. In overseas and domestic wholesale fashion markets, each season begins with models parading before invited members of the press and potential retail purchasers of the merchandise. Because the opening of a season is packed with many designer offerings, the industry tries to orchestrate the times when the major shows will be held so that store buyers and reporters can examine all of the lines. In Paris,

the most famous designers belong to Chambre Syndicale de la Haute Couture Parisienne, an organization that, among other things, regulates the times of fashion shows.

At these promotions, the fashion world sees not only apparel collections but a host of innovations, including shoes, jewelry, hosiery, hats, cosmetics, and hair styles that enhance the designs. Sometimes, a particular hair style or hat makes such an impression that it gains as much attention as the collection's key items, the apparel.

Charity-Sponsored Events After the runway shows, which are directed at the buyer and press market, have been completed, some designers address yet another segment for further exposure. Fashion-conscious, affluent consumers, who are the ultimate purchasers of this merchandise, are often treated to events in which they may view a line before the general public. These presentations, which might be of the typical runway type or one that combines a dinner along with the fashion program, are presented in theaters or hotel ballrooms. Charities are sometimes involved in the festivities, with the evening's proceeds going to worthy causes. This combination often turns out the best potential purchasing audience.

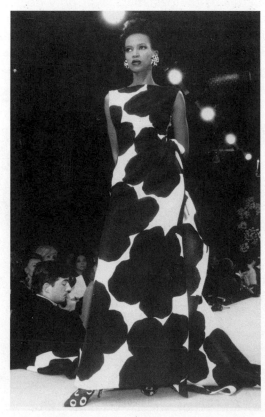

Figure 6-5 The Yves Saint Laurent gown is enhanced on the runway with earrings and shoes that bear similarity of design. (Courtesy of Yves Saint Laurent)

Advertising The major advertising emphasis for designers of high-fashion collections is in the print media. The markets served are the field's professionals such as fashion directors and coordinators, merchandisers and buyers, and the consumers who ultimately decide the fate of the new offering.

Of major importance in reaching the industry's participants is the trade journal or magazine. Fairchild Publications' *Womens Wear Daily* and *DNR* are the bibles of the fashion industry and are religiously read by those in the trade. Although it is hoped that the previously mentioned press kits would result in some favorable editorial publicity, this is not always the case. Seasoned designers know the value of these periodicals and often invest advertising dollars in their pages.

Although the consumer magazines such as *Vogue, Glamour, Harper's Bazaar,* and *Elle* are earmarked for American households and *Linea Italia, Paris Vogue,* and *L'Officiel de la Couture de la mode de Paris* are for European readers, they also serve as a means to get the fashion message to retail executives. Because the retailers benefit from knowing what fashion news is being fed to their potential customers, it serves their purposes to regularly read the same magazines.

Magazines are extremely important in reaching the public with styles and silhouettes of the designers. Not only does the initial purchaser examine the magazine's pages, but readership may double or triple as these publications are passed on to others. Unlike the life of a newspaper, which is limited to the next day when another issue is published, the magazine is often kept and reread for months or even longer periods of time.

Figure 6-6 The fashion magazine heralds designer collections.

Trunk Shows Many designers of high-fashion apparel use the trunk show to introduce their collections to retail audiences. The technique involves a company representative to bring the line "in a trunk" to key salons where special orders may be taken. Because the merchandise is usually costly, few retailers are able to stock an entire collection, thus, they choose only a few representative styles for their inventories. The trunk show not only displays all of the designer's offerings, but it sometimes enables shoppers to have certain items customized to suit their personal needs.

The Bob Mackie collection is often promoted through a trunk show.

Personal Appearances Some purchasers of high fashion merchandise are motivated to view their favorite collections in stores at times when the designer or company representative makes a visit. Sometimes the appearances are promoted in the newspapers for a general audience or the store might send special invitations to key customers to attend the presentation. The designers, or company reps, usually deliver a brief address about the line and are then available for individual consultations. It is the individual attention afforded by these industry experts that motivates shoppers to attend.

DESIGNERS OF BRIDGE, MODERATELY PRICED APPAREL AND ACCESSORIES

Bridge clothing, the price lines that bridge the gap between couture and "better" merchandise, and moderately priced apparel use a variety of means to promote their fashions. Popular labels such as Jones New York, Ellen Tracey, and Perry Ellis are considered to be bridge collections, with Liz Claiborne and Evan Picone classified as moderate lines. The promotion of these merchandise offerings involves some of the means used by their high-fashion designer counterparts, such as advertising and runway shows, thus eliminating the need for separate discussion. There are, however, some other promotional techniques used by this fashion segment that need exploration.

Wardrobe Consultation To capture their share of the bridge and moderately priced market, many manufacturers make the rounds of fashion retailers to meet with the shoppers. Because the designers of these merchandise price lines are generally not household names, and in some cases no longer have at their helm the designers who once created the collections, such as Liz Claiborne, company representatives provide this promotional function. They are generally stationed in the department that features their clothing and are available to discuss appropriate dress and how their specific lines may be worn for many occasions.

Consumers are made aware of these visits through newspaper advertising and direct mail invitations.

In-house Video Presentation More and more apparel and accessories manufacturers are benefiting from the use of videos that feature their items. For comparatively little expense, in terms of the exposure they achieve, videos that highlight merchandise and how it may be used are produced and sent to retailers for continuous showing to the shoppers.

Today's retail environments are filled with television receivers that constantly play eye-appealing tapes. The tapes might feature only the season's newest offering or it may be somewhat instructional.

Although retailers stock the merchandise seen on the videotapes, the visual presentations are often poor. The video presentation shows the line on runway formats or on models in environments that entice the customer to search for the goods on the selling floor.

The swimsuit industry is one that sometimes uses the video format. Rather than depend on the shopper to select from swimsuits that hang on racks, the tapes usually depict attractive models wearing the items at the beach. If the presentation is appealing and the merchandise shown is displayed within reach of the television screen, the shopper is likely to examine the goods and, hopefully, purchase them.

Using the instructional mode, the manufacturer might show how an item may be manipulated for many uses. The sale of scarves significantly increased when a manufacturer with incentive produced a tape that showed the many different ways in which scarves may be worn. The model used a step-by-step approach to show versatility of the product. Stationed in the scarves area, sales often increased after the video had been seen.

Samples and Premiums In some merchandise categories such as cosmetics and fragrances, many manufacturers use promotions that offer samples or premiums with a purchase. The practice was started in the cosmetics field by Estee Lauder who gave away samples of her products with a purchase. This has become a major practice in the industry. Other companies opted for premiums such as umbrellas, small pieces of luggage, and even jackets, each bearing the manufacturer's names or logos. At Christmas, the Ungaro line of fragrances offers hand-painted Christmas tree ornaments for purchasers of their products.

RETAILERS OF FASHION

Thus far, we have seen that designers and manufacturers of fashion materials, apparel, and accessories have invested in advertising and promotion that brings their merchandise to the attention of industry professionals and ultimate consumers. The main purpose is to sell to the buyers and merchandisers and to alert the public to the fact that their offerings exist.

Figure 6-7 This Ungaro-sponsored promotion utilizes hand-decorated Christmas tree ornaments. (Courtesy of Bloomingdale's)

On the other hand, retailers spend significant sums on advertising and promotion to attract the customers to their stores; it is not always a specific line or item that they must sell, but it is to make the cash register ring!

Retailers often invest great sums for advertising, special events and promotions, and visual merchandising in the hope that they will distinguish themselves from their competition. The commitment varies according to the retailer's classification. Specialty chains, for example, spend considerably less than their large-store counterparts, the department stores. Off-pricers and discounters use their monetary resources differently from the traditional merchants. Some retailers, particularly the individual proprietorships, or "mom and pop stores" as they are often called, spend very little on advertising and promotion. They often choose "word-of-mouth" as the means of attracting shoppers into the store.

The promotional endeavors are addressed according to retail classifications.

DEPARTMENT STORES

Without question, traditional department stores such as Macy's, Marshall Field, and Dillards and specialized department stores like Saks Fifth Avenue and Nordstrom spend more on advertising and promotion than do any of the other retail groups. Typically, their involvement includes advertising, special events, and visual merchandising and display.

Because they are the anchor stores in malls and major shopping districts, they are the ones who draw the customers to their particular areas.

Advertising The newspaper is the department store's forte. It is a timely publication that can reach a predetermined target audience quickly. Because different newspapers attract different people with specific demographic characteristics, it is easy to reach a particular audience. In terms of readership, the newspaper is relatively inexpensive to use.

The ads use either a promotional approach, which features specific items, or one that is institutional and focuses on store image or topics of consumer interest such as the environment, an event such as Valentine's Day, or the opening of the opera season. Sometimes, department stores use a combination of both approaches. The goal, in any case, is to motivate the customers to visit the store or buy through the mail or toll-free 800 numbers.

Magazine advertising is used less frequently because of its limitations. First, the costs are considerable because of the excellent repro-

Figure 6-8 This combination ad features specific merchandise and the store's commitment to service. (Courtesy of Neiman Marcus)

duction qualities of the publication. Second, the audience served by the periodical is usually far away from the store. For example, if a reader in a small midwestern town sees an advertisement for a New England-based department store, there is little chance that a visit to the store is practical. On the other hand, a company such as J.C. Penney, with stores from coast to coast, might use the magazine with its vast circulation potential. Some of the upscale stores such as Saks Fifth Avenue, Neiman Marcus, and Henri Bendel use magazine advertising as a means of promoting their fashion image in all parts of the country.

Television advertising also plays a secondary role for department stores. The few who do indulge, do so locally. That is, when each local station belonging to a network identifies itself on the hour and half hours, the commercial seen is different in each part of the country. Although the NBC affiliate in New York might see a Bloomingdale's commercial, people in Chicago might see a Marshall Field ad, and those in Florida might view one by Burdine's.

Direct mail has become more and more popular. The simplest, least costly approach involves the insertion of a pamphlet or bulletin with the customer's end-of-the-month credit card statement. The postage is already accounted for in the mailing of the statement, and the enclosure is frequently prepared by a manufacturer who wants his or her merchandise promoted by the store. Of course, direct mail has been expanded not only to advertise a particular item but a host of offerings in the retailers' catalogs. Retailers are spending more money each year for the use of this promotional technique.

Storewide Celebrations One of the major promotions some department stores use to kick off a new season or to make a fashion statement is the storewide celebration. This involves a temporary transformation of the entire store to highlight the event. Bloomingdale's, for example, has promoted the fashions of specific foreign countries on a storewide basis. The People's Republic of China's "Year of the Dragon" celebration presented merchandise from that country in most of their fashion departments. To enhance the event, the visual merchandising team created a variety of special environments such as a replica of the Great Wall of China in the men's department and pagoda telephone booths throughout the store.

Neiman Marcus has also used the foreign country theme to great success with its Fortnight celebrations. In a two-week period, the store is altered to feature environments and merchandise from the honored country.

Special Events Many stores use the special event concept as a promotion device. America's fascination with film and theater, for example, have served as promotional centerpieces. When *Phantom of the Opera* gained immediate recognition from the public, Macy's quickly capital-

ized on its success with a promotion that featured the Phantom character on the store's marquee and in some departments. The fanfare surrounding the opening of the *Dick Tracy* movie gave Bloomingdale's, in its Chicago flagship, a theme on which to create a promotion.

If the special event is met with a large shopper turnout, it might be featured again and again by the store. One of the most successful of these annual events is Macy's Flower Show. Each year, at the beginning of the Spring season, the New York flagship is transformed into an enormous botanical garden with flowers, plants, and trees from all over the world. As a contrast to the often gloomy remains of winter on the outside, the store interior tells the customer that good weather is around the corner and warm-weather fashions are ready for purchase.

Figure 6-9 Brochure for Macy's annual special event, the Flower Show. (Courtesy of Macy's, New York)

Fashion Shows As we discussed earlier in this chapter, department stores often feature individual designer and manufacturer's collections on their premises. Many times, the store produces a show that is a departure from the one-designer concept. It might be a back-to-school runway presentation, a show that features appropriate styles for business, or apparel that is easily packed for travel.

In addition to this formal presentation, many department stores use informal modelling throughout the store. These events feature models dressed in special outfits who casually parade through the selling floors. They carry informative signs indicating where the items may be found.

Visual Merchandising and Display Once the customers are motivated to visit the store, it is the visual merchandising team that is called on to present merchandise in a manner that invites close inspection and, hopefully, purchasing.

The department store invests more money and effort in this process than any other segment of retailing, and it is the apparel and accessories classifications that get the most attention.

The major department stores employ in-house staffs to carry out the visual function. The teams include creative designers, carpenters, sign-makers, artists, and display installers, each performing a specific activity to ensure the success of the presentations.

In the downtown central-district flagship stores, both the windows and interiors require display attention. It is the windows, however, that are the major attractions. The passersby can quickly absorb both the store's image and its merchandise philosophies through examination of the window displays. Windows are regularly trimmed at least once a week to give the many departments a chance to put their best foot forward. Fashion merchandise, with its ever-changing character, is usually creatively shown in a variety of backgrounds. The themes might concentrate on a specific designer collection, a fashion-forward emphasis, lines of merchandise that are exclusive to the company, or anything that might be fashion newsworthy.

Many department store branches that are located in malls have less formal window space than their flagship counterparts. In these cases, interior display plays the more important visual role. Each department is decorated to enhance the merchandise currently featured. Mannequins and props are used for the enhancement.

Fashion Clinics In most department stores, fashion directors or coordinators serve in a number of capacities. One features these specialists as fashion consultants. In the store's special events area, they hold clinics or seminars ranging from wardrobe suggestions for the office to the proper use of cosmetics.

Figure 6-10 Mannequins often serve as the display's focal point. (Courtesy of Adel Rootstein)

The sessions usually involve at least one or more consumer volunteer whose appearance is evaluated and is ultimately the beneficiary of a total make-over. The audience is treated to before-and-after glimpses of whomever is used in the demonstration.

If the event is a success, it will translate into sales for the store.

SPECIALTY STORES

Unlike the department store, the fashion specialty chains such as The Limited, Merry Go Round, Victoria's Secret, and Casual Corner do little in the way of advertising or promotion. Because they are generally located in busy downtown areas or malls within the shadows of the major department stores, they rely on those companies to use resources to bring the crowds. Thus, if Marshall Field or Carson Pirie Scott uses advertising and promotion to get customers to its stores, the chains, by virtue of their close proximity to these stores, will benefit from the crowds the major store attracts.

The major promotion emphasis for the fashion specialty chains is display. The companies use either teams that move from unit to unit to make window and interior changes, in-store managers or assistants who reproduce displays that have been created at the home office, or, in the case of the smaller companies, freelancers who perform the visual duties on a contract basis.

In comparison with the department stores, the amounts they spend on visual presentations are minimal and the installations are more routine than unique.

Only occasionally will a specialty store use some type of special event. They might present a fashion show for potential customers and, if so, it is usually for local fund-raisers such as charities. Sometimes, if the store merchandise includes private labels, posters and banners might be used throughout the store to promote the exclusive lines.

OFF-PRICERS AND DISCOUNTERS

Bargain pricing is the emphasis at such stores as T.J. Maxx, Burlington Coat Factory, Today's Man, and Marshalls. Their advertising and promotional emphasis is on informing the consumer about the values they offer.

Special events are centered around sales. Syms, for example, often features temporary price incentives at holidays such as President's Week. Marshalls regularly uses newspaper advertising when special purchases are offered and Filene's Basement goes the route of the newspaper ad when it has bought out inventories of Neiman Marcus and Lord & Taylor.

TRADE ASSOCIATIONS

Within each of the fashion industries, trade associations are organized for a variety of reasons. Of the many roles they play, few are as important as the ones that deal with promoting each industry's image and purpose. If they are successful in their efforts, the public will learn about such areas as the textiles field, men's wear, furs, men's fashions, and leather.

A cross-section of selected industries and their trade associations, which focus attention on promotion, is explored next.

TEXTILE INDUSTRY

Few, if any, industry segments offer the variety of trade associations as do textiles. Some specialize in one specific fiber such as Cotton, Inc., whereas others such as the Man-Made Fiber Producers Association represent groups of fibers and fabrics.

The following trade associations are among the more notable, including how they promote their industries.

National Cotton Council In addition to being involved in research, marketing competitiveness, and technology, it is extensively involved in a great deal of public relations and promotion.

The council regularly produces "Cotton Currents," a monthly service focusing on the benefits associated with the fiber, a Cotton Radio Hotline to answer call-ins about the product, educational materials and teaching kits that familiarize educators and consumers of the fiber's virtues, and sponsors a promotion to select the "Maid of Cotton."

The Maid of Cotton program has been the centerpiece of the National Cotton Council's promotional commitment since 1939. The selected woman is called on to model cotton clothing and to act as a goodwill ambassador for the U.S. cotton industry.

She addresses civic clubs, takes part in retail store promotions, and meets with legislators to bring her message of cotton to a large segment of the marketplace.

Her wardrobe is created by famous designers who primarily focus their collections on cotton materials. On each of her tours, she is preceded by official press kits, which are circulated in advance of her appearance to media contacts in each city. Each kit features a Maid of Cotton official photograph of that year's representative, along with credits to the designers and cosmetics consultant who have arranged her dress and grooming. In that way, these participants' names might also give publicity to the promotion.

As a result of the advance work done for each on-site visit, the Maid of Cotton participates in television interviews and provides the commentary for cotton-oriented fashion merchandise.

Each year the promotion grows stronger and stronger, with personal appearances now spreading all over the globe to such places as Japan, Hong Kong, and Thailand.

Figure 6-11 The "Maid of Cotton" appears on television as part of National Cotton Council's promotion. (Courtesy of National Cotton Council)

Figure 6-12 The Woolmark logo is used in this Nordstrom ad that features a woolen garment. (Courtesy the Wool Bureau, Inc.)

Cotton Incorporated This group provides a great deal of visibility to the industry as well as to the consumer. First, it regularly promotes its well-known logo, which accompanies pure cotton items through advertising campaigns. Next, through the dissemination of press releases to the media, which feature photographs of models wearing cotton apparel, the fiber's benefits and uses are often covered by the press. Each of the packet's pictures displays a well-known designer's creation, thus giving the cotton fiber even more fashion credibility.

The Wool Bureau The American branch of the International Wool Secretariat participates in numerous campaigns to bolster the fiber it represents. It is a regular participant in cooperative advertising between manufacturers and the fiber producers as well as a partner in retail advertisements that feature woolen products. In all of these layouts, there is the inclusion of the Woolmark logo. Through the efforts of the association, the symbol has become accepted as a guarantee that the products featured are made of pure wool.

Other organizations that engage in making the world more aware of their fibers and fabrics include the American Sheep Producers Council, Belgian Linen Association, International Silk Association, and the Textile Distributors Association.

LEATHER INDUSTRY

Promotion of leather is accomplished through such groups as Leather Industries of America and the Leather Apparel Association. The former's promotional efforts are concentrated on the shows it presents three times each year. At these events, it offers buyers and merchandisers an overview of what the industry's manufacturers are featuring in their collections.

The Leather Apparel Association is a not-for-profit organization that sponsors the industry's marketing campaign. It produces and distributes press kits that feature the latest in industry news and innovative designer creations in leather. Through its efforts, the industry achieves press coverage in *Leather Today,* the field's leading trade publication, as well as consumer fashion magazines.

FUR INDUSTRY

Although the industry's promotional endeavors have been substantial, never has it paid so much attention as now to recapturing the consumer's fascination with furs. With the adverse press it receives from animal rights groups, associations such as the Fur Information Council of America are taking their case to the public via educational campaigns addressed in flyers and advertisements.

On a more traditional publicity route, the American Fur Industry, a trade association, produces a brochure that features both color and black and white photographs of models wearing different designer fur garments. It is actually a pictorial press kit that is sent to editors of trade and consumer publications. The media is invited to make selections from this menu of styles, with better quality, individual photos available for those who request them for their newspapers and magazines.

THE MEN'S WEAR INDUSTRY

The Men's Fashion Association, or MFA, a name by which it is commonly known, is the publicity arm of the men's wear industry. It interfaces with manufacturers, designers, retailers, fiber and fabric manufacturers, and the press who cover men's wear fashions.

Its promotional endeavors use a number of techniques. It sponsors the Aldo Awards, which recognizes outstanding fashion reporting and helps to gain a foothold in the pages of the print media and time on television and radio. The annual Cutty Sark Men's Wear Awards to fashion innovators is also an event that gains press coverage from the media.

A very special press kit, complete with black and white photographs and color slides of apparel and accessories for each season, is sent to the media. About 50 styles, which represent an overview of the season's offering, is sent to trade papers and magazines in the hope that they will be published.

NEWS RELEASE
240 MADISON AVENUE NEW YORK, NY 10016 (212) 683-5665 FAX: (212) 545-1709

CONTACT: TOM JULIAN/ FOR IMMEDIATE RELEASE
 DAVID LALIBERTE

**APPAREL INDUSTRY UPSWING CLOSE AT HAND
SAY EXPERTS AT MFA PRESS PREVIEW**

Over 200 menswear executives and 80 national press gathered to discuss
strategies for the future of the fashion industry at the Men's Fashion
Association's Press Preview in Rye Brook, New York, June 6 - 9, and the
outlook is upbeat.

This three day event included 27 presentations from 40 companies including
new members Diesel, Guess?, Timberland, Country Road Australia and
Lorenzo Vega. American designers Jhane Barnes, Andrew Fezza and
Alexander Julian presented the best of their collections. Fashion wasn't the
only issue, however, as business strategies and marketing ideas were
reviewed. Manufacturers, retailers and designers, looking back on what they
see as the worst of the recession, are now forecasting an upswing in their
businesses.

International marketing is becoming commonplace for organizations
seeking a broader share of the market. " We have positioned ourselves as a
world-wide brand, spreading our business internationally. We have
succeeded because we don't give mixed messages; the product we sell here
in the U.S. is the same product we sell in countries abroad," says Mike Dwyer
of Timberland. Randa's William Phillips says," We have structured ourselves
as an international neckwear company with tremendous success." Hartmarx
is introducing a series of international labels to broaden their tailored
clothing with Lagerfeld and Corneliani. Footwear companies like Hush
Puppies and Allen-Edmonds are prospering under their international
marketing plan. Even designers find that world-wide marketing is
beneficial to their business. Linda Tepper, design director of Shady
Character, says, " I know some fabrics are not for all, but for a few special
customers. However, those special customers are all over the world."

Figure 6-13 This MFA news release publicizes the men's wear industry. (Courtesy of MFA)

MISCELLANEOUS INDUSTRY ASSOCIATIONS

There are numerous other trade associations that provide some form of
promotional assistance. They are the Fashion Footwear Association of
New York, known as FFANY, which produces four-color magazines sever-
al times a year and is aimed at both the processors of raw materials used in
shoe production and the fashion shoe retailers; the Fragrance Foundation,
which reports the latest in fragrance launches as well as trends in the field,
with the hope of attracting a larger retail market; Chambre Syndicale de la
Haute Couture Parisienne, which helps to inform the world about couture
design in France; the National Association of Gloves, which, as do many
other trade organizations, assists in the dissemination of industry news to
buyers and merchandisers; and the International Ladies Garment Workers
Union (ILGWU), which promotes merchandise made in the United States
in both newspapers and television.

REVIEW QUESTIONS

1. How much does it cost to launch a new fragrance such as Calvin
 Klein's "Obsession?"
2. Describe the types of fashion shows used by the textile fiber producers.
3. To which two markets does the textile industry focus its advertising
 campaigns?

4. In what way have the fur processors tried to fend off the adverse effects of the campaigns initiated by animal rights activists?

5. To which groups do leather tanners appeal at the trade shows?

6. What is a press kit and how does the high-fashion designer benefit from its use?

7. How does the runway fashion show used by haute couture differ from the major fiber fashion show presentations?

8. Which medium is the major one used by high-fashion designers in reaching their retail customers?

9. What purpose does the wardrobe consultant serve for bridge clothing?

10. Why does the in-house video format often achieve positive results for apparel and accessories manufacturers?

11. What is meant by instructional video presentation for scarves?

12. In what way has the cosmetics industry promoted its line to shoppers inside of retail environments?

13. Of all of the retail classifications, which one spends the most on advertising and promotion?

14. Differentiate between retail promotional and institutional advertising.

15. Why is the magazine sparingly used by fashion retailers?

16. Describe the term *storewide celebration*.

17. Explain why retailers spend less on display in their mall locations than in their downtown flagships.

18. Why is it unimportant for specialty chains to spend large sums on advertising and promotion?

19. What is the "Maid of Cotton?"

20. Describe how the MFA helps promote the men's wear industry.

EXERCISES

1. Select a major department store and examine its advertising and promotional endeavors for a two-week period. Make certain that you examine your city's newspapers and the direct mail that you might receive for that time.

 Prepare an oral presentation and a display board featuring ads and other promotional materials about the store you have studied. Included in the report should be such topics as promotional and institutional advertising, special events, promotions, and so forth.

2. Choose a specific apparel or accessories industry and prepare a written report describing the manner in which it promotes itself. Information may be obtained by writing to manufacturers, designers, or trade associations.

SECTION 3

THE MATERIALS OF FASHION APPAREL AND ACCESSORIES

CHAPTER 7

TEXTILES

LEARNING OBJECTIVES

After reading this chapter, the student should be able to:

1. Discuss the various techniques used in fiber production.
2. Explain the numerous types of methods used in the transformation of fiber into fabric.
3. Prepare a natural fibers table that includes the characteristics inherent in each type.
4. Develop a list of natural and man-made fiber fabrics and their uses as wearable products.
5. Differentiate among the different methods of printing and dyeing used in textile production.
6. List several finishes that are applied to fabrics and the advantages afforded by each.
7. Summarize many of the marketing tools used by the industry in the distribution of their goods.

INTRODUCTION

The distinctive rustling sound made by the movement of taffeta, the intricately detailed jacquard designs embellished in spectacular brocades, the quiet, elegant feel of furlike cashmere, and the bold, colorful patterns inherent in exciting stripes and prints all help bring the fashion designer's sketches to life. The excitement generated by the parade of collections on the world's fashion runways is heightened by the fabric choices used in

Figure 7-1 A high-performing fabric, Coolmax, affords tennis ace, Michael Chang, coolness as well as flair during the most grueling matches. (Courtesy of DuPont)

the apparel models. It is not a chance marriage that couples the fabric and silhouette; it is the blending of these two elements that makes each piece into an individual style.

Aesthetics, alone, are not sufficient when fabrics are being produced. Although the appearance is certainly an essential ingredient, function, as well, must be considered. The business traveler who must make a fresh entrance immediately following a long journey should arrive looking as freshly and impeccably dressed as though his or her travel time was brief. The fabrics used in the garments worn for this purpose must withstand the unwanted wrinkles and unsightly creases. The pleasure traveler's tightly packed wardrobe must be removed from the garment bag, unruffled, and be ready for use in many areas where freshening facilities might be difficult to find.

The textile industry is a highly sophisticated network of specialists whose technological knowledge interfaces with the needs of the apparel and accessories world. The constant interaction of these fashion segments assures that the end product, the needs of the consumer, will be served.

Although the United States is the world's leader in textiles, manufacturers and apparel designers search all corners of the earth for the fibers and fabrics that they could use in the production of their collections.

Some fibers, such as silk, are domestically unavailable and must be secured elsewhere. The quality of Belgian linen is unrivaled and must be purchased from that region if high quality is desired. Hand-loomed woolens are exquisitely crafted in Italy, and when superb quality men's wear is the goal, acquisition from that market is a must.

Of course, America has no competition when man-made and synthetic fabrics are needed for an apparel line. Major companies such as J.P. Stevens, Monsanto, and West Point Pepperell fit the bill with any type of fabric that the garment industry desires at a price that is impossible to beat anywhere.

For the clothing designer to assess the fabric's characteristics in terms of drapability and function, for the buyer to recognize various fabrics and fibers and their inherent qualities, and for the salesperson to assist the consumer by making the right fabric choices for special needs, a working knowledge of textiles is imperative.

The material presented in this chapter provides an overview of the various segments of the industry, the fibers and their characteristics, the methods used in fabric construction, the finishes used to enhance both the appearance of the fabrics and their usefulness, and the marketing strategies used to publicize the field. Although the industry serves many different fields, it is its relationship with apparel and accessories that is discussed.

AN OVERVIEW OF THE INDUSTRY

Few industries rival the size and scope of textiles. In the United States alone, more than 700,000 people are employed, producing enough yardage to reach to the moon and back 23 times with a sufficient amount left over to circle the Earth 14 times. Not many years ago, most of the construction required human hands to do all or most of the work, and no matter how many hours they toiled, relatively small amounts of fabric were the result. The processes and procedures that once took months are now achievable in a matter of minutes. Sophisticated looms can turn out more than 100 yards of cloth in an hour! In fact, according to the American Textile Manufacturers Institute, the industry is capable of producing enough fabric in one minute to make 2,000 dresses, and 24 hours later, there will be a sufficient amount for nearly 3 million dresses.

To stay abreast of the many technological advances, the industry annually spends approximately $1.5 million on new factories and equipment and computer systems that monitor all of the processes.

Of the total textile output, about 37 percent is used by the fashion industry in the production of apparel and accessories. Every conceivable fabric, from the conventional to the unique, is made available for transformation into garments.

The industry is carefully controlled and regulated by a number of legislative acts that help to protect the consumer. They include the Flammable Fabrics Act, the Wool Products Labeling Act, the Permanent

Care Labeling Ruling of the Federal Trade Commission, and the Textile Fiber Products Identification Act, among others. In addition to these mandated controls, the textile industry involves many private segments such as the American Textile Manufacturers Institute, the American Wool Council, Cotton Incorporated, The American Fiber Manufacturers Association, The Wool Bureau, and the National Cotton Council of America that help to promote industrial standards.

Starting with the harvesting of the crops in the fields for natural fibers such as cotton and flax and the development of the man-made fibers in the laboratories and culminating with the finished product, many people performing many tasks constitute the enormous world of textiles.

TEXTILE FIBERS

Dating back to ancient times, Egyptians wore garments made of cotton, flax, and wool. Cotton fabrics, woven 5,000 years ago, have been discovered in India. From that time until the beginning of the twentieth century, our forefathers' needs were limited to those same natural fibers as well as silk. Although they were able to satisfy their clothing requirements with these basic fibers, certain limitations in terms of their availability restricted their use. Cotton, for example, could not withstand the cold climates of Europe's northernmost regions, and silk, found primarily in Asia, was in short supply. They were severely limited to a modest variety of fabrics made from the natural fibers, and it was not until a chemist's curiosity about how silkworms made silk led to the discovery of the first man-made fiber, rayon, that the industry's horizons expanded.

A fiber is any substance, natural or man-made, that comes in single hairlike strands. These very small parts are then made into yarns and ultimately into fabric. The natural fibers come from a variety of plants and animals. Man-made is the generic term that includes all chemically made textiles, including rayon, acetate, polyester, nylon, acrylic, metallic, saran glass, olefin rubber, and modacrylic. Each of the natural or man-made fibers has characteristics that make them suitable for various uses.

NATURAL FIBERS

Cotton and flax are the major natural plant or vegetable fibers used in the creation of apparel and accessories. Others such as hemp, ramie, and jute are also found in garments but to lesser extents. Wool, cashmere, alpaca, vicuna, camel's hair, angora, and mohair are animal fibers, of which wool is the most widely used. Silk, although taken from the shell or cocoon of the silkworm, is also classified as an animal fiber because it is primarily made up of the secretions of the worm.

Cotton. Cotton grows in warm climates, with the bulk of it grown in the United States, the Soviet Alliance of Nations, the People's Republic of China, India, Brazil, Egypt, Mexico, Pakistan, and Turkey.

The planting process generally begins in the spring, but some areas of southern Texas begin as early as February 1 and others such as Missouri, as late as June 1. The seeding is accomplished with mechanical planters that open trenches, drop the seeds inside, and cover them. Fertilizers are used to enhance growth, and chemicals keep weeds and insects from impairing the crops. Once the crops have ripened and the leaves have been removed, they are harvested by machines that work 50 times faster than people who were once hired to do the job.

The cotton is next transported to the gin where it is cleaned and ginned, a process that separates the seed from the fiber. The ginned fiber, called "lint" at this stage, is pressed into large bales that weigh about 480 pounds. Because cotton is a natural fiber, it is available in a number of different grades. At this point in the process, each bale is examined to determine its grade in terms of the length of the fiber, known as the "staple," and its color and cleanliness. It is the fiber that now heads for the textile industry with the linters, small fuzzy downlike substances, and the seeds head for other industrial use. The staples run anywhere from ½ to 2½ inches in length and are considered for their final fabric usage.

All cotton must be carded, which is a disentangling procedure. Cotton that requires a silkier, smoother appearance is also combed. Cotton that is combed drapes better than that which has been only carded. Wool, as we will see later, also uses carding and combing.

Cotton affords the wearer numerous advantages. Among them are:

Softness It has a natural textured surface that cushions itself against the skin and feels more comfortable.

Breathability It helps remove body moisture by absorbing it and transmitting it into the air, thus making it cooler and lighter for the wearer.

Absorbency Because the fiber absorbs so much moisture, drawing it up through its interior layers or walls, it is perfect for terry-cloth apparel such as beachcoats that require immediate water absorption.

Temperature control It is a year-round fiber. In the cold weather, cotton fabrics protect against the wind without trapping body moisture. In warm weather, cotton garments help to keep the body cool and dry. Its versatility makes it one of the most widely used fibers.

Performance It is static-free, hypoallergenic, and pill-free. It is simple to care for, washes with no trouble, and easily retains its original feel and color.

As do all other fibers, cotton has some unfavorable characteristics. Most, however, when properly applied with finishes, can be corrected. It has little luster, poor elasticity and resiliency, and has a tendency to mildew. It also has a tendency, if not pretreated, to shrink considerably when laundered. The finishes used for cotton and the other fibers are addressed later in this chapter.

Figure 7-2 The cotton-producing regions of the United States. (Courtesy of National Cotton Council)

Some of the cotton fabrics that are found in apparel and accessories include:

Broadcloth A plain-weave, smooth, flat fabric that is used extensively in shirts, blouses, and sportswear.

Chambray A plain-weave fabric that uses a set of white and colored yarns—used for dresses, sportswear, children's wear, pajamas, and shirts.

Corduroy A ribbed, pile fabric that comes in a variety of patterns and weights and is used for trousers, jackets, and other casual wear.

Denim A durable, rugged fabric, constructed with the twill weave. It

was used initially for work clothes but has remained a fashion favorite for jeans and other leisure wear.

Jersey A single-knit fabric characterized by a fine, chain stitch—used for apparel that requires draping, comfort, and body-cling.

Oxford A group of fabrics that are plain or basket woven and used extensively for shirts.

Plisse A crinkled-looking fabric that is produced with the application of caustic soda.

Poplin A finely ribbed fabric that is used for casual attire and summer suits.

Sateen A satin woven fabric that has a smooth, lustrous surface.

Seersucker A crinkled, bumpy fabric whose texture is achieved during production rather than with finishes. It is used extensively for summer-weight suits and shirts.

Terry cloth A looped, pile fabric that readily absorbs moisture.

Velour Dimensional fabrics that are pile produced.

Velvet, Velveteen Pile-produced fabrics that have a rich, uniform surface—used for a wide range of garments from the fanciest to the casual.

Flax. In its natural state, flax is a gold-colored, strawlike plant whose stems are used for the fiber. It is principally grown in the Soviet Alliance of Nations, France, Belgium, Ireland, Egypt, Poland, and Italy. It requires a consistently moist, mild climate for its growth and takes considerably more care than cotton. Machines perform the majority of the tasks required in flax cultivation, saving the significant amount of time it took for many people to perform the same functions.

Flax is planted in the early spring and is left to grow to approximately three feet. Large machines harvest the crop by pulling them from the soil; the stalks are then bundled and left in the field to dry. The process of retting loosens the fiber from the stalk by using a number of techniques. Dew retting naturally separates the stalk when the bundles are left on the field's dewy surface. Tank retting requires the bundles to be steeped in concrete tanks of river water that is heated to 75°F and gradually increased to 90°F, a method favored in Belgium for the production of durable, lustrous fiber. Some chemical retting is also used to separate the stalks, but this is not considered appropriate for fine production. The retted stalks are then scutched, which actually removes the fiber, and then hackled, which helps to align the fibers smoothly next to each other. The fibers are sorted according to the length of their staples, which run as much as 20 inches long. The flax is now ready for production into linen, the name given to fabrics made from flax.

Some of the characteristics of flax that make it a desirable fiber for linen apparel are:

Durability It is extremely strong, outdistancing cotton by two to one.

Figure 7-3 Seersucker is a standard fabric for men's summer apparel. (Courtesy of Cotton, Inc.)

Performance Because it is a smooth fiber, dirt does not readily collect on it, and when it is soiled, it washes easily.

Absorbency It absorbs moisture quickly and dries faster than cotton, making it a comfortable fiber.

Appearance Its silky, lustrous look is natural to the fiber as is its textured appearance, giving it a uniqueness.

Comfort It is an excellent conductor of heat, quickly carrying warmth away from the body. This makes it feel cooler than any of the other natural fibers.

The only distinct disadvantages associated with the fiber is its tendency to wrinkle and, when laundered, it is difficult to press. When it is blended with polyester, however, it becomes a product that requires little or no ironing.

Some of the types of linen used in apparel and accessories include:

Art linen It is a closely woven fabric that is mainly used for embroidered blouses or dresses.

Cambric A fine linen that is used in handkerchiefs.

Canvas A tough, coarse linen that is popular for use in handbags.

Crash Coarse fabric that is used for suits, jackets, and trousers.

Damask Woven on a jacquard loom, this design features intricate patterns. Its appearance is often three-dimensional with varying dull and shiny surfaces that enhance the design. Although used extensively for table linens, it is sometimes used in apparel construction.

Figure 7-4 Damask fabric, produced on the jacquard loom, gives the designer a great range of expression. (Courtesy of American Textile Manufacturers Institute.)

Handkerchief linen　Technically called cambric, it is used for handkerchiefs and blouses.

Lawn　The sheerest, finest linen, it is used for delicate blouses.

Wool. In Central Asia, about 10,000 years ago, man discovered that, in addition to food, sheep could provide a soft, warm covering. Still a unique resource, sheep continue to fill our needs as they did so long ago. Today, the industry offers a broad choice of wool fibers from different grades and types of sheep. In the United States alone, there are more than 18 breeds of sheep that produce wool that ranges from the finest to the coarsest fibers.

The processing begins with shearing when a skilled shearer, using electrical shears, removes the fleece from the sheep in less than five minutes. Experts can shear as many as 100 sheep in a single day! The fleece is then inspected and graded to classify the wool according to fineness and fiber length. The grading determines the value and final use of the fleece. During the washing and scouring stage, grease, vegetable matter, and dirt is removed from the raw wool. After submersion in a detergent bath and a series of rinses, it is squeezed to remove the excess moisture and then hot-air dried. The scouring removes the oils that are eventually purified and used in soaps and cosmetics. The fibers are then blended to achieve color uniformity. Wool may be dyed either at this stage or at a later date. The specific dyeing techniques are examined later in this chapter.

There are two major classifications for wool yarns and fabrics, woolens and worsteds. Woolen fabrics are characterized as being fuzzy, thick, and bulky and are made from shorter fibers that have been carded. Worsted yarns are spun from longer staples that have first been carded and then combed, which further straightens the fiber, and drawn, which brings it to a thinner, more uniform diameter. Worsteds are crisper, smoother, and lighter in weight than woolens.

Wool is an extremely versatile fiber that benefits the wearer in many ways. Some of the advantages they afford are:

Durability　It provides long wear, resists snags and tears, and does not easily pill.

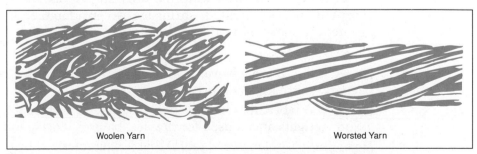

Woolen Yarn　　　　　　　　Worsted Yarn

Figure 7-5　Woolen and worsted yarns. (Courtesy of American Wool Bureau, Inc.)

TABLE 7-1: A COMPARISON OF WOOLEN AND WORSTED FABRICS

	WOOLEN FABRICS	WORSTED FABRICS
Fiber	Short, curly fibers; generally 1" to 3" in length	Long, straight fibers, generally 3" to 6" in length
Yarn	Carded only; less twist; bulkier, fuzzier yarn	Carded and combed; tight twist; smoother, finer yarn; greater tensile strength
Finish	Generally soft hand, hairy surface; fulling, flocking, napping, steaming; generally face finished for a variety of effects	Generally hard finish; singed, steamed; decated for clear, crisp surface
Appearance and Touch	Soft, fuzzy, thick	Clear, smooth, crisp
Examples of End-Products	Tweed sport jackets, Shetland sweaters, Melton top coats	Gabardine suits and shirts, whipcord trousers, Merino Extra-fine sweaters

Resiliency It resists wrinkling, returns to its original shape, letting the wrinkles fall out naturally, drapes beautifully, and stays resilient when wet.

Absorbency It absorbs moisture, holds air layers next to the skin providing warmth in winter and coolness in summer, sheds liquids, and "breathes," making it comfortable to wear.

Adaptability It can be used in fabrics that range from the most sheer to the most dense.

Performance It dry cleans easily, retaining its shape, and can be steamed or pressed with little effort.

Some of the drawbacks to the fiber are its inability to be laundered, except if specially treated, shrinkage is considerable, and if not mothproofed, it is an easy victim of the moth.

Some of the more popular wool fabrics are:

Convert A closely woven, lightweight twill fabric that is used for topcoats, suits, and sportswear.

Crepe A fabric that has a pebbly or crinkled surface that comes in various weights and is used for dresses, blouses, coats, and suits.

Donegal Woolen tweed fabric that is characterized by randomly woven multicolored yarns.

Felt A nonwoven fabric that is primarily used for hats and trimmings.

Flannel Lightweight, soft cloth that has a slightly napped finish.

Gabardine A durable, tightly woven worsted fabric that has a hard finish and is used for men's and women's apparel.

Herringbone A twill woven fabric that produces a zigzag design.

Loden A thick, coarse, coating material.

Merino A fine grade of wool from the Merino sheep. It is excellent for high-quality woven and knitted materials.

Serge A durable, twill woven fabric that is used for men's and women's clothing.

Shetland A soft, raised fabric made from wool from the sheep in the Shetland Islands in Scotland.

Tweed A rough-surface fabric that uses a variety of colors to achieve various patterns.

Silk. Considered by many to the most luxurious of all fibers, silk was discovered approximately 4,000 years ago. For nearly 3,000 years, the Chinese successfully guarded the secret of the silk cocoon until the Japanese penetrated the mystery in A.D. 300; later, India learned to grow the worm that produces the fiber.

Silk is the filament or continuous fiber a silkworm spins for its cocoon. Unlike the other natural fibers, which come in short or staple lengths and must be attached or spun to form yarn, a single silk filament ranges from 800 to 1300 yards in length.

The production of the cocoons for their filament is called "sericulture." The process involves the caterpillar or silkworm to spin a shell or cocoon around itself for protection to permit the development of the chrysalis, which emerges from the cocoon as a moth. The moth then lays eggs and continues the life cycle.

The silkworms are either found in the wild or are raised by silk farmers. After being fed a diet of mulberry leaves for about five weeks, they grow to 70 times their original size and are ready for the fiber to be harvested. The production of man-made fibers, which is explored later, is based on a small opening in the silkworm's jaw called a spinneret. It is this opening that man has expanded on to produce filament yarns in the lab!

When the cocoons have achieved their desired size, they are first sorted according to color, shape, and texture, all of which affects the quality of the final silk product. After they have been sorted, the sericin, a gummy substance, is softened and removed so that the silk can be unwound. The unwinding process is called "reeling," which takes place in a hot water basin. Because one silk filament is too fine to unreel by itself, approximately 10 are unwound at the same time and drawn together into one filament. Any remaining sericin is boiled off either at this point or after weaving to uncover the fiber's natural beauty.

Some of silk's advantages are:

Strength Because it is the strongest of the natural fibers, it resists abrasion and gives the wearer many years of service.

Comfort It is extremely smooth to the touch and is soft on the skin. It is elastic and retains its original shape. As it readily absorbs moisture, it is comfortable in a warm atmosphere.

Care It may be dry cleaned or washed. Washing, however, should be done by hand, unless the garment has been processed for machine laundering.

Shrinkage The amount of shrinkage is minimal. If there is some after washing, the garment can be put back into its original size through pressing.

Appearance It is the most luxurious of all fibers, with a natural luster unknown to other fibers.

On the negative side, silk tends to water spot, will damage when exposed to perspiration, and will weaken if continuously exposed to sunlight.

Silk is used extensively for wearable products and comes in a variety of weights and textures. Some of those used in fashion apparel and accessories include:

Alpaca A fine-textured, slightly lustrous fabric that is woven to resemble cloth made from South American alpacas.

Broadcloth A spun silk, woven with a firm yet soft feel.

Bouclé A nubby textured fabric, woven of yarn that has been twisted to produce a loopy thread.

Chiffon An airy, gossamer sheer that has a floating quality in motion.

Crêpe de Chine A lustrous, light crepe with a soft rippled effect.

Georgette A soft, sheer fabric with a crepelike texture.

Honan The best grade of Chinese silk, similar to pongee, but more finely woven.

Point d' esprit Silk net that is woven with a raised dot.

Poult de soie A rich, soft fabric with a faint rib.

Pongee A light or medium weight Chinese silk fabric made from tussah silk.

Satin A smooth, shining fabric.

Shantung A soft, lustrous fabric with sparse, irregular ridges in the texture.

Surah A soft, silk fabric with a pronounced diagonal rib.

Taffeta A fine, lustrous fabric that is characterized by both its crispness and sound made through movement.

Tussah A springy silk with sparse, irregular ridges in the texture that has been woven from the silk of uncultivated silkworms in Asia.

Miscellaneous. In addition to the most commonly used natural fibers, designers often choose some that are lesser known to best suit their cre-

Figure 7-6 A silk crêpe de Chine Karl Lagerfeld design emphasizes the flow of this fabric. (Courtesy of Karl Lagerfeld)

ative needs. They might be chosen for their naturally inherent textures, unusually soft feel, unique appearance, or an ability to perform better than some of the more commonly used fibers.

Some may be extremely expensive such as cashmere and vicuna, whereas others may fall into the less costly range such as ramie. They fall into two distinct classifications, the animal or hair group and the vegetable category.

HAIR FIBERS

Cashmere A soft, luxurious fiber that is used in the finest of sweaters and other costly apparel and accessories. It comes from the Asian goat.

Angora Rabbit Hair Moderately priced, when compared with cashmere and some of the other specialty hairs, it comes from a French rabbit that is specially raised for its fiber. It is extremely fine and is used primarily for sweaters. One of its drawbacks is that it sheds.

Vicuña One of the costliest of the group, its thin, soft hair comes from the vicuña of South America.

Mohair It is a strong, resilient fiber, naturally lustrous, that comes from the Angora goat.

Alpaca Known for its silky appearance and its strength, it has hair that

is much longer than ordinary sheep's wool. Raised in the Andes, its hair is used for fine coats and suits.

Camel's hair Its woollike texture is extremely soft and lustrous and comes from Mongolian and Tibetan camels. It is used primarily for coats, suits, and sports coats.

VEGETABLE FIBERS

Ramie A strong, abrasion-resistant fiber that is used extensively today in combination with cotton for sweaters.

Jute Medium quality strength, with a rather rigid feel, the fiber is sometimes used for belts and canvas-type handbags.

Hemp Coarse and brittle, its uses are limited. It is occasionally used when there is a need for rough textured materials.

MAN-MADE FIBERS

A chemist's curiosity about how silkworms made silk led to the discovery of the first man-made fiber, rayon. The chemist developed his first artificial fibers about 1850 from a substance when he extracted from the inner layers of the tree that produced mulberry leaves, the diet of the silkworm. That substance was cellulose. When a French chemist, Count Hilaire de Chardonnet, displayed a few yards of "artificial silk," the name used to describe the fiber, at an international exhibition, it created a sensation. In 1891, he built the first commercial artificial silk plant in France, and it was not until half a century later that the fiber was called rayon, the "ray" because of its sheen and the "on" to suggest a fiber such as cotton.

It was not until 1910 that rayon was produced in the United States at a fiber factory in Pennsylvania. In 1924, a second cellulose product known as acetate was introduced. Little did the world know that this was just the beginning of things to come that would revolutionize the textile industry and produce a vast array of fibers that could be manufactured in the laboratory.

There are two basic types of man-made fibers, cellulosic and noncellulosic. The former group, rayon, acetate, and triacetate, is made from fibrous substances found in plants and is made with a minimum of chemical steps. The latter, noncellulose group is much broader and uses molecules in various combinations of carbon, hydrogen, nitrogen, and oxygen derived from petroleum, natural gas, air, and water.

The Federal Trade Commission, a regulatory agency of the federal government, has assigned generic names to the 20 noncellulosic fibers, among which are acrylic, nylon, polyester, olefin, and spandex. Numerous manufacturers such as DuPont, Fiber Industries, Inc., Monsanto, and BASF Corporation produce these fibers under trade names such as Dacron, Acrilan, Trevira, Lycra and Cantrece. Not all of the major

generic fibers can be used as wearable fabrics and are therefore relatively unknown to the consuming public. Only those that are used by the fashion apparel and accessories industries are addressed in this chapter.

Man-made fibers, although delivering enormous advantages for textile producers and fashion manufacturers as well as the consumer, have sometimes had less than enthusiastic acceptance from the public. Polyester, for example, with all of its virtues has been frequently labeled a "tacky" fiber. Although in 1951 it was considered the miracle fiber of the twentieth century, it has fallen on hard times as a fashion fiber. Its poor image was difficult for the industry to reverse until a "new polyester" started to make headlines in the late 1980s, when designers such as Calvin Klein embraced microfiber for their upscale collections. Fashion forecaster David Wolfe of the Doneger Group, one of America's largest resident buying offices and market consulting groups, refers to it as "a Godsend for the American consumer, a dream come true." So significant are its virtues and potential, with sales expected to reach $1 billion by the late 1990s, that it deserves special attention as a fashion fiber.

The three major producers are DuPont, using its trade name Micromattique; Fiber Industries, which calls its product MicroSpun; and Hoechst Celanese, which produces Trevira Micronesse.

Among the advantages afforded by this fiber are:

Feel It can be maneuvered to have the feel of several different fabrics, including washed silk, chamois, fine cotton, taffeta, satin, and velvet.

Drapability It drapes extremely well and can be used to enhance form-fitting designs.

Practicality It is lightweight, easy to launder, strong, and wrinkle-free.

Price Given all of its attributes, it is only 50 percent more expensive than standard polyester.

Versatility It takes prints with greater clarity than other fibers and is colorfast.

Major Generic Groups. There are 12 major groups of man-made fibers, eight of which are found in considerable abundance in fashion apparel and accessories. Each has specific characteristics that are unique and are available under trade names that belong to their producers.

The textiles that are achieved with these man-made fibers come in a wide range of textures, appearances, and feels. They are used to produce fabrics that bear the same names as those produced with natural fibers such as batiste, which is synonymous with cotton; flannel, generally associated with wool; satin, often a silk fabric; shantung, another silk favorite; and crash, a heavyweight linen product. The manner in which they are converted from their fiber state to yarn and then to fabric, dictates the types of fabrics that will eventually be used for wearable items.

TABLE 7-2: MAJOR GENERIC GROUPS OF MAN-MADE FIBERS

MAJOR GENERIC FIBERS AND TRADE NAMES*	CHARACTERISTICS	MAJOR DOMESTIC AND INDUSTRIAL USES
ACETATE Ariloft[8] Estron[8] Celebrate[11] Loftura[8] Chromspun[8]	Luxurious feel and appearance; wide range of colors and lusters; excellent drapability and softness; relatively fast-drying; shrink-, moth-, and mildew-resistant.	*Apparel:* Blouses, dresses, foundation garments, lingerie, linings, shirts, slacks, sportswear. *Fabrics:* Brocade, crepe, double knit, faille, knitted jerseys, lace, satin, taffeta, tricot. *Home Furnishings:* Draperies, upholstery. *Other:* Cigarette filters, fiberfill for pillows, quilted products.
ACRYLIC Acrilan[12] Orlon[7] Zefkrome[5] Bi-Loft[12] Pa-Qel[12] Zefran[5] Creslan[2] Remember[12] Fi-lana[12] So-lara[12]	Soft and warm, woollike, light-weight; retains shape; resilient; quick-drying; resistant to moths, sunlight, oil, and chemicals.	*Apparel:* Dresses, infant wear, knitted garments, skirts, ski wear, socks, sportswear, sweaters, work clothes. *Fabrics:* Fleece and pile fabrics, face fabrics in bonded fabrics, simulated furs, jerseys. *Home Furnishings:* Blankets, carpets, draperies, upholstery. *Other:* Hand-knitting and craft yarns.
MODACRYLIC SEF[12]	Soft, resilient, abrasion- and flame-resistant; quick-drying; resists acids and alkalies; retains shape.	*Apparel:* Deep pile coats, trims, linings, simulated fur, wigs, and hairpieces. *Fabrics:* Fleece fabrics, industrial fabrics, knit-pile fabric backings, non-woven fabrics. *Home Furnishings:* Awnings, blankets, carpets, flame-resistant draperies and curtains, scatter rugs. *Other:* Filters, paint rollers, stuffed toys.
NYLON A.C.E.[1] Compet[1] Shareen[6] Anso[1] Cordura[7] Shimmereen[5] Antron[7] Courtaulds Tolaram[15] Blue"C"[12] Nylon[6] Ultron[12] Cadon[12] Crepeset[5] Vivana[5] Cantrece[7] Cumuloft[12] Zafran[5] Capima[1] Hydrofil[1] Zefsport[5] Caplana[1] No Shock[12] Zefstat[5] Caprolan[1] Patina[1] Zeftron[5] Captiva[1]	Exceptionally strong, supple, abrasion-resistant; lustrous; easy to wash. Resists damage from oil and many chemicals. Resilient; low in moisture absorbency.	*Apparel:* Blouses, dresses, foundation garments, hosiery, lingerie and underwear, raincoats, ski and snow apparel, suits, windbreakers. *Home Furnishings:* Bedspreads, carpets, draperies, curtains, upholstery. *Other:* Air hoses, conveyor and seat belts, parachutes, racket strings, ropes and nets, sleeping bags, tarpaulins, tents, thread, tire cord, geotextiles.

Number after the fiber trade name indicates the manufacturer as follows. [1] Allied-Signal, Inc., [2] American Cyanamid Co., [3] Amoco Fabrics & Fibers Co., [4] Avtex Fibers, Inc., [5] BASF Corporation, [6] Courtaulds North America, Inc., [7] E.I. DuPont de Nemours & Co., Inc., [8] Eastman Chemical Products, Inc., [9] Fiber Industries, Inc. [10] Hercules Incorporated, [11] Hoechst Celanese Corp., [12] Monsanto Chemical Co., [13] North American Rayon Corp., [14] Phillips Fibers Corp., [15] Tolaram Fibers, Inc. Reprinted with permission of the American Textile Fibers Institute.

TABLE 7-2: CONTINUED

MAJOR GENERIC FIBERS AND TRADE NAMES*	CHARACTERISTICS	MAJOR DOMESTIC AND INDUSTRIAL USES
OLEFIN Avtex[4] Nouvelle[10] Patlon[3] Elustra[10] Marquesa Spectra[1] ES Fiber[4] Lana[3] Tolaram[15] Herculon[10] Marvess[14]	Unique wicking properties that make it very comfortable. Abrasion-resistant; quick-drying; resistant to deterioration from chemicals, mildew, perspiration, rot, and weather; sensitive to heat; soil resistant; strong; very lightweight. Excellent colorfastness. (Spectra is a high performance fiber with unequaled strength-to-weight ratio, excellent chemical, stretch, cut, and abrasion resistance, plus optimum flex fatigue and superior dielectric constant.)	*Apparel:* Pantyhose, underwear, knitted sports shirts, men's half hose, mens knitted sportswear, sweaters. *Home Furnishings:* Carpet and carpet backing, slipcovers, upholstery. *Other:* Dye nets, filter fabrics, laundry and sandbags, geotextiles, automotive interiors, cordage, doll hair, industrial sewing thread.
POLYESTER A.C.E.[1] Fortrel[9] KodOsoff[8] Avlin[4] GoldenGlow[5] Silky Touch[5] Ceylon[11] Golden Strialine[5] Comfort Touch[5] Tolaram[15] Fiber[11] Hollofil[7] Trevira[11] Compet[1] Kodaire[8] Ultra Dacron[7] Kodel[8] Touch[5] E.S.P.[11] KodOfill[8]	Strong; resistant to stretching and shrinking; resistant to most chemicals; quick-drying; crisp and resilient when wet or dry; wrinkle- and abrasion-resistant; retains heat-set pleats and creases; easy to wash.	*Apparel:* Blouses, shirts, career apparel, children's wear, dresses, half hose, insulated garments, ties, lingerie and underwear, permanent press garments, slacks, suits. *Home Furnishings:* Carpets, curtains, draperies, sheets, and pillow cases. *Other:* Fiberfill for various products, fire hose, power belting, ropes and nets, thread, tire cord, sails, V-belts.
RAYON Avril[4] Courcel[6] Zanaire[5] Avtex[4] Durvil[4] Zankare[5] Beau-Grip[13] Fiber 40[4] Zankrone[5] Coloray[6] Fiber 240[6] Zantrel[5] Courtaulds Fibro[6] Rayon[6]	Highly absorbent; soft and comfortable; east to dye; versatile; good drapability.	*Apparel:* Blouses, coats, dresses, jackets, lingerie, linings, millinery, rainwear, slacks, sports shirts, sportswear, suits, ties, work clothes. *Home Furnishings:* Bedspreads, blankets, carpets, curtains, draperies, sheets, slipcovers, tablecloths, upholstery. *Other:* Industrial products, medical/surgical products, nonwoven products, tire cord.
SPANDEX Lycra[7]	Can be stretched 500 percent without breaking; can be stretched repeatedly and recover original length; lightweight; stronger, more durable than rubber; resistant to body oils.	*Articles (where stretch is desired):* Athletic apparel, bathing suits, delicate laces, foundation garments, golf jackets, ski pants, slacks, support and surgical hose.

ACETATE

Produced under such trade names as Ariloft, Chromspun, Estron, and others, acetate has a luxurious feel and appearance, is available in a wide color range, drapes extremely well, is relatively fast drying, and is resistant to shrinkage, mildew, and moths. It is used for blouses, dresses, foundation garments, lingerie, linings, shirts, slacks, and sportswear.

Fabrics used with the acetate fiber include brocade, crepe, double knit, faille, knitted jerseys, lace, taffeta, and tricot.

ACRYLIC

Acrilan, Creslan, Orlon, and Zefran are just some of the trade names for the fiber. It is a soft, warm, woollike, lightweight product that has considerable strength, is resilient, dries quickly, and is resistant to moths, sunlight, oil, and chemicals. It is used for dresses, infant wear, knitted garments, skirts, ski wear, socks, sportswear, and sweaters.

Its fabrics include fleece and other piles, fake furs, jerseys, and facing for bonded fabrics.

MODACRYLIC

Produced by Monsanto under the SEF trade name, it is soft, resilient, abrasion and flame resistant, dries quickly, and retains its shape. It is used for deep-pile coats, trims, linings, simulated fur, and hairpieces.

For apparel, its fabrics include fleece and knit pile.

NYLON

There are more trade names for nylon than for any of the other man-made fibers. Its exceptional strength, ability to resist abrasion, and ease in laundering make it an extremely desirable fabric. It is available from its producers as Cantrece, Caprolan, Cordura, Antron, Patina, Zafran, and many other names. It is used for hosiery, blouses, dresses, foundation garments, lingerie, underwear, raincoats, ski wear, snow apparel, and suits. It is available as either knits or woven goods.

OLEFIN

As with nylon, it has extreme strength, dries quickly, resists deterioration to mildew and perspiration, and has excellent colorfastness. It is made into hosiery, underwear, sport shirts, sportswear, and sweaters. It is also, as nylon, available in a wide range of knitted goods and woven fabrics.

POLYESTER

This is the second largest of the man-made fibers in terms of specific trade names. They include Dacron, Fortrel, Kodel, Trevira, and Ultra

Touch and are used in blouses, shirts, suits, children's wear, hosiery, insulated garments, ties, lingerie, and garments used for travel. Characteristically, it offers great strength, resistance to stretching, quick drying, retains heat-set pleats and creases, and is easy to launder. The fabrics come in a wide range from knits to wovens and appear to look and feel like fabrics made from natural fibers.

As previously noted, the new breed of polyesters, produced under the microfiber group, is available in fabrics that rival silk.

RAYON

Soft and comfortable, easy to dye, and extreme versatility make this a useful fiber in the fashion industry. It is used for sportswear, blouses, jackets, lingerie, linings, rainwear, shirts, and ties.

It is produced by various textile manufacturers such as Avril, Coloray, Durvil, Zantrel, and many others.

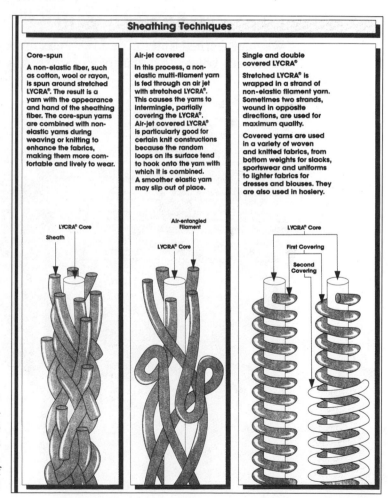

Sheathing Techniques

Core-spun
A non-elastic fiber, such as cotton, wool or rayon, is spun around stretched LYCRA®. The result is a yarn with the appearance and hand of the sheathing fiber. The core-spun yarns are combined with non-elastic yarns during weaving or knitting to enhance the fabrics, making them more comfortable and lively to wear.

LYCRA® Core
Sheath

Air-jet covered
In this process, a non-elastic multi-filament yarn is fed through an air jet with stretched LYCRA®. This causes the yarns to intermingle, partially covering the LYCRA®. Air-jet covered LYCRA® is particularly good for certain knit constructions because the random loops on its surface tend to hook onto the yarn with which it is combined. A smoother elastic yarn may slip out of place.

Air-entangled Filament
LYCRA® Core

Single and double covered LYCRA®
Stretched LYCRA® is wrapped in a strand of non-elastic filament yarn. Sometimes two strands, wound in opposite directions, are used for maximum quality.

Covered yarns are used in a variety of woven and knitted fabrics, from bottom weights for slacks, sportswear and uniforms to lighter fabrics for dresses and blouses. They are also used in hosiery.

LYCRA® Core
First Covering
Second Covering

Figure 7-7
The three techniques used to "cover" Lycra spandex. (Courtesy of DuPont)

Fabrics produced from rayon include satin, velvet, crepe, flannel, broadcloth, crash, taffeta, and nearly everything else.

SPANDEX

Produced exclusively by DuPont as Lycra, its major advantage is its ability to be stretched 500 percent over and over without breaking, always returning to its original length. It is lightweight, more durable than rubber, and resistant to body oils. It is used wherever stretch is required such as in athletic apparel, bathing suits, foundation garments, ski pants, and sportswear.

It should be understood that the man-made fibers are sometimes used alone in garments and, at other times, in blends and combinations with natural fibers. The blending or combining provides the finished product with characteristics that are often unavailable from exclusive use of the man-made fibers alone.

TRANSFORMING FIBER INTO YARN

We have learned that the natural fibers must go through some preliminary processes before they can be considered sufficiently viable to be turned

Figure 7-8 Fiber undergoing the ring-spinning process. (Courtesy of American Textile Manufacturers Institute)

Figure 7-9 Open-end spinning. (Courtesy of American Textile Manufacturers Institute)

into yarn or continuous threadlike strands. Cotton and flax, for example, have to be separated from their plants and wools cleaned after being shorn. The man-made fibers need no extra processing because they are laboratory produced and ready for transformation into yarn after the appropriate chemicals have been mixed.

Natural fibers are either short or thin and must be condensed in some manner to make them appropriate for use as fabrics. They must undergo spinning at this point. Fibers that are engineered in the laboratory do not generally require spinning, except in cases in which they are meant to resemble fabrics that are usually made of natural fibers.

SPINNING

Cotton, flax, and wool have staple sizes that range from approximately ½ to 36 inches in length. Their sizes require that they be spun together to form the yarn needed for textile construction. Although silk is naturally produced in long filaments and does not need to be spun, many cocoons are damaged, causing the filaments to break into smaller pieces. These shorter silk staples then undergo spinning much the same as the other natural fibers.

Our ancestors used the hand-driven spinning wheel to make yarn. Today, modern textile plants use a variety of machines and numerous spinning techniques to accomplish the same result.

Man-made fibers are produced as continuous filaments and may be used in fabric production without using the spinning process. To produce some materials that resemble the natural spun varieties, however, these

Figure 7-10 Julian Hill of DuPont reenacts the discovery of man-made fiber. (Courtesy of DuPont)

filaments are cut into smaller pieces or staples and then spun in the same manner as their natural fiber counterparts. Rayon, for example, when used to imitate linen, goes through the spinning process.

There are various spinning methods used, with ring spinning the most common in the United States. Open-end spinning is a newer system that is three to five times faster, with air jet the fastest at a rate that is seven to ten times that of the conventional ring technique.

During the filament processing, manufacturers use certain additives such as dye before the solution is extruded. The technique of dyeing is discussed along with the other additives in a later section of this chapter.

FILAMENT PRODUCTION

All man-made fibers are formed by forcing a thick, syrupy substance through tiny holes in a metal plate, which resembles a shower head, called a "spinneret." The process is known as extrusion, from the silkworm who extrudes the strands of silk in the same manner. The size of the filament yarn is determined by the size of the holes in the spinneret. The holes in each device range from one to as many as a thousand.

After emergence from the spinneret, the fibers are solidified. The extrusion and hardening process is called "spinning." There are three such spinning techniques: wet, dry, and melt.

As they are hardening or after they have solidified, the fibers are stretched to reduce their diameter and this process increases strength and stabilizes their ability to stretch without breaking.

FABRIC CONSTRUCTION

There are several methods used in the construction of fabric. Weaving is the most widely used, followed by knitting. Other techniques used for apparel, accessories, and trimmings include, felting, crocheting, and bonding.

WEAVING

Fabrics that are woven are constructed by the interlacing of two or more sets of yarns at right angles. The vertical, or lengthwise, yarns are called warps and are the stronger of the two. They are placed first on the loom. The horizontal, or crosswise, yarns are fillings and are interlaced with the warps. There are three basic weaving techniques: plain, twill, and satin. Others such as the pile, jacquard, and dobby require more complicated construction.

Plain Weave. The simplest method, the plain weave, is accomplished in a manner that is similar to that of stringing a tennis racket. The filling yarns are interlaced in a regular over and under course through the warp

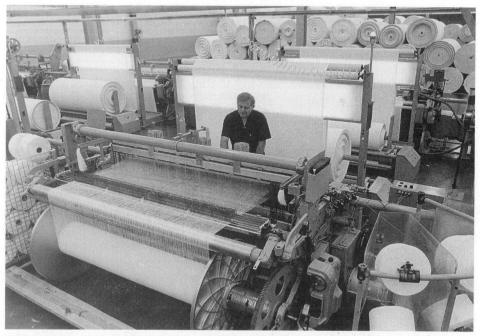

Figure 7-11 This modern weaving machine has a light panel for fabric inspection. (Courtesy of American Textile Manufacturers Institute)

Figure 7-12
Hand production
of the plain
weave.

yarns. Both fine and thick fabrics may be manufactured in this manner, the end result being determined by the yarns used.

A variation, called the basket weave, can be used to achieve a different appearance. It requires the interlacing of two or more sets of yarns as though they were one. Although the end result is a fabric that has a different dimension than that of the traditional plain weave, the disadvantage is that the yarns may shift out of place during the apparel manufacturing stage or during laundering.

Twill Weave. When durability is desired, the twill weave, which produces a diagonal line, is used. The technique involves each filling yarn to follow an over-one, under-two course through the warp yarns. Variations of this weave can create different effects as in the case of the herringbone pattern. In this fabric, the diagonals run upward to both the right and left side of the fabric. Denim is a prime example of fabric made with the twill weave.

Satin Weave. When the desired result is a smooth, shiny surface, the satin weave is chosen. The yarns are not interlaced at close intervals as in the other basic techniques, but are floated from four to twelve times before interlacing takes place. The floating, or reduction in the number of interlacings, allows for more light on the surface giving fabrics of this type their natural luster. Although a shiny surface has been accomplished, the fewer interlacings cause the fabric to wear poorly and show abrasion after repeated wearings.

Pile Weave. When a furlike, plush surface is desired, the pile weave is used. Its production requires three sets of yarns, a regular set of warps, a regular

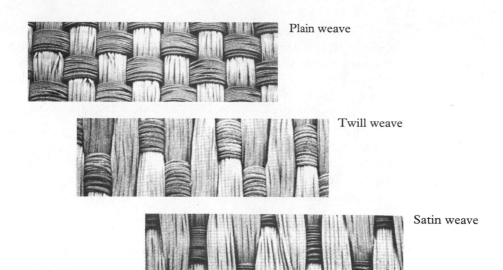

Plain weave

Twill weave

Satin weave

Figure 7-13 Most apparel fabrics are woven using the plain, twill, or satin weaves. (Courtesy of American Textile Manufacturers Institute)

set of fillings, and an additional set that may be either warps or fillings that forms the dimensional surface. The raised surface yarns may then be left alone, as in the case of terry-cloth, or cut, as in the case of velvet.

Jacquard Weave. The most complicated of the techniques is the jacquard weave, which requires an intricate loom, called the jacquard loom, for its construction. A series of punched cards, that predetermine the design, were once used to achieve the most intricate of patterns. Today, the computer aids in the production of jacquard designs, helping to reproduce the patterns in a fraction of the time it once took to do so. Unlike the other construction techniques that use one set of warps, the jacquard loom may use as many as 4000 to achieve the effect! Given the complexity of the production, needless to say, fabrics made in this manner are costly and are used only for detailed, unusual motifs.

Dobby Weave. A simple geometric pattern may be produced with the dobby weave. Constructed on a special loom, the technique produces fabrics such as "birdseye pique," used in some women's sportswear and small patterns for men's ties.

KNITTING

Fabrics that are knitted are done so by using hooked needles to pull one loop of yarn through another loop and interlocking them. As new loops are formed, they are drawn through those previously shaped. This may be accomplished by hand, when fine, quality garments are the goal, or by machine. Of course, hand-knitted wear is costly and has a limited market.

There are basically two types of knitting techniques, weft and warp. Goods that are horizontally produced are called weft, with the stitches running from side to side for the width of the fabric. Warp knitting uses a large number of yarns to make the goods, with each yarn looped around a single needle and vertically attached to other loops.

The sophistication of the knitting machines enables manufacturers to produce a vast array of goods, using the finest to the thickest fibers. Single jersey, double jersey, ribs, and intricate jacquards are easily manufactured with these specialized machines. The latest technology of the electronic knitting machines enables the industry to turn out goods at unimaginable speeds.

FELTING

The production of fibers such as wool into fabric without first transforming them into yarn is known as "felting." The process requires the mechanical action of agitation, friction, and pressure in the presence of heat and moisture. The scales on the edges of the fiber interlock, preventing them from returning to their original position. The major use of felted fabrics is for hats, with occasional use in casual jackets.

BONDING

The process of bonding requires the adherence of two fabrics together. Each may be first constructed with the same or different methods. The front side or face of the fabric may be woven and the backing, knitted. Webs are formed that adhere to the two layers, producing the bonded fabric.

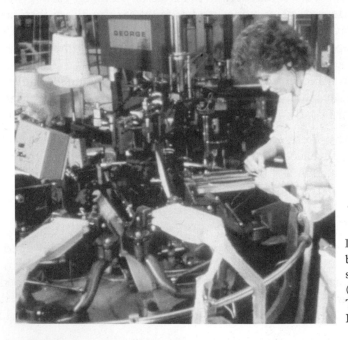

Figure 7-14 Fabric being knitted on a sophisticated machine. (Courtesy of American Textile Manufacturers Institute)

CROCHETING

Very intricately designed laces may be produced through crocheting. It requires the use of threads made with hooks. They are either accomplished by hand or machine, with the former available at considerable expense. Full-crocheted garments and accessories such as hats and gloves are sometimes available, but the majority of the fabric is used for trim.

FINISHING FABRICS

Although the fabrics are somewhat serviceable at this point, most do not have the appearance to arouse customer inspection nor the enhancements that improve their characteristics. Color is a primary finish that gives life to the garments or accessories and makes them stand out from the rest. Patterned designs may also change the common or ordinary textile into something spectacular. Pucci prints, for example, with their bold, geometric shapes, transform the mundane into the sensational.

In addition to dyeing and printing, fabrics "in the gray," or gray goods as they are referred to as they come from the looms or knitting machines, are often in need of appearance enhancers and applications to improve their functional characteristics. It is the addition of these processes, collectively called finishes, that differentiates a fabric from all others.

The gray goods are enhanced by an individual or company known as the converter that purchases the unfinished fabrics and has them dyed, printed, and finished to make them more attractive and serviceable.

DYEING TECHNIQUES

When a fabric is to be colored, it may be done so at different times during the construction process and achieved with a number of types of dyes. Each technique and time frame affords the fabric different benefits. It is the final use of the fabric that usually determines when and how the dyeing will be approached. With more than 1500 different types of dyes available today, the methods of application and the sophisticated technology surrounding the application require the expert attention of professionals. Just imagine if a swimsuit were dyed with a product that was not colorfast and the color ran when worn in the water; the industry would be flooded with customer complaints.

Solution Dyeing. When cellulose is being dissolved into liquid, as in the case of rayon fiber production, or carbon, hydrogen, and other chemicals are being dissolved as in the case of nylon, color may be added to their mixtures before they are extruded through the spinneret. Known as solution dyeing, the process furnishes a "color sealing." This binding of the dye gives the fabric a high degree of colorfastness and eliminates much of the problems that might occur when colorization is applied later in the construction of the fabric. Although this certainly provides

for a distinct advantage, it could also become problematic for use in garment construction.

The drawback comes from the necessity to make color decisions early in the production. In the fashion industry, style and color decisions are generally made early, leaving little room for error. If fabrics are colored at the earliest moment, as in the case of solution-dyed fabrics, the wrong color might be decided on and the possibility of turning back would be out of the question. When color decisions are deferred, as in the case of some of the other techniques we discuss, there is less risk to be taken and plans could be adjusted to reflect new thinking. Benetton, manufacturers of apparel in Italy, leaves the color decisions until the customer orders the garments. It produces an abundance of its products in gray goods, applying color only when the purchase request reaches the manufacturing plant. In this way, it can accommodate its stores with almost any desired color choices.

Stock Dyeing. Natural fibers that require a high degree of color penetration are stock or fiber dyed. The end result is a fiber with color uniformity and evenness throughout. As in solution dyeing, this requires early decision making, and poor judgment can result in the production of unwanted colors.

Yarn Dyeing. Dyeing may also be delayed until the yarn has been produced. This allows for a little more time for the ultimate color decision. The majority of solid-colored fabrics that have not been solution dyed are yarn dyed. The degree of color penetration is still excellent at this point. Through a variation on this process, space dyeing enables the use of multicolored effects on the yarn.

Piece Dyeing. Textile manufacturers who wish to keep their goods as long as possible store gray goods and then enhance them with colors. Although the color penetration is not as dense as in the aforementioned processes, it does benefit the producer by enabling the delay of coloration.

Cross Dyeing. Whereas piece dyeing implies that only a one-color product is possible, cross dyeing, a similar technique, allows for two or more colors to be applied during the fabric stage. When the fabric has been constructed of two or more different fibers, each will be affected by different dyes. Thus, when a fabric is immersed in a dye bath, only one set of fibers will be affected by the dye. Then, an additional immersion into a dye bath with another type of dye will color only the undyed fibers. Plaids, checks, and other patterns can be inexpensively achieved in this manner.

Garment Dyeing. The example using the Benetton organization exemplifies the use of garment dyeing. The products are generally limited to knitted apparel and accessories because of their simple construction. Tailored garments such as suits and dresses, which use a variety of different elements such as pads, zippers, and so forth, are less likely to be

exposed to this method because the different parts of the garment are subject to uneven shrinkage. Of course, when all of the obstacles have been addressed, this technique allows coloring to take place as late as possible.

DYE SELECTION

With the enormous host of dyes available to today's textile industry, the choices are significant. Aside from each coloring agent's ability to impregnate fabrics with various coloration intensities, each has specific functional characteristics that may make it more suitable for one project than for another.

One of the most important decisions that must be made in dye selection is influenced by the product's final use. Colorfastness, the degree to which the dye can withstand fading, is crucial in many cases. Washables, for example, must be colorfast so that bleeding, the running of color, will not take place when the garment is laundered or used for swimming. Fading is another factor that must be considered, especially when exposure to sunlight is a factor, as in the case of active sportswear.

Fabrics that are improperly colored cause numerous problems for the mills, garment manufacturers, retailers, and consumers. One wrong dyeing decision can generate displeasure for every part of the distribution cycle. The consumer returns the damaged product to the store, often causing the retailer to refund the purchase price; the retailer, in turn, returns the garment to the manufacturer, requesting credit for returned goods; the producer finally becomes embattled with the mill and requests an adjustment.

An in-depth study of the various dye classes and their properties is appropriate for anyone wishing to enter the textile industry. Some of the general classifications are offered to give an indication of their important characteristics to the apparel and accessories industries.

Acid dyes Excellent to achieve bright colors; not fast to washing, but able to withstand the chemicals used in dry cleaning.

Chrome dyes Excellent color fastness to light and washing; however, the resulting colors are dull.

Basic dyes Bright shades are easily achieved; generally colorfast to washing and light; fabrics colored with this dye are usually resistant to crocking, the color will not rub off from friction.

Direct dyes Poor color fastness to laundering as well as to light penetration; dry cleanable in most cases.

Disperse dyes Their potential for colorfastness varies according to the fiber being colored; color fastness to crocking, perspiration, and dry cleaning is generally good.

Fiber reactive dyes Perfect for bright colors; good overall color fastness, except to chlorine, which eliminates it as a useful agent in the dyeing of swimsuit fabrics.

Napthol dyes Bright colors; color fastness to light varies, depending on the specific makeup of the dye; colorfast to washing.

Vat dyes Excellent color fastness to sunlight, washing, and perspiration.

PRINTING PROCESSES

A variety of patterns from the smallest traditional styles to the boldest geometrics can be achieved on fabric. Just as different dyeing techniques afford different results, so do the numerous printing processes. The dyes used in their production must also be cautiously selected, as was the case in fully dyed goods.

Screen Printing. Although it is one of the oldest printing processes, it is still extensively used today in the production of fashion-oriented fabrics. The goods may either be hand or roller-screen printed, the latter providing the speed necessary to accommodate large-scale fabric production. When limited quantities are the goal, hand screening is still used.

In both cases, an artist designs the print and transfers it onto one or more screens, the number being dependent on the different colors in the pattern. Screens were originally made of silk, but today, synthetics are generally used. The screens are covered with a "film" that adheres to the screen

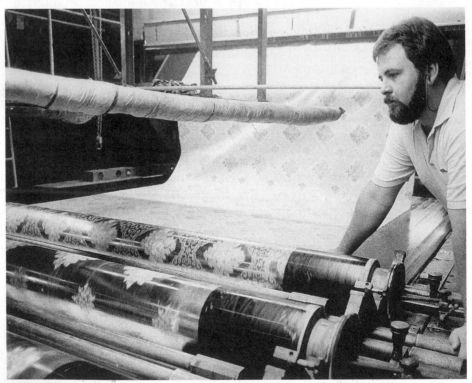

Figure 7-15 Fabric being rotary printed. (Courtesy of American Textile Manufacturers Institute)

and is cut away wherever the color must penetrate. The fabric passes under each screen and this is repeated until all of the colors have been applied. This process is known as flat-bed screen printing.

Rotary screen printing is usually used today and it is capable of printing more than 100 yards of cloth in a minute. In this process, dye is fed inside the screens and forced through tiny holes onto the fabric. Each cylinder on a printing machine adds a different color and a different part of the pattern. Modern technology enables the textile industry to print high-quality fabrics in this manner and, with carefully selected dyes, they will produce colors that will not fade.

Roller Printing. Copper-plated rollers are engraved with patterns that will be transferred on the fabric. If 10 colors are to be used in the design, 10 different rollers will be engraved, each for a different part of the pattern. The rollers, which have been etched with a photoengraving process, rotate through a dye bath and transfer dye onto the fabric. After all colors has been applied, the print is complete.

Numerous effects can be achieved through this process. Fabrics may be simultaneously printed on two sides, raised patterns can be achieved in a process known as flocking in which paste is applied to desired areas and then dye adheres to the raised paste surfaces, and areas of dye can be removed from already colored fabrics in areas where the natural fabric color is wanted for a particular pattern. Roller printers can operate at speeds of up to 200 yards per minute.

Heat-Transfer Printing. This techniques takes a pattern that has been printed on paper and transfers it to fabric through heat and pressure. Individuals who have purchased patterns and have transferred them onto their T-shirts at home with an iron have basically performed heat-transfer printing. It is sometimes the process of choice because of the limited expense involved in the purchase of the equipment, its ease of application, and its final, low cost.

APPEARANCE ENHANCERS

In addition to coloration, numerous finishes are applied to the fabrics that will make them more attractive to the purchasers. There are literally hundreds of ways in which fabrics may be treated both for appearance and to improve their functional characteristics. Some of the more commonly used appearance-enhancing finishes are:

Calendering An ironing process that passes fabric between two sets of rollers to smooth its appearance and give it more luster. The end result is a stiffer fabric that has a polished look and is sometimes called polished cotton when that natural fiber is used.

Flocking The application of short fibers to fabric with adhesives to give them plush, velvet, or sueded effects.

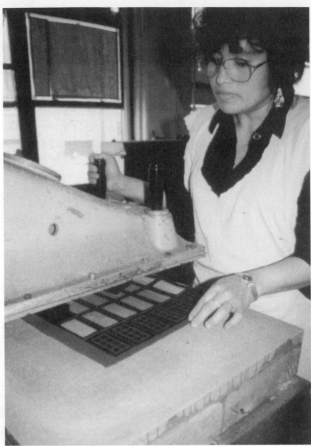

Figure 7-16 Operator using heat-transfer technique to print pattern on fabric. (Courtesy of Tickle Me)

Napping Brushes pass over the fabric to raise the surface and give it a fuzziness. Not only does this change the appearance, the raised surfaces provide additional warmth.

Embossing Dimensional designs are etched into fabrics that result in raised and lowered surfaces. This is accomplished with engraved rollers that are etched with the embossed designs.

Moireing To achieve a moire or water-marked design, etched rollers pass over the fabric and impregnate the pattern.

Delustering Many man-made fabrics have naturally inherent shiny surfaces that often makes them less attractive. To remove the unwanted sheen, a variety of chemicals in varying degrees are used.

Singeing Fabrics that have been constructed with short staples tend to have a fuzziness on the surface. To even the fabric and make it smoother, it is quickly passed over a gas flame to burn off the tiny fibers. To eliminate the sparking that often accompanies the singeing, the fabric is immediately placed in a water bath and then dried.

Mercerization Used on cotton to increase the sheen, the fabric is immersed in a solution of sodium hydroxide for a few minutes. This finish also improves strength and absorbency, making it a functional finish as well as an appearance enhancer.

Schreinerizing A type of calendering that produces a low-luster appearance on the surface. This is achieved by fine, diagonally engrained rollers that pass over the fabrics.

Fulling A finish that is used on wool for a more compact, dense appearance. This process involves scouring and laundering, which actually shrinks the fabric rendering it "fuller."

Plisseing A crinkly effect is gained by using sodium hydroxide, which is pasted on the fabric where shrinkage would take place to produce a puckered look.

Shearing Pile-woven fabric surfaces are irregular as they come from the loom and must be evened. Using equipment that is similar to a lawn mower, the pile is uniformly cut.

Figure 7-17 Point d'esprit design is flocked on a sheer coat. (Courtesy of Bill Blass)

FUNCTIONAL FINISHES

Whereas the previous finishes are used to please the eye, the following group is basically responsible for rendering fabrics more serviceable to their users.

Durable press A finish achieved with resins and heat curing, which helps a garment keep its shape with little or no ironing after washing.

Flame retardency A term used to describe fabrics that have received a chemical treatment to make them resistant to burning.

Preshrinking A variety of processes that retards fabric shrinkage. Sanforized is a well-known trade name for a preshrinking process that guarantees treated fabric will not shrink by more than 1 percent.

Sizing Adding starch or similar materials to fabrics to add strength, body, weight, and stiffness; it can also prevent damaging.

Water repellent Fabrics are treated with special finishes to resist water but still permit air to flow through them. Waterproofing, which actually prevents penetration, requires a rubber-coated base.

Wrinkle resistance Special chemicals are used that will either disallow fabric wrinkling or will shake them out at once.

Anti-static Applying chemicals to the fabrics to keep them from clinging.

Mothproofing By using chemical sprays, wool, which is attractive to moths, is made unattractive to them.

Permanent press Through heat setting, resins, or liquid ammonia, fabrics may permanently hold creases or pleats. Although some man-made goods are naturally permanently pressed, others, as well as the natural fibers, may be required to undergo the finish to improve salability.

Soil release This finish is extremely important to fabrics that have been permanently pressed because they tend to hold dirt. Soil release is accomplished by adding special chemicals that enable the garment to release stain more easily.

TEXTILE REGULATIONS

The Federal Government has enacted many pieces of legislation that have helped consumers to evaluate properly the fibers that are in the products they buy. Some address all fibers and fabrics, whereas others address specific individual fibers.

Some of these have had far-reaching effects; consumers are more aware of fibers than ever before. The following briefly outlines the important points of some of these acts.

Textile Fiber Identification Act Each garment must be labeled to include the generic names of the fibers used, the percent of the individual fibers, and, if imported, the country of origin.

Wool Product's Labeling Act The percent of wool and its "category" must be listed. The categories include wool, fiber that has never been

used before (new or virgin wool designations are appropriate), fiber that has fallen away during processes such as carding or combing, or fibers that have been reclaimed from spun yarn or knitted products; reprocessed wool, fiber that was made into a wool product that was never used but restructured back into wool fiber; and reused wool, fiber that was made into a product that was used by the consumer and then turned back into the fiber state.

Flammable Fabrics Act This act originally outlawed the use of highly flammable fibers and permitted only those that passed a burning test. It was later amended to include non-textile fibers such as plastics. Some specific tests administered under the provisions of this act are the 45°-angle test for wearing apparel, which touches a flame to the fabric at that angle, and the vertical test for children's sleepwear, which vertically exposes the garment to flame and records the burning time.

Federal Trade Regulation Rule Relating to the Care Labeling of Textile Wearing Apparel Apparel must have permanent tags affixed that give appropriate care and maintenance instructions.

MARKETING TEXTILES

Few industries use as many approaches to the marketing of their products as the textile industry. Fiber producers such as DuPont, Monsanto, Avtex, Eastman Chemical Products, and North American Rayon Corporation spend enormous sums trying to get the product into the ultimate consumers' hands.

Promotion does not stop at this level. A great deal of involvement comes from trade associations and organizations that interface with the manufacturers. The following is a list of some of these and their endeavors.

The Wool Bureau Established in 1949, it is the U.S. branch of The International Wool Secretariat (IWS), which represents major growers in the Southern Hemisphere. Its role is to educate the public on the merits of wool through advertising and promotion and assist manufacturers and retailers through wool product research and development. They created the now familiar Woolmark as well as the Woolblend Mark, which immediately tells the consumer that the product is made of wool. They also maintain laboratories that help to improve wool products, have merchandising programs that initiate cooperative advertising between the wool producers and the apparel designers, and provide information on color, fabric, and fashion trends through their Fashion Office.

Cotton Incorporated This organization is responsible for increasing the retail market share of American cotton fiber. Its goal is to enhance U.S. consumer preference for cotton and cotton-containing fabrics. It accomplishes this by planning and executing a strategic program of research, product development, and market promotion. It operates a

Cottonworks library, a vital source of information for the manufacturing industry, which showcases fabrics from more than 270 mills and knitters who manufacture cotton products.

National Cotton Council This is the unifying force of the U.S. raw cotton industry's seven segments: producers, ginners, warehousemen, merchants, cottonseed crushers, cooperatives, and textile manufacturers. Its mission is to compete effectively and profitably in fiber and oilseed markets at home and abroad. It is involved in the technical aspects of the industry, public relations, and promotion. One of the better known promotions initiated by the council is the Maid of Cotton promotion, which was discussed in the earlier chapter "Fashion Advertisers and Promoters."

As discussed earlier, advertising and promotion of the apparel and accessories industry is significantly enhanced by every level of the fashion industry. The major industrial fashion shows, spearheaded by the field's giants, the numerous fiber- designer advertisements, and the cooperation of public relations groups such as the Men's Fashion Association each help to make the consuming public more aware of the fibers and fabrics that are used in the garments they purchase.

This is an industry whose cooperative efforts have helped to established it more than most of the other industries in the world.

REVIEW QUESTIONS

1. In addition to the aesthetics of the fabric, what else must be considered before it is used in the manufacture of a garment?
2. Differentiate between the terms *fiber* and *yarn*.
3. List the four major natural fibers and an important characteristic of each.
4. Why has cotton remained a favorite of both the apparel industry and the consumer?
5. Describe velvet, denim, and sateen.
6. What purpose does the hackling of flax serve?
7. Discuss the differences between woolens and worsteds.
8. In what way does silk fiber differ from cotton, flax, and wool?
9. Name four hair fibers and a characteristic of each.
10. What are the two basic types of man-made fibers?
11. Why is "microfiber" being heralded as the greatest fabric innovation of the past decade? What is its fiber base?
12. What advantages does polyester afford the wearer?
13. Define the terms *spinning* and *filament processing*.
14. What is a spinneret?

15. How does the basket weave differ from the plain weave?
16. Why is it so difficult to produce a jacquard design? How is the process accomplished?
17. In what way is felting different from weaving or knitting?
18. Define the term *gray goods.*
19. Which dyeing technique allows for color sealing?
20. Describe the process that enables a two-colored piece of fabric to receive its colors.
21. What is the most important consideration when choosing a dye that is to be laundered or worn in water?
22. Briefly discuss the silk screening process for printing.
23. Define *calendering, embossing,* and *moireing.*
24. What is the difference between water repellency and waterproofing?
25. Discuss the purpose of the Wool Bureau.

EXERCISES

1. Write to any of the major textile trade associations to request materials about the organization. Using the acquired information, prepare a report on the manner in which it serves the textile fiber it represents.
2. Cut narrow strips of paper, eight inches long, and construct "fabrics" that use the basket weave, an eight-float satin weave, and a twill weave. Take the constructions to a fabric retailer and locate swatches of material that use the same techniques that you have used in your task. Mount them in pairs side-by-side on a foam board, so that the class can compare your work with the pieces obtained at the store.
3. Examine a number of issues of fashion magazines for the purpose of collecting designs that reveal their fiber contents. Prepare a presentation on foam board for five designs, indicating by the side of each the fibers used and their benefits to the consumer.

CHAPTER 8

LEATHER

LEARNING OBJECTIVES

After reading this chapter, the student should be able to:

1. Assess the size of the leather industry and discuss its importance in terms of the apparel and accessories markets.

2. Trace the processing stages that turn hides and skins into materials suitable for consumer use.

3. Understand the language of leather used by the industry's professionals.

4. Learn how leather products should be cared for so that their usefulness will be maximized.

5. Discuss some of the programs and services afforded the industry by its trade associations.

INTRODUCTION

A cyclist roars into town on a Harley Davidson and an anxious job applicant patiently waits to be interviewed at a prestigious law firm; although from completely different worlds, each uses a common element to underscore his or her presence. What single ingredient could be used in these totally different situations by these totally different personalities? In a word, the answer is leather! The biker, resplendent in his thick leather garb, accentuated by heavy zippers and studs, makes the indelible "macho" impression, whereas the fledgling attorney, her apparel dis-

◄ **Figure 8-1** Biker-style jacket by Mirage, updated for weekend wear. (Courtesy of the Leather Apparel Association)

► **Figure 8-2** Silk-screened suede from Siena, transforming the ordinary material into a fashionable one. (Courtesy of the Leather Apparel Association)

creetly but prominently accessorized with the "right" Coach leather briefcase, exudes an air of confidence and sophistication. What other single fashion ingredient is capable of quickly establishing an image for its wearer?

Leather offers something for everyone. Men, women, and children from all walks of life seem to have an increasing fascination for the mystique of this raw material and the array of products fabricated from it. The motorcycle jacket has made the transition from the standard gear of the biking world to fashionable attire for the fashion conscious by coloring it bright orange or silver or acid washing it to make an even more exciting statement. Printed suedes for special occasion dressing, plaid leather suits, bomber jackets emblazoned with peace symbols, and ski wear that can be washed by either hand or machine are just some of the industry's creations that have extended the nature of and use for this material.

The days when leather was thought of as merely a serviceable material have long passed. Its functional qualities coupled with its many fashion orientations and uses make it an exceptional material for designers to use to reach many markets.

Figure 8-3 "Hair-on" cowhide boots excellently accessorize Western apparel. (Courtesy of the Leather Apparel Association)

Figure 8-4 Leather, with its characteristic breathability, adapts to both cool and warm climates. (Courtesy of the Leather Apparel Association)

THE SCOPE OF THE INDUSTRY

With significant technological advances that have enabled leather designers to silk screen colorful prints and create a variety of soft textures, the industry continues to expand. The Leather Apparel Association reported that the United States' retail sales of leather garments had quadrupled between 1985 and 1990, reaching an all-time high of $3 billion. From every indication, it believes the future is even more promising for the industry.

The three major world centers of cattle producers for leather are the United States, The Soviet Alliance of Nations, and Western Europe. Argentina, Brazil, and Mexico also figure prominently in cattle production.

In the United States alone, tanning and finishing is a multibillion dollar business that employs more than 200,000 workers in factories across the country with major centers concentrated in the Northeast, Midwest, Middle Atlantic states, and California. The shoe and leather goods industries, in America alone, number more than 200,000.

LEATHER CATEGORIES

Leather is the general term for all hides and skins with their original fibrous structure more or less intact. The hair may or may not have been removed from the hides (pelts of the larger animals) or skins (pelts from smaller animals).

There are numerous animal groups that are used in the production of leather for apparel and accessories. They and their specific uses are:

Cattle Steer, cow, and bull hides are used for shoe and slipper outsoles and heels, briefcases, gloves, garments, handbags, and wallets. Large calves or undersized cattle (collectively, the producers of kipskins or kips) are used to manufacture shoe uppers and linings, gloves, garments, and hats.

Sheep and lamb The wooled skins, hair skins, and shearlings, typical of this group, are used for shoes, gloves, garments, pants, handbags, and hats.

Goat and kid The skins in this classification are used for shoe and slipper uppers, fancy leather handbags, gloves, and garments.

Equine Horse, colt, and zebra produce leather that is primarily used for shoe uppers and soles, gloves, and garments.

Buffalo Both domesticated land and water buffalo hides are used for shoe soles and uppers, fancy leather goods and portfolios, and handbags.

Pig and hog This group includes the skins from the usual pig, hog, and boar, but also includes the peccary and carpincho variety of pigs, which are characterized by special markings. Collectively, this classification is used for gloves, fancy leather products, and shoe uppers.

Deer Fallow deer, reindeer, antelope, gazelle, elk, and caribou skins produce leather for shoe uppers, gloves, apparel, fancy leather accessories, and moccasins.

Kangaroo and wallaby Their usage is restricted to shoe uppers.

Exotic and fancies Frog, seal, shark, walrus, and turtles are the aquatics of the group; camel, elephant, ostrich, and pangolin are the land classification; and alligator, crocodile, lizard, and snake represent the reptiles. Each has distinctive characteristics and markings that make them appropriate for unusual apparel and accessories.

All of these hides and skins must be processed before they can be used in production.

PHYSICAL PROPERTIES OF LEATHER

As we learned in the previous chapter "Textiles," different fibers have different characteristics and properties that make many of them unique for specific purposes. The laboratories have engineered man-made fibers that give us an enormous range and variety of fibers. With leather, how-

ever, the material is natural and, except for certain finishing applications that are applied during its processing, the inherent properties in all of the hides and skins are virtually the same.

Not only does its beauty enhance any design, but its physical properties make the final products functional as well as fashionable.

TENSILE STRENGTH

Leather is extremely high in terms of tensile strength. By definition, it can withstand a significant amount of stress without tearing apart. With all of the stretching that the material must undergo in its initial processing and then later by the manufacturers of shoes, in particular, who must significantly stretch the leather over lasts, or forms on which construction takes place, excellent tensile strength is important.

TEAR STRENGTH

When compared with textiles, leather is far superior in terms of its ability to resist tearing. When fabrics are used, except for felt, it is necessary to turn the edge of the material and sew it so that it will not fray or tear. With leather, however, this is rarely necessary and, even in the cases necessary for punched holes or slits, stitching is not generally essential for additional tear resistance.

ELONGATION

Leather is very versatile in terms of elongation; it can be stretched to varying lengths without fear of breaking. The elongation property can be controlled, as the need arises, when tanning and fat-liquoring take place, as we discuss in the section on Processing Leather.

FLEXIBILITY

The flexibility of leather under a wide range of temperatures is considerable. When properly tanned or preserved, it will usually withstand the problems of brittleness and cracking due to cold and heat. It is also a perfect performer when wet.

ABSORPTION

Leather absorbs liquid water as well as moisture from the air and removes it from other materials with which it comes into contact. This is particularly important for shoes in which perspiration is absorbed from the lining materials and quickly spread throughout the leather uppers for greater foot comfort.

BREATHING AND INSULATING

If you have ever worn a plastic or man-made leather imitation you probably noticed that they can cause the feet to feel hot and uncomfortable. A

leather jacket, when worn in either cool or warm climates, adjusts to the outside temperatures. The secret is in its absorbency and insulating properties. It is significantly porous and adjusts to various climate conditions.

LASTING MOLDABILITY

When leather is forced over a form such as a shoe last, it conforms to it and retains that shape not only during the period of lasting but during all of the years it is worn.

All of these combinations have made leather a unique material that far outshines imitations.

PROCESSING LEATHER

The processing of the hides and skins into leather requires 20 individual stages before it may be used for apparel, accessories, and other products. All of these operations bear a certain relationship to each other, and it is the tanner who must exercise strict control of these stages so that problems will not occur.

RECEIVING AND STORAGE

The hides and skins generally arrive in a cured state that protects them from protein-destroying organisms. At the hide house, they are sorted for thickness then weighed into bundles. Each bundle is marked and identified in terms of size, weight, type of skin, and any other information that would be helpful for later processing. The hides or skins then travel through the tannery as a unit or batch.

SOAKING

As a result of the curing process, the hides and skins will have lost a lot of moisture. This must now be restored, so that the chemical processing that follows can fulfill its purpose.

The soaking is done in water to which chemical wetting agents and disinfectants are added. Proper soaking takes anywhere from eight to 20 hours, depending on the thickness of the hides, after which they are cleaner, softer, and easier to manipulate.

UNHAIRING

Through either mechanical or chemical means, the hides are now ready to have the hair, epidermis, and certain soluble proteins removed. In cases in which the removed hair is to be used for other commercial purposes, the hair-save process is used. This does not destroy the hair, as in the other techniques, but merely destroys the hair root, leaving the hair itself to be mechanically recovered. After the hair is removed, it is washed and dried and sold to textile manufacturers for use in making felt.

TRIMMING AND SIDING

A conveyor belt that has a circular blade now removes the heads, long shanks, and other areas. Leaving them in place would interfere with the tannery equipment, and because these perimeter areas do not make good leather, they serve no purpose.

FLESHING

The hides and skins are then mechanically fleshed to rid them of excess flesh, fat, and muscle on their undersides or flesh sides. The machine is composed of a number of rollers, the most important of which is a cylinder with many cutting blades. Each hide is stretched to full width during this process to prevent bunching up and, thus, allowing the flesh to be totally removed.

BATING

After the flesh and hair have been eliminated, the residual chemicals from the prior stages of processing must be removed. The bating process is a two-fold procedure. The first eliminates the lime and alkaline chemicals and the second adds the bate, which are enzymes similar to those found in the digestive systems of animals. After the chemical agents have finished their jobs, the hides are again washed to rid them of all of the substances that this process has loosened or dissolved.

PICKLING

Before the actual tannage, one last preparatory step called pickling remains. The hides are placed in an acid bath ready to receive the tanning materials used in chrome tanning, a procedure addressed in the next stage. Salt or brine is then added to the acid bath to attract and tie up the excess moisture that would otherwise cause the fibers to swell. This operation is a preserving technique, which allows the hides and skins to stay in this condition for long periods of time until they are needed.

TANNING

There are different ways in which hides and skins may be tanned or preserved. Any method chosen serves the same purpose, to convert the raw collagen fibers of the hides or skins into a stable product that is no longer susceptible to rotting.

It may be accomplished through the application of oak bark, oils or vegetable substances, or, for the majority of the cases, with the use of chromium sulfate referred to in the industry as chrome. Where the oak and vegetable tannage takes several weeks to accomplish, chrome tannage is completed in four to six hours!

Chrome produces the best quality leather suitable for garments and accessories and, because of the speed of the operation, certainly benefits the industries that need leather for their products.

WRINGING AND SORTING

At this point, the hides and skins undergo a wringing process that removes the excess moisture that has been picked up in some of the preceding stages of processing. After the moisture has been removed, the skins are sorted according to their thicknesses. The sorting is necessary because many will have to be split, as described in the next phase.

SPLITTING AND SHAVING

The hides and skins vary in degree and uniformity of their thickness. Because these variations could cause problems, any differences must be eliminated. A splitting machine receives the hides and skins and slices them, yielding a top or grain portion of uniform thickness and an underneath layer that is called a split. Sometimes, the splits in some hides are sufficiently thick to be used by themselves as leather. Because the top layers have been removed during this process, the remaining splits are void of any grain and are sometimes further processed for other uses. Suede, for example, may be a split that has been napped to raise the surface, making it a valuable leather for apparel and shoe uppers.

After the splitting has been accomplished, a shaving machine is used to produce a hide with overall, exact thickness specifications and to open the fiber structure to enhance further processing with chemicals.

RETANNING, COLORING, AND FAT-LIQUORING

The hides are again placed in drums to perform these operations. Although each serves a different purpose in industry, they follow one another for approximately four to six hours without interruption and are considered as a unit.

Retanning. Actually being a second tanning, retanning combines different tanning agents such as vegetable abstracts, syntans, and mineral compounds that give the leather many valuable properties.

Coloring. The demands for leather as a fashion material requires that it be produced in many different colors. Dyeing leather is an art unto itself and, unlike the natural and man-made fibers used in fabrics that are simply colored, leather dyers must contend with several other factors not usually considered for those substances.

Being products of nature, there are built-in variabilities among hides and skins such as differences in pigmentation and grain characteristics. Although shade variations often enhance the beauty of the leather, significant coloration differences may make them visibly unappealing. Another problem is the penetration of leather with dyes. One dye can rarely be used to reach the depths of the leather, requiring the combination of two or more that will work well together.

Aniline-type dyes, derived from petroleum, are used as coloring agents. They are dissolved in hot water and added to the rotating drum as the retanning step is being completed. The dyes combine with the hide fibers to form an insoluble compound that becomes part of the hide itself. The length of time the dyes are used in this process influences the resultant shade.

There are literally hundreds of dyes used today, with each offering specific benefits and properties such as resistance to fading, bleeding, and crocking (friction), and the capability to undergo dry cleaning and laundering.

The most commonly used dyes include:

Acid dyes Easily and quickly penetrate the leather and imparts a bright, lively array of colors.

Metalized dyes Produce subdued, pastel tints.

Direct dyes For surface use, deep shades are easily accomplished.

Basic dyes Used when surfaces are enhanced with brilliant shades.

Fat-Liquoring. To lubricate the leathers and increase their softness, this additional wet operation makes them more pliable and increases their strength. By using oils and related fatty substances from animal, vegetable, and mineral sources, collectively known as fat-liquors, the tanner can produce leathers that range from a firmness that is needed for shoe and boot construction to a suppleness found in today's fashion apparel.

SETTING OUT

Moisture must be removed again and is done so in this, the final stage of the wet operations. The hides are smoothed and stretched, which compresses and squeezes out the excess moisture.

DRYING

Different methods are used to dry the leather. As the simplest technique, hanging requires nothing more than draping the hides and skins over a horizontal shaft and letting them dry the same as you would do with garments on a clothesline. To quicken the process, the pieces are moved through a large oven by means of a conveyor belt. Temperature control is imperative and usually kept at 130°F to minimize shrinkage.

Toggling, another drying technique, requires the use of toggles or clips, which keep the hides and skins in a stretched position. They are attached to frames that are moved along and passed through drying ovens.

Most of today's leathers are dried by means of pasting. The hides and skins are actually pasted onto 6-by-11-foot surface plates that are attached to a continuously moving monorail system. After the plates are scrubbed and wiped dry, a spray gun spreads a paste solution over them

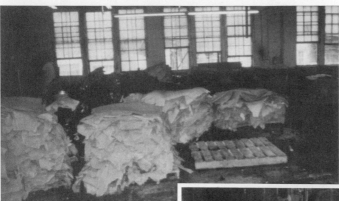

▲ **Figure 8-5** Leather that has been chrome tanned, known as "blues," ready to be processed. (Courtesy of Seidel Tanning)

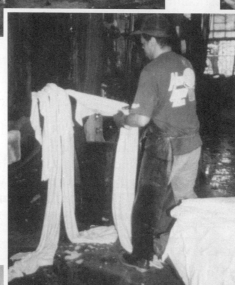

Figure 8-6 Excess moisture is removed from leather before splitting and shaving processes. (Courtesy of Seidel Tanning)

▲ **Figure 8-8** "Blues" are sorted and graded on the basis of grain quality. (Courtesy of Seidel Tanning)

▲ **Figure 8-7** After leather has been split, it is shaved for uniformity of thickness. (Courtesy of Seidel Tanning)

▶ **Figure 8-9** After skins are colored, they are smoothed and rid of excess moisture. (Courtesy of Seidel Tanning)

▲ **Figure 8-11** Toggling is another drying technique, which stretches and dries leather on a frame prior to finishing. (Courtesy of Seidel Tanning)

▲ **Figure 8-10** Some skins are dried by simply hanging them. (Courtesy of Seidel Tanning)

▶

Figure 8-12 For a textured appearance, some leathers are plated. (Courtesy of Seidel Tanning)

◀

Figure 8-13 Finished leather ready for garment and accessories production. (Courtesy of Seidel Tanning)

that provides sufficient adhesion for the largest of hides. After the drying phase, the hides are stripped or peeled from the frames.

Vacuum drying is the newest of the drying techniques. This system involves the smoothing of a wet hide onto a heated stainless-steel plate that is covered by a perforated steel plate that, in turn, is covered by cloth. A vacuum then extracts the moisture from the leather.

CONDITIONING

Sometimes, the leather that is available at this point is too hard for use in garments and shoes. A specific degree of softness or suppleness, usually referred to in the trade as temper, is needed. This treatment requires wetting back, which involves the spraying of a fine mist of water to the leather surfaces. Several pieces of leather are then layered on each other onto a table and fitted with a watertight cover. The leather is left to dry overnight to permit uniformity of moisture.

STAKING AND DRY MILLING

To make the leather even more pliable, it is then mechanically staked. Through an automated procedure, the leather is carried by a conveyor belt between a large number of oscillating, overlapping fingers. They pound, hundreds of times from above and below, as it passes through the machines, stretching the leather in all directions. The sophisticated machinery today is capable of staking up to 300 large hides per hour and more than 500 smaller skins in the same time. Any excess moisture is removed through additional drying.

A different type of softening is used when soft, lightweight leathers are being produced for supple garments. The dried leather is thrown into a large dry drum and tumbled anywhere from ½ to 8 hours until the desired softness and grain patterns are achieved.

BUFFING

Because of the natural blemishes inherent in the leather or the scratches that might have been produced along the way, the appearances of the hides and skins usually need improvement. Although some of these markings are indicators of the authenticity of the material as leather and not a synthetic, the imperfections need to be minimized. A buffing machine that uses a sand cylinder with an abrasive material smooths the leather. The sanding leaves a clean, smooth surface that is now ready to receive any other finishes. Because the buffing leaves some dust on the surface, it must be removed through either rotary brushes, jets of compressed air, or vacuuming.

FINISHING

To enhance the appearance of the leather and render it more serviceable, a number of finishes are used. Today's fashion leather apparel and acces-

sories indicate the use of many different procedures to give the final products their unique beauty and function. Color, initially applied during an earlier stage, may be made opaque at this point with the addition of certain pigments. Many sophisticated materials are available such as acrylate, vinyl polymers, nitrocellulose, and polyurethane that are used as coatings to render the articles resistant to abrasion and staining.

PLATING

At this stage, the decision is made as to whether the leather is to have a smooth appearance or one that is textured. Plating is the final step that influences these looks. The process is similar to high-pressure, hot ironing. The coating materials that have just been applied are now firmly affixed to the leather. Generally, the finishing and plating procedures span four or five days, alternating each finish with another plating and repeating the operations until all have been accomplished.

If a textured surface is desired, embossing presses capable of extremely high pressure are used. Embossing machines that are fitted with engraved plates can impregnate any desired pattern on the leather. In the case of splits, where there is no natural grain, this process significantly improves the appearance.

GRADING

The leather is now graded according to thickness and color uniformity and the extent of any defects on the surface. These final grading measurements will dictate the price and use of the leather.

MEASURING

Leather is sold to the apparel and accessories manufacturers on the basis of its area or size. Unlike fabric, it is irregularly shaped and requires measurement by a special machine. With the use of photoelectric cells and built-in computers, the square footage is assessed. The hides pass over a sensing device by a conveyor as a machine automatically calculates the footage. The measurements are then stamped on the flesh side of each piece.

Having gone through 20 operations for approximately four weeks, the leather is now ready to move on to the designers and manufacturers who will transform them into fashion products.

FASHION LEATHER TERMINOLOGY

With the advanced technology used in the processing and finishing of leather, today's fashion consumer is the beneficiary. Through advertisements, promotions, and eager sales personnel, they are alerted to a variety of new names and terms used by the industry. Some of those that are commonly heard in the purchasing market are listed for general review.

Nubuck A leather that is lightly buffed until it takes on a very fine nap that appears smoother than suede. Many of the silky suede skirts, pants, or blazers are made of nubuck.

Buffed cowhide This is similar to nubuck except that the finish is more matte than nap; it is used often for casual shoe uppers.

Napa The surface of a soft leather hide that has a shiny smooth or pebbly surface.

Suede A velvetlike surface that is made from buffing the underside of a hide.

Full grain leather When the top grain or surface is not manipulated to change the appearance; it is the best quality leather.

Split When new layers are created from slicing a thick hide.

Lamb leather One of the softest and most expensive types of leather.

Shrunken lamb A more pebbly grained leather that is achieved during the tanning process.

Distressed leather Uneven coloration and markings, achieved during tanning, to give leather a fashionable, weathered appearance.

Painted leather Opaque pigments or other materials that are applied to the leather's surface.

Analine leather When the natural characteristics of the leather are to be featured, transparent dyes are used in coloration.

LEATHER MANUFACTURING GUIDELINES

As with any other materials, natural or man-made, certain precautions must be taken when they are to be made into products. Leather is no exception. The very nature of the material and its relatively expensive cost to the consumer makes the maintenance of specific standards important and that appropriate materials are used in their production as garments and accessories.

The Leather Apparel Association has developed a set of guidelines for the industry so that they and the ultimate consumers can benefit from their use.

The guidelines cover a wide range of areas such as the fabricating materials used in production, for example, glues and inner components, trims, and ornamentation.

GLUES

Glues should either dissolve completely or not at all when immersed in cleaning solvents. In cases where total dissolve is important, rubber cement is suggested. When only partial dissolving is realized, unsightly markings might be permanently affixed. Testing the glue is necessary before any final decisions are to be made.

TANNER IDENTIFICATION MARKS

Ink used for logos or codes stenciled on the back of unfinished skins have been known to bleed, or run, during the cleaning process. It is better to

Figure 8-14b A printed finish makes this suede shirt by Saxony Sportswear a fashion favorite. (Courtesy of the Leather Apparel Association)

Figure 8-14a Metallic finish puts a fashionable spin on this garment by Collage. (Courtesy of the Leather Apparel Association)

Figure 8-14c Quilting adds another fashion dimension to this garment by La Nouvelle Renaissance. (Courtesy of the Leather Apparel Association)

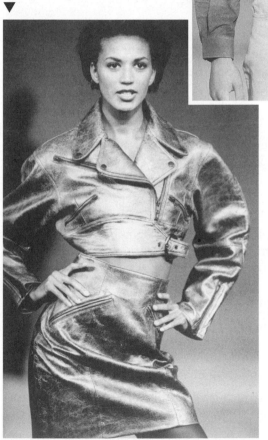

place these identification marks on scrap edges so that they can be removed during cleaning.

INNER COMPONENTS

Interfacings should not be secured with glues that might dissolve during cleaning because they tend to shift and distort the garment. Polyester or other fill that increases warmth should be securely tacked at intervals to prevent shifting and distortion.

LININGS

White or light pile linings should be made removable when used with dark leathers because some of the garment color might run during dry cleaning and discolor the linings.

BUTTONS

As some types of buttons melt when placed in solvents, they should be tested first before they are attached. Although replacing buttons seems to be a simple procedure, the disintegrated buttons will often adhere to the leather, ruining the garment.

ZIPPERS

Thin plastic zippers should be avoided because they may melt. Heavy plastic or metal is preferred.

COMBINING FABRICS

Many garments combine leather with other decorative fabrics. Some have different shrinking tendencies; these must be assessed to avoid damage from cleaning.

EMBOSSED DESIGNS

If thin, weak leather is embossed, the patterns can be altered during cleaning. Test cleaning is recommended to determine the ability of the embossed leather to withstand the solvents.

MULTICOLORED GARMENTS

If more than one color is used, the garment should be test cleaned to make certain that one color will not bleed into another.

CLEANING OUTFITS

Because one part of an outfit may require cleaning and the other not, it is important to test and make certain that the two will match after the cleaning process.

In the earlier chapters on designing and manufacturing, you recall that the various techniques and procedures used in the creation and production of the merchandise is described in general terms and applies to many different materials, including leather.

CARE OF LEATHER

1. Garments should be stored on broad hangers and free to breath in the air. Plastic coverings should be avoided to prevent the leather from drying out.
2. When caught in the rain, the leather should be left to dry naturally. Heat will cause damage.
3. Wrinkles will generally iron themselves out. If pressing is necessary, place a layer of heavy paper between the garment and the iron, which should be on a low setting without steam.
4. Hems may be best repaired at home with a small bit of rubber cement.
5. Hair sprays and perfumes should not touch the garments and neither pins nor badges be attached. All of these could cause irreparable damage.
6. Dirt may be wiped away with a soft, dry sponge or cloth. Napped surfaces may be brushed.
7. Make certain that if you use a conditioner, it is appropriate for your type of leather.
8. Professional, special dry cleaning is necessary to maintain the garment. The traditional dry cleaning techniques could cause damage.
9. Matched garments should be cleaned together because most treatments will change the color.
10. Water and stain repellent agents may be applied. They should be used immediately after purchase of the garment and after each cleaning.

TRADE ASSOCIATIONS

As in every other industry, there are associations that have been organized to help their members address the problems associated with their own businesses and to provide information that will make the industry more responsive to consumer needs. One of the oldest is Leather Industries of America, which was founded in 1917, and one of the newest is the Leather Apparel Association. A brief description of their respective goals and efforts will serve to describe their reasons to exist.

LEATHER INDUSTRIES OF AMERICA

"To foster, develop, and promote scientifically the art of tanning and the leather industry, and the mutual welfare and improvement of those

engaged therein, and to supervise, classify, and systematize the exportation, importation, and distribution of hides, skins, leather, tanning material, and their products," best describes the organization in its own words.

The areas with which it assists itsr members are numerous and include interfacing with the government to intercede in the problems associated with exports and trade restrictions; maintaining a research laboratory to provide technical and environmental information that affects its material; offering technical education through the presentation of seminars; supplying statistical services that address imports and exports, trends, offshore competition, and the nation's economy; and arranging shows and meetings such as The Accessory and Garment Leather Show in New York, the USA/LIA Pavillions at the Hong Kong International Trade Fair, and the Semaine du Cuir, the world's largest international leather fair.

LEATHER APPAREL ASSOCIATION

A not-for-profit organization, it was established in 1990 to "sponsor the industry's aggressive marketing campaign to increase the demand for leather garments, and associate products and services."

Unlike the LIA, it is specifically associated with manufacturers of leather outerwear, sportswear, evening wear, and active wear. it is not in business to represent the tanners.

It develops consumer and trade publicity programs, educational materials, and does extensive advertising and market research to help each company in its membership build a stronger, broader, more profitable business. Its membership network includes both large and small organizations.

REVIEW QUESTIONS

1. Which are the countries that dominate in cattle production for use in leather?
2. Define the term *leather*.
3. List the names of the animals in five of the major categories whose hides and skins are used for leather apparel and accessories.
4. What are three properties of leather that make it so serviceable as a fashion material?
5. Why must leather be tanned before it is commercially used?
6. In what way is chrome tannage favorable over the other methods?
7. Differentiate between *full grain leather* and *split leather*.
8. List three of the major dyes used in leather coloring along with the benefits of each.
9. Why are leathers buffed after they have been staked and dry milled?

10. What is nubuck?

11. Describe analine leather.

12. Explain why specific glues should be tested before they are used in leather construction.

13. Why should tanner identification marks be placed on scrap edges of the leather?

14. List five ways in which the consumer should care for his or her leather product.

15. How do the Leather Industries of America and the Leather Apparel Association differ?

EXERCISES

1. Secure as many different types of leather as possible and mount each on a board for display to the class. Along with each swatch, the uses of each should be indicated along with any technical information on dyeing and finishes.

 Scraps and swatches are available from many sources. You may write to a tanner (the names are available from the LIA in Washington, D.C.), visit retailers who specialize in leather furniture and offer a variety of swatches to consumers (much of it is the same as that used for apparel and accessories), or write to leather garment and shoe manufacturers (their names are easily found in classified directories of major cities).

 A five-minute talk should then be prepared to accompany the visual aids you have created.

2. Examine a variety of fashion magazines and remove five photographs of each of the following leather accessories:
 a. handbags
 b. gloves
 c. shoes
 d. wallets
 e. attaches and briefcases

 Accompanying each should be the type of leather used, the price, and any other descriptive benefits.

CHAPTER 9

FURS

LEARNING OBJECTIVES

After reading this chapter, the student should be able to:

1. Discuss the state of the industry and its major characteristics.

2. Explain the techniques used in fur farming and the role the industry plays in setting standards for the procedures.

3. Describe the various stages of fur processing and the techniques used to construct fur garments and accessories.

4. Prepare a list of the different types of furs and the characteristics that distinguish each group.

5. Write a report on how the fur industry has expanded from one that primarily produced garments for special occasions to one that addresses the product as everyday apparel.

INTRODUCTION

The arrival of elegantly dressed women at special galas often overshadow the events themselves. Although opening night of New York City's Metropolitan Opera season heralds the beginning of an artistic series, the stories and photographs that accompany the event sometimes seem more important than the reviews of the performance. Similarly, the purpose of the charitable gala is often foreshadowed by the photojournalists' reports on the attendees' costumes. Fashion attention on these happenings that

Figure 9-1 Plaid and tapestry mink coats designed by Oscar de la Renta. (Courtesy of the American Fur Industry. Rob Klein, Photographer)

take place during the fall and winter seasons usually focuses on the extravagant furs that are worn. Because the "papparazzi" are usually not allowed to enter the occasions' arenas and are therefore unable to capture the essence of what is being worn by the patrons, they station themselves on the outside and record the fur creations for all the world to admire. Although this generates excitement for the industry, it is not the only market being served.

Furs, today, are likely to be worn in everyday life. The woman hurrying to work may emerge from a taxicab or bus dressed in a mink coat. Shoppers, similarly, stroll the aisles of their favorite stores dressed in garments that were once reserved for more formal occasions. Young and old, the affluent and those with more limited disposable income, and people from all walks of life have embraced the fur garment as one that is not merely "showy" but also functional. With these new markets and a significant range of price points, the fur industry has branched out and successfully expanded its horizons.

The fur industry is made up of several segments, each of which performs a specific task before the garment reaches the sales floor. Each of these is explored as is the marketing of the product, the types of furs

Figure 9-2 Furs and fur-lined garments are worn for less formal occasions. (Courtesy of Silva-Cone for the American Fur Industry)

available for use in apparel and accessories, the various techniques used in transforming them into garments, and the rules that were enacted to set standards for the participants.

MAJOR SEGMENTS OF THE INDUSTRY

By the time the consumers have a selection of fur garments and accessories from which they may choose, each product has passed through a variety of professional hands. The experts who transform the "skins of the animal with the hair intact," the technical definition of fur, fit into three general classifications: the farmers and trappers, the processors, and the designers and manufacturers.

FARMERS AND TRAPPERS

More than three quarters of the fur produced in North America is raised on family farms, primarily based in Wisconsin, Minnesota, and Utah in the United States and Ontario and Quebec in Canada. Comprising more than 3,700 family farms, they sell approximately 6 million pelts annually at a $230 million price tag.

Standards for the industry were developed by the farmers themselves and are administered by the Fur Farm Animal Welfare Coalition in the United States and by the Mink Breeders Association in Canada. The

guidelines address such areas as farming methods, nutrition, veterinary care, and humane harvesting procedures. Coming under attack by a variety of humane organizations, the industry has recognized the need to develop sound farming principles that cause little, if any, discomfort to the animals. The young farmer of today generally has a college degree in agriculture, biology, or business and serves at least one year of apprenticeship on a well-established farm to learn the complete annual fur-production cycle.

Trappers are responsible for the procurement of furs from wildlife. They no longer trap endangered species, thanks to the careful control regulations at the national and international levels. Wildlife managers oversee the production, setting trapping seasons and applying quotas where necessary. Research is ongoing in the industry to make certain that the most humane methods of trapping are carried out. Aside from the skills being passed down from one generation to the next, today's participants learn the latest methods by taking pertinent, educational courses.

The experienced trapper knows precisely how to set the traps to make certain that only the "wanted" animals are snared.

The pelts, undressed skins with the hair intact, are most often sold at auction. Trappers generally sell their bounties to agents who resell them to the auction companies or, in some cases, wholesalers who keep inventories from which manufacturers may purchase. Farmers almost always sell their pelts at public auctions to wholesalers, manufacturers, or brokers. The auctions are held all over the world with the major centers located in New York City, Minneapolis, and St. Louis in the United States and London, St. Petersburg, (formerly known as Leningrad), and Montreal.

PROCESSORS

Before a pelt can be turned into a salable garment or accessory, it must undergo considerable processing. This includes "dressing," dyeing, bleaching, and glazing, all of which are fully discussed later in this chapter.

DESIGNERS AND MANUFACTURERS

After the furs have been transformed into viable skins, they are ready to become part of fashion. The fur designer was once a relatively unknown individual working in the back rooms of the manufacturer's headquarters. Most companies had their own designers who primarily approached fashion design using traditional styling and silhouettes. Today, the designer is no longer an unsung hero but the individual who is often responsible for apparel and accessories.

Through the licensing route, where designers are paid to create fur collections for fur manufacturers on a contract basis and allowing the companies to use their prestigious names, the industry has taken on aura of haute couture. Names such as Arnold Scaasi, Oscar de la Renta, Louis Dell'Olio for Anne Klein, and Donna Karan are found in fur salons all

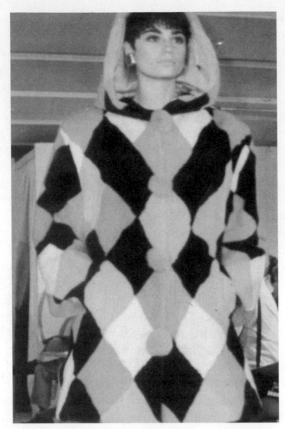

Figure 9-3 Arnold Scaasi's harlequin sheared mink for the Mohl Fur Company. (Courtesy of the American Fur Industry. Rob Klein, Photographer)

over the world. Of course, some unsung heroes still operate in anonymity and help deliver many of the styles to the marketplace.

After the design has been developed, the pelts are ready for production. The matching of the skins, cutting, and sewing numerous finishing touches are all accomplished at the manufacturer's workrooms. The specifics of these stages are explored in a later section of this chapter.

PROCESSING FUR

When the shipments arrive from the auctions, they are merely undressed pelts that must be transformed into pliable, attractive skins. The feel of the dressed pelt and the beauty it offers to the wearer is a result of considerable conditioning.

DRESSING THE PELTS

The pelt consists of the skin or leather and two types of hair, the guard hairs (longer hairs) and the fur fiber (the soft, downlike short hairs). The initial stage oversees the removal of any of the substances, including flesh, that still adhere to the skin. After this removal comes a soaking and

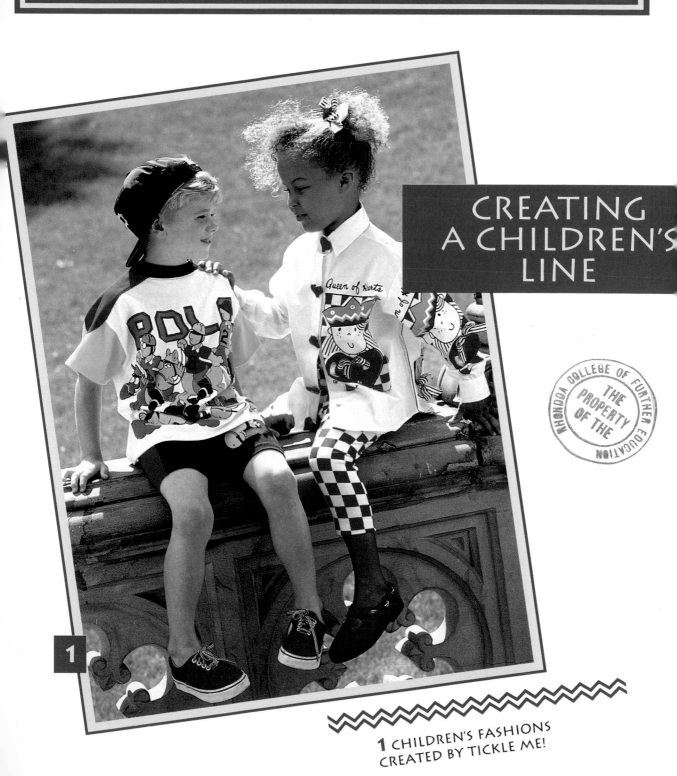

CREATING A CHILDREN'S LINE

1

1 CHILDREN'S FASHIONS CREATED BY TICKLE ME!

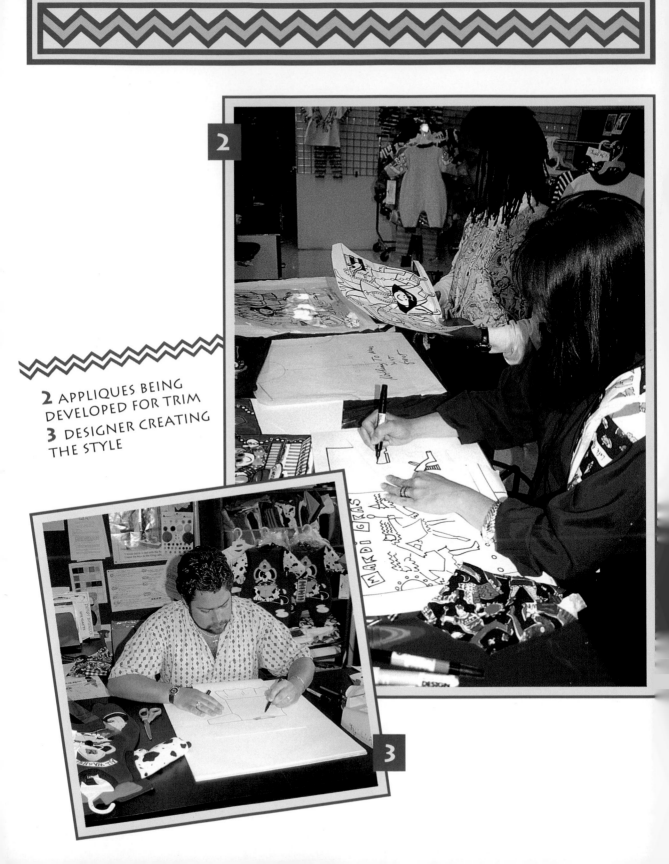

2 APPLIQUES BEING
DEVELOPED FOR TRIM
3 DESIGNER CREATING
THE STYLE

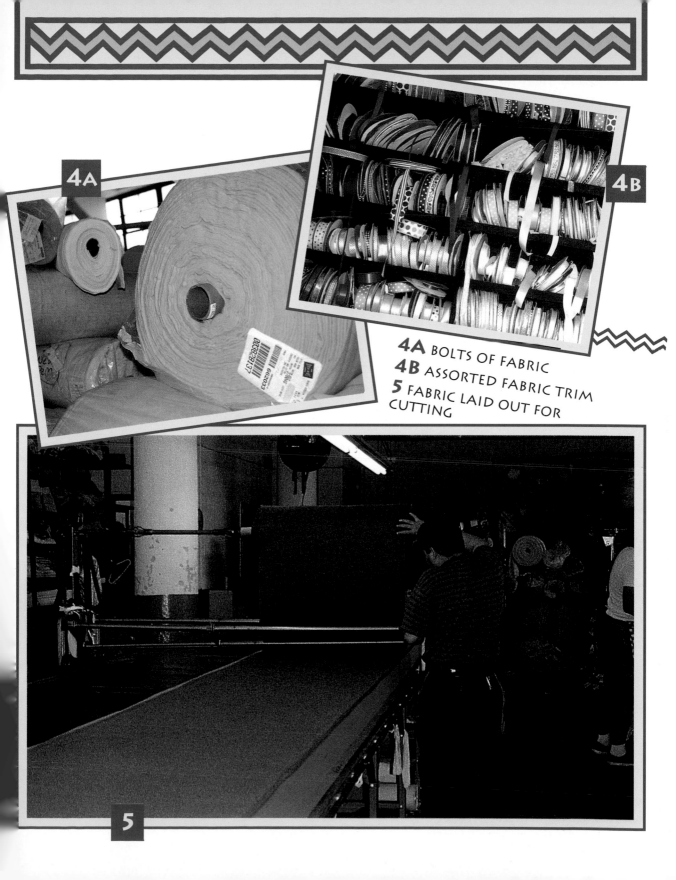

4A BOLTS OF FABRIC
4B ASSORTED FABRIC TRIM
5 FABRIC LAID OUT FOR CUTTING

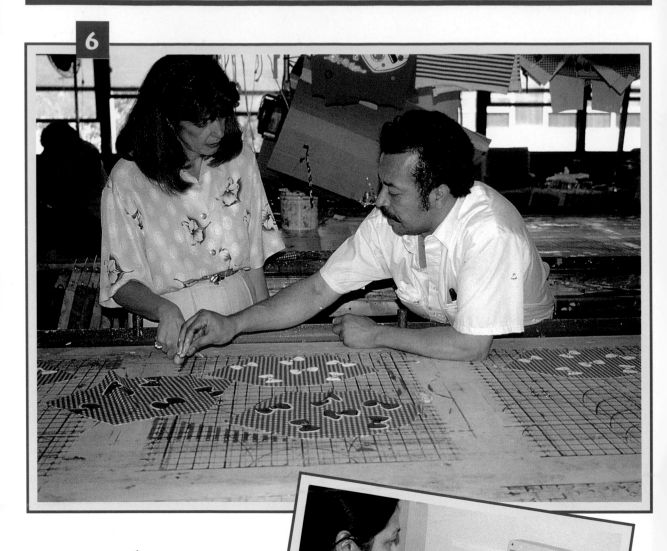

6 HEAD DESIGNER, FRAN COLEMAN, WORKING OUT PATTERN DETAILS ON GRAPH

7 PATTERN SHAPES CREATED BY COMPUTER (CAD)

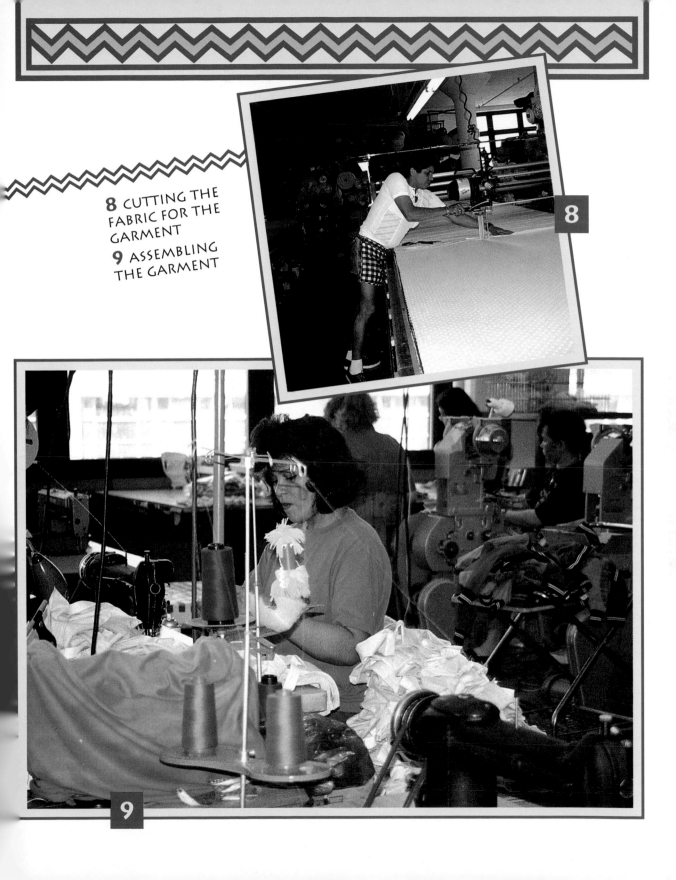

8 CUTTING THE
FABRIC FOR THE
GARMENT
9 ASSEMBLING
THE GARMENT

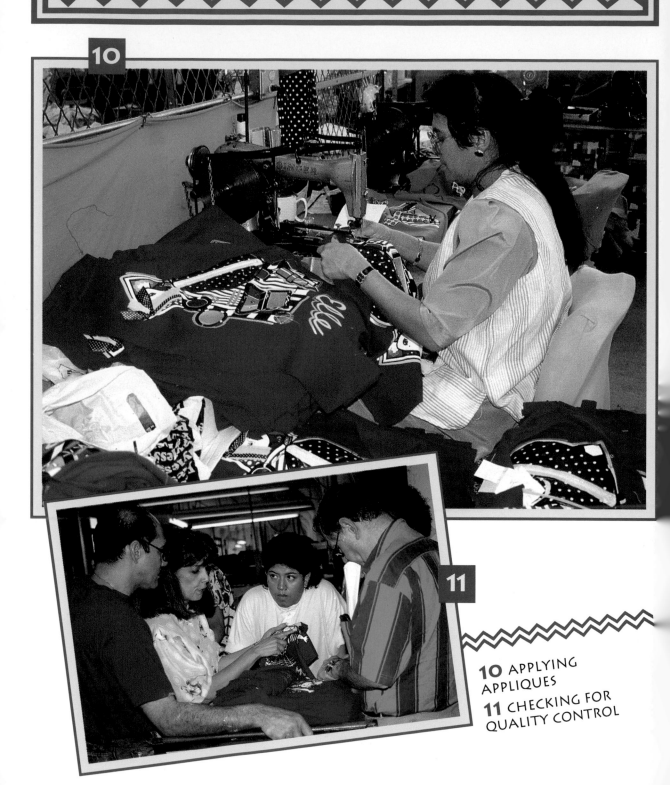

10 APPLYING APPLIQUES

11 CHECKING FOR QUALITY CONTROL

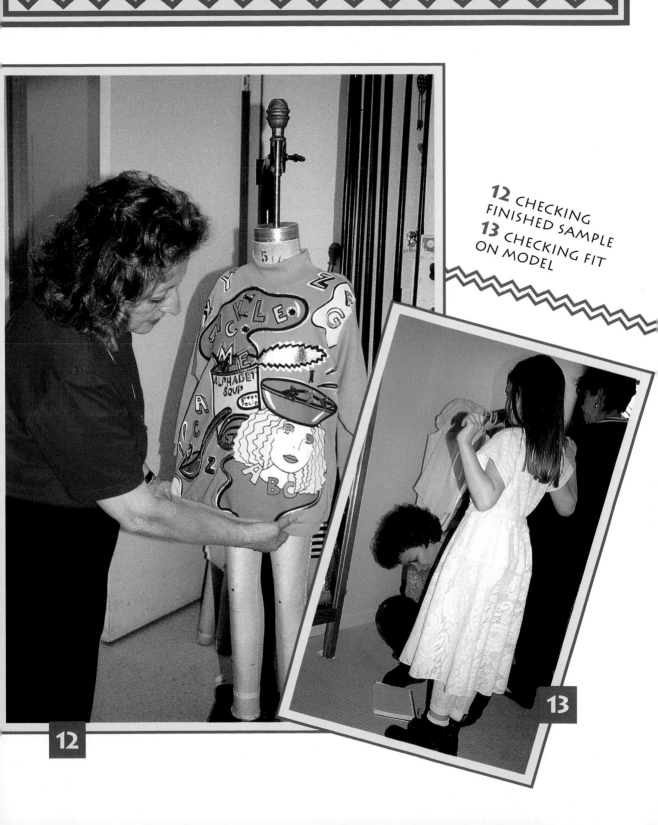

12 CHECKING FINISHED SAMPLE
13 CHECKING FIT ON MODEL

12

13

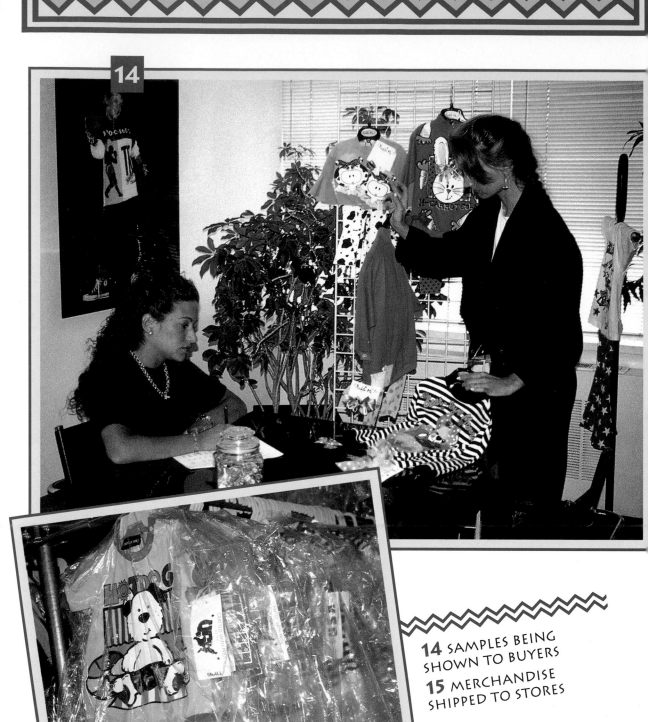

14 SAMPLES BEING SHOWN TO BUYERS

15 MERCHANDISE SHIPPED TO STORES

mechanical treatment known as tanning or aging, which is a process similar to that used in leather conditioning. The skins must now be rendered pliable and workable; the tanning process tends to remove some the natural oils, which are replaced through a process known as "kicking." This involves beating the furs against each other, which ultimately restores the lost oils. The excess lubrication necessitates removal, and this is accomplished by placing the furs in a sawdust-filled, rotating drum.

Depending on the desired final appearance of the fur, different processes may now be applied. Many fashion designers, for example, design garments that are to have velvety smooth appearances. In this case, the longer, protective guard hairs must be removed. This calls for either a shearing or plucking procedure; the choice depends on the specific pelt species. After this has been completed, the fur is again cleansed and readied for further refinement.

DYEING AND BLEACHING

Many pelts are moved on to the construction area for transformation into a garment. The natural coloration may be used without any changes. Minks, for example, are produced in a variety of natural colors that make magnificent fashion statements without the need for enhancement. Such skins are generally of the highest quality and their natural beauty fetches better prices.

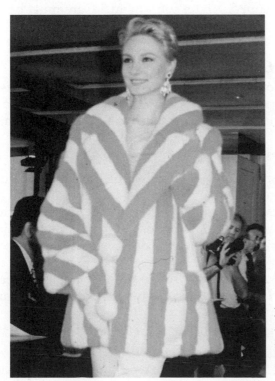

Figure 9-4 Striped mink jacket by Arnold Scaasi was achieved through means of dyeing and bleaching. (Courtesy of the American Fur Industry. Rob Klein, Photographer)

Lesser quality skins are often dull or color impaired. There might be variation in the "bundle" that requires dyeing for uniformity of color. The designer collections of today are often highlighted by colored fur garments and accessories. It is not because the skins are inferior and necessitate camouflage, but the innovative use of color adds another dimension to the line and invites owners of traditional furs to purchase something extra. Bold bands of color, harlequin designs, and plaids are just a few of the end results of dyeing.

Depending on the desired effect, different dyeing techniques are used. When total color enhancement is the goal, the entire bundle of skins may be immersed in the dye bath. Not only does this dip dyeing change the fur color, it also colors the leather. If the intention is to enhance the natural color of the pelt, tip dyeing, the brushing of dye only to the hairs, is used. When the need for a particular pattern arises, "stencil" dyeing is the approach.

The removal of color is sometimes necessary when furs are to be lightened or blemishes need removal. In cases where pale shades are the ultimate goals, bleaching might be required before the application of dye.

GLAZING

The final step in preparation for the manufacturing process is glazing. The fur is first sprayed with water or chemicals and then carefully pressed to add luster, evenness, and a soft "hand." Care must be exercised during this stage to avoid any damage to the skins.

CONSTRUCTING THE GARMENT

The skins are now ready for transformation into garments by a team of skilled craftspeople. Individuals usually specialize in specific aspects of this operation, applying his or her expertise to the "assembly-line" production.

MATCHING THE SKINS

To produce a garment that is visually satisfying, the bundle of skins must be carefully arranged on the pattern. The skilled worker aligns the pelts so that they "match" or complement each other, paying attention to hair length, texture, and color, if the skins are to be used in their natural state. Distinctive markings, as in the case of lynx, must lay in close harmony so that the overall pattern will be enhanced. The patterns they use during this stage are either standard and used to produce ready-to-wear garments or specially detailed to fit a specific customer's exact measurements.

CUTTING AND JOINING

After the skins have been satisfactorily arranged on the pattern, they must be cut and sewn. Depending on the type of fur, its quality, desired appear-

ance, and ultimate cost considerations, a number of different techniques may be used. Furs destined to become inexpensive garments are often machine cut, with hand cutting reserved for the more expensive products.

One of the following methods is then chosen to join the skins:

Skin-On-Skin Construction. Because most of the pelts are too small to be used without piecing them together, they must be sewn in some manner to produce a fur that is long enough to fill the pattern. In the production of inexpensive fur garments, the skin-on-skin method is the one that is most likely used. The operator places one skin below the next and joins them until the desired length is reached. Because many skins are short haired and concealment of the seams difficult, the end result is a telltale horizontal line around the garment.

Letting-Out Construction. To elongate the fur to the necessary length and, at the same time, eliminate the unwanted horizontal seam, the letting-out method is the choice. This is time-consuming, costly, and, therefore, only used in the construction of quality garments.

Furs such as mink and sable are let out. A skilled craftsperson first makes a vertical cut down the center of the pelt's dark stripe. The pelt is then cut on the diagonal into ⅛-inch strips. Each strip is then sewn above and below and repositioned into an elongated skin. The dark, center stripe is maintained and the skin is now sufficient in length without having to use horizontal seaming.

The let-out skins are then rematched and sewn together to fit the design.

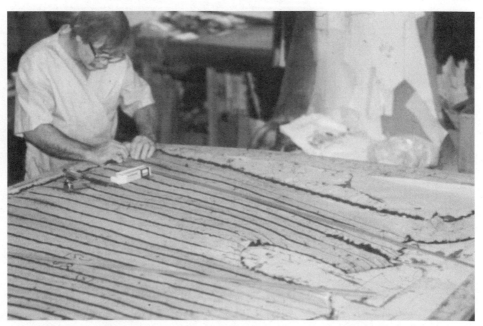

Figure 9-5 Fur technician elongating mink pelt through letting-out process.

Split-Skin Construction. Female mink skins are generally favored. They are usually silkier, lighter in weight, and narrower in appearance than their male counterparts. They are, also, more costly. To create a mink coat or jacket that gives the impression of the sleek, female skin, split-skin construction is often chosen. The operator slices the plump, male skin down the center and now has two fur pieces with which to work. Each piece is then let out and elongated for use in the garment. The construction is still costly; however, the ultimate price is lower because fewer male skins are needed for a coat and because they are less desirable, each coat costs less than one made from the female.

Whole-Skin Construction. When a small jacket or accessory is being produced, a full skin might be sufficient for production. In such cases, sewing or joining of the skins is unnecessary. The full skin is merely cut according to the pattern.

Leathering. When bulky fur pelts are used, it is sometimes desirable to insert strips of leather or other materials between the rows of skins to eliminate bulkiness. Each pelt is sewn to a strip, which in turn is sewn to another until the process is completed. The strips may be carefully concealed if the guard hairs are long and bushy, rendering the garment as a full fur. The procedure also reduces the number of pelts needed and, therefore, makes the garment less costly.

For additional styling, sometimes the leather strips are visibly displayed. In these cases, designers use a variety of materials in the leathering process.

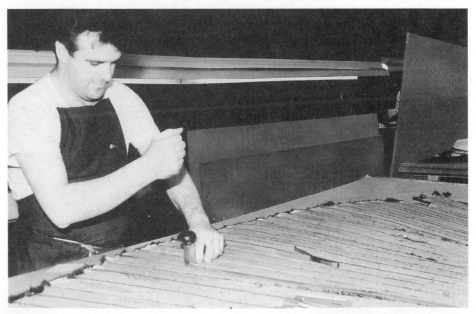

Figure 9-6 Technician hand staples the wetted-down pelts to fit the specific pattern. (Courtesy of the American Fur Industry)

Figure 9-7
Operator expertly closes the garment by joining its individual parts. (Courtesy of the American Fur Industry)

ASSEMBLING THE GARMENT

After the individual skins have been sewn, horizontally, as in the case of skin-on-skin construction, or extended and reset through letting out, the various pieces are assembled into either one large or several small sections. The strips or sections are then carefully sewn together by machine. Those pieces are wetted down and aligned on boards to facilitate hand shaping to fit the designer's pattern and then stapled. When the fur is dry, it will retain the curves and lines of the silhouette.

Closing the garment is the next step and this requires all of the parts to be sewn together by hand. This requires expert workmanship and calls for the most skilled people in fur manufacturing.

FINISHING THE GARMENT

The final stage entails sewing the lining to the fur and attaching one of several closing devices to the garment. Concealed hooks and eyes are used when an invisible closure is required. Snaps are not noticeable and might also be used when no break in the line of the product is desired. Many designers are using conspicuous zippers and buttons to add a fashionable dimension to the look. Zippers are usually used for sporty or casual jackets, and buttons for any length garment that is supposed to impart a less formal flare.

FURS AND THEIR FAMILIES

Not many years ago, before 1952, consumers were subjected to many invented fur names that added confusion to the selection process. These "fur names" were created by manufacturers to give credibility to less desirable furs, culminating in purchases that were not exactly what the customer thought they were. Names such as "sealine," to connote baby seal, and "mouton lamb" were bandied about throughout the industry.

On August 9, 1952, the federal government enacted the Fur Product's Labeling Act, later amended a few times to broaden its implications, which set guidelines by which fur manufacturers, wholesalers, and retailers had to abide. Advertisements, promotional materials, and garment labels had to use the proper English name of the animal used in the product, its country of origin, and any color-altering techniques that were used. Dyed muskrat soon replaced the then famous "Hudson-seal dyed muskrat." If the garment is composed of waste pieces of fur that have been assembled to give the appearance of full skins, that must also be noted.

This code has taken a great deal of the mystery out of consumer purchasing, but it still has not helped the untrained eye to discern the various subtleties of quality. These are discussed later in this chapter.

Furs are usually classified under their individual names such as mink, fox, and squirrel, each belonging to a specific family group. There are scores of furs to choose from, some more popular than others because of appearance, durability, and fashion acceptance at a particular time. The fashion designers and manufacturers strongly influence which furs are more fashionable at a given time and which furs are less desirable in terms of their fashion appropriateness. Some, such as mink, seem to be the traditional standard bearers and never lose favor throughout the years.

THE WEASEL FAMILY

The weasel family collectively represents the most expensive group of furs. These include: mink, the most popular of the group; sable; and ermine.

Mink. Every designer-fur fashion show, industry promotion, or retail salon usually features mink as the central point of the offering. The variety of natural coloration from wildlife and fur farming, its ability to be easily colored and manipulated into different appearances, and its availability at numerous price points makes it the perfect fur for many consumer markets.

It is extremely durable, with the best varieties originating in the northern part of the United States. It has long guard hairs and short, soft fur fibers. It provides considerable warmth, with the female species much lighter in weight than the male. Its characteristic central dark stripe adds to its natural beauty.

The industry's fashion houses and designers often ignore the typical dark-skinned Blackglama or natural, lighter colored lunaraines that have

Figure 9-8 Dennis Basso's mink swing coats. (Courtesy of the American Fur Industry)

crossbred for color variation and opt for hot pinks, royal blues, purples, and other fashion colors that rival those that embrace woolen outerware. To provide excitement, they sometimes pluck or shear the guard hairs to produce soft, luxurious garments that feature only the downlike fur fibers.

Sable. Rarity and costliness are the terms that often accompany the marketing of these garments. The best quality comes from the northernmost reaches of Russia and often sells for as much as $200,000 for the finest coat. Sable somewhat resembles mink, but its guard hairs are shorter, denser, and fluffier, giving an overall bushier appearance than does mink. It is considered by the professionals in the trade to be the world's most prestigious fur.

Ermine. Although it has not been considered a sought-after fashionable fur for many years, ermine stills offers its own mystique. Naturally brown in color, it acquires its pure white coloration when the animal is raised in the coldest parts of the United States or Siberia. The white is characteristically accentuated with dark black tails, which are used and featured in the garment designs. Always the fur that has been associated with royalty and their pomp and circumstance, ermine is visible in many of their formal or state processions.

Figure 9-9 Sheared mink trench coat by the Christie Brothers. (Courtesy of the American Fur Industry. Rob Klein, Photographer)

Miscellaneous Weasels. Other members of the weasel family often make fashion statements in fur collections. Furs such as fisher, baum marten and stone martin, wolverine, skunk kolinsky, fitch, and otter are found in a wide range of coats and jackets.

THE RODENT FAMILY

Running the gamut from the rare and costly chinchilla to the plentiful and inexpensive rabbit, the rodent family is a significant source of pelts. Many are used in their natural states, whereas others, because of their versatility in imitating other, more costly furs, are colored, sheared, and produced in a variety of "fun" creations.

Chinchilla. At the top of the scale, pricey chinchilla is naturally available in a variety of gray colorations. Other shades are reproduced on the ranches or farms as mutations. The fur is soft and fluffy and prone to wear poorly. It is one of the most perishable of all furs. Besides coats and jackets, chinchilla pieces are used as collars and other adornments on fashion apparel.

Rabbit. Rabbit is the antithesis of chinchilla in terms of cost. It is abundant and inexpensive. It comes from many parts of the world, with the French rabbit considered the best of the species. It can imitate many furs such as beaver, seal, ermine, mink, and sable, but its problem with shedding immediately reveals that it is not one of those furs. When it is newly processed, it has an appealing, fresh quality that it quickly loses after repeated wear.

Nutria. One of the most durable furs, nutria is used in its natural state with both the guard hairs and fur fibers intact or is sheared or plucked to reveal only the soft, downlike fur fibers. It defies most abuse and is considered one of the most serviceable and functional furs.

Muskrat. Readily available in most parts of the United States and Canada, the muskrat has always been used as an imitator of mink, sable, and seal. With its dark stripe color-enhanced, it may pass as mink when observed by the untrained eye. Sheared and dyed, it is reminiscent of beaver. It is relatively durable and is always part of a lower-to-moderate priced collection of furs.

Beaver. Beaver is usually plucked to remove the coarse guard hairs that protect the animal's body and then sheared to render a uniform layer of fur. Hence, the name "sheared" beaver is generally associated with this fur. It is extremely durable and is used in its natural coloring or exquisitely dyed or bleached to give it a fashion focus.

Squirrel. Inexpensive and plentiful, this soft fur comes in a variety of shades of gray, many with white or black markings. It is used in its natural state or dyed to imitate more costly species. Its one disadvantage is its lack of durability.

Marmot. Inexpensive, it is often dyed to imitate finer, long-haired brown furs. Its guard hairs are coarse and harsh and possess a dominant lustrous appearance. It is moderately durable and serves the consumer who wants to enjoy fur ownership but hasn't the resources for something better.

THE CANINE FAMILY

This group is primarily represented by fox, which comes in a variety of natural shades that have been captured in the wild or raised on farms and produced as distinctly colored mutations.

Characteristically, fox has long, luxurious guard hairs and lush fur fibers. It is showy and provides a great deal of glamour for special occasions. Its exaggerated fullness tends to make it bulky, and many coats are constructed with leather inserts between the skins to eliminate some of the bulkiness. In some cases, the "leathering" is concealed; in others, it is emphasized to add an extra dimension to the garment's design. Fox tends to be perishable and, therefore, not practical for daily wear.

Red Fox. Noted by their orange-reddish appearance, this variety is wild and possesses long, thick guard hairs. It is infrequently used in coats, but does serve a market for jackets and as trim on cloth coats and suits.

White Fox. The whitest of the species comes from the northernmost reaches of the United States and Canada. It is extremely striking and is basically used for dramatic evening wear.

Blue Fox. The label indicates blue fox; however, the fur in the garment is decidedly brown with a bluish cast or tinge. This is often misleading to the inexperienced consumer who is looking for a shade of blue. It is the Norwegian blue fox, developed as a mutation in fur farming, that is actually blue.

Silver Fox. Dominated by silvery guard hairs and underscored with blue-black fur fibers, silver fox is generally raised on ranches. A mutation of the species is platinum fox, which has a more silvery surface than the typical silver variety.

Gray Fox. The least desirable of the breed, gray fox is inexpensive and generally dyed to give the impression of silver fox.

Miscellaneous Canines. Different in appearance from fox, but, none the less, members of the same family, coyote and wolf are used for sporty or casual wear. They both have coarse guard hairs, are relatively durable, and are distinctively colored in browns and tans, speckled with white or black markings.

THE CAT FAMILY

The natural, distinctive patterns and shadings of these furs distinguish them from any other family. Although many are favorites of the fur designers and wearers, some are no longer used in garment production because they are endangered species. The leopard, for example, is presently unavailable for use because of its endangered status.

Lynx. A costly fur, lynx is light-colored, long-haired, and fluffy. Its dark, distinctive markings on a whitish surface make these garments extremely striking. Lynx is best for jackets or three-quarter-length coats; the full-length style is simply too bulky for most wearers. The fur is used extensively as trim for high-fashion apparel. Cat lynx, a cousin to the lynx, is slightly less expensive and is also used for short coats and trim.

Leopard. Although it is presently unavailable for use, its discussion is still appropriate because it is conceivable that the restriction might, one day, be lifted. The best quality comes from Africa, where the creamy, yellow-colored backgrounds are accentuated with black markings. The fur has moderately stiff guard hairs that lay flat. The ocelot is similar in characteristics, but it is not as costly or striking as fine leopard.

Figure 9-10 Russian sable coat by André & Lisa Bisang. (Courtesy of the American Fur Industry)

▲ Figure 9-12 Cat lynx short coat by Louis Dell'Olio for Anne Klein. (Courtesy of the American Fur Industry)

Figure 9-11 Chinchilla pea coat by Arnold Scaasi. (Courtesy of the American Fur Industry)

◀ **Figure 9-13** Broadtail suit by Galanos.
(Courtesy of the American Fur Industry)

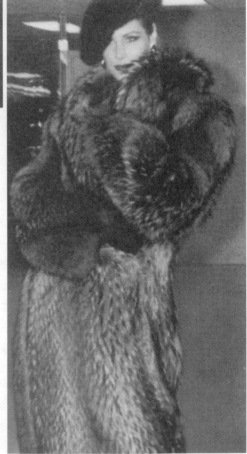

▶

Figure 9-14 Mary
McFadden's raccoon coat.
(Courtesy of the American
Fur Industry)

THE UNGULATE FAMILY

Animals that are hoofed and feature tightly curled fur pelts are classified as ungulates.

Persian Lamb. The best known of the group, they are farm-raised animals who primarily come from African and central Asian regions. The skins are almost always black and curly, but some are naturally colored grays and browns. The prized species are the newborn, which are called broadtail and are characterized by flat, water-marked patterning. Both varieties are lustrous, with broadtail costing more. When the bundles of skins are laid out for garment construction, it is the expert craftsperson who carefully arranges each pelt next to the other to make certain that all markings are arranged in a complementary set to enhance the ultimate, overall pattern.

The fur is extremely durable and serviceable for everyday wear. Pieces that fall away during product construction are often used as decorative trim on cloth coats and suits. Larger pieces are sometimes assembled and made into "fur plates," used in making inexpensive attire.

South American Lamb. This fur, which is inexpensive and durable and provides the wearer with considerable warmth, comes from South America. It is the one that is used to produce mouton-processed lamb and broadtail-processed lamb. The former is achieved through shearing the fur and electrifying the remainder to relax the pattern. It is then dyed. The latter is sheared, leaving a marked undercoat that resembles broadtail. Both are relatively inexpensive furs.

Lesser Known Species. Caracul lamb has short, wavy, flat fur that primarily comes in white, but is also available in black or brown; kidskin is inexpensive and perishable; pony skin is a heavier version of kidskin. They are all used in less expensive garments and as trim.

MISCELLANEOUS FURS

In addition to the specific groups of animals, categorized as families, others do not fit any general classifications.

The raccoon has remained a popular fur for many years. It was once the darling of the college football game spectators who warmed themselves in the abundantly thick, fur coats. Eventually adapted for regular street wear, the raccoon coat has transcended many periods in fashion. They range in color from shades of browns and grays and are sometimes color enhanced to make them more attractive. They are versatile and can be plucked and sheared to resemble more expensive furs such as nutria. Tanuki is a finer, lighter colored raccoon that is costlier than the others.

Fur seal comes from Alaska, South Africa, Siberia, and Japan, with Alaskan seal considered the best quality. The skins are dyed numerous colors that range from the lightest tints to the darkest shades. They are durable and give the wearer a great deal of practicality.

MARKETING FUR GARMENTS

Although most fashion products are similarly marketed to the consuming public, the fur industry uses some approaches that are almost exclusively its own. These actions are necessitated by such factors as the significant cost of some of the merchandise, the size of the farms that raise the animals, and the protestation of the animal rights activists.

Some of the following marketing strategies are used by the fur industry:

LICENSING

As initially discussed, renowned apparel designers have entered the fur industry through licensing agreements with fur manufacturers. Their names, when conspicuously placed on fur labels and in advertisements, often generate additional interest in the merchandise. Rather than assessing the value of a costly fur that is produced by an unknown designer in terms of style and quality, the recognizable signature gives the garment fashion credibility. Close inspection of the collections carried by fur retailers reveals an increasing number of the designer-licensed furs.

CONSIGNMENT SELLING

When a buyer goes to the market for ready-to-wear, accessories, and most other fashion merchandise, he or she is ready to expend budgeted dollars for the goods. In the case of furs, however, this is not always the

Figure 9-15 Velour mink short coat designed by Oscar de la Renta under licensing agreement for Wagner Fur. (Courtesy of the American Fur Industry. Rob Klein, Photographer)

rule. Because of the costs of the items, with individual pieces costing as much as $100,000 in some cases, the amount needed to stock an inventory is often prohibitive. Most fur manufacturers approach the problem by offering their inventories on the basis of consignment. That is, the retailer signs an agreement that provides inventory that need not be paid for until, and if, it is sold. In that way, the producer gets customer exposure and the retail merchant has a sufficient number of garments from which customers may choose. The consignment route may be used as a means of developing a basic inventory over a full season or for short periods of time when retailer promotions take place. If you ever read about a store's three-day fur sales event, for example, that promises a large selection of garments at lower-than-usual prices, you can be certain that the regular selection has been expanded via the consignment route for that brief period of time. The pieces that are sold are paid for, the remainder is returned to the vendor.

THE SALES ARENAS

Selling to the consumer is accomplished at many different types of "sales floors." They include the typical fur specialty stores that feature off-the-rack as well as custom-made garments; manufacturer's salons that, in addition to serving as production points for wholesale purchasers, deal with private clientele who want the feeling of dealing with the design source; department stores that have separate departments that are usually leased and operated by independent producers who have entered into formal arrangements with the stores; and fur "expositions" or "fairs" that move from arena to arena for a few days each.

The exposition or fair has become a successful marketing tool for the industry. Typically, a promoter or major fur specialty retailer arranges with several vendors to supply large inventories, on consignment, for a few days use. Sports arenas, convention centers, and other large facilities are stocked with items that have been advertised at less than the traditional prices. Unusually large crowds are drawn to these events because of the magnitude of the cooperative effort. The events usually take place at the end of the season, enabling both the suppliers to rid themselves of unwanted inventories and the retailers to make a quick profit.

OVERCOMING ADVERSE PUBLICITY

No other segment of the fashion industry has ever had to deal with the problems generated by the animal rights activists. So vocal and effective have their campaigns been that some major retailers such as Harrods in London have closed the fur salons in their stores. To counteract the negative atmosphere that these groups have established and to bring sales levels to the position they once enjoyed, the fur industry participates in a variety of marketing strategies. These include advertising campaigns that

underscore the humane treatment of animals on fur farms; the preparation and distribution of numerous pamphlets, which attempt to make the fur fancier more knowledgeable and to dispel the myths that their opponents disseminate; appearance by industry representatives on national talk shows to do battle with their adversaries; and legal battling to control customer harassment at entrances to stores that sell furs.

CARE OF FURS

The nature of the fur garment requires specific care and attention to be paid so that it can afford its customers long-lasting wear. Some simple rules follow that will help the fur retain its original beauty and serviceability.

1. Warm, dry places for daily storage should be avoided so that the leather portion of the fur will not dry and crack. Hang in a cool closet, on a fur hanger that is sufficiently large and durable for shape retention, and the garment will retain its freshness.

2. If the fur is wet, it should be left outside of the closet to dry and never left near a heater. The extreme warmth could crack the leather.

3. Sitting on most furs could cause unsightly matting and damage. Whenever possible, during long seated periods, the fur garment should be opened and loosely draped over the wearer.

4. During the summer months, furs should be placed in cold storage to avoid the damages brought about by high temperatures.

5. Furs should be cleaned and glazed once a year both to remove the excess oils that have built up and to restore the luster.

6. Damages should be repaired as soon as they occur to prevent possible major problems that could shorten the life of the garment.

REVIEW QUESTIONS

1. What are the two methods by which furs are secured for use in garment construction?

2. How do fur trappers learn their skills and, thus, prevent any unnecessary cruelty to the animals?

3. Describe the method used by most fur farmers to sell their wares to the industry.

4. In what way has the fur manufacturer attracted the renowned apparel designers to play a role in the fur industry?

5. Why must the pelts be "dressed" before they are made into garments?

6. How are furs dyed?

7. Explain the process of glazing and the advantages it affords the fur.

8. Which methods of construction are used to join the skins?

9. Describe the method of letting out and the advantages derived from its use.

10. What are the reasons for using the leathering process in the construction of some fur garments?

11. Name the piece of legislation that was enacted to protect the consumer from unscrupulous practices.

12. What rules were prescribed by this law?

13. List the three costliest furs in the weasel family.

14. Discuss two advantages and disadvantages of rabbit fur.

15. What is the difference between blue fox and Norwegian blue fox?

16. Are broadtail lamb and broadtail-processed lamb the same?

17. Why is consignment selling an approach used in the marketing of furs?

18. Discuss the use of exposition or fair selling in furs.

19. How is the fur industry counteracting the negativism of the animal rights activists?

20. List some of the things to do for the proper care of furs.

EXERCISES

1. Using photographs of fur garments that have appeared in fashion periodicals such as *Elle, Harper's Bazaar,* and *Vogue,* prepare a visual presentation that covers the industry at this time. Furs that fit into the specific families should be grouped together, each occupying a separate foam or construction board for viewing by the class.

 In addition to the artwork, each piece should be accompanied by details that include whether or not the fur has been colored, obvious processing, and anything pertinent to its design. Each group should also feature a composite chart that lists its overall characteristics, price points, advantages, and disadvantages.

2. Make arrangements to visit a fur manufacturer or retailer to take slides of the company's collection. Each picture should be set into a "carousel," according to family groups, and presented to the class along with a narrative that addresses the characteristics of the items.

 The company should be alerted to the fact that this is for educational purposes and that it is for the enlightenment of students.

3. Visit a fur manufacturer, designer, or retail merchant to collect scraps of fur that may be used for a visual presentation. The pieces should be mounted on a board and accompanied by information that is important to the use of the various fur types.

CHAPTER 10
METALS AND STONES

LEARNING OBJECTIVES

After reading this chapter, the student should be able to:

1. Discuss the different types of precious metals used in fashion accessories.

2. Explain how base metals are used in combinations with the precious types.

3. Describe the process of alloying.

4. Describe the characteristics that are unique to the different types of natural stones.

5. Understand the different technical terminology used in the markets of metals and stones.

6. Differentiate among the various "cuts" used for stones.

INTRODUCTION

Whether it is The Tower of London's display of Britain's crown jewels, Istanbul's Topkapi Palace laden with such jeweled treasures as the 86-carat Spoonmaker's Diamond, the lavish Egyptian gold and silver pieces at New York City's Museum of Natural History that date back over 4000 years, or the common costume jewels of imitation stones and ordinary metallics that abound in every flea market, the richness of the real and the imitation are found in virtually every fashion consumer's wardrobe.

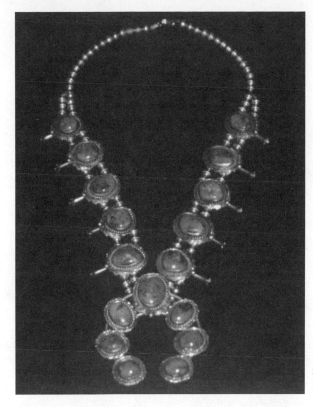

Figure 10-1 Squash blossom necklace combines turquoise and sterling silver.

Although the diamond has symbolized a betrothment for as long as anyone can remember and turquoise encased in the "squash blossoms" have hung from the necks of American Indian's tribal chieftains, metals and stones need neither be rare nor precious to make a fashion statement. Barbara Bush, United States first lady from 1988 to 1992, made fashion headlines with her preference for imitation pearls. Her embrace of the modestly priced, man-made imitation gave the industry a product that had fashion credibility and was within every consumer's reach.

The full complement of metals and stones are used in fashion apparel and accessories. The precious group, those having intrinsic or real value, are primarily for jewelry. The others are used for costume jewelry and for accessories such as belts, handbags, and other items. In the apparel market, stones and metallics are found on dresses, sportswear, sweaters, and suits. Collectively, these materials constitute a range from the rarest to the ordinary and from the priciest to the dollar variety. Designers creating for every price point regularly craft the whole spectrum of metals and stones. Although the master jewelers to the world such as Harry Winston, Cartier, and Tiffany design masterpieces for a selected few, others continue to toil with every conceivable raw material so that even those with limited funds can make lasting fashion impressions.

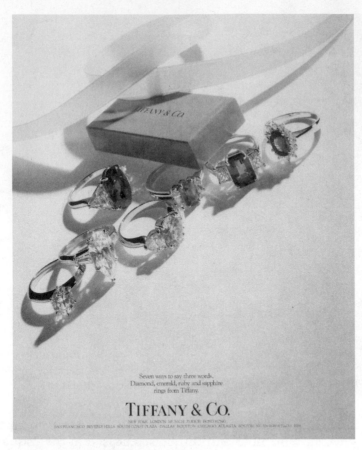

Figure 10-2
Advertisement featuring diamond, emerald, ruby, and sapphire stones. (Courtesy of Tiffany & Co.)

This chapter concentrates on metals and stones as materials of fashion, their characteristics, and how they are processed. Chapter 15 "Jewelry and Watches" deals with the various accessories that use these materials.

METALS

Characteristically, all metals have shiny surfaces that can either be enhanced to give them a brighter look or treated to alter or dull their appearance. They are malleable, enabling them to be twisted, bent, or pounded into a variety of shapes, and can be elongated into wirelike threads that may be used to weave designs. After they have been extracted from the ground, and separated from the natural ore, they may be used by themselves or combined with other metals. In the case of jewelry for adornment purposes, the metals are most often alloyed or plated with other metals.

An alloy is a combination of two or more metals. By using this technique, several advantages are achieved. Color variations are often the result of an alloy. For example, when a small bit of silver is combined with steel, the result is a silvery appearance. This not only increases the beau-

ty, but adds value to the new metal. Some metals in their pure form are too soft to use for most purposes. Gold, for example, is extremely soft and is usually alloyed with a base metal such as copper to add strength.

"Plating" is the process in which one metal is coated with another. By applying the more appealing metal on the surface and the lesser one inside, the final product takes on a better appearance. This may be accomplished either through dipping one metal into another one that has been heated, bonding the layers of metals together, or through a technique called "electroplating." This is a relatively inexpensive process; the metal used to plate another is dissolved and, through an electrical current, is attracted to the other. Often, a precious metal such as gold or silver is plated over a base such as copper, which produces an attractive metal at low cost.

Considerations such as cost, appearance, availability, durability, workability, and color dictate the methodology that will be used to transform the raw material into one that is useful for accessories and apparel.

PRECIOUS METALS

Metals that are costly and relatively rare are known as precious metals. In the case of accessory use, precious metals are generally reserved for jewelry and watches. They are simply too costly to be used as garment adornments.

The most expensive of this group is platinum, followed by gold, and then silver. Their prices fluctuate every day, contributing to an increase or decrease in the prices charged for the finished products. Gold, for example, was a controlled "metal" for many years and sold at $35 per ounce. When the restriction was eliminated, the cost of gold skyrocketed on the open market and sold for as much as $850 an ounce. As of this writing, the price has steadily hovered around the $350 mark. Platinum costs even more, and silver costs considerably less. Silver, at this time, sells for about a couple of dollars an ounce, making it the precious metal that can be most easily marketed.

Platinum Because of its extreme cost, it is used almost exclusively as settings for fine quality diamonds. Most diamond ring settings, however, that have the appearance of platinum are actually white gold, a less costly metal. Platinum is a soft metal and it must be alloyed to give it strength. The finest platinum products are usually 90 percent platinum and 10 percent iridium, a metal with considerable strength. Unlike silver, which tarnishes, platinum does not.

Gold In its natural state, gold is a bright yellow metal that is extremely soft. Thus, it must be mixed with other metals to be usable for commercial purposes.

For jewelry, the metal is either karat gold, gold-filled, rolled-gold plate, or electroplated.

Items that are labeled as karat gold cost the most. The designation refers to a certain part pure gold and the rest comprising other metals such as copper and nickel. For example, 14 karat, or 14 K as it is labeled, is 14 parts gold and 10 parts of another metal. The total weight must add to 24, gold in its purest form. In most European countries, the predominant gold alloy is 18 K. To be considered karat gold, there must be a minimum of 10 K in the alloy.

In addition to giving it added strength, the gold color may also be altered through alloying. The base metal used will change the color.

Gold-filled items are composed of thin sheets of gold that have been rolled and adhered to a base metal. The karat gold is melted and rolled and pressed onto the base. If the term gold-filled is used, the amount of gold in the product must be a minimum of $\frac{1}{20}$ of the total weight of the item.

Rolled-gold plate is similar to gold-filled, except that its gold content is less. The amount of gold used must be at least $\frac{1}{40}$ of the total metal's weight.

When an inexpensive piece of jewelry or trim requires the shiny look of gold, electroplating is the answer. It uses the thinnest gold surface, which ultimately might wear away from its base metal. The method used is the same as the one described earlier in this chapter.

Silver Its relative low cost and shiny white surface make it an extremely valuable precious metal for use in jewelry. As with the other precious metals, silver is too soft to use alone. It is alloyed with copper for more expensive jewelry pieces that bear the name "sterling silver" or, for less costly designs, it is electroplated.

Sterling silver is an alloy of pure silver and copper. The silver provides the luster, the copper the strength. To be classified as such, the alloy must contain 925 parts silver and 75 parts copper.

As in the case of gold, less costly silver jewelry is achieved through electroplating. To maintain the silvery look for many years, the base metal must be heavily coated.

Figure 10-3 This stylized heart was achieved by means of the annealing process.

Figure 10-4 A pin that was made by drawing wires and welding posts.

BASE METALS

Available in very large quantities at comparatively low prices, certain metals are used as alloys with the precious varieties. Because they are either malleable, easily transformed into various shapes, or have considerable strength, they are extremely valuable in jewelry production.

Copper One of the most important of the base metals for jewelry. It is alloyed with gold to produce karat gold and silver for sterling silver in precious jewelry. For less expensive ornamentation, in addition to mass-produced jewelry such as buttons, copper is alloyed with zinc to produce brass and tin to form bronze.

Chromium A lustrous, bluish-colored metal. Its durability and tarnish-resistant nature make it ideal for inexpensive, shiny jewelry when plated on brass, copper, or steel.

Iron The main ingredient in the use of steel. Its extreme strength and durability make it a perfect base metal for stainless steel watch casings.

Nickel A silvery metal that is used to add hardness and whiteness when alloyed with other metals. When white karat gold is needed, nickel's natural color and distinct durability produce the perfect alloy.

Tin A very soft, lustrous, silvery metal. It is easily shaped and, therefore, excellent for jewelry and other ornamentation that requires twisting. It is the main ingredient in pewter, a grayish metallic alloy that is sometimes used in the production of fashion jewelry.

METAL PRODUCTION TERMINOLOGY

In the transformation of metals into viable materials for use in jewelry or embellishments on fashion apparel and accessories, a variety of techniques are used. They include:

Annealing The process of heating metals to make them more workable.

Rolling Pressing metals into sheets so that they can be cut or bent to the required shape.

Drawing A technique that produces metal wires that can be woven into designs. The metals are forced through a series of holes, each narrower than the previous, until the desired thickness is achieved.

Forging The heating and hammering of metal into shapes.

Welding When two or more metals are to be joined together by heat and pressure.

Embossing A process that implants a design on metal through the use of pressure.

Casting Metals are melted for this process and then poured into a mold.

Engraving Scratching a design into metal by hand or machine.

Florentining Engraving the surface with a series of fine scratch marks.

Chasing Tapping a design into a metal surface.

Etching Through the use of acid applications, certain portions of the metal are eaten away to achieve the desired effect.

Antiquing The application of chemicals to darken the metal to give it an old or antique appearance.

Figure 10-5 The design of this Gothic maple-leaf pin was achieved by means of embossing.

Figure 10-6 Machine-engraved bracelets.

STONES

We all know that the fabulously emblazoned, stone-encrusted evening gowns and sweaters are not really diamonds, emeralds, and rubies, but imitations that are made to resemble the real thing. When, however, a sparkling engagement ring is being shown, it is difficult to tell if the stones are diamonds or something else that bear exceptional similarities. In the case of the diamond, another natural stone, the zircon, may be used as the imitator. The eye is often fooled by a chemically produced stone such as strontium titanite, which is marketed under the trade name Fabulite. Fabulous fakes are not restricted to diamonds. They are produced to imitate emeralds, rubies, sapphires, and every other stone. Although the real and the imitators offer similar visual impressions, the prices for the two groups are at extreme ends of the price spectrum.

The stones used for jewelry and other enhancements are categorized as natural, synthetic, simulant, or imitation. All of these may eventually become part of a designer's creation.

NATURAL STONES

Those that are classified as natural are either mined or, as in the case of pearls, found in the sea. As with any natural products, there are considerable variations that are influenced by the environments in which they grow. Unlike the synthetics, which are laboratory created, each natural stone has a distinct appearance or personality of its own.

The stones are identified in any number of ways. Although color often indicates a particular kind of natural stone such as green for emeralds and red for rubies, the color test is not always conclusive. Many natural stones are available in a host of colors; for instance, there are yellow diamonds and pink rubies.

Figure 10-7 A natural rock lined with amethyst.

Hardness measurements may be used to differentiate natural stones. Each stone has its own distinct degree of hardness and can be judged on that basis. The Mohs Scale, developed by Friedrich Mohs in 1882, is still the most commonly used means of hardness measurement. He chose 10 well-known minerals*, and assigned them numbers in order of their scratch hardness, as follows:

TABLE 10-1: THE MOHS SCALE OF HARDNESS

MINERAL	HARDNESS
diamond	10
corundum	9
topaz	8
quartz	7
orthoclase feldspar	6
apatite	5
fluorite	4
clacite	3
gypsum	2
talc	1

* It should be noted that different stones fall within each mineral category. Ruby and sapphire, for example, are in the corundum classification, and emerald and aquamarine (known technically as beryl) have the same hardness as topaz.

In other words, diamond with a hardness of 10, can scratch any mineral, while topaz, with an 8 rating, can scratch anything from quartz down to talc.

An even more precise measurement of scratch hardness can be made with a sclerometer. The stone is mounted and a sharp diamond point is drawn across it. The pressure on the point is regulated with the addition of weight, until the stone is scratched. The weight is then compared with predetermined values.* The following values were determined with the sclerometer:

TABLE 10-2: HARDNESS MEASUREMENTS DETERMINED WITH SCLEROMETER

MINERAL	HARDNESS
diamond	140,000
corundum	1,000
topaz	459
quartz	245
feldspar	191
apatite	53.5
fluorite	37.3
calcite	15.3
gypsum	12.03
talc	1.13

* It should be noted that scratching can cause damage to a stone and should not be used on one that has been fashioned.

Other methods of identification consider gravity and light refraction. Each stone has a specific gravity that may be tested by dropping it into water and comparing it with the preestablished numbers for each type. When light enters a stone, the light is slowed and bent away from its normal course. Each stone has its own angle of light bending and may, therefore, be classified as a result of this test.

Natural stones are subdivided into two categories: precious and semiprecious.

PRECIOUS STONES

Diamonds, rubies, sapphires, emeralds, and natural pearls are classified by jewelers as precious stones. Although some might argue that the pearl isn't really a stone, it is generally acknowledged as such by those in the trade.

Diamond The only precious stone that is made entirely of one chemical composition, carbon, it is without question the one that receives

Figure 10-8 Jeweler examining a stone with a loupe.

the greatest amount of attention from the consuming public. Long the symbol of bethrothment, it also signifies success and achievement and is treasured by a large segment of the population. Not all diamonds are created equal, however, but its mere mention causes excitement.

Diamonds are found anywhere between 75 and 120 miles below the earth's surface, where the necessary conditions of temperature and pressure exist. First discovered in India about 500 B.C., the stone's deposits are in many different parts of the globe. A large proportion of the world's diamonds come from Australia, South Africa, and Russia, with many professionals considering the Russian diamonds as the best in quality.

Diamonds, and other stones, are measured in carats. One carat equals 0.2 grams. It would take 142 carats to equal one ounce! Because fractions of a carat can significantly alter the price, it is necessary to be even more precise in measuring. The carat is broken down into points, with each representing $\frac{1}{100}$th of a carat. Thus, there are 100 points to the carat.

To evaluate the worth of a particular diamond, the jeweler makes an assessment based on the four Cs: carat weight, color, clarity, and cut.

The beginning point is usually the carat weight. This does not mean that a 2-carat stone is more costly than one that is half the size. The final value will be determined when all of the other factors have been considered.

Although most consumers think of diamonds as colorless stones, they come in a variety of colors. There are yellow, gray, brown, and even black diamonds. Some of the colored stones are so rare that they cost more than the conventional types. These are classified as fancie.

The degree to which a diamond is "blemish and inclusion free" (a term to describe the internal imperfections) is known as its clarity. It is virtually impossible to find a stone that is free of these imperfections. When, however, neither a blemish nor an inclusion is observed under 10-power magnification of the "jewelry loupe," the stone is considered to be flawless. Such specimens are rare and highly prized. Of course, many stones contain imperfections that are visible to the naked eye and have inclusions that could affect durability. These stones are significantly less valuable than those with limited imperfections.

Next, the cut of the stone contributes to its value and cost. A talented diamond cutter can cut the natural stone in such a manner as to minimize flaws. When observing the rough stone, the skilled craftspeople must determine both which style of cut will best serve the stone in terms of retaining as much weight as possible and will produce an eye-appealing diamond. The various cuts are discussed later in this chapter as they apply to different types of stones.

Finally, the stones are graded according to the four Cs. The industry standard for the grading, established by the GIA, Gemological Institute of America, is adhered to by the world's jewelry professionals.

Some of the more renowned diamonds that have become historically significant are: The Empress Eugenie, a 51-carat perfect diamond; The Eureka, a yellow diamond with a weight of 21.25 carats rough that was cut to 10.73; the Cullinan I and II, the former weighing 530.20 carats and the latter 317.40, both fashioned from the Cullinan with a rough weight of 3106.75 carats; and the Great Table, a pink stone measured at 250 carats!

Ruby The most valued of all gemstones, it is a variety of the corundum family. Its rare, red characteristic makes it more costly than another member of the same family, the sapphire. It is a hard stone that is sometimes referred to as oriental ruby to distinguish it from its close relative the spinel ruby. The latter has neither the hardness, density, nor value of the ruby. The colors range from deep red to rose red. The most valued are those that are tinged with a bit of purple, and sometimes called pigeon's-blood red by the professionals in the field.

Sapphire Also a member of the corundum family, it is a transparent, highly valued precious stone. It is basically made of the same substance as ruby, but its coloration ranges from pale blue to deep indigo, the rarest. Sapphires are also occasionally found colorless or in shades of yellow, green, pink, and purple, sometimes confusing them with other stones. In such cases, their true identity may be determined only by the hardness tests.

Emerald It is generally recognized by its deep green color. It is a member of the beryl family, as is the less expensive aquamarine. The emer-

ald is the only precious stone of that family, the others being classified as semiprecious. The emerald is softer than the other precious gemstones, with a hardness rating of 7.5. In ancient times, the emerald was considered to have many virtues, including a preservative against epilepsy and an ability to drive away evil spirits.

Pearls When natural, they are formed when a tiny irritant such as a speck of sand invades the oyster. As a means of alleviating the irritation, the oyster coats the tiny matter with a nacreous solution, the same element that coats the oyster's shell, thus, eventually forming a pearl. The most valuable of the pearls are those that are perfectly round, and are formed next to the oyster's body. The translucent quality and iridescent color make it a desirable gem. Those that are found as formations attached to the oyster's shell are labeled "baroque," and are irregularly shaped.

Unlike the other precious stones, which are measured in carat weight, pearls are measured in millimeters. The larger the millimeter, the greater the cost. When made into necklaces or bracelets, the matching of size and color determines the cost.

Although most pearls range in color from a creamy beige to a faint pink tint, they are also formed in colors that include yellow, brown, green, blue, and black.

Figure 10-9 Pearl earrings, necklace, and bracelet. (Courtesy of Neiman Marcus)

SEMIPRECIOUS STONES

In addition to the rare, precious natural stones, many semiprecious types are significantly beautiful. They are, of course, less expensive than their precious counterparts, but, none the less, they are important to the jewelry industry. We explore those that are especially popular.

Zircon This is a transparent stone that comes in a variety of colors that include yellow, orange, and red. In its colorless form, it is often used to imitate the diamond. Although it has significant sparkle, it does not have the fiery brilliance of the diamond and, because of its softness, tends to scratch easily.

Turquoise A stone that ranges from deep blue to a light shade of green. It is opaque and has a soft, smooth surface that scratches easily. It is used in a wide range of jewelry products and is especially prized when teamed with sterling silver in American Indian-designed pieces.

Alexandrite A transparent stone that features a greenish tinge under normal daylight and dramatically changes to red under artificial light. It is common in small sizes, but when it weighs more than 2 carats, it is relatively scarce and costly, compared with other semiprecious stones. A weight of 3 carats easily commands a $20,000 price tag!

Cat's-eye A translucent stone that ranges in color from yellow to emerald green. It feels velvety to the touch. When properly cut, it produces a bright, white light down its center. It symbolizes long life and is considered to be protection from the "evil eye" by some of its owners.

Coral This ranges from semitransparent to opaque. Its coloration runs from white to the deep red variety. The latter is the costliest of coral. The majority of the stones found in jewelry is red-orange in color. Although much of the coral used for jewelry is cut and fashioned by craftspeople, a significant amount of this stone is used in its uncut stage.

Amber It is somewhat different from the other semiprecious products. It is not a stone; it is petrified tree sap. In its natural formation, colors generally range from yellow to dark brown. The lightest of the gems, amber can be distinguished by its ability to float. As a test to determine its authenticity, it may be immersed in a salt-water solution. Only amber will float.

Amethyst One of the most popular of the semiprecious stones. In colors that range from light to dark purple, it is the birthstone of February. Available in large weights at a modest price, this durable stone will provide the wearer indefinite years of use.

Onyx A member of the quartz family, ranges from semitranslucent to opaque. Its coloration includes the spectrum of colors from red to

apricot, with white sometimes evident in the stones. It is usually the stone used to carve "cameos." Although many people think black onyx is a variation of the natural stone, this is not the case. It is a dyed version of chalcedony (a variety of quartz)!

Aquamarine This is a member of the beryl family, as is the emerald, but it costs considerably less than the precious emerald. It ranges in color from light blue to dark blue, with the latter the more valuable. Spectacular rings that bear as much as a 15-carat stone are available at relatively modest prices; however, they are becoming increasingly scarce.

Garnet A hard, durable stone that comes in a variety of shades of greens, reds, yellows, and oranges. When a brilliant green is desired, but emeralds are too costly, a fine garnet is an alternative and is much more affordable.

Jade Comes in two varieties, jadite and nephrite. The former is the more expensive and is naturally available in green, a white and green combination, light gray, pink, brown, yellow, orange, and lavender. The most desired is the emerald-green color, often referred to as imperial jade. Nephrite colors are more limited, with dark green its mainstay, and costs much less than jadite.

Opal Features a brilliant array of colors in each stone, somewhat like a rainbow coloration. Color is the major characteristic for judging its value. The costliest of the variety is the black opal, which is extremely rare. A gem that is about the size of a lima bean can cost as much as $50,000. To "extend" the black opal, it is often produced as a doublet, a combination stone that uses both an opal and a less expensive variety in its presentation. Combination stones are explored further later in this chapter.

Lapis-lazuli Is a natural, opaque blue stone. The most prized variety is the deep blue, with no traces of gold or silver specks in the pieces.

Topaz This is a versatile stone that comes in yellow, a range of browns, red, shades of green, and sometimes it is colorless. There are many stones that are sold as topaz, but they are generally imitations of the real variety. Most are quartz topaz, which costs considerably less.

Cultured pearl Is a pearl that is cultivated with the assistance of people. It is produced by the insertion of an irritant such as a bead of mother-of-pearl into the oyster. The oyster is then returned to the water and over a period of several years, it secretes a substance around the bead to form a pearl. Fine cultured pearls are extremely expensive, with the costliest possessing the same qualities as its precious, natural counterpart. The BIWA cultured pearls are grown in fresh rather than sea water and are cultivated much faster. Pearls of any type are either smooth and round or are the baroque type which possess an irregular shape.

Other semiprecious stones that are used by jewelers, but to a lesser extent than those discussed, include: andalusite, a hard, durable stone in a wide color range; bloodstone, a dark variety of quartz; labradorite, a grayish, opaque stone; moonstone, a milky-white, transparent member of the feldspar family; obsidian, a dark-brown, inexpensive stone used for Mexican jewelry; peridot, the birthstone for August that comes in shades of green; rhodochrosite, a soft stone that ranges from white to deep rose; serpentine, a green stone that is sometimes used as a jade substitute; and spinel, which is available in reds, oranges, blues, greens, purple, and black. Its various types are often confused with ruby, sapphire, amethyst, and garnet.

SYNTHETIC STONES

Is it a natural stone that has been mined and fashioned by the jeweler or is it one that has been manufactured and made to look like the "real thing?" Some of the synthetics are so perfectly produced that they easily fool the untrained or unsuspecting. In many cases, only the eye of a professional jeweler is capable of distinguishing the imitation from the natural gemstone.

These man-made reproductions of mined stones have essentially the same chemical compositions, structures, and visual and physical properties of the stones they mimic. Some of the more popular synthetics are those that simulate the precious emeralds, rubies, diamonds, and sapphires and many of the costly semiprecious varieties such as opal and turquoise.

The new technologies for making the synthetics are so advanced that, on occasion, even the professional jeweler can make a mistake. These costly mistakes can be verified only when actual testing is undertaken.

SIMULANTS

Anything that is marketed as look-alikes for natural stones are called simulants or imitations. Unlike the synthetic group, these have none of the properties inherent in the real stones that they imitate. Glass, for example, has been carefully cut and backed with a foil surface to imitate diamonds. Not all simulants, however, are produced to fool the public. When used as a trim on apparel and accessories or as elements in elaborate, inexpensive jewelry, only the less informed would believe the rhinestone was actually a diamond.

Ceramics have often been manipulated to resemble turquoise or coral. When the prices are comparatively low, it is most certainly true that the final product is not the real thing.

With today's shortage of real ivory, plastics are being manufactured as imitations for use in jewelry and apparel ornamentation.

Some of the more popular simulants or imitations that are successfully marketed today as diamonds are YAG (yttrium aluminum garnet) and GGG (gadolinium gallium garnet).

BIRTHSTONES

For hundreds of years, specific gemstones have been associated with particular months of the year. The birthstones, a name given to the stones that fall within each month, have not always been the same throughout history. Today, the birthstone list, established by the Jewelry Council of America in 1952, is the one that is followed by the jewelry industry.

Some months have a single stone earmarked for them, whereas others have two or more. The list is as follows:

TABLE 10-3: BIRTHSTONES

MONTH	STONES
January	Garnet
February	Amethyst
March	Aquamarine or Bloodstone
April	Diamond
May	Emerald
June	Pearl, Moonstone, or Alexandrite
July	Ruby
August	Peridot or Sardonyx
September	Sapphire
October	Opal or Pink Tourmaline
November	Topaz or Citrine Quartz
December	Turquoise or Zircon

COMPOSITE STONES

When a stone actually comprises more than one part it is called a composite. The combination of different stones is used to enlarge the size of the stone or enhance its color.

The most popular composites are called doublets or triplets. The former uses two parts, and the latter uses three. The different stones are held together with cement.

In the case of the doublet, the natural stone is the top part, which is seen, with the bottom being a glass imitation. Triplets use the real stone at the top, a glass insertion in the middle, and a real stone at the base. Figure 10-10 shows how the parts are engineered to make up the composites.

Today the combination stones are less frequently manufactured because of the excellent quality of the synthetics that are being produced. Some combinations that have been created in the past, however, are still available today.

Most doublets use the garnet as the top portion of the creation. Its excellent luster and durability accounts for its popularity. The garnet-topped doublet, for example, uses a blue-glass bottom for a sapphire

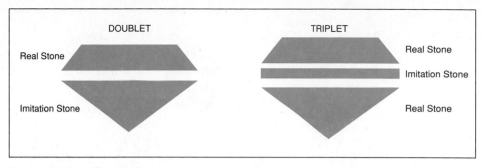

Figure 10-10 Composite stones.

piece and a green-glass bottom when an emerald appearance is the choice. Sometimes, a colored cement is used to fuse two colorless stones, resulting in a colored stone.

CUTTING STONES

Most of the rough stones must be cut to enhance beauty and, sometimes, hide imperfections or inclusions. For fashion purposes, the occasional use of an uncut stone may be in order. Coral, for example, may be cut or left in the rough. In the case of pearls, of course, no cutting is necessary; the natural beauty lies within the shapes as they come from the oyster!

Stones are either faceted or cabochon cut. Facet refers to the series of faces or planes that make up the cut. Cabochon, on the other hand, is a facetless cut that produces a smooth, rounded surface.

FACETED CUTS

The lapidary, or stonecutter, examines each stone to determine which type of faceting would make it most desirable when finished. There are many different types of faceted cuts from which to choose.

Brilliant Sometimes referred to as a full or round cut, it imparts the greatest amount of "fire." It is usually the traditional choice for engagement rings.

Emerald This name is used because it is the most popular method used for cutting emeralds. Diamonds and other stones, however, are often emerald cut. Its facets are similar to miniature steps. Sometimes it is referred to as the step cut.

Pear It is rounded at the top and tapers down to a point, resembling a teardrop. It tends to make the stone seem larger than the round or emerald cut varieties of the same weight.

Marquise If visual size is important, this cut gives the impression that it is larger than round stones of the same weight.

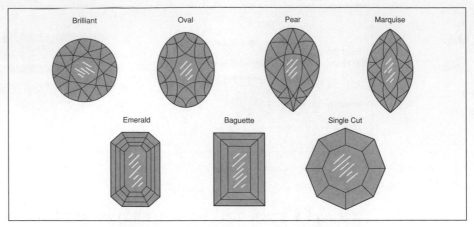

Figure 10-11 Seven popular faceted cuts.

Oval The newest cut, the oval is actually a variation on the brilliant or round cut.

Baguette Small rectangular stones have been baguette cut. They often flank a larger stone.

Single cut A variation of the round or brilliant cut, it features fewer facets and is used for small stones. Drawings of each of these cuts are depicted above.

Facted stones are discussed and evaluated in technical terminology. Some of the more common terms are:

Crown The top of the stone.

Girdle The widest part or edge of the stone.

Culet The lowest part of the stone.

Table The flat, top of the stone.

Table spread The width of the table.

The diagram shown in Figure 10-12 indicates these parts on a brilliant cut.

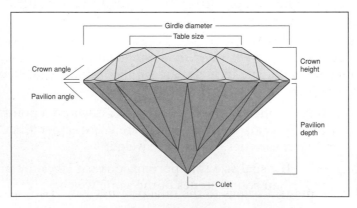

Figure 10-12
Technically labeled
faceted stone.

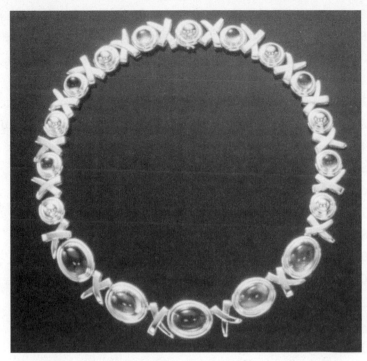

Figure 10-13
Paloma Picasso's
cabochon necklace
was designed exclu-
sively for Tiffany's.
(Courtesy of
Tiffany & Co.)

CABOCHON CUT

When a smooth, rounded surface is desired, this type of cut is used. It is less complicated than the faceted types. Stones that feature this cut are translucent, letting light through without being transparent, or opaque, in which light cannot come through. Coral, jade, labradorite, moonstone, opal, turquoise, and some alexandrites are cabochon cut.

Imitations, such as rhinestones are frequently used as apparel and accessories enhancements. This is discussed in Chapter 18, "Trimmings and Findings."

REVIEW QUESTIONS

1. Define the term *malleable* and how this characteristic of metal enables the jewelry designer to create different designs.
2. What is an alloy and why is it used in jewelry production?
3. Describe the method of electroplating.
4. Differentiate between items that are labeled *karat gold* and *gold-filled*.
5. For what major reason is silver not used in its pure form in jewelry?
6. What is sterling silver?
7. Name some of the base metals used in alloying and discuss the advantage it brings to the final product.

8. How do jewelers identify stones?

9. What is the Mohs Scale of Hardness?

10. List the five stones that are considered to be precious.

11. Differentiate between *carat* and *karat* measurements.

12. What are the four Cs used by jewelers to assess the value of diamonds.

13. Discuss the difference between the natural and the cultured pearl.

14. Does color definitively disclose the name of a stone?

15. Are synthetic stones and simulants the same?

16. What is a doublet and why is it produced?

17. Describe the job of a lapidary.

18. List and briefly describe three faceted cuts.

19. Name the various parts of a faceted stone.

20. How do cabochon cuts differ from the faceted varieties?

EXERCISES

1. Using the listing of birthstones in this chapter, select the one for your birthday. Prepare an oral or written report on your birthstone. The information can be obtained by writing to or visiting any of the following sources:

 The Gemological Institute of America

 Jewelry Council Of America

 American Gem Society

 Local jewelers

 Jewelry manufacturers

 The report should feature visuals of drawings, advertisements, and any other illustrations that feature your birthstone.

2. Select one of the many alloys discussed in the text. For the one chosen, prepare a report that discloses:

 the alloy's composition

 the benefits of the alloy

 the jewelry for which the alloy was formed

 Photographs of the products that feature the alloy should be included in the report.

SECTION 4

APPAREL
CLASSIFICATIONS

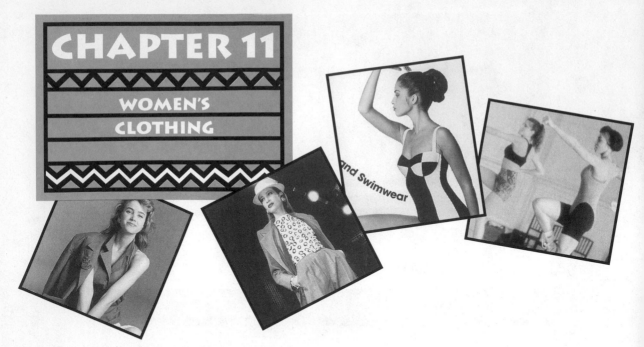

CHAPTER 11

WOMEN'S CLOTHING

and Swimwear

LEARNING OBJECTIVES

After reading this chapter, the student should be able to:

1. Discuss the various classifications that comprise the women's clothing industry.

2. Explain the pricing structure that is used to segment women's apparel.

3. List the types of size ranges used in women's wear and discuss their characteristic differences.

4. Differentiate between the numerous styles and silhouettes that dominate the apparel designs.

5. Describe the concepts used in the marketing of women's merchandise lines.

INTRODUCTION

Ever since Eve covered herself with the biblical, functional figleaf, women through the ages have covered themselves in ways that have made fashion history. Although function has always played a significant role in the apparel world, it is the outrageous and exciting costuming that makes an indelible mark in the mind.

Women dressed in fabulous ball gowns at the Metropolitan Opera's opening night and the stars who make their grand entrances clothed in ingenious designer creations have stolen the spotlight away from the

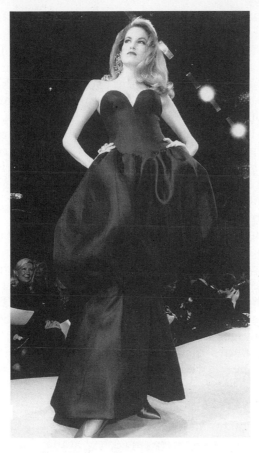

Figure 11-1 An Yves Saint Laurent ballgown, like this, is a certain scene stealer. (Courtesy of Yves Saint Laurent)

events themselves. The print and broadcast media often spend more time and space critiquing the clothing than reviewing the performances. The discussions of who wore what seem to remain the subject of the viewing audience longer than anything else about the eventful evenings.

Although these glamorous nights certainly generate fashion excitement, there are other segments of the industry that play significant roles in the business of women's clothing. The appropriate business suit for the successful executive, the swimsuit that combines both fashion and function, and the sportswear that blends style perfectly with comfort are all components of women's fashion apparel.

Before the 1800s, any suggestion of fashion in women's clothing was restricted to the domain of the affluent. Only royalty, the wives and daughters of heads of state, and the affluent, socially prominent women could have seamstresses to create garments to suit their needs. It was not until 1858, when Issac Singer developed his sewing machine, that ready-to-wear was available for the masses.

Since the beginning of the twentieth century, women's clothing has gone through many phases and stages of design. The pinched-in waist-

line of the early 1900s, Poiret's abandonment of the full, bouffant petticoat styles and introduction of the narrow silhouette, the beaded and fringed dressers of the 1920s "flappers," the elegance of the strapless gowns highlighted by Vionnet in the 1930s, the 1940s padded-shoulder suits and dresses, the expansion of the sportswear market that Claire McCardell and Bonnie Cashin introduced at the close of the previous decade in the 1950s, the "mod" fashions popularized by Mary Quant and the minis and boots with which they were worn, featured in the collections of Courrèges in the 1960s, the 1970s with the craze for unisex designs, the return of elegance in the 1980s with the Christian LaCroix pouf skirt, and the freedom of choice in terms of skirt length and silhouette that opened the 1990s are just a few of the styles that have had successful runs in women's fashion apparel.

In fashion capitals across the world, more than 4000 companies regularly produce clothing at every price point to fit every need and occasion. Some restrict their offerings to narrow product lines, whereas others feature collections that cut across several product classifications.

In exploring the field of women's clothing, attention focuses on the various classifications that constitute the industry, the price points of the industry, the size ranges that are produced to fit specific wearer needs, the styles and silhouettes that regularly find their way into the fashion cycles, and the manner in which the industry markets its wares.

CLOTHING CLASSIFICATIONS

Most of the apparel manufacturers specialize in one specific merchandise category such as dresses or sportswear. A few of the giant companies cut across product lines and feature a wide range of merchandise. The Anne Klein label, for example, may be found on dresses, sportswear, swimsuits, and accessories. Those that take this diversified route often do so by manufacturing some of the merchandise themselves and by using licensees for the rest, as is the case with Ralph Lauren.

The following products classifications encompass women's clothing:

DRESSES

The dress has long been the mainstay of a woman's wardrobe, with styles that range from the simple to the fancy. Most manufacturers identify the particular market they wish to serve and concentrate on a specific type of dress. By specializing in a narrow segment of the classification, a company may be both better able to make a name for itself in the industry and more easily able to market its line.

SPORTSWEAR

Until the 1940s, the sportswear market was practically a nonentity in the apparel field. Properly attired women wore dresses for every occasion.

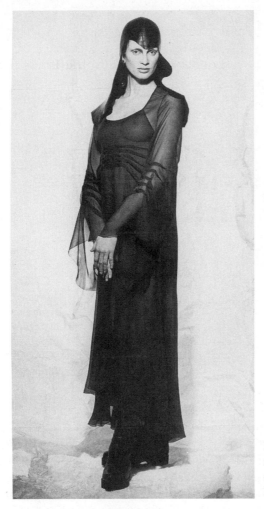

Figure 11-2 This high-fashion, mousseline, layered dress epitomizes creative design. (Courtesy of Karl Lagerfeld)

During World War II, a more relaxed attitude toward dress emerged, and designers like Claire McCardell and Bonnie Cashin revolutionized the field with their casual clothing styles. Women who once relied entirely on dresses for every social and business engagement, began to opt for the newer approach to dressing. They chose a variety of separate pieces for their wardrobes such as skirts, pants, sweaters, blouses, and jackets, which could be interchanged or mixed and matched to create different outfits. There was enormous enthusiasm generated by this merchandise craze, and manufacturers who once limited their lines to dresses soon joined the bandwagon and began to produce sportswear.

Some manufacturers such as Liz Claiborne, for example, produce a variety of sportswear collections that include all of the elements of the classification, whereas others restrict their offerings to only one, for instance, pants or skirts.

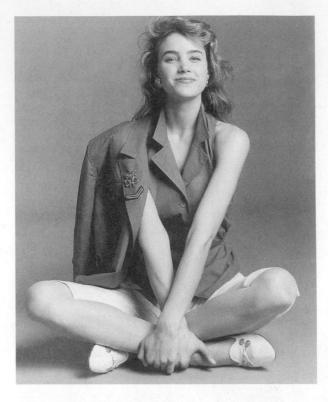

Figure 11-3　Sportswear separates, by Nancy Heller, are easily interchanged to expand the wardrobe. (Courtesy of Cotton Incorporated)

ACTIVE SPORTSWEAR

Participation in sports such as golf and tennis usually called for special attire to be worn by the players. The manufacturers Head and Fila specialized in apparel that was expressly made for these events. During the 1980s, with the physical fitness craze taking hold in America, the offerings of these and other companies were expanded to include jogging suits, bicycle pants, and other items to suit the needs of the participants.

Although the number of people involved in these and other sports increased, making the need for these products greater than ever, another segment of the population brought the active sportswear classification into even greater prominence. Significant numbers of people who had never sought the challenges of physical fitness or sports activities began to embrace the mode of dress worn by those who participated in the games. It became common to see warmup suits, tennis outfits, and golfwear, worn with a host of different tennis and athletic shoes, at restaurants and gathering places where regular sportswear was once the order of the day.

The end of the 1980s and the beginning of the 1990s witnessed the invasion of this market both by many manufacturers whose product lines had little to do with an active sportswear orientation and many new companies that began to capitalize on this trend in casual dress.

Figure 11-4 Spandex bicycle shorts and tops are perfect for physical fitness workouts. (Courtesy of Nike Inc.)

SUITS AND COATS

Although there has always been a substantial market for coats and suits, the industry significantly expanded its offerings as more and more women entered professional careers. Not only was the right dinner or occasion suit needed by women, but appropriate suits were needed to satisfy the requirements of appropriate business dress.

At the same time, the coat manufacturers also began to feature a wider and more diverse merchandise assortment to satisfy both the casual wearer as well as the women whose work assignments demanded proper coats.

Most producers in this area generally restrict their lines to either coats or suits; only a few manufacture both. Many men's coat and suit makers expanded their businesses by offering lines for women. Companies like Saint Laurie Ltd., which once focused its attention on the needs of the male executive, now feature compatible lines for the female counterpart.

Many retailers, recognizing the need to cater to this newly found suit market, established separate departments, which feature suits for the woman executive. Carson Pirie Scott, in its Chicago flagship, opened its successful "Corporate Level" department specifically to cater to the needs of career women, and stocks a wide assortment of business suits to address those needs.

Figure 11-5 With more and more women working outside of the home, the business suit has met with great success. (Courtesy of Criscione)

KNITWEAR

Although sweaters have played an important role in casual dress since the 1940s, the knitwear industry has never been as important as it is today. In addition to the more tailored styles that once dominated this market, the sweater has become a feature for almost every occasion. Hand knit and bulky for everyday wear, bejeweled and beaded for use at the most formal events, and intricately detailed with artistic and creative patterns, this market has never been larger or better.

Since the 1950s, and the enormous success of the sweater, most makers have expanded their lines to feature a full complement of knitted merchandise. Dresses, two- and three-piece coordinates, pants, and outerwear have joined the sweater as apparel for almost every situation. Whether it is for leisure time activity or a special occasion, knitwear continues to be a favorite among women.

SWIMWEAR

Once a functional product only, swimwear gained its fashion reputation when companies such as Rose Marie Reid and Cole of California gave it a new look. With styling that was as inventive as that demanded by other segments of the women's fashion industry and with fabrics, color, and

Figure 11-6 Sweater dressing for the '90s includes leggings. (Courtesy of Bill Blass)

trim that showed a new enthusiasm, a different life began for the swimsuit. It was no longer classified as the "bathing suit" that had but a single connotation. It was transformed into a fashion item with pizazz and glamour. Lamé, metallics, laces, velvets, and sequined lycras joined the more traditional fabrics and the assortment significantly grew.

To give it the ultimate fashion image, many swimwear manufacturers have entered into licensing arrangements with apparel designers who style the new lines and affix their signatures to them. Today, along with the traditional entries of Jantzen, Cole, and Catalina, names like Bill Blass and Anne Klein grace swimsuit collections.

The industry expanded even more when matching jackets and skirts were added.

RAINWEAR

Once worn only during times of inclement weather, the raincoat has become a fashion apparel product that transcends different seasons and uses. Many women have chosen the raincoat to replace the traditional cloth coat for winter and spring wear. Constructed with interlinings that are removable, as demanded by the changes in temperature, this all-purpose coast has been chosen by many women.

Figure 11-7 Lycra Spandex has given the swimsuit wearer both comfort and a feel of fashion. (Courtesy of DuPont)

The industry comprises two segments, one that produces the traditional models, as in the case of Burberry and Aquascutum, and the other that regularly changes its styles, colors, and fabrics as frequently as fashion dictates.

PANTS

When American women took their places on factory assembly lines during World War II, not only did they perform the jobs that once belonged to their husbands, sons, and lovers, but they also adopted the factory style of dress. Wearing coveralls or pants and shirts, which provided both comfort and convenience on the job, women soon began to carry over that mode of dress for casual occasions.

Manufacturers, believing that there was market for such products, developed lines of pants. Immediately, they were eagerly accepted by many women who wore them in place of skirts. The rest is history!

Today, pants are worn everywhere. Whether it is the casual type for shopping or the dressy, festive styles for special occasions, they remain favorites among women.

The product lines come from a variety of places. Some are produced by men's wear manufacturers who adapt the male-oriented styles to the female figure. Others are produced by sportswear companies as part of their regular collections. Still others come from producers who make only pants in a variety of fabrics and styles.

Figure 11-8　Pants, worn for casual or dressy occasions, have been a traditional favorite. (Courtesy of Yves Saint Laurent)

BLOUSES

Until the 1970s, blouse manufacturers played an important role in the fashion industry. In recent years, many of those companies have expanded their operations to include other "separates" in their lines. Few devoted their businesses strictly to the blouse.

In the past few years, there has been a small resurgence in the blouse business, necessitated by the number of women who have entered a variety of careers. With suits often considered the only appropriate form of dress in industries such as banking, finance, accounting, and management, the obligatory blouse, worn under the business suit, became a necessity, increasing the demand for this product.

INTIMATE APPAREL

Garments worn beneath dresses, suits, and other clothing had never received the recognition as a separate product classification as they do today. Once hidden away in lost corners of department and specialty stores, intimate apparel has come into its own since the 1980s, when

Figure 11-9 The teddy suggests that intimate apparel is as exciting as the garments worn over it. (Courtesy of DuPont)

Victoria's Secret, a division of Limited Inc., began to merchandise a variety of intimate items in a romantic manner. In stores that are decorated like ladies boudoirs, the merchandise is visually presented in a new way. No longer kept in drawers or featured on lackluster racks, each item is displayed on settees, in baskets, and in other less traditional containers, surrounded by charming potpourri and fragrances.

The product lines have been expanded by Victoria's Secret and manufacturers who serve them, and other stores such as Macy's which has used the same format, takes intimate apparel out of the mundane category. With colors and patterns found in other fashion merchandise, the customer is motivated to purchase a host of items rather than the few basics.

Designers of other apparel have also helped bring a new freshness and uniqueness to this merchandise. Calvin Klein, with a full line of women's boxer shorts, has captivated the market and made women believe that the product was as appropriate for them as for their male counterparts.

Now that the "rules" of intimate apparel have been broken, it appears that this merchandise classification will continue to grow.

MATERNITY WEAR

Not long ago, pregnant women were left behind in terms of fashion apparel. They often resorted to choosing larger sizes in regular clothing while they could and then made the transition into lackluster maternity clothing. All of that has changed since the demand for stylish fashion that began when many women worked until a week or two before their delivery dates. As a result, the need for well-styled business clothing has become important.

Today, many maternity specialty stores have opened that feature fashion that is comparable with the items found in other shops. Dresses, suits, jeans, dress pants, and other garments, in a wide variety of fabrics and designs, serve the needs of this market.

JEANS

Once used primarily as functional, rugged pants for heavy-duty occupations and activities, jeans emerged in the 1970s as a fashion product. The traditional Levis, Lees, and Wranglers gave way to the more exciting fashion designer jeans that featured such names as Calvin Klein and Pierre Cardin. Soon after the enormous acceptance of this "new" product that became a status symbol with the designer's name prominently displayed on the outside of the back pocket, other companies began to move their efforts into the jeans arena. Denim was now adorned with leather and metallic studs and prices soared. Jeans were worn for most every occasion and by every age group.

Today, the fancy jeans coexist with the Levis and Lees, each having appeal to different markets. It has become the standard mode of dress for students at all educational levels and occupies more store space than ever before.

BRIDAL

At every price point from the inexpensive ready-made dress to the haute couture creation that has no price limitation, the bridal gown has been successfully merchandised for generations. Where young women have sacrificed in many ways, it is often the purchase of the wedding gown that entices them to spend effortlessly.

The industry is relatively small, but the styles produced cover every conceivable shape and silhouette. Using the most extravagant tulles, laces, silks, satins, and brocades, the results can be spectacular.

Designers like Arnold Scaasi play important roles at the industry's highest price points, producing custom-made dresses for an elite clientele. Their designs are generally copied immediately by the waiting manufacturers who quickly produce replicas at a fraction of the original designer price. Sales to the consumer are made through special departments in department stores, specialty shops, boutiques, and at the manufacturer's own premises.

Figure 11-10 The bridal gown has prompted many women to spend extravagantly. (Courtesy of Yves Saint Laurent)

SIZE RANGES

Before the mid-1950s, women had few sizes from which to choose that were specifically tailored to fit their measurements. At that time, most apparel was available in misses sizes that generally ranged from 10 to 16 or 18, large sizes, and few junior sizes. With so limited a selection, alterations were commonplace.

Since then, more and more size variations have surfaced, with garments manufactured in size specializations to fit almost any figure.

MISSES

Also referred to as missy, this size offering is for the fuller-figured and longer-waisted customer. Manufacturers usually restrict their production to five sizes in the range, with most featuring a run from 8 to 16. Some manufacturers of misses sizes extend their lines and produce garments in sizes as small as 2 or 4, with others featuring size 18.

The decision for the exact range depends on the typical characteristics of the line and the customers to whom it is being targeted. Rarely will a single manufacturer offer a full complement of sizes ranging from 2 to 18.

JUNIORS

Although many consumers consider the term *junior* to describe a younger customer, this is not technically the case. In sizes, the junior garment is one that is proportioned to fit the slimmer-hipped, short-waisted figure. Because younger people often possess these basic characteristics, the producers of juniors generally manufacture garments that have a more youthful appeal for this size specialization.

The sizes are odd numbered and range anywhere from 1 to 15. As do the misses manufacturers, those that make juniors also limit their ranges. Typically, the most popular range begins at 3 and extends to 13.

PETITES

Short women always had problems when it came to buying clothing before this special size offering became popular. They had to buy juniors or misses sizes and have them altered to better fit their bodies. Not only did this provide an inconvenience to the customer, but the expense of the alteration increased the price of the garment.

Today, women who are 5 feet 4 inches or shorter find scores of manufacturers who produce apparel tailored to their measurements. The success of this size range is evidenced by the fact that many designers and manufacturers of misses and junior lines often produce the same garments in petite. Liz Claiborne and Jones New York, for example, feature complete collections of their designs in the size petite range.

WOMEN'S

Although the word *women's* is used in the fashion industry to describe all of the product classifications associated with the female, it is also used to describe the size range for the largest, fullest figured female of average height. Size availability usually ranges from 14 to 24, with some manufacturers adding a 12 and others extending the line to include 26.

The major complaint from the wearers of women's sizes had been the lack of styles that were indicative of the fashions of the times. The needs and desires of the customer hadn't been properly addressed by the producers who merely decided by themselves what the fullest figured women should wear. Dark colors and simple lines generally made up most of the collections.

Since the middle of the 1980s, the image of the large-size market changed. With companies like The Limited, through its large-size stores, Lane Bryant, and The Limited Woman, recognizing that fashion was first and foremost on their customer's minds, the merchandise mix began to change significantly. Today, customers of this market can find any type of merchandise that was once available only in smaller sizes, from brightly colored knitwear to lavishly beaded gowns.

Not only has the product mix been expanded, but business in this size range has never been better. Once satisfied with only the basics, the women's-size customers are purchasing extensive, fashion wardrobes.

HALF SIZES

This range also targets the fullest figured females, but they are shorter than those who wear women's sizes. They are not only shorter but short-waisted and might be considered as the heavier versions of the junior petite market. Their sizes generally range from 12½ to 24½ with some manufacturers featuring 26½.

This size specialization has also undergone major changes such as the women's sizes with the expansion of the lines that now feature everything available in misses and juniors.

TALL SIZES

Women of above-average height usually had difficulty finding clothing to fit them. Although the tall woman wears a regular misses size, the lengths in that size specialization were inappropriate.

Today, in sizes that range from 8 to 20, women 5 feet 8 inches and taller can find every type of merchandise available to them. Specialty shops have sprung up all over the country, and many department stores have now opened tall-size departments.

SILHOUETTES, STYLES, AND DETAILS

Women's clothing design comprises basic silhouettes, or shapes; styles, the characteristic appearance of the garments; and details, the individual parts that make up the garment's structure.

Silhouettes, styles, and details do not change, but it is their popularity and acceptance at a particular time that makes them a part of the fashion scene. Every garment passes through the stages of the fashion cycle, beginning with its introduction, then moving through a period of growth, then onto the maturity stage, and ending with its decline in sales. The length of time that each style's popularity lasts is difficult to predict or measure. Some have endured for years, whereas others have quickly moved out of popularity in a matter of a few months. Those with extremely short-lived acceptance are called fads.

Designers of women's apparel, and any other garments or accessories, adapt, manipulate, and alter all of the basic elements that make up the product. By doing so, designs of distinction make their way into the marketplace to be judged by the consumers who will either buy them or reject them.

SILHOUETTES

Although there are scores of different styles that are produced and marketed every season, each is constructed along a basic shape or outline. They are the tubular silhouette, whose lines are straight; the bell silhouette that features a bouffant form and emphasizes both the woman's bustline and hips; and the bustle configuration that accentuates the back of the garment.

It is the creative ability of the designers that takes these three basic shapes and transforms them into individual styles.

STYLES

Basically, a style is the characteristic appearance of the garment that distinguishes it from all others. In the fashion industry, the term is used not only to describe the actual appearance of the complete garment but its elements as well. A pleated skirt, for example, is often referred to as a style.

The following is a compilation of some of the popular styled dresses, skirts, coats, jackets, pants, and blouses that have enjoyed fashion success.

Dresses and Skirts.

A-line When the skirt portion of the dress barely hugs the waistline, skims the hips, and flares to the hemline. In a skirt, the waistband is fitted and the hips are merely skimmed by the fabric.

Blouson When the bottom of the blouse portion of a dress is loosely gathered at the waistline and "puffs up," making the waistline invisible.

Chemise The epitome of the tubular look, it is straightlined and void of a waistline. During the most popular period of its acceptance, in the late 1950s and early 1960s, it was called a shift.

Dirndl A waistline of a full-skirted dress or separate skirt that features "gathers."

Empire Instead of placing the waistline at its usual place, it is inserted just below the bust.

Gored A full skirt that is made up of individual panels that are narrow at the top and wide at the bottom.

Jumper A sleeveless dress that is worn either with a blouse or by itself.

Peplum A style that uses a straight or flared tier of material that is attached to the waist and extends to the hip.

Pleated Dresses or skirts that feature folds of material that are either flat pressed or stitched into place. The width and construction of the pleats vary. Knife pleats, for example, are narrow and fold in just one direction, whereas box pleats are generally wider and fold in two directions.

Princess A form-fitted torso and full skirt that is made of angular shaped gores without the incorporation of a waistline.

Shirtwaist A dress whose bodice resembles a man's shirt and skirt that is either straight or flared.

Trapeze An exaggerated version of the A-line shape.

Trumpet A form-fitted skirt that flares out like a trumpet at the knees.

Tunic A sleeveless or sleeved garment that extends to the thigh and is worn over a skirt.

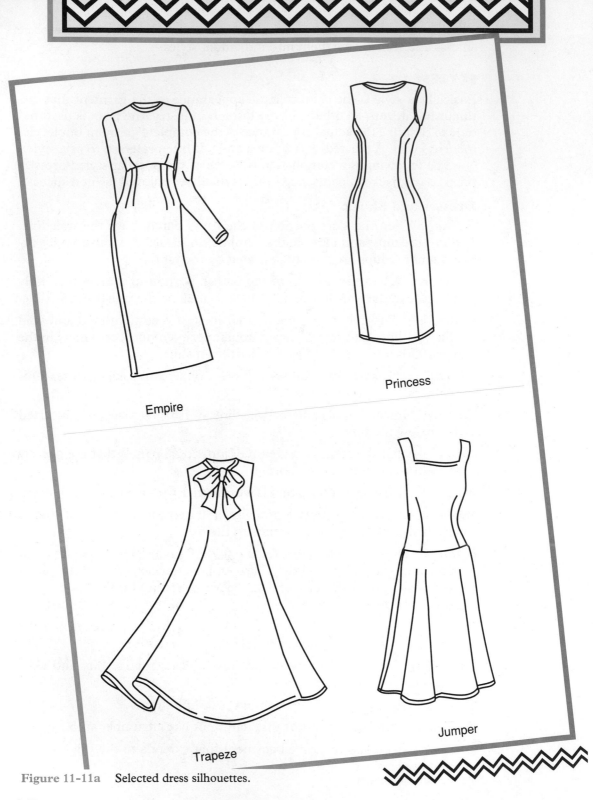

Empire

Princess

Trapeze

Jumper

Figure 11-11a Selected dress silhouettes.

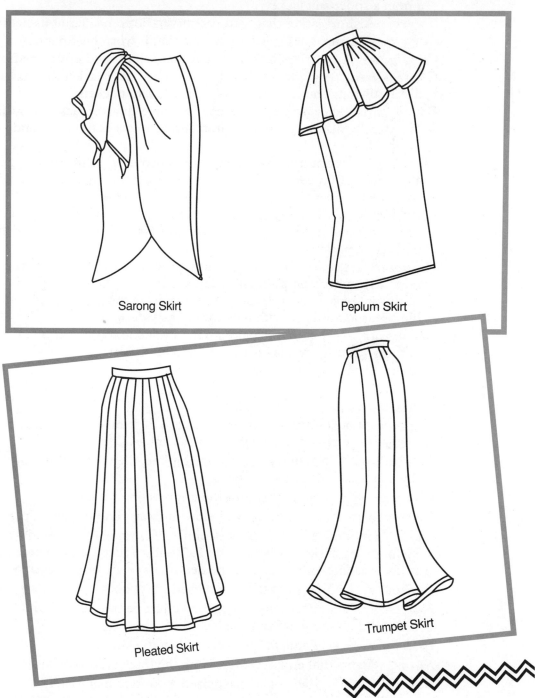

Sarong Skirt

Peplum Skirt

Pleated Skirt

Trumpet Skirt

Figure 11-11b Selected skirt silhouettes.

Coats and Jackets.

Blazer A basic, single- or double-breasted jacket that is fashioned after a man's sport-suit jacket.

Bolero A short jacket that features curved bottom sides at its hemline.

Car coat A three-quarter-length style that is worn over pants.

Cardigan A collarless jacket or coat that is buttoned down the front.

Chesterfield A single- or double-breasted coat or jacket that has as its distinguishing features a velvet collar and flap pockets.

Duffel Also known as a toggle coat or three-quarter jacket, it is made of a sturdy material such as melton and uses wooden toggles and loops for its closure.

Mandarin A coat that has been adapted from the Chinese. It is generally made of brocade fabric and is characterized by a small stand-up collar, wide sleeves, and off-center, loop-type closing.

Norfolk A hip-length, sport jacket that is generally constructed of heavy tweeds or shetland materials and features a box-pleated front and patch pockets.

Raincoat A coat that was originally produced to be worn during the rain. It has become popular today as an everyday coat replacing the traditional spring coat. Its stylings range from the classic single or double breasted to those with a contemporary designer flair.

Redingote A coat that is paired with a matching dress. It often uses a cutaway front that enables the dress to be shown.

Reefer A princess-line coat.

Pants.

Baggies Loose-fitting pants that achieve their fullness from the "gathers" at the waistline and tight fit at the ankles.

Bell bottoms Narrowly fitted at the hipline, they flare beginning at the knee and extending to the shoes.

Culottes Short pants that give the impression of a skirt.

Hip huggers Pants that begin below the waist and hug the hips.

Jeans Predominantly made of denim, they originally featured western styling. The designer craze in the 1970s introduced jeans that featured more detailing and displayed the designer's name on the back pocket.

Jodhpurs Riding pants that are tucked into boots.

Knickers Short pants that are gathered just below the knee and feature a band or elastic that hugs the leg.

Pedal pushers Pants that fall just below the knee.

Shorts Pants that end anywhere from the thigh area to below the knee.

Stretch pants Made of an elasticized or knitted material, it is form fitting and often uses a strap under the foot to hold them in place.

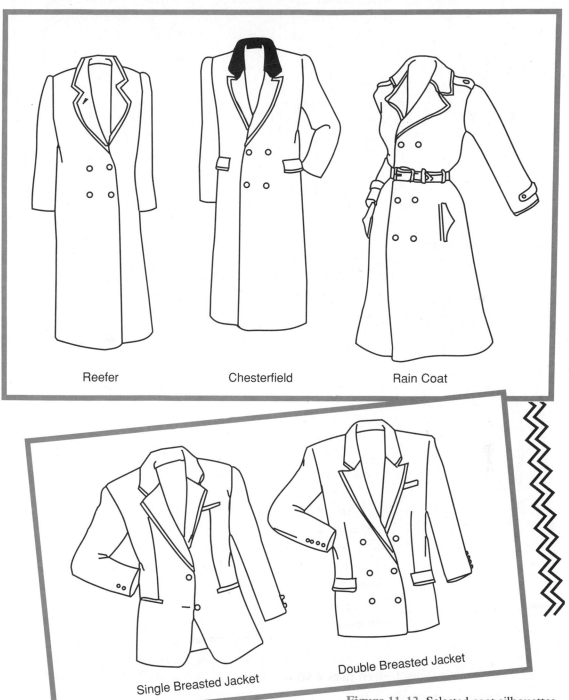

Reefer

Chesterfield

Rain Coat

Single Breasted Jacket

Double Breasted Jacket

Figure 11-12 Selected coat silhouettes.

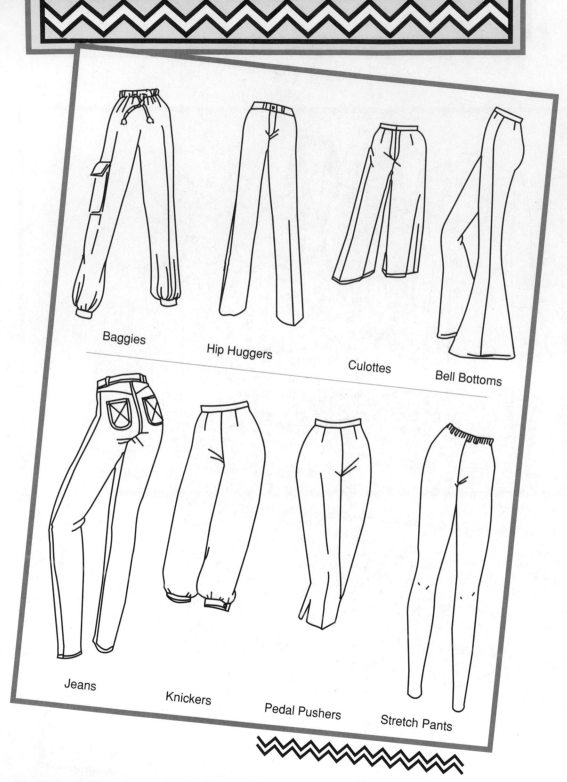

Figure 11-13 Selected pants silhouettes.

Blouses.

Blouson A loose-fitting style that uses elastic or a drawstring at the waist to form "gathers."

Camisole Originally used as a lingerie coverup of the bra, it is also worn separately as a garment. Generally, it has two narrow straps that extend over the shoulder.

Man-tailored A shirt that resembles a man's dress shirt that has button-front closings and either plain or French cuffs.

Middy Copied from the sailor's uniform, it features a low waist and long sleeves and a squared collar on its back.

Polo A knitted shirt with half sleeves.

Smock A loose-fitting shirt that features a "yoke" back and a full gathers or "smocking" that extends from the yoke giving it its fullness.

Tank top A sleeveless, loose-fitting top.

T-shirt A collarless, knitted shirt.

DETAILS

A unique neckline, imaginative sleeve insertion, or inventive closure are details that help distinguish one style from another. Necklines, collars, sleeves, cuffs, and trim, by themselves, are just parts of the finished product. When each successfully augments or complements the others, the result is a complete garment.

Necklines and Collars. Whether it is a simple collar or neckline or one that is intricately featured, it is this part of the design that is often the focal point of the dress, suit, coat, jacket, or blouse.

Bateau Usually referred to as a "boat" neckline, the design is open and wide and close to the neck.

Bertha A large collar that resembles a cape, which extends from the neck and covers the shoulders.

Bow A strip of fabric that is either attached at the neckline or is made removable with the use of buttons or snaps and is sufficiently long to be tied into a bow.

Button-down Traditionally used in "preppy" or "Ivy League" styles, the collar features two small eyelets or openings through which buttons on the shirt are inserted.

Choir boy A large, rounded collar that ends in two points and features two bands of fabric that are tied into a bow.

Convertible A collar that is used either open or closed.

Cowl A collar that is cut on the bias or diagonal to permit either front or back draping.

Crew A rounded neckline, without a collar, that fits close to the neck.

Man-Tailored Shirt

Side Front

Middy

Blouson

Smock Blouse

Figure 11-14 Selected blouse silhouettes.

Halter A backless neckline that is fastened around the neck.

Jabot A ruffled or pleated extra piece of fabric that is featured at the neckline.

Jewel A round neckline that is void of a collar. It is often worn to display a necklace.

Keyhole An open design that resembles the shape of a keyhole from which it gets its name.

Peter pan A small, flat, rounded collar.

Plunging A neckline that is low and open.

Puritan A large, flat, rounded collar.

Sailor A "V" front and square back collar, which is adapted from the Navy uniform.

Strapless Any neckline that is void of straps.

Surplice A "V" that is formed when one piece of fabric is wrapped across another on the front of a blouse or the bodice of a dress.

Sweetheart A heart-shaped neckline.

Turtleneck A high neckline that is folded over or turned down.

U-neck A collarless design that is low cut and forms the shape of a " U."

V-neck A neckline in which the letter "V" is formed.

Sleeves and Cuffs. From the fullest to the most tapered varieties, sleeves and cuffs may be both fashionable and functional at the same time.

Barrel A cuff, sometimes called a button-type, that uses one or more buttons as its closure.

Bell Sometimes referred to as a flutter sleeve, it flares into a soft, bell-like shape.

Cap A short cape design that covers the shoulder.

Dolman A sleeve design that features a wide armhole that tapers to a narrow wrist closing.

Drop shoulder The sleeve is seamed below the shoulder.

French cuff A double cuff that folds back and features eyelets or openings for the insertion of cuff links.

Leg-of-mutton Also known as the Gibson Girl sleeve, it has fullness at the shoulder that is formed through gathers, and is tapered below the elbow.

Puff A long or short, full, set-in sleeve that is closed with a tight cuff to accentuate its fullness.

Raglan A sleeve that extends from the neckline of the garment and drops over the shoulder in one piece.

Set-in A term used to describe any sleeve that is fitted and sewn into the armhole.

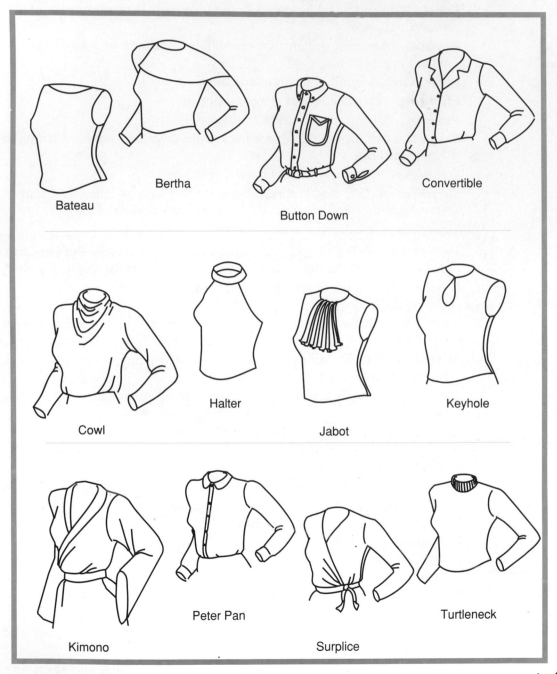

Bateau

Bertha

Button Down

Convertible

Cowl

Halter

Jabot

Keyhole

Kimono

Peter Pan

Surplice

Turtleneck

Figure 11-15 Selected necklines.

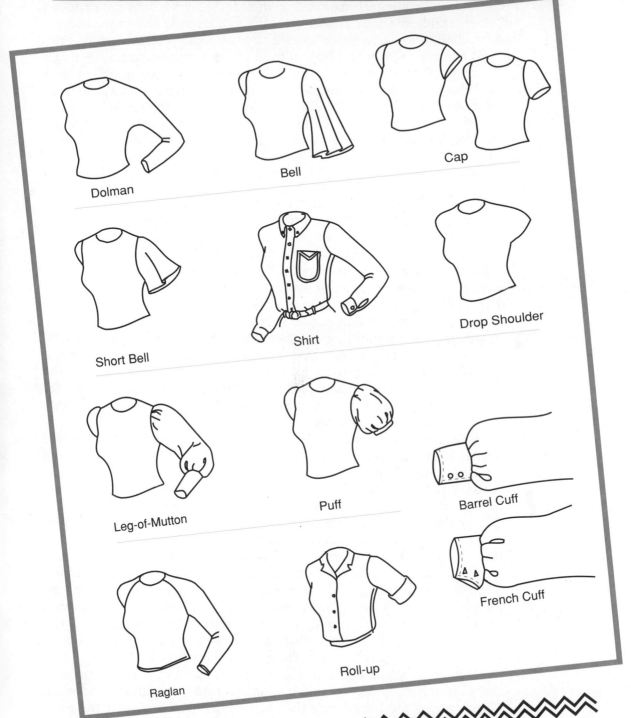

Figure 11-16 Selected sleeves.

MARKETING WOMEN'S CLOTHING

The women's apparel market is significantly larger than either men's wear or children's wear. It changes more frequently than its two counterparts, with as many as six or seven new lines being produced each year.

Internationally based, buyers from stores regularly comb the major and regional markets looking for new resources and hot items. In their own absence, they use market representatives from resident buying offices to assist them in checking out the pulse of these markets.

To successfully sell women's clothing, the manufacturers and retailers apply numerous techniques and approaches. These include the production of different lines for the different seasons, showing and selling the collections, promotional endeavors, and merchandising.

THE SEASONS

Typically, the women's industry manufactures four or five different lines each year. The number is generally dependent on the individual producer's needs and the target markets (the consumers for whom the merchandise is made). The one season that is not always addressed by some manufacturers is resort wear, which introduces warm weather merchandise for cruises and tropical climates. Only those whose product lines are at the upper end of the price point scale such as the designer and bridge classifications consider this a viable time to show a new line. Not only does it give the companies a chance for additional sales and profit, but it also serves as a testing ground for goods that will be produced for the next summer season. Lower-priced merchandise is not appropriate for resort wear because the consumers to whom it is targeted have neither the dollars nor the time necessary for vacations at this time of the year.

Fall, holiday, spring, and summer are the traditional seasons for women's wear manufacturers. Fall is generally the season in which most businesses expect the greatest amount of profit. It is longer than the others and, thus, provides the most potential for sales. Fall, however, is the time for the greatest amount of style and detail change. During this period, the designers might attempt a new skirt length or the introduction of a new pants silhouette. Radical changes are often risky, and may lead to the demise of the manufacturer who wrongly read the needs of the market. When a few seasons witness the successful marketing of miniskirts and the next introduces a longer length design, a great deal of concern focuses on the industry and its manufacturers until the style's acceptance or rejection is known. Although fashion, with its excitement and originality, is what the business is all about, innovation and change can often cause irreparable harm to manufacturers and retailers alike.

Holiday is a time when the glitter and glitz surfaces. It is a brief season that generally has its retail selling period concentrated between Thanksgiving and New Year's Eve. Many manufacturers enter this period cautiously by using successful silhouettes and styles from the fall and

embellishing them with dazzling fabrics and showy trimmings. In this way, there is some certainty to the success of these new garments. The problem with holiday collections is that once New Year's Day has arrived, the remainder of the merchandise is sacrificed at low prices.

Although the arrival of spring generally signals a time for coats to be shed and the heavy garments of winter to be stored away, the uncertainty of the weather causes considerable trouble for manufacturers and their retail customers. It was once a time when lightweight coats and suits were produced in fabrics that were less bulky than those used for fall and winter, but heavier than the ones that would be used for summer goods. Today, spring lines can provide more problems than profit. A significant percentage of the female consumers make the transition from winter to summer without stopping to purchase the in-between spring garments. This being the case, the industry, in recent years, has intentionally neglected the spring season, showing only modified lines of merchandise.

With less importance attached to spring collections, most manufacturers and retailers invest heavily in summer merchandise. The season is longer than ever before, with some lines surfacing in the stores immediately after the traditional Presidents' Day clearance sales. From then to the end of June, dresses, suits, and sportswear classifications have been joined by swimsuits and active wear. Some manufacturers introduce two summer lines, one for early delivery and one for a later period so that the store's inventories will have a fresh look.

Some women's manufacturers such as Liz Claiborne and retailers like The Limited and The Gap, who produce their own lines under private labels, have instituted merchandising policies that feature more than the traditional four or five lines. They promote six or more collections to constantly provide the stores with fresh merchandise. Some of the new goods spruce up retail environments that are loaded with leftover marked-down items. With the availability of fresh products, those who have neither the need nor desire for the shopworn items can treat themselves to something new.

SELLING THE LINE

The producers of fashion apparel reach their retail customers by a number of means. The major American manufacturers maintain permanent showrooms in the wholesale markets. The majority of those are in New York City's Garment Center, the largest of the markets. Regional markets such as The Chicago Apparel Center also house showrooms that feature the merchandise produced in the Midwest as well as merchandise produced in New York and other fashion-producing centers. In these showrooms, buyers come to inspect the lines and order merchandise that they think is appropriate for their clientele. Although the showroom is usually the place where the collections are first previewed, retailers rarely come to buy there unless their stores are in the same area.

Figure 11-17 Fashion producers sell their lines in a host of environments. (Courtesy of Larkin)

Manufacturers who do not have the capital to operate showrooms on a continuous basis opt for other means to display their wares to the buyers. They may choose to lease space in a trade mart for special times when buyers are known to visit them such as market week, an event at which the next season's merchandise is first featured, or at trade fairs such as the International Boutique Show that run for a few days in major cities.

Some buyers, particularly those who represent the smaller retailers, find it difficult to visit the market regularly, if at all, because of the expense involved and their other in-store responsibilities. To reach those companies, manufacturers employ road staffs who come to the customer's premises to show the merchandise. These sellers travel throughout a predetermined territory, carrying either the entire line or those items that have the most potential sale value. Some manufacturers use their traveling salespeople to offer trunk shows, which are aimed at the retailer's customers, to display the lines and special-order merchandise. This format is reserved for high price point merchandise and items that can be customized for the consumer.

Another method used by producers is the employment of manufacturer's reps, who operate their own showrooms and feature several noncompeting lines. The manufacturer pays a commission to the rep for everything that is sold. This technique works extremely well, especially if the rep has a good reputation in the market and has a good list of buyers who regularly visit the showroom.

Figure 11-18 The International Boutique Show is a trade presentation that features women's apparel and accessories. (Courtesy of Larkin)

PROMOTING THE MERCHANDISE

As we discussed in Chapter 6, "Fashion Advertisers and Promotion," with all of the competition in the apparel industry, companies must call attention to themselves and their products. A variety of techniques are used by the manufacturers and the retailers to motivate their potential customers.

Manufacturers stage fashion shows that range from the simple runway type to full-scale productions and run advertisements both in trade papers to catch the attention of the store buyers and in consumer newspapers and magazines to help presell their lines to the consumers. Some also provide money to their retail customers so that they will run their own ads, which might encourage business.

Retailers present special events and a variety of promotions, invest in advertising in all of the media, and operate visual merchandising departments that create interior and window displays.

PRESENTING THE MERCHANDISE TO THE CONSUMER

There are several approaches used in retailing to feature the merchandise. The traditional method is to present the goods in individual departments according to price points. Others include merchandising by collection and the use of the shop-within-a-shop concept.

MERCHANDISING BY PRICE POINTS

In most large department stores, merchants use the departmental approach for apparel such as dresses, suits, and sportswear. In separate areas or departments, the merchandise is segmented according to four basic price designations. They are designer prices, which feature the highest prices in the store; bridge prices, with concentrations on merchandise that is below the costly designer lines and above the moderately priced offerings of the industry such as Jones New York and DKNY; moderate prices, which are just below the bridge items and feature names like Liz Claiborne and JH Collectibles; and budget prices, which represent the lowest price points in the store.

MERCHANDISING BY COLLECTION

To fully promote a popular merchandise line, many retailers devote space to a particular collection. This way, a devotee of specific labels can go directly to the department that specializes in one line without having to examine the rest of the merchandise. Names like Liz Claiborne, Evan Picone, Jones New York, DKNY, and Adrienne Vittadini often have special collection areas in the stores.

SHOP-WITHIN-A-SHOP MERCHANDISING

An even greater attempt has been made to separate some women's clothing from others than that used in the merchandise by collection method. Some manufacturers such as Ralph Lauren and Esprit have special shops in the major stores that are actually separated from the rest by glass walls and special entrances. In this way, the customer has the feeling of being in a manufacturer's boutique and can easily see that companies entire collection. This type of merchandising was once reserved only for the couture collections of such designers as Yves Saint Laurent, Donna Karan, Christian LaCroix, and Emanuel Ungaro.

REVIEW QUESTIONS

1. Which two designers helped launch the sportswear industry into the prominence it now holds?

2. What has accounted for the enormous expansion of the active sportswear classification?

3. What prompted the expansion of the coat and suit industry?

4. What has enabled the swimwear industry to reach designer status?

5. When did the American woman embrace pants as a practical approach to proper dress?

6. How did Victoria's Secret help intimate apparel become a leading segment of women's wear?

7. In what way was the jeans market transformed into a major fashion classification?

8. Differentiate between *misses* and *junior* sizes.

9. How does the women's size differ from the half size?

10. Define the terms *silhouette* and *style*.

11. Discuss what is meant by clothing "details."

12. Differentiate between the *empire* and *princess* styles.

13. How many seasons are considered traditional in women's apparel? What are they?

14. Why don't all price point manufacturers produce resort collections?

15. If a manufacturer maintains a permanent showroom, why is it necessary to employ road staffs?

16. What is meant by "merchandising by collection?"

EXERCISES

1. Choose one of the basic silhouettes used in women's clothing and find styles that represent it. Fashion magazines such as *Elle*, *Harper's Bazaar*, *Vogue*, and *Glamour* regularly feature photographs of many items from which you may choose.

 Select five different styles that use this basic silhouette and discuss how each one has been enhanced by its designer to make it a unique creation.

2. Visit a large department store to determine the manner in which it features one product classification. If dresses are used, for example, indicate the specific departments that house dresses and the concept used in the merchandising of each.

3. Write to a sportswear manufacturer to determine the specific seasons for which they produce their lines and why those seasons were selected.

 The names of companies are easily found on merchandise labels and hang tags in every type of fashion retail operation.

CHAPTER 12

MEN'S CLOTHING

LEARNING OBJECTIVES

After reading this chapter, the student should be able to:

1. Assess the scope of the men's wear industry in terms of its dominant geographical wholesale markets.

2. Identify the various clothing classifications that constitute the men's wear industry.

3. Classify the different sizes and fit categories of men's wear and discuss their characteristics.

4. Describe the styles, silhouettes, and details that are used in men's fashions.

5. Discuss the methods used in the marketing of men's apparel and accessories.

INTRODUCTION

Once a severely neglected segment of the apparel industry, men's wear, with a wealth of innovative design and distinction, has taken its place as a fashion classification that rivals the women's market. Although in terms of actual size and distribution it pales by comparison to the magnitude of the women's clothing industry, its importance is evidenced by the number of manufacturers and designers who continue to address clothing for men.

Looking back in the fashion pages of history, it is difficult to find photographs or drawings of men resplendent in finery equal to that worn by

Figure 12-1 Men are no longer relegated to boring fashion apparel and accessories as evidenced by this El Paso design for Code West. (Courtesy of MFA)

women. Although some of the upper-class gentlemen had an assortment of outfits to fit various business and social occasions, their styles and silhouettes were traditionally shaped or otherwise unexciting.

Women, throughout the decades of the early twentieth century, and even before then, were the mainstays of the fashion designer. The likes of Worth, Paquin, Lanvin, Poiret, Chanel, and Dior were busily engaged in the creation of the "latest" designs to capture the female audience.

It was not until the early 1960s that the male figure was "discovered" and men were believed to be ready for the "avant-garde" or contemporary stylings that were being abundantly lavished on women. The conventional approach to fashion was now to be augmented by different trouser cuts, jackets of unconventional designs, flamboyant colorations, and fabrics that were not before considered acceptable for men to wear.

As we approach the twenty-first century, men today have all of the choices that were once left only to women. Scores of designers and manufacturers are devoting their talents to dressing the male figure. A significant number of those who once designed only for women have expanded their businesses with the addition of men's wear collections. This is often reflected by men and women, parading together on the fashion runways of the world.

Today's men's wear is a market that features the "new and daring" along with the traditional models, recognizing the fact that men are as individualistic as women in their need for fashion.

With the designers and manufacturers of fashion merchandise, including those who participate in the men's wear arena, already explored in Chapter Four, the focus of attention in this portion of the text concentrates on the scope of the men's wear industry, the specific clothing classifications, the industry's size and fit structure, the shapes and silhouettes, some of the accessories or furnishings that are predominantly male oriented, the seasonal nature of the product lines, and the trade organizations that assist in the marketing of the industry's collections.

Many of the accessories that cut across fashion lines such as shoes, jewelry, belts, watches, gloves, hats, fragrances, and trimmings is discussed in other chapters.

SCOPE OF THE INDUSTRY

As in the case of the women's apparel business, men's wear is internationally based. The markets are numerous, with some centers playing central roles in design, production, and distribution.

The United States plays the overall dominant role in this market. There are more clothing companies in America than in any other part of the world, with some foreign countries playing smaller but, nonetheless, important roles. Without question, the hub of the men's wear industry is New York City, where the hustle and bustle of the producers and wholesalers interfacing with buyers during market weeks make the city hum with excitement.

Clothing, with its fastidious, custom detailing, is as readily available in the New York City marketplace as is the abundance of lower price point merchandise. Merchants may avail themselves of almost any fashion direction that is appropriate for their customers with no need to go to another market. Those, however, who prefer to remain nearer home for the merchandise acquisition might prefer one of many regional markets. Although there is far less design and manufacturing taking place in these regional locales, many of the industry's leading companies that are based in New York City maintain permanent regional showrooms for their clients. Other men's wear firms sell to their customers via the trade show route and take up residence several times a year at convention centers and apparel marts.

Other domestic markets that produce and sell their collections outside the New York City arena include Los Angeles, San Francisco, Miami, Chicago, and Boston. Milan, Rome, Florence, Hong Kong, London, and South Korea serve as important foreign markets.

CLOTHING CLASSIFICATIONS

Most of the industry's participants concentrate on a specific merchandise classification such as tailored clothing, formal wear, or active sportswear. A few of the giants, for example, the Armani empire, are more diversified

in their offerings and have expanded their operations to run the gamut from high-fashion, elegant business suits to jeans and T-shirts in a variety of price points. Some major companies produce collections under a wide range of labels, with each targeted toward a specific market segment. Whatever the approach, the industry is involved in an assortment of product classifications.

CLOTHING

Sometimes classified as tailored clothing, this category includes coats, suits, sports coats, and dress trousers. It has remained the nucleus of the men's wear industry's offerings because a significant number of men are required to wear such attire for their careers. Although there has been less formality in appropriate attire for business, there are still parameters for men to observe in choosing their wardrobes.

The relaxing of the conventional rules has expanded tailored clothing fashions. Once relegated to the traditional two-button suit, often with a matching vest, the wearer now can choose from high-fashion double-breasted models, less structured suits, or sports coats and pants in a variety of styles, fabrics, and colors. Few companies stay within the rigid confines once dictated by this fashion segment, and they have expanded their lines as the dress codes have relaxed.

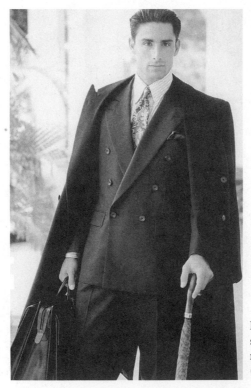

Figure 12-2 This classic yet progressive suit and overcoat by Alfred Dunhill epitomizes men's fashion business attire. (Courtesy of MFA)

SPORTSWEAR

From jeans to sweaters, sportswear production and consumption have continued to rise since the 1970s. With the aforementioned relaxing of the rules of dress, a man may opt for a more casual approach when the demands for formality are taken away. Not long ago, for example, a night at the theater or a visit to a restaurant or club necessitated more structured dress. Business suits were the accepted attire. Today, numerous men not only dress casually for such social engagements, but they choose other types of clothing.

Jeans, once considered appropriate only for performing more vigorous tasks such as gardening or boating, are now perfectly acceptable for many occasions when worn with a blazer or sweater. Calvin Klein, Levi Strauss, and The Gap continue to widen their offerings to include even greater latitude for the jeans wearer. In addition to the traditional blue with all of the variations, which include acid and stone washing and fading, Levis, for instance, feature such fashion colors as azalea, citrus, and lime. A great deal of additional experiments regularly take place to keep the jeans market a profitable venture for the industry.

A visit to most men's departments or specialty stores reveals immediately that sportswear has become a profitable venture.

Figure 12-3 Cotton canvas and denim are teamed in Ruff Hewn's sportswear outfit. (Courtesy of MFA)

Figure 12-4 The U.S. Olympic team inspired this warmup suit. (Courtesy of MFA)

ACTIVE SPORTSWEAR

Once relegated to the gym or participation sports, a number of products have become the mainstay of the wardrobes of many men who are definitely not considered active in sports. Jogging suits, tennis outfits, biking shorts, golf clothing, running gear, exercise pants, and tank tops are being worn regularly where they would once have been considered off limits. Of course, the major revenue-producing product in active sportswear is athletic shoes, once referred to as sneakers. Their importance, as well as the composition of that industry, is discussed in a later chapter dealing with footwear.

The blending of comfort and innovative styling have made this fashion classification appealing to a large audience. Men perform their supermarket chores in warmup suits, shop the mall in summer in tennis outfits, have lunch in tank tops and biking pants, or visit friends in golf attire.

Although the target market for such items was originally the younger, slimmer set, it is common today for men of all ages, sizes, and shapes to wear active sportswear. Stores that specialize in larger sizes and tall men's shops, headquarters for conservative dress, and others have joined this current trend and, therefore, have ultimately increased their profits.

Figure 12-5 The tuxedo, like this one from After Six, has become a staple in many wardrobes. (Courtesy of MFA)

FORMAL ATTIRE

Although formal attire is considered by many to be a part of the "clothing" segment, its importance in today's wardrobe necessitates its discussion as a separate category.

Formal wear was once worn only by those few men whose business and social lives required them to attend galas and other formal functions. The term *formal* meant "white tie and tails," while semiformal indicated wearing a tuxedo. Although the more formal attire was insignificant in terms of men's clothing production, tuxedos were the important components for special evening events.

Today, the "black tie" requirement has spread to all levels of socializing, with the average man often finding himself invited to social functions that request the wearing of such an outfit. Where "renting" was often the way to approach this occasional formal invitation, more and more men are finding that owning a tuxedo is an excellent investment. In fact, for many, the "black tie uniform" has replaced the necessity of the traditional black suit.

Tuxedos are produced by many manufacturers and designers in a variety of models that range from the traditional suit to the double-breasted model. Unusual fabrics and stylings are often introduced to

capture the attention of the man who feels the need to expand his formal wardrobe much the same as he does for his everyday apparel. Designer labels like Pierre Cardin, Bill Blass, Yves Saint Laurent, and Hugo Boss are all actively involved in this growing apparel segment.

OUTERWEAR

This fashion segment usually refers to those garments such as parkas, toggle coats, ski jackets, windbreakers, and any others that are outdoor oriented. Originally, they were designated for warmth or protection from the elements. The heaviest woolens, corduroys, meltons, and flannels were used in their construction. They were more functional than fashionable.

Today, this category has been expanded to include the brightest, boldest solids and plaids and fabrics that are lighter in weight but, nonetheless, warm. The layering of sweaters and shirts has enabled manufacturers to produce lighter outerwear in denims, twills, and other heavy cotton fabrics. The ability of the textile industry to produce fibers such as Thinsulate, which provides warmth without weight, has also helped to enlarge the classification's product mix.

Figure 12-6 The denim stadium toggle coat is an outdoor classic. (Courtesy of MFA)

SHIRTS AND FURNISHINGS

What was once a product that was limited to white shirts for business and dress wear and some prints and plaids for leisure time is now one that has no limits. A visit to a major store's men's wear department immediately reveals a merchandise assortment that features almost any color and pattern for career dressing and many fabrics, textures, colorations, and styles for casual attire. The plain broadcloth and oxford shirts have been joined by flannels, corduroys, denim, and others.

The success of the shirt industry may be best understood by the "names" that produce these items. Designers who once spent most of their time creating apparel for men and women are well represented in the shirt category. Beene, Lauren, Blass, Ellis, Cardin, and Saint Laurent shirts fill the counters along with the standard brands.

The furnishings designation is sometimes used to describe items such as bathrobes, pajamas, underwear, hosiery, ties, and braces. As with everything else in men's fashion, they too have evolved into a more exciting category. Ties, braces, and hosiery, for example, once basically structured additions or extensions to suits and shirts, are now making tremendous fashion statements on their own, which is discussed separately in the following section on accessory enhancements.

Figure 12-7 The Geoffrey Beene shirt and tie indicate a new fashion look for men. (Courtesy of MFA)

Underwear was once thought of as being strictly functional rather than fashionable. Along came designers like Calvin Klein who revolutionized the industry with significant changes. The common "jockey brief" offering was expanded to include more minimal coverings, and the staid, conservative "boxer shorts" became a fashion item in fabrics that now include fine cottons, rayons, and silks and colors and patterns to please almost all male types. The boxers, once shunned by younger males, have become, for many, the underpants of choice. Along with form-fitting "muscle" undershirts, they have become fashion statements.

Pajama lines have also been expanded to include newer models and fabrics than the more traditional fare. With comfort a priority for many men, "ski-types," made of knits, have been added rather than wovens in absorbent materials. Some even make the transition from the bedroom to the informal, outdoor workout.

ACCESSORY ENHANCEMENTS

Ties, braces or suspenders, and hosiery have finally found a niche for themselves in the men's fashion world. Rather than serving as functional additions to men's dress and casual wardrobes, they have made a place for themselves as fashion "staters." Who has not heard of the "power" tie that is so often worn by industry's movers and shakers?

Figure 12-8 Bill Blass enhances the business shirt with a smashing tie and braces. (Courtesy of MFA)

Many attribute the tie revolution to Ralph Lauren, who, as a salesmen in that industry, helped to introduce the "wider" tie. It immediately took the market by storm and catapulted both Mr. Lauren and the product classification into prominence in the 1960s.

The importance of the tie today has progressed even further. The names of Hugo Boss, Geoffrey Beene, Pierre Cardin, Burberry, Ermenegildo Zegna, and Perry Ellis grace ties that sell individually for as much as $100. The styles range from the more conservative, standard width "reps," which use the popular diagonal stripes, to the widest, boldest flowers and geometric forms. Along with these models, there is usually an offering of bow ties for the man who wishes to make yet another fashion statement. The bow-tie wearer who considers himself a purist always chooses the type that requires hand tying rather than the ready-made variety that is often found accompanying the dress shirt for formal wear. Although bow tying is difficult for some men to master, those who can are usually proud of their accomplishment and ready to teach novices.

The Knot Shop, a subspecialty store that sells ties exclusively, offers several thousand units in its stores. They present the tie as "philosophical accoutrements to life" rather than as everyday commodities. They subscribe to the theory that "before the world sees your car, your house or your wife's jewelry, it sees your tie."

Socks, too, once hidden under pantlegs, have now entered the fashion foray. No longer limited to basic blacks for dresswear or some subtle coloration for casual attire, the product line has taken on new dimensions. Plaids, argyles, patterns, stripes, and daring colors in a variety of fabrics cost purchasers as much as $30 per pair. They are as carefully selected by many wearers as are the pants and shoes with which they coordinate.

Braces are no longer the suspenders used to keep trousers from falling. Whereas they were once necessary for proper dress for financiers and business executives, they are now finding a way to make a fashion statement. All colors, stripes, and patterns in the "button type" or "clipons" are available in increasingly greater numbers and are attracting the attention of the younger, contemporary males, who are eager to remove their jackets in the work place so that their unique braces are exposed. Sometimes, they eventually become a wearer's trademark, as in the case of Larry King, the television interviewer, who often receives as much attention from callers who comment on his extensive collection.

At one point, these enhancements added little to the basic cost of the wardrobe. Today, however, more and more men are spending greater sums on these products, adding significantly to the total retail sale.

RAINGEAR

Classic or basic raincoats were once produced exclusively as functional apparel. Their purpose was to repel water and protect the wearer from getting wet. Khaki or tan, still the number one seller, made selection limited.

Figure 12-9 Raincoats are anything but basic as shown in this double-breasted Pierre Cardin design. (Courtesy of MFA)

In today's world of men's fashion, the raincoat has become a replacement for the overcoat or topcoat. Many come with removable warm linings and make the transition for wear in any season. Newer styles have joined the ranks of the classics, as have additional colors and fabrics.

Rain jackets, rainsuits for joggers during inclement weather, extra long coats with contrasting fabric collars, and other contemporary models have made the raingear category a more dominant fashion entry.

SIZES AND FIT

The various men's wear classifications are produced in a wide range of sizes to fit almost any customer. Whereas regulars, longs, and shorts were standard fare for suits and sports coats, the lines have been expanded to address the needs of others that are less traditionally shaped. Stores that cater to large sizes or tall men are now commonplace as are sizes that fit those other unusual dimensions. Although the availability of these different size types have made shopping easier for men and the need for costly alterations usually unnecessary, it has provided a dilemma for many merchants. Those wishing to offer a wide range of sizes for their clientele often find their space too limited to do so. Even those who manage to find sufficient room to merchandise the different "fits" come on another problem. The end of the season results in large assortments of "broken

sizes" with considerable markdowns as the only way to dispose of the remaining goods.

It is the clothing and shirt classifications that feature the most sizes and sportswear the least.

CLOTHING

Business suits, formal wear, sports coats, and coats are primarily available in sizes that represent men's chest measurements with variations that account for different heights. Regular is usually available in sizes from 36 to 46, with some manufacturers adding smaller or larger sizes to their lines. Men wearing the regular model usually stand anywhere from 5 feet 8 inches to 5 feet 11 inches. Short is the size designation for smaller men who have chest measurements that are similar to regulars except that they are usually from 5 feet 5 inches to 5 feet 7 inches. Long is for men who range from 6 feet to approximately 6 feet 3 inches and have chest sizes of 38 to 48. For those who are even taller, extra long is available for those 6 feet 4 inches or more, with chests that measure 38 to 48. Portly is a size that is geared to the man who is of average height but has a wider waistline. Stout is suited for the wearer who is short but needs a size that exceeds 48, and extra large is proportioned for the taller man with chest measurements greater than 48. Athletic cut has become a popular size range for those who have expanded their chest through physical fitness training. These physiques are usually full chested with waistlines that are narrower than the regular models afford. Before this size was recognized, wearers had to expect considerable alterations to ensure proper fit.

The following chart represents a comparison of clothing sizes.

TABLE 12-1 COMPARISON OF CLOTHING SIZES

RANGE	SIZE	HEIGHT
Regular	36 to 46	5'8" to 5'11"
Short	36 to 44	5'5" to 5'7"
Long	38 to 48	6'0" to 6'3"
Extra Long	38 to 48	6'4" or taller
Portly	(Same dimension as regular, with wider waist)	
Stout	50 or more	5'5" to 5'7"
Extra Large	50 or more	6'0" or taller
Athletic*	40 to 44	5'8" to 5'11"

* These models pair narrower waists and broader chest sizes

SHIRTS

Sports shirts and dress shirts are usually sized by two different means. The former is less complicated and offers sizes that are small, medium, large, and extra large. Because the styles and cuts are less structured, and casually worn, there is no need to complicate the merchandising of these items. On the other hand, dress and formal shirts are more carefully measured and sized. Because they are worn with ties, requiring that they be closed at the collar, and must conform to the length of the suit or sports coat sleeve, both neckband and sleeve sizes are required. To complicate matters even further, many manufacturers offer an additional size feature called "cut" that ranges from tapered to full cut. This allows for better conformity to the male chest size.

Typically, neckband sizes range from 14½ to 17 with larger and smaller available from some vendors. Sleeve lengths vary from 32 to 35 with additional lengths also available, although somewhat limited, as are neck sizes. Many manufacturers are producing shirt lines today that feature less specific sleeve lengths so that they can better control merchandising. Sleeves labeled 34/35, for example, are geared to both the 34 and 35 size. These sizes are generally reserved for less fit-conscious men and shirts offered at lower price points.

Custom-tailored shirts are becoming increasingly popular and are made to measure for discriminating wearers.

SWEATERS AND T-SHIRTS

With the use of stretch or knitted materials, there is no need to offer as exacting a size range for sweaters and T-shirts as is the case for woven shirts. Manufacturers, therefore, use small, medium, large, or extra large for those products. Because sleeves may be adjusted "up" or "down" or not at all for half-sleeves, there is no need to address length.

Some producers who cater to the tall male clientele produce knitwear that is extra long and better fits that torso.

STYLES, SILHOUETTES, AND DETAILS

Basically, every individual garment or accessory is made up of various components that, when assembled, emerge as distinctive designs. It is the manipulation and coordination of the shapes or silhouettes, enhanced by "detailing," that culminates in a style. As previously discussed in an earlier chapter, basic styles remain constant; it is their acceptance at a particular period of time that makes them fashionable. That is, a battle or bomber jacket is a particular style, one that is fitted to conform to the waistline. It does not imply, however, that it is fashion. Its style is always available for reintroduction to the marketplace by the designer.

In the context of this discussion, the term style is used to discuss a general classification of design, silhouette to denote shape, and details to indicate specific characteristics such as stitching and trouser pleats.

SILHOUETTES

Unlike women's apparel, with its significant number of silhouettes, men's wear is primarily focused on a few basic shapes. Sometimes referred to as models or "cuts," they are the traditional, contemporary, or European.

In men's suit jackets or sports coats, the traditional silhouette is one that is full cut, uses a natural shoulder line with little padding, is single-breasted, and features a single vent at the center of the base of the jacket's back. It is a comfortable fit and is perfectly suited for the larger hipped male figure. Contemporary models are more closely shaped to fit the body. The waistline is nipped in, the shoulders are slightly more padded than the traditional, and either single or double vents are used. The European shape is the most form fitting of the group. The fit is tight across the chest, shoulders are heavily padded, and the waist is snuggly fitted to accentuate the figure.

All three models are produced in single- or double-breasted versions and feature either notched or peaked lapels. Although standardization of these models were more prevalent, today's fashion creators freely take more "design license" and produce various versions of the basic silhouettes.

Trousers are primarily straight legged producing a straight line from the hip to the ankle area; baggy from the waist to the ankle forming a soft, casual feeling; bell-bottomed, with a narrowing through the hip area and flaring from below the knee to the ankle; or flared from the hip to the foot. When treated with a variety of details, numerous styles emerge. It is important to understand that although each of these is considered a shape, not each one is considered to be in fashion.

Shirts come in a narrow choice of silhouettes. They are either full or traditionally cut to serve the needs of the average body breadth; tapered, to snuggly fit the chest of the slimmer male; or somewhere in the middle and known as semitapered or semifitted. They, too, are produced in a variety of styles, the end result coming from different collars, cuff closures, and other details.

STYLES

There are numerous styles that constitute the men's wear collections. Some are basic and generally available, whereas others fall in and out of favor. The following is a list of various styles:

Coats and Jackets.

Battle jacket Adaptation of the single-breasted, waist-length, banded jacket worn by members of the American armed forces. The baseball jacket is similar in design but uses snaps instead of a zipper for closure and displays symbols, names, or numbers for differentiation.

Blazer A single- or double-breasted jacket mostly used for casual wear. The fabric and pocket detailing provide variation of the style.

Chesterfield coat or jacket Semifitted garment that is either single or double breasted. The distinguishing feature is a contrasting velvet or velveteen collar.

Duffle or toggle coat Three-quarter or knee-length coat for casual use that is constructed in a "boxey" fashion and is fastened with wooden toggles. Fabrics are usually heavy meltons or other coarse materials.

Nehru jacket A straight, form-fitting style that features a long row of button closures and a stiff, stand-up collar.

Overcoat A term used to describe a variety of heavy, warm fabric outer garments. They are worn over suits and sports coats and include such models as the chesterfield, balmacaan, raglan, and ulster.

Parka A jacket that is usually three-quarter-length and hooded.

Pea coat Generally double breasted, the garment is standard gear for American sailors. It is usually navy blue and made of a heavy material like melton.

Raincoat Single or double breasted, these garments use either water-proof or water repellent cotton fabrics to protect the wearer from the rain. Many feature removable linings and are suitable as all-weather outerwear.

Safari jacket Adapted from the garments worn "on safari," it features epaulets as shoulder design, four patch pockets, and is tied with a belt of the same fabric as the garment.

Ski jacket Originally designed for the ski slopes, the jacket has become a fashion item for casual wear. It is made of a variety of lightweight treated cottons or synthetics such as Thinsulate, which provides warmth without weight. Many are lined with down filler for extra warmth. It features a visible or a concealed hood and usually uses a zipper front.

Top coat A lightweight version of the overcoat.

Trench coat Using military detailing such as epaulets and brass buttons on a double-breasted construction, it is typically produced in water resistant materials and doubles as a raincoat.

Tuxedo A semiformal or "black tie" suit that is single- or double-breasted with notched, peaked, or shawl collars. The pants are most often of the same material as the jacket and features a satin strip of material on the each side.

Trousers.

Baggies Softly flaring out from the waistline and either snuggly or loosely culminating at the ankle, the pant is a prime example of contemporary, casual dress. Soft, drapable fabrics enhance the flow of the line.

Bermudas Short pants, sometimes called walking shorts, that end somewhere around the knee.

Continentals The waist is an extension of the narrow pantleg with the absence of belt loops. Fit is achieved with the use of adjustable side tabs at the waist.

Conventional A full-cut, loose-fitting style that has either belt loops or an extended waistband and is worn with or without cuffs. Pleated or nonpleated details are used for this style, which is most often featured as part of a dress or sports suit.

Jeans Adapted from the "dungaree" work pant, they are usually constructed from denim and feature numerous variations. They range from the narrow, straight-legged, "five-pocket" style popularized by Levi Strauss to the more "designer-oriented" models, which include baggy pantlegs, flared bottoms, or anything "inventive."

Knickers Characteristically, they are short, loose pants that gather and fit the leg below the knee. They are sometimes seen on the golf course.

Overalls Initially a style worn by farmers or construction workers, the pant is extended by means of a panel that fits over the chest. They, like jeans, are generally constructed of denim and have become fashionable with the younger set.

Shorts A shorter version of the Bermuda or walking short that ends somewhere along the thigh.

Ski pant Originally designed for use on the slopes, they are now featured for casual wear, jogging, as pajama and lounge-wear pants, and for physical fitness use. Made of knitted materials, the type being dependent on the use or activity, the waist is usually elasticized and the bottom gathered at the ankle.

Shirts.

Dress shirt A general style that includes men's long- or short-sleeved models, a variety of collars, different cuff closures, and available in different degrees of roominess.

Formal shirt Used in conjunction with "black tie" suits and "dinner jackets," the front panels are usually adorned with pleats or ruffles. The shirts are generally fastened with "studs," small jewelry accessories, at the chest and cuff links at the wrists. Collars are either winged or standard as in the case of regular dress shirts.

Ivy League Constructed of either broadcloth or oxford shirting, the style features a "button-down collar," is loosely fitted, uses a "barrel" or plain sleeve closing at the wrist, and may or may not have a loop at the yoke of the shirt's back panel.

Polo shirt A knitted, short-sleeved style that is detailed with a ribbed collar and sleeve trim.

Sport shirt A catchall term to describe a casual short-or long-sleeved shirt. They range from the form-fitting to the loose-fitting variety and are produced in a wide number of fabrics and patterns.

T-shirt Void of buttons or other closures, it is usually short sleeved, collarless, and used with any casual pants.

Western Dominated by patch pockets, snap closings at the chest and sleeves, and constructed with a yoke back, its origination came from the standard dress of ranch hands. It is also called a cowboy shirt.

DETAILS

Silhouettes and styles remain constant, but are enhanced by the use of additions, trims, or construction techniques that may be classified as details. The seasoned designer is knowledgeable in terms of "detailing" and uses one or several that may make the final garment distinctively original and functional in design.

Some of the more commonly used details are categorized under three major classifications: coats and suits, trousers, and shirts.

Coats and Suits.

Lapels They are generally peaked or notched. For sports coats, the notch lapel sometimes features an additional tab extension.

Shoulders They range from the natural, which follows the contour of the body, to the padded varieties. The padding might be slight, as in the case of traditionally cut coats and jackets, or exaggerated, as used in many European-cut models.

Pockets Three categories are generally used that serve as functional devices or mere embellishments. Patch pockets are usually reserved for sportier or casual garments and are plain, tucked, or accented with flaps. Flap styles, with concealed pockets, are mostly used for business-type suits and are either placed horizontally on the coat and suit or on the diagonal. A sleeker look is achieved with the use of insets where the pocket opening is discreetly placed and the actual pocket is inside of the coat or suit body.

Vents Suits are detailed with center vents, two side vents, or are ventless. Coats are either single-vented or ventless. The center vent is anywhere from a minimum of six to 10 inches from the hem of the garment. They are the most commonly used types. Side vents are usually deep cut, about eight or more inches, and are used in more contemporary models. Ventless detail is used for European-cut suits. It does not allow for the extra room needed for many typical male figures.

Various types of visible stitching, suede patches at the elbows, buttons, tabs at the base of the sleeves, prominent zippers, toggle closings, epaulets, piping, seaming, and other details are added to make the basics more distinctive.

Trousers.

Pockets Many are similar to those found in coats and suits, but others are also used for both decoration and function. The scoop variety is

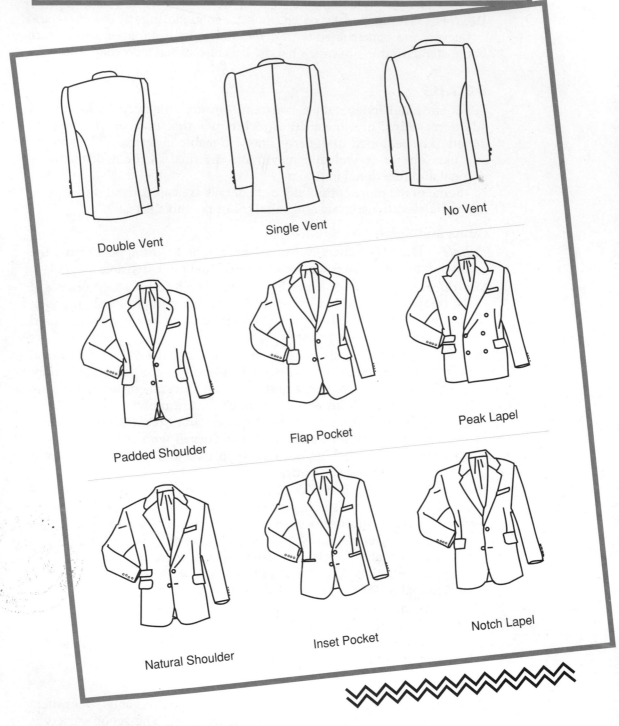

Figure 12-10 Selected coat and suit details.

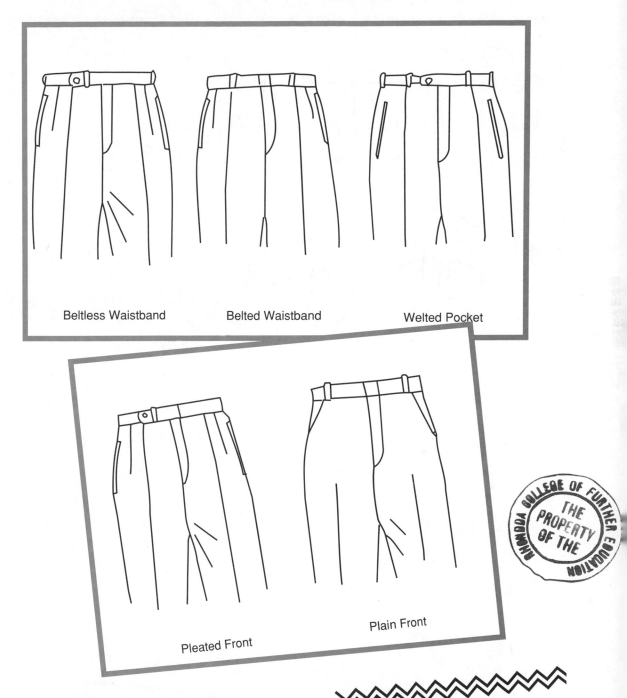

Beltless Waistband Belted Waistband Welted Pocket

Pleated Front Plain Front

Figure 12-11 Selected trouser details.

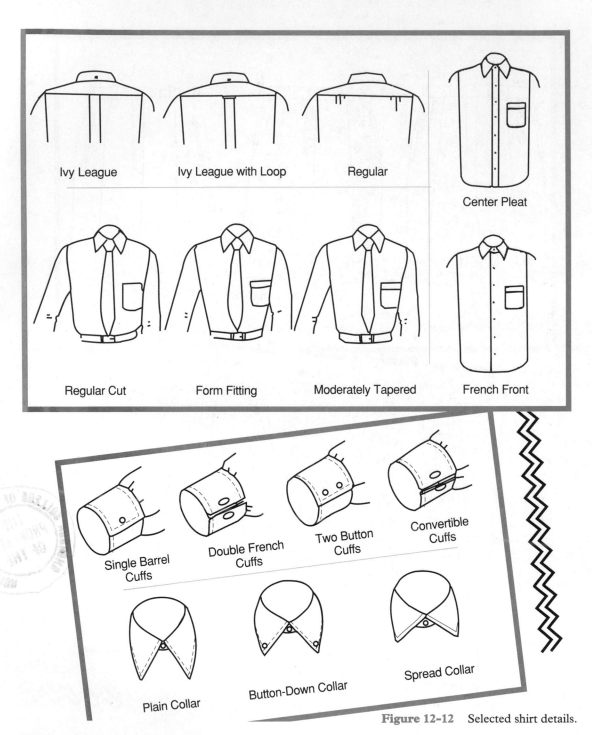

Ivy League Ivy League with Loop Regular

Center Pleat

Regular Cut Form Fitting Moderately Tapered French Front

Single Barrel Cuffs Double French Cuffs Two Button Cuffs Convertible Cuffs

Plain Collar Button-Down Collar Spread Collar

Figure 12-12 Selected shirt details.

slightly rounded, the patch comprises an additional piece of fabric, the set-in is concealed save for the welt and slight opening.

Hems Pantlegs are either horizontally hemmed, diagonally hemmed, or are cuffed.

Plain front The fabric is void of pleats and conforms closely to the midsection.

Pleated front Single, double, or triple pleats provide for additional room at the midsection and add a fashion emphasis.

Belted Loops are provided for the belts.

Beltless A sleek look that sometimes has adjustable tabs for better waistline fit.

Brace buttons Buttons are placed inside the waistline braces or suspenders.

Shirts.

Cuffs Four varieties are common for men's shirts. They are French cuffs, which have "links" for closing; single barrels, which use one-button fasteners; two-button cuffs; and convertibles, which are also worn with "links."

Fronts The center pleat uses a placket, the French type of plain overlap.

Backs The traditional or regular has a straight yoke across the top and is free of plackets or pleats, and the Ivy League variety uses a box pleat down the center and sometimes features a loop at the yoke.

Collars Numerous types are used. They include pointed, button-down, tab, spread, traditional eyelet, rounded, and winged.

The previous diagrams feature sketches of the details used in the discussion of coats and suits, trousers, and shirts.

MARKETING MEN'S WEAR

After the designer creates the line or collection and it is ready for production, it must be presented to the professional buyers. Each industry has its own procedures for the marketing of its products. The seasons must be addressed, as must the manner in which buyers are approached to view the lines, trade organization utilization, public relations assistance to capture the attention of the media and the retailer, and advertising and promotional endeavors to stimulate consumer acceptance and sales.

SEASONAL OFFERINGS

Unlike the women's wear market, which typically prepares for four or five separate seasonal collections, men's wear usually concentrates on two, fall/winter and spring/summer. This is particularly true of the clothing classification in which suits, coats, sports coats, and trousers do not

necessitate frequent change. A man will wear a heavier weight garment for the colder periods and lighter weight models for the warmer times. In fact, the styles or models do not often change, but it is the fabric selections and color choices that demand the most attention.

In sportswear, some manufacturers prepare for a third season, resort wear. Companies that invest in this season do so for two reasons. Of primary importance is the need to generate additional sales during periods that bridge the two traditional seasons. A secondary advantage in the development and marketing of resort collections is the ability to assess the performance of new products. Those that prove popular during this season are usually included in later offerings.

Some companies introduce new lines more frequently than the traditional seasons. The Gap, producers of its own private label collections, for example, presents new groups in its stores every eight weeks. In this way, fresh merchandise is constantly arriving to motivate the shoppers. Claiborne, too, subscribes to the more frequent introduction of merchandise groupings rather than staying within the rigid confines of seasonal offerings.

PRESENTING THE COLLECTIONS

The men's wear industry unveils the new seasons in one of two manners. Some companies maintain permanent showrooms at company headquarters or in regional trade marts that enable the buyers to visit them when their needs are best served. Others present their collections during market weeks at trade shows. Many companies use both formats, making certain that every prospective purchaser has an opportunity to shop their lines.

To augment these visits to the wholesale markets or regional showings, a number of men's wear firms use manufacturers representatives who feature one or more lines in their own showrooms or who call directly on the customer at the store.

Wholesale Market Showrooms. The larger designers and manufacturers maintain their own permanent showrooms in major cities. In New York City, for example, labels like Claiborne, Perry Ellis, Pierre Cardin, Bill Blass, and Evan Picone are sold in permanent sales facilities. Many of these locations are adjacent to the company design workshops where the buyers and the creators can easily interface and learn about each other's needs. Buyers can come and go as frequently as needed to inspect and order merchandise. These facilities also serve the needs of the resident buying offices or market representatives who perform specific purchasing and research tasks for retailers.

Regional Trade Marts. Some producers, with sufficient sales potential in various geographic areas, make use of the regional trade marts. At the Chicago Apparel Center, for example, companies operate branch offices that feature the lines on a regular basis throughout the year. Some of the trade marts also offer temporary facilities for trade show use.

Trade Shows. The men's wear industry, in particular, has embraced the trade show as a successful format. Where the women's wear market is considerably broader and replete with more producers, it is difficult to physically house a significant number of willing participants in one arena setting. On the other hand, the designers and manufacturers who create apparel and accessories for men are fewer in number and are more inclined to enter into trade show participation.

The trade show enables the buyers to scout the marketplace in a short period of time under one roof. Buyers with limited time to evaluate both product lines and new vendors who have recently entered the field and need to compare, firsthand, collections that are similar to each other find this to be an excellent route for merchandise acquisition.

Trade shows such as National Association of Mens Sportswear Buyers (NAMSB), Mens Apparel Guild in California (MAGIC), and THE DESIGNER COLLECTIVE are regularly presented by the men's wear industry. Some are enormous presentations. With more than 1000 individual companies showing to more than 30,000 potential purchasers, NAMSB is the largest of the shows. Financial support for the group comes from membership of store buyers. Aside from the separate booths that fill the Javits Center in New York City, the home of the show, other activities such as clinics, seminars, and fashion shows help buyers get a glimpse of the latest and the greatest.

MAGIC, the California counterpart of NAMSB, is similarly organized and emphasizes the casual offerings of that region.

Figure 12-13 SEHM, a men's trade show, in Paris. (Courtesy of ITEF)

DESIGNER COLLECTIVE is the antithesis of NAMSB. When that group grew to such proportions, a small number of designers no longer felt that the magnitude of the show served their needs. They were the creators of high-fashion, quality men's wear. The need to be more selective, in terms of admission to the group and the types of merchandise displayed led them to develop a format that accepted participants by invitation. After an applicant's collection is screened and the work is found to be appropriate for the goals of the group, he or she is invited to join. The atmosphere of the presentation is low-key, confined to a few floors at a prestigious New York City hotel, and void of the ballyhoo that surrounds the giant trade shows.

Some of the shows are international presentations with collections presented by manufacturers and designers from around the world and retailers from countries across the globe who come to patronize them. One major entry is SEHM, the Salon International de L'Habillement Masculin in Paris. Semiannually, more than 40,000 potential buyers come to Port de Versailles, Parc des Expositions to shop the lines.

Other trade expositions concentrate on narrow segments of merchandise or products from specific regions. The common denominator of all of the presentations, no matter how large or small, is customer convenience.

Figure 12-14 Men's Fashion Association preview press kit. (Courtesy of MFA)

PUBLIC RELATIONS

No segment of the fashion industry, in terms of centralized public relations, is better organized than men's wear. Designers and manufacturers, retailers, and materials producers are members of Men's Fashion Association (MFA), which, twice a year, promotes the industry to the press.

MFA hold seminars for its members to provide an overview of the market and prepare press kits that feature black and white photographs and color slides of the upcoming season's highlights. These are available to the print media for communication with the public.

ADVERTISING AND PROMOTION

To get the message across to the various levels of the fashion industry, a number of formats and approaches have been undertaken by participants of the trade, as addressed in Chapter Six. These include both print and broadcast advertising and a host of special promotions and events.

REVIEW QUESTIONS

1. Why is New York City the major wholesale market in the United States?

2. What is meant by the term *classification*?

3. List the major men's wear classifications and briefly describe the products that fall within each one.

4. Discuss why formal wear has become a mainstay in the wardrobes of many average men.

5. How has "tie merchandising" changed and why?

6. Define the term *braces*.

7. Differentiate between regular, short, and long men sizes. What are the measurements for each?

8. In what way does "athletic cut" differ from the "regular" size in men's suits?

9. Why are men's sports shirts sized from small to extra large and dress shirts more specifically sized?

10. How have some manufacturers of men's dress shirts "reduced" their size offerings yet still address the consumer's needs?

11. What does the term *silhouette* signify?

12. Discuss the major differences between the "regular" and the "European" silhouettes.

13. Define the *battle jacket*, *chesterfield coat*, *toggle coat*, and *safari jacket*.

14. What is the major feature of the "Ivy League" shirt?

15. What are design details and how do they impact on style?

16. Why do some men's wear manufacturers subscribe to seasonal offerings other than those that are traditional?

17. In what way does the wholesale market showroom differ from that of the regional trade mart?

18. List three trade shows and describe their operations.

19. What advantage does the trade show afford the buyer?

20. Who are the beneficiaries of the MFA?

EXERCISES

1. Visit the shirt department of a specialty or department store to observe this season's offering in the dress shirt category. Using this information, prepare sketches of each style that dominates the current field. The sketches should then be mounted on construction board and augmented with newspaper and magazine advertisements that feature similar models.

 The sketches should emphasize the "details" of each selection.

2. Prepare an oral report on the wholesale men's wear markets. Be sure to include the major wholesale locations as well as the regional offices. Information about these geographical locales may be secured by researching such periodicals as *DNR, M Magazine,* and many other trade papers available in libraries.

3. From various consumer magazines that specialize in men's wear such as *Esquire* and *Gentlemen's Quarterly,* gather photographs of one of the current season's trends. For example, you could concentrate on apparel, formal wear, casual attire, active sportswear, or accessories.

 Mount each photograph on a presentation panel and present your findings to the class.

CHAPTER 13

CHILDREN'S CLOTHING

LEARNING OBJECTIVES

After reading this chapter, the student should be able to:

1. Trace the history of children's clothing from the early 1900s to the present.

2. Discuss the state of children's wear manufacturing in both America and foreign countries.

3. Assess the current trends in the retailing of children's merchandise.

4. Explain the size classifications in the industry.

5. Discuss how children's merchandise is marketed.

INTRODUCTION

Whether it is the runway presentation at a children's trade show, the windows and interiors of today's children's retailers, the styles featured rival the collections earmarked for adults. The excitement generated by today's children's clothing industry is relatively new.

Photographs of children at the turn of the twentieth century reveal that, except for the wealthy, the costumes worn were anything but fashionable. Little girls and boys are seen wearing lackluster, functional apparel that was specifically made for them by their mothers or outfits that were cut down and remade from their parent's discards. Only the wealthy had the financial resources to spend on fashionable clothing, most of which was custom made.

Figure 13-1 The Teenage Mutant Ninja Turtles were the basis for a wealth of children's products.

Yesterday's children were quite different from today's younger generations. Decisions on most things, such as clothing, were made by their parents. If one were fortunate enough to get something new to wear, the selection was made by the adults

Today, with the immense offerings of television directed at children's audiences, a newfound independence has surfaced. Successful programs, such as The Teenage Mutant Ninja Turtles, are the basis for new lines of clothing. Even the smallest toddlers react to the fashions worn on the screen. By the time they are of school age, many are making their own clothing choices.

Because the children's market is made up of so many different age groups, from infancy to preteens, the offerings are quite diverse. Some manufacturers concentrate on specific age markets, whereas others cover the full range.

This chapter examines the history of the industry, domestic and off-shore manufacturing, retailer trends of merchandising children's wear, the different size classifications, and how the manufacturers market their goods.

FASHION HIGHLIGHTS OF THE TWENTIETH CENTURY

Before the twentieth century, children's fashion was restricted to mini-versions of adult attire. The clothing designs for children echoed the tastes and needs of their parents. Early in the century, however, there was

some indication that fashion would begin to play a more important role in the dressing of children.

Each decade saw the introduction of new fashions. Some reflected changes in attitude and mores, others included protests of the times, and still others were based on events that captured the public's attention.

1900S

As a carryover from earlier times, children's fashions were still confined to copies of what adults wore. Because both men and women were greatly influenced by the Victorian and Edwardian eras and their costumes reflected these periods, children's clothing followed suit. Less restrictive and confining designs would start to appear following the next decade.

1910S

At the beginning of this decade, formality in attire still reigned. There was, however, a trend to a more relaxed mode of dress when styles influenced by the movement westward started to appear. In 1915, Levi Strauss introduced denim coveralls that were both durable and functional. Little did the people of those times realize that denim clothing would later resurface and serve fashionable as well as functional purposes.

During the same time, the United States Rubber Company produced a shoe that combined canvas uppers with rubber soles. These were the original Keds that are still worn by people of all ages today. At the time, the product was also considered a functional shoe like the coveralls with which it was worn. It, too, has remained popular over the years and has been a mainstay for both athletic endeavors and as fashion apparel accents.

1920S

After emerging victorious from World War I, the nation was paused to reach out to newer fashions. Much of the industry's production would still mimic the styles of their parents; however, more relaxed silhouettes were becoming the norm.

The major innovation of the time was the flapper dress that was worn by older women as well as young girls. For the flapper silhouettes to be properly worn, the undergarments had to be radically changed. Those that were previously appropriate were too bulky for the new style. The Carter company introduced short, cotton-knit undergarments that better suit the new dresses.

Children were treated to other denim styles that were popularized by the early Levi Strauss coverall. In 1921, Osh Kosh B'Gosh, still an important children's wear manufacturer, introduced overalls for boys that resembled the ones worn by their fathers; soon after, Lee designed the first jeans to use a zipper-fly front. Boys wore baggy, tweed pants that

ranged from shorts for the younger set to full length for those in their pre-teens. Knickers, too, were fashionable for boys during the 1920s.

1930S

After the economic disaster of the crash of the stock market, the early 1930s saw little at first to change fashion. Children's clothes continued to echo their parents' wardrobes. The flapper style was a thing of the past and, soon, older girls emulated their mothers by wearing longer, leaner dresses.

Child stars and movies began to influence fashion. Little girls preferred dresses similar to the ones worn by Shirley Temple, perhaps the most famous of all child stars. The major Shirley Temple design featured red and white polka dots and became the favorite of little girls all over the world. For the first time, a major women's swimsuit manufacturer, Cole of California, offered a children's line of swimwear and sports apparel. Children of the upper class sported coats that were trimmed with fox fur.

The theatrical event of 1939 was the opening of *The Wizard of Oz*. It also played a role in promoting girl's dresses. Every young miss was eager to purchase the farm girl dress worn by Dorothy in the movie.

By the end of the 1930s, a new style was emerging in Europe. Children's close-fitting ski jackets and pants were introduced, bringing a fresh look that combined both fashion and function.

1940S

Although the United States was deeply involved in World War II, there was a continued fascination with Hollywood and its famous actors. Cowboys rode their horses on the movie screen and little boys' sweaters, fashioned after the ones worn by the cowboy hero, Hopalong Cassidy, became the rage. The western influence started to gain major acceptance in children's fashion.

Buster Brown, the shoe manufacturer, introduced a line of children's hosiery to accompany their footwear as well as a line of apparel. Out of the necessity of quickly dressing youngsters in warm clothing for middle-of-the-night trips to air raid shelters as, for example, in London, the siren suit, better known as the snowsuit, was developed. Its popularity soon spread to the United States, where it was accepted by parents as the best protection for their children from the cold winter.

1950S

Across the United States, the move to suburbia played a role in apparel design. The look became more relaxed, with denim jeans and sneakers replacing more traditional clothing. The fascination with theatrical celebrities continued to dominate the children's clothing scene when children's wear was influenced by the movie stars James Dean and Elvis Presley.

One of the big success stories came from a new use for felt. Full skirts of that material, emblazoned with large poodle appliques and worn over full crinoline petticoats, were the rage. The princess line was the shape that was most popular for girls' dresses. Saddle shoes and penny loafers were considered to be the decade's most stylish footwear.

When the occasion called for more traditional dress, boys of all ages were attired in miniature Frank Sinatra clothing that featured a three button suit and a tyrolean-styled hat. The boys were dressed as small copies of their fathers.

Some of the specific trends of the decade included mother-daughter dresses from Lanz of California, a heightening of the preference for western wear due to the enormous popularity of the westerns that dominated television, raccoon hats that emulated the one worn by Davy Crockett, coordinated beach sets that were identical to what parents were wearing, and stretch pants that would become increasingly popular with young girls.

1960S

This was an era in which children's wear took on a brand new look. Fashion trends were influenced by the Kennedy White House, its occupants being younger than any who had preceded them, and the Beatles who brought the newfound British fashions to the United States.

At the beginning of the decade, mother-daughter dresses were the rage. The styles were simple, following the designs created for First Lady Jacqueline Kennedy and her daughter, Caroline. The famous suit silhouette of President Kennedy became a favorite of men all across the country, with boys' replicas soon following.

Television made an impact on clothing for both boys and girls. Patty Duke's princess dress was quickly adopted as the party dress for preteen girls, *Leave It To Beaver* inspired casual dress for boys, and *The Monkees* television show introduced the eight-button, Edwardian-style shirt that was embraced by the boys' wear market.

With the arrival of the Beatles in the United States, boys clothing took a new turn. Not only did the Fab Four introduce the "mod-look" in apparel, but most young boys wore their hair longer and fashioned it after the cut favored by the entertainment world's new sensations.

Bell-bottom pants were introduced in 1968, and their popularity lasted well into the following decade.

1970S

This was the decade in which synthetic fibers replaced the natural ones, double knits became popular, and new standards of dress allowed girls to wear pants to school instead of dresses.

Bell-bottoms, now wider than ever, were joined by flared pants and hip huggers as the decade's most fashionably correct pant silhouettes.

Made of various types of denims and worn with midriff tops, this was one of the most successful of the children's styles.

Designer names, once reserved exclusively for the apparel worn by men and women, were introduced to the children's market. Through licensing arrangements, famous designer labels such as Pierre Cardin would be found on a wide range of clothing for the youth of America.

Again, television had a major impact on the designs of the day. This time it was the popular *Brady Bunch* that influenced fashion. Printed shirts worn with denim pants that were augmented with vinyl belts for the boys and maxidresses for the girls were worn by children of all ages.

John Travolta's *Saturday Night Fever* introduced the three-piece polyester suit that would immediately take the young men and boys' market by storm.

By the end of the decade, the designer jeans would again stir new approaches to fashion. First introduced by such names as Calvin Klein and Gloria Vanderbilt for adult styles, the fashion spread to children's wear. Where denim was once regarded as appropriate functional, casual attire, it would now be accepted as the right choice for numerous social occasions. This crop of jeans became status apparel, with the names of the designers featured on the outside of the garment for everyone to see. Not only did denim take on a new meaning, but the designer emphasis significantly increased the prices to new heights.

1980S

The eighties was a time when prosperity abounded in the United States. Children's wear business soared to new heights, as the "baby-boomers" of the 1950s met with significant monetary success and had families that the industry would target.

The advent of MTV provided new entertainers on whom children's fashions could focus. The styles sported by such performing artists as Michael Jackson and Madonna were quickly translated into apparel that the younger generation happily embraced.

Manufacturers and designers of men's and women's collections now entered this new arena with collections that featured complete assortments of apparel. Names like Boston Traders, J.G. Hook, and Ralph Lauren successfully filled this market's needs. Others, including Liz Claiborne, so prominent with adult designs, could not find their right niche and closed their children's divisions.

The three-piece polyester suits of *Saturday Night Fever,* which were so popular with boys in the 1970s, were replaced with the unconstructed silhouettes featured in *Miami Vice*.

The entertainment world still strongly influenced the inspiration of fashion design. The success of The Teenage Mutant Ninja Turtles in the movies, on television, and in comic books transferred into significant wealth for the manufacturers who were licensed to produce products

Figure 13-2 Dior, once reserved for men's and women's fashions, has now entered the children's market.

depicting the Turtle characters. At the close of the decade, *The Little Mermaid* film proved to be a licenser's dream, as manufacturers capitalized on the success of the film with a large number of thematic products.

By the close of the decade, items such as cargo pants, jams, denim overalls, Spandex bicycle shorts, miniskirts, leggings, capri pants, and athletic shoes, once reserved for the gym, were the choices of the young.

THE EARLY 1990S

As the last decade of the twentieth century began, there were many carryovers from the 1980s. Kids chose athletic footwear styles for almost every situation from such companies as Nike and Reebok.

Bell-bottoms were again introduced, but their success was nowhere near that of earlier times.

Casual wear included jeans and sweatshirts, which bore the names and logos of professional teams as well as colleges among other things, as mainstays. Baseball caps were one of the most important accessory items at the beginning of the decade.

Once again, blockbuster movies played a major role in children's designs. Both *Beauty and the Beast* and *Aladdin* served the industry well.

Figure 13-3 Colorful cartoon characters were featured in boys' and girls' wear in the 1990s. (Courtesy of Tickle Me)

The remaining years of the twentieth century will certainly bring its fashion statement to children's clothing. No one knows for certain what turns style will take.

Some of the well-known designers of children's fashions have made predictions about the future. Michael Sui forecasts that jeans and T-shirts will continue to be the nucleus of most wardrobes, with oversized and fitted silhouettes sharing the spotlight. At Osh Kosh B'Gosh, the design team believes that environmental concerns will play a role in children's clothing. They predict a leaning toward natural colors that require less dye, denim will continue as a major player, and that clothes will be functional as well as fashionable.

Only time will tell if their predictions are right!

MANUFACTURING TRENDS

A look at the Census of Manufacturing in 1967 indicated that the state of domestic children's wear manufacturing was solid. There were 2077 manufacturers producing in America that produced at least one classification of children's clothing. The census, taken every 10 years, shows that there has been serious erosion ever since. In 1977, the number fell to 1674, and in 1987, the figures were even more bleak, with manufacturers in the United States numbering 793!

These startling figures indicate that the shift from domestic production to foreign shores has been significant. Manufacturing of children's products has shifted to the Far East and the Carribean Basin countries primarily because of cheap labor. In the United States, manufacturers have to deal with the increases in minimum wages, payments for workers compensation, as well as spiraling costs of health insurance. The offshore producer's ability to better handle the intricacies required in manufacturing detailing the U.S. counterparts also contributes to the domestic decline.

Not only are the American-based manufacturers using overseas factories for their production, but most of the private label children's wear such as that sold at Gap Kids and Limited Too is being manufactured in Third World countries.

The only reasons why some manufacturers still produce in the United States are convenience and speed of delivery.

From all indications, the $20 billion kid's industry will have off-shore producers as the main lines of supply.

RETAILING CHILDREN'S WEAR

The nature of the retail segment of children's wear has significantly changed since 1974. The most notable changes show that department stores and independent specialty stores, once the backbone of the industry, have been in constant decline. Independents, or single store units, enjoyed an 18.1 percent market share in 1974. At the start of the 1990s, their share has fallen to 11.3 percent.

Department stores, too, have suffered considerably. From a market share in 1974 of 24.2 percent, 1990 showed a drop to 11.5 percent. Not only have they been hampered by the efforts of the discounters who have become key players in the game, but the demise of such stores as B. Altman and Bonwit Teller has affected this retail segment. A primary reason for the decline has been the department stores' inability to meet the price competition of the discount chains. When an economy falters, price competition becomes a major factor in some retailing. With the short life expectancy and perishibility of the product, children's wear is a natural for declining business at traditional price points.

The largest market share in 1974 was held by what is known as "The Big Three," Sears, J.C. Penney, and Montgomery Ward. At 33.3 percent, they owned a third of the entire retail market. At the beginning of 1990, that figure plummeted to 19.4 percent. Sears, in particular, has had its share of problems. To try to improve its situation in children's wear as well in its other merchandise classifications, it embarked on an everyday low-price policy to meet the discounter's prices. So far, this approach has not improved its position. The abandonment of the Sears catalog in early 1993 also makes it inconceivable for the company to maintain a stronghold in children's wear. Penney's has used another approach to regain its

place as a leading retailer. It has redirected its merchandising efforts to higher price points and more fashionable merchandise, trying to distance itself from the discounters who usually concentrate on lower price points. Montgomery Ward, like Penney's, is also trying to update its fashion image and alter its marketing strategy by directing its promotions toward children rather than the mothers.

At a sales volume of $7 billion at the start of 1990, discount stores such as K-mart, Wal-Mart, Target, and Caldors are the fastest growing retail children's segment. In 1974, this retailing classification had a 15.7 percent market share and reported an increase to 40.4 percent in early 1990. They have capitalized on the belief that more consumers wait for sales to do their purchasing and that by regularly offering discounted merchandise, they would have steady business. Their assessment of the consumer as a value-conscious customer has paid off!

In 1974, specialty chains were almost nonexistent. They enjoyed a mere 0.7 percent market share. By the start of 1990, they had increased their proportion of the business to 8.8 percent, the largest percentage increase for the time period. Companies such as Kids R Us, Holtzman's Little Folks Shops, Children's Place, and Gap Kids have caught the fancy of children's wear purchasers. Limited Too, a division of Limited, has also started to emerge as a leading specialty chain. In addition to the large amount of private label merchandise, which defies comparison shopping that stores such as Gap and Limited Too feature, many of these specialty retailers have recognized the value of catering to children while their parents shop. In-store play areas and television centers that feature an abundance of children's videos both help entertain the children and give parents more purchasing time.

MERCHANDISE CLASSIFICATIONS

The categories of children's fashions may be broken down in any number of ways. The one that is most frequently used by professionals in the field is the one chosen by *Earnshaw Publications,* the business magazine of the children's wear industry. Most of the classifications include both boys' and girls' items in every range of sizes. Some, for example, dresses, naturally represent only the girls' market.

JEANS

The single largest classification is the jeans category. Made of denim, the silhouettes range from the straight leg variety to others that include bell-bottoms and flares. Most of the styles feature fly-front closures. For small children, the waistband is often elasticized. Although denim is the sole fabric used for jeans, recent technology has given this rough, durable fabric new looks. Processes such as acid washing and tie dyeing have given the traditional jeans a new look.

Figure 13-4
Fake fur jackets
for little girls
give outerwear
a fashion flair.
(Courtesy of
Denny's)

OUTERWEAR

The range in this group includes coats, parkas, baseball jackets, ski jackets, and snowsuits.

Coats A wide range of styles that feature lengths anywhere below the knee. They are available in a variety of weights from the heaviest woolens to the water-resistant cottons and blends used for raincoats.

Parkas A three-quarter-length outergarment that usually features an attached hood and "toggle" closures.

Baseball jackets A design copied from the outerwear worn by professional baseball players. They are usually made of flannels or meltons that use two contrasting colors in the designs. Many of the styles are exact duplicates, logos and all, of the various baseball teams. From time to time, the jacket is produced in leather.

Ski jackets Originally used as standard wear for skiing, they are favorites for regular casual dress. The major feature is warmth without weight. Once produced in nylon, the newer fibers such as Thinsulate have given these styles even greater warmth and less weight than before.

Snowsuits They are produced in a variety of styles. Most are one-piece and feature zippers for easy access. A variation on the snowsuit is the bunting, which uses a "pouch" bottom instead of two pant legs. This is primarily designed for infants.

SWIMWEAR

The products simulate those worn by adults. They come in a variety of styles for boys and girls. The boys' designs are either the loose-fitting

types that resemble shorts and are available in short or longer versions or the tight-fitting versions that are fashioned after the preferred style of serious swimmers. Girls' swimsuits are either one or two piece. They feature snug fitting silhouettes, "boy" legs, or ruffled skirts.

Interest in swimwear has increased in recent years with the introduction of patterns that echo children's favorite television or movie characters.

SLEEPWEAR

The variety mostly concentrates on one- or two-piece pajamas and nightgowns. Small children's styles usually feature such favorites as The Teenage Mutant Ninja Turtles, Snoopy, or Barney. The most popular pajama style for boys resembles ski wear, with snug-fitting elasticized waists and ribbed bottoms for cold weather and short styles for summer. Whereas little girls also wear pajamas, their older sisters often prefer nightgowns.

Bathrobes are part of this classification and come in a variety of materials that include velour for warmth, terry cloth for absorbency after a bath, and lighter weights for other times.

UNDERWEAR

The majority of children's underwear is knitted. Babies and toddlers wear sleeveless shirts or T-shirts in either 100 percent cotton, which provides the most comfort, or blends of cotton, nylon, and polyester, which provide absorbency plus additional durability.

Preschool children wear sleeveless shirts or T-shirts over their underpants. Little girls' styles usually use some ruffling or trim to enhance the

Figure 13-5 A sleepwear line being sold to the retailer. (Courtesy of Denny's)

basic designs. Little boys' underpants are usually of the "brief" variety and feature popular cartoon characters of the period.

Older children continue to wear the styles worn as preschoolers, with patterns also reflecting their favorite television characters.

SWEATERS

The basic styles are either cardigans, which have button closures, or those that slip over the head. The sleeve lengths range from sleeveless to full length. The necklines are generally crew or collarless, turtlenecks or mock turtles, or collared in a variety of designs.

Sweaters are knitted and serve the wearer by providing warmth to the body. The fibers used range from the finest gauges to the bulkiest varieties. Either machine or hand-made, sweaters come in wool, wool blends, man-mades, cotton, and linen.

BOYS' SHIRTS AND TOPS

Woven skirts and knits are in this group. Most of them are knitted and come in a variety of styles. They are primarily the T-shirt types or the polo variety with small collars. T-shirts have become the number one ele-

Figure 13-6 A young scholar, dressed in a striped oxford shirt, is ready for school. (Courtesy of Cotton Inc.)

Figure 13-7 Little boys' ▶ trimmed, knitted shirt, sweater, and matching pants. (Courtesy of Health Tex)

...AND THE WINNER IS...

Thank You!
Thank You!

Tickle Me!

Figure 13-8 *The dress and pants combination is a departure from the traditional dress. (Courtesy of Tickle Me)*

ment in a boys' shirt wardrobe since the industry began to produce patterns that featured famous cartoon characters and logos of athletic teams. The polo shirt is mainly used for more formal occasions. The woven shirt has lost a great deal of appeal and is used only when the social occasion demands it.

GIRLS' SHIRTS AND BLOUSES

As with their male counterparts, girls may also select from wovens and knitted varieties. Although girls wear more woven shirts than do boys, the market has significantly shifted to knits. The designs range from the plainest crew necks and turtlenecks to the fanciest trimmed versions.

DRESSES

With the continued popularity of pants for most occasions, the use of dresses has somewhat declined. There are, however, size groups that still show an interest in dresses. Specifically, in the infants' and toddlers' markets, and the preteen category, dresses have remained favorites.

BOYS' DRESSWEAR

A relaxation of dress standards has seriously affected boys' dresswear, which includes suits, sports coats, and pants. The acceptance of a pair of jeans topped with a knit shirt has caused this decline in more formal boys'

Figure 13-9 The suspender skirt and shirt is a favorite for sizes 3 to 6X. (Courtesy of Cotton Inc.)

wear. Where dress pants and woven shirts were a must for schoolwear and a suit or sports coat and dress slacks were traditional for social functions, the less rigorous dress codes have caused erosion in this market.

ACCESSORIES

There has been considerable interest in children's accessories. They include belts, hair ornaments, handbags, hosiery, hats, and jewelry. Along with these traditional elements, a relative newcomer is the knapsack. It is both functional and fashionable. Children of all ages may be seen wearing these bags to school.

Children's accessories were favorably impacted when many licensing arrangements permitted the use of Disney, Warner Bros., and other characters to be emblazoned on the various items.

SIZE CLASSIFICATIONS

Whereas adult size categories are determined by the heights and weights of the wearers, children's sizes are generally classified according to age; that is, children pass through different size ranges as they enter each chronological age. The smallest sizes are categorized as infants' clothing and the largest is preteen for girls and student or youth sizes for boys.

Figure 13-10 The short-sleeved shirt and pull-on pants from Ocean Pacific are perfect for this little skateboarder. (Courtesy of Cotton Inc.)

INFANTS

Newborns and young infants wear sizes that are designated according to months. The smallest size is three months and progresses at three-month intervals until 24 months. Although age is specifically used as the barometer in this classification, the infants actual length and weight are also important in the choice of a particular size. Large newborns and extremely thin six-month-old children might wear the identical size. The individual sizes merely focus on typical weights for each age.

TODDLERS

When the infant sizes no longer fit, the next classification produced is the toddler size. Small children from ages of about 1 to 2½ who have been crawling for a while and are beginning to walk generally graduate to this size range. The sizes range from T1 to T4, and the styles usually have a fullness in the pants that easily fits over bulky diapers.

CHILDREN

Clothing that fits into this category ranges from about 3 to 6X for girls and about 3 to 7 for boys. These sizes are targeted toward small children who have shed their diapers. Children from ages 3 to 6 usually stay in this size range. Because the diaper is no longer needed, the trousers probably feature narrower or slimmer silhouettes.

GIRLS

This size range is produced in sizes 7 to 14 and is earmarked for girls 6 years and older. Typically, regular girls' sizes are on the narrow side. In addition to the regular size range, "chubbies" are also offered for fuller figured youngsters.

BOYS

These sizes are the counterparts to the girls' classification. They begin at size 6 and go up to 20. Because there is such variation in boys' shapes, this category is subdivided into three classifications. Regular is for the average size boy, slims for the thinnest, and husky for the chubbiest.

PRETEEN

Having outgrown the size range worn for many years, girls of about 10 to 12 years of age move into the preteen category. The sizes range from 6 to 14. Because those in this market are no longer satisfied with the styles they have worn for so long, a radical change in design takes place. Preteen clothing mimics the styles of teenagers, but in shapes that are proportioned to fit their less developed figures.

Figure 13-11 This preteen miniskirt outfit mimics the fashions of teenagers. (Courtesy of Cotton Inc.)

YOUTH

The boys' counterpart to preteen is known as youth or student sizes. They are fashioned for boys who have outgrown size 20, but have not developed enough to wear traditional men's sizes.

MARKETING CHILDREN'S WEAR

The children's wear industry is the smallest of the apparel markets. There are few major players in this industry, with the earliest dating back to the late 1890s.

Many companies specialize in a specific type of clothing and size classification, whereas the offerings of others cut across different size ranges.

The industry typically offers two major collections each year, with some introducing a third for holiday and resort. The larger manufacturers maintain permanent showrooms for their lines, whereas others are grouped together in the offices of manufacturer's representatives. The

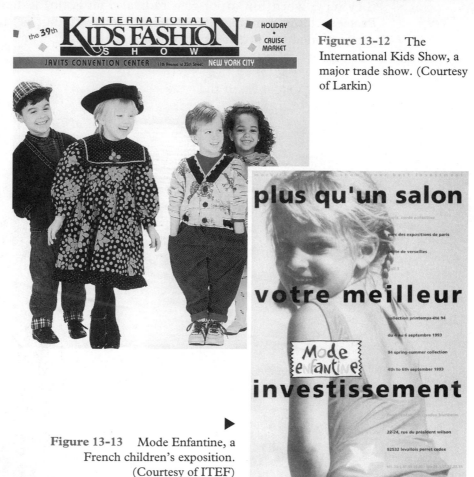

◄ Figure 13-12 The International Kids Show, a major trade show. (Courtesy of Larkin)

► Figure 13-13 Mode Enfantine, a French children's exposition. (Courtesy of ITEF)

largest of these producers maintain branch offices in regional markets across the country.

In addition to these showrooms, many children's wear firms use the trade show route to sell their products. Throughout the world, buyers congregate during children's market weeks to view the new offerings. At the typical trade fair, producers from around the globe set up booths that feature their merchandise lines.

Among the major trades shows are the International Kids Show, sponsored by the Larkin Group, and held semiannually in New York City; Mode Enfantine, a French exposition held in Paris; Modaberlin, a show that features children's clothing and accessories along with men's and women's lines; and Pitti Immagine Bimbo, in Florence, Italy.

In addition to the display of each manufacturer's lines, most of these trade expositions feature fashion shows to show the buyer the next's seasons direction and seminars that assist both manufacturers and retailers with future merchandising plans.

Although the showrooms and trade shows are used successfully in the marketing of children's wear, not every retailer visits them to make purchases. To reach that group, many companies call on potential customers in their stores. The companies' trading areas are divided into regions or territories to which sales personnel are assigned.

To call attention to their merchandise assortments, many manufacturers use trade publications such as *Earnshaw* and *Women's Wear Daily,* which have special sections devoted to the children's market, to show new merchandise to prospective customers. Some use consumer periodicals such as *Parent's Magazine* to entice consumers into asking for the merchandise in their favorite stores. Cooperative advertising is often used to entice certain merchants to feature specific items. In these situations, the manufacturers contribute 50 percent of the cost of the retail advertisement.

Although the industry is relatively small, it is highly competitive. Only those companies that market their products carefully may be the ones to get a share of the business.

REVIEW QUESTIONS

1. Which periods before the 1900s influenced children's fashions?
2. When were the first denim products offered for children, and which company was responsible for their introduction?
3. In what period was the first canvas shoe combined with rubber soles, and what were they called?
4. What was the major dress silhouette for girls of the twenties?
5. Who was the first child movie star to influence girls' fashions?
6. Name the famous movie of 1939 that influenced the style of dress for

the next few years. What specific dress style became popular because of that film?

7. In the 1940s, what theatrical trend in film influenced apparel that was worn by boys'?

8. Discuss how felt was used as a popular fabric in the 1950s.

9. What was the name given to the clothing styles worn by the Beatles in the 1960s?

10. Who was the first famous European designer to enter the children's market via licensing?

11. Who initiated the change of status for jeans in the late 1970s?

12. What fashion did John Travolta in *Saturday Night Fever* popularize for boys?

13. Discuss some of the fashion trends of the early 1990s for children.

14. For what reasons have off-shore producers captured a significant share of the children's apparel market?

15. Which major retailing classification no longer enjoys the sales volume it once held?

16. Which retailing classification has enjoyed the greatest percentage increase since 1974?

17. What is the single largest merchandise classification in children's wear?

18. What has been the greatest influence in today's children's wear styles?

19. Why has the boys' dresswear category lost its popularity?

20. Describe the wearers of toddler sizes.

EXERCISES

1. Prepare a report tracing the history of children's wear prior to the 1900s. Along with the report, drawings of the typical styles of the time should be mounted on foam board.

2. Visit a children's department in a department store and a discounter to assess their merchandise assortments. For each one, determine the following:
 a. Price lines
 b. Size ranges
 c. Merchandise assortments
 d. Merchandise arrangements
 e. Manufacturers featured

3. Visit a major children's retailer to determine the proportion of merchandise produced domestically and off-shore.

SECTION 5

ACCESSORIES AND ENHANCEMENTS

CHAPTER 14

FOOTWEAR, HANDBAGS, AND BELTS

LEARNING OBJECTIVES

After reading this chapter, the student should be able to:

1. Identify the various component parts of shoes and boots.
2. Discuss the concept of "lasting" and its importance to proper shoe fit.
3. Explain how shoe designs are transformed into patterns.
4. Describe the various manufacturing processes of shoe production.
5. Contrast the methods of cementing and stitching in the "bottoming" process.
6. Identify the various types of footwear styles.
7. Outline the procedure for proper footwear fitting.
8. Describe the best way in which to care for footwear.
9. Discuss the handbag industry and identify its various styles.
10. Explain the importance of belts as fashion accessories.

INTRODUCTION

As well-dressed men and women are being catered to in prestigious shoe salons bearing such names as Salvatore Ferragamo, Gucci, Susan Warren and Edward Bennis, Cole-Haan, and Bally, other fashion enthusiasts are steadying themselves on one foot in flea markets as they contemplate the purchase of a pair of shoes. In both of these totally different environments and in others such as department and specialty stores, consumers are shopping for footwear to enhance their apparel. Only in rare instances does the reverse take place and shoes are central to the purchase of apparel.

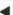

Figure 14-1 Double kiltie slip-on, by Johnston & Murphy, is a natural for the fastidiously dressed male. (Courtesy of MFA)

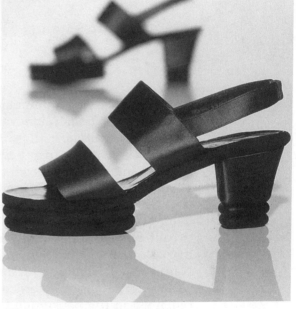

Figure 14-2 Yves Saint Laurent's version of the platform shoe. (Courtesy of Yves Saint Laurent)

Although the spectacular runway shows herald the apparel creations of designers everywhere, significantly less attention is focused on the shoes and boots that enhance and augment the clothing. Only rarely does a footwear style generate long-lasting excitement that seems to come to life over and over again. Carmen Miranda, a diminutive Latin American musical star of the 1940s, achieved greater physical stature with outrageous platform shoes. The craze immediately captured the attention of women all over the world and every decade seems to reintroduce the platform shoe. Courrèges, who helped transform couture from the traditional to the more avant-garde, gained international attention with his go-go

Figure 14-3 This handbag serves both fashion and function. (Courtesy of Coach)

boot designs that accompanied the miniskirts of the 1960s. Although these footwear fashion innovations achieved distinction, the ones that do number nowhere near those accomplishments in apparel. Since 10,000 B.C., however, when man began to construct shoes for protection of the feet, the industry has grown to one that annually produces more than 7 billion pairs of shoes. Although function remains a concern of the manufacturers and wearers, it is a business that is primarily fashion driven.

The United States Shoe Corporation and the Brown Shoe Company, two of United States' industrial giants, account for a large portion of market share with such names as Selby, Cobbie, Joyce, Naturalizer, and Natural Sport. The style designers of these companies never received the acclaim or attention afforded their counterparts of apparel design and remained in the background as the unsung heroes of their companies. Since the early 1980s, however, the industry has rapidly expanded with designer names that were once found only on men's and women's clothing labels. Recognizing that powerful fashion names could sell almost any product, it seemed natural for the world's renowned apparel creators to venture into the shoe business. Primarily through licensing agreements, the likes of Liz Claiborne, Bill Blass, Pierre Cardin, Ralph Lauren, and others grace the labels found in shoes.

Handbags, too, have made the transition from a product that was once only functionally oriented. A bejeweled Judith Leiber evening bag can command as much as $6,000, often more expensive than the dress with which it is worn. Although this is certainly not the focus of the mar-

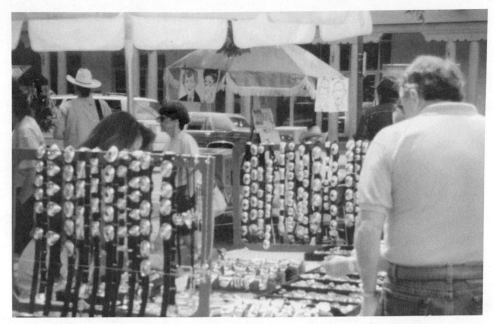

Figure 14-4 Silver concho belts are the perfect accessory for western wear.

ket, it does indicate that fashion, no matter what the product, is not bound by dollar constraints.

Although many components of the fashion industry have been plagued by counterfeits or copies, it is more prevalent in the handbag industry than in most of the others. Louis Vuitton, the world famous creator of the LV vinyl bags that sell for as much as $800, is always plagued with "camera" imitations, which line the stalls of the nation's flea markets at approximately $40 apiece. The aforementioned Judith Leiber is copied exactly, without the use of the name, for a tiny fraction of the original. Names and logos of Chanel, Gucci, Dior, and Fendi are also available in perfect copies for little money. Although such exploitation chagrins the designers, they seem to coexist with the copycats, each serving different consumer markets.

Whether it is the fine leather bag manufactured by Coach or Dooney & Burke or vinyls and plastics at the lower end of the scale, the handbag is so important to the wearer that its purchase is as carefully approached as is that of apparel.

Once merely a functional product designed to keep trousers from falling, the belt has also made the important transition to fashion. Using materials that include leather, metals, fabric, and plastics, and featured at many price points from a few dollars to several hundred, belts are also used to enhance almost every apparel classification. They, too, are bought with considerable enthusiasm from a wide range of sources and continue to grow in importance in most fashion wardrobes.

Each of these accessories will be explored in terms of construction, styles, material usage, and its importance as fashion products.

FOOTWEAR

Although the American market is still a leader in shoe production with such brands as Fomalare, Amalfe, Calvin Klein, Pappagallo, and Easy Spirit domestically produced, the industry is internationally based. Where once only the finer leather quality shoes were imported from countries such as Italy, footwear at all price points are being produced in countries other than the United States. With lower production costs abroad, many American companies have opted for participation in those locales through joint venture ownership.

Although production in America is primarily based in St. Louis, Missouri, home of the Brown Shoe Company; Cincinnati, Ohio, head-quarters for the United States Shoe Corporation; Maine, home to both Cole-Haan and Dexter; and Oregon, where Nike operates, it is New York City, with its large network of wholesale showrooms, that interfaces with store buyers from all over the world.

In addition to the traditional styles that have always been part of the fashion scene, the industry underwent significant changes in the late 1970s when a new generation of footwear emerged. Once reserved for use on tennis courts and other athletic events, sneakers made the transition from functional footwear to fashion. No longer was the "tennis shoe" appropriate only for the game, but it became appropriate gear for

Figure 14-5 The sneaker has become part of casual dress. (Courtesy of MFA)

many other uses. Today, such industrial giants as Nike produce hundreds of different athletic shoes that are equally appropriate for physical as well as social activities.

Footwear design inspiration comes from many places, with the initial signal for a particular season's styles coming from the apparel industry. Except, perhaps, for athletic wear, shoe designers must be in sync with men's and women's clothing so that the shoes will appropriately enhance the clothing. When the season's emphasis in women's apparel, for example, is light and airy fabrication and styling, a heavy, broad-based shoe would not sell.

More than any other segment of the accessories market, shoes are the most difficult to merchandise. Not only does each style require a specific range of sizes, most are produced in half-sizes in an array of different widths and colors. Thus, a particular man's shoe that is available from sizes 8 to 12, in widths from AA to DDD, and in black, brown, and cordovan requires, for one of each size, an order of 48 pairs. To make certain that a sufficient number of pairs will be available to accommodate the consumer, more than one pair must be ordered in the more popular sizes resulting in minimum orders for at least 100 pairs of a style! This not only requires a significant outlay of capital by the retailer, but must also provide for considerable inventory space. It is not unusual for the end of the season to arrive and find the retailer left with hundreds of "broken sizes" that must be sold. Because of the difficulty in shoe merchandising, the initial markups taken are generally greater than that of other fashion items.

No matter at which level of the shoe industry one participates, it is imperative that there be a complete understanding of the product including its component parts, production techniques, and styles. Through total comprehension, the sellers will be better prepared to serve the needs of their customers.

THE SHOE'S COMPONENT PARTS

The shoe is composed of three main parts: the upper, the soles, and the heel.

The upper basically consists of three pieces: the vamp, which covers the the toes and the front portion of the foot and includes the shoe's tongue; and the two quarters, which encompass its back portion. More complicated styling could add additional pieces to the upper.

The sole is actually more than one layer consisting of the insole, which lies on the inside of the shoe, directly below the foot; the midsole, another layer lying between the insole and the outsole; and the outsole, the outermost layer of the sole, the one that is thicker than the others because of the friction caused by contact with the ground.

Heels, or bottoms as they are often referred to in the manufacturing process, come in a variety of styles and heights and are the last parts to be added to the shoe.

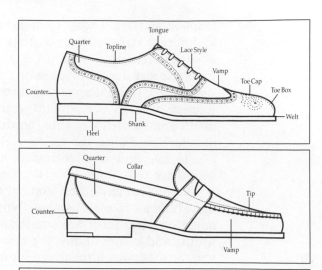

Figure 14-6 A drawing of the component parts of the man's wingtip and moccasin and the woman's pump. (Courtesy of Cole-Haan)

The assembly of these components may be achieved in a number of ways, each of which is discussed later in this chapter.

FROM CONCEPT TO CONSTRUCTION

Shoe designers, or line builders, a name used in the industry to describe the creators of the product, are responsible for styling. As is the case with designers of apparel and other accessories, their inspirations come from a variety of sources. These may come from the fashion forecasters who predict, sometimes as early as a year in advance, what trends will be favored in the companion industries such as clothing and sportswear, indicating which shoe styles might complement those designs; from a theatrical production such as the eternal favorite *The King and I,* which not only delighted audiences with the intrigues of the Siamese court, but significantly influenced shoe design at the time of its initial popularity; from a period in fashion history that may be reintroduced; or from the designer's own original creative genius.

Although fashion plays a dominant role in footwear design, it should be understood that comfort and utility are also of considerable importance. In the enormous market for athletic shoes, for example, fit and comfort are key ingredients that have been enhanced in recent years with

the addition of designer touches that embellish the numerous styles. Colorful accents and ornamentation have taken this utilitarian product and moved it to center stage in terms of overall market share in the footwear industry.

Although the designer performs the creative task, he or she generally works in conjunction with both the merchandisers who assess the needs of the marketplace and the production team which translates the styles into wearable models.

The route from the original concept to the finished product involves many stages, including the development of the designer last, the translation of the designer last into the production or development last, making the pattern, manufacturing the dies, cutting the materials, fitting or stitching, lasting, assembling the remaining components, bottoming, and finishing. Some construction is so complicated that more than 200 individual operations are involved from beginning to end.

Development of the Designer Last. After the design has been sketched, a form or last must be created on which the model shoe will be constructed. Each last embodies the style, size, and fit characteristics that will make up the finished shoe. The designer last is most often sculpted from wood by skilled craftspeople. After the last has been examined and the decision has been made to go ahead with the style as part of the line, it is then transformed into a production or development last.

Creation of the Production or Development Last. A separate last is needed for each style in every size and width that will be produced. If there are to be 50 specific size and width combinations, for example, there will be a need for 50 individual lasts.

Typically, the production last is mechanically built from polyethylene logs that are placed on duplicating lathes that copy the designer's original last. With the use of the computer aided design (CAD) system, engineers can then produce a flat representation of the last that will then be used for making the patterns.

Pattern Making. The objective of pattern making is to represent the last, which is three-dimensional, as a flat surface. There are many parts to the shoe, each of which must be made into a perfectly, accurate pattern to assure a problem-free final product. The pattern parts include the uppers, linings, insoles, outsoles, heels, and any other functional or decorative pieces.

There are several methods by which the patterns are created. One that is popular begins with wrapping the last with strips of adhesive tape that are then pencil marked to indicate the key design and reference points. The tape is then cut along the design lines and peeled away from the last and flattened onto pattern paper, where each piece is then traced and finally cut. At this point, many companies grade the patterns needed for the various shoe sizes. Once this has been completed, cutting dies must be manufactured.

Die Manufacturing. To cut through the many layers of material needed to make the shoe, cutting dies, similar to cookie cutters, are made. Sharp steel strips are bent around the various paper patterns to form individual dies for each part of the shoe.

Cutting. After the dies have been completed, they are used to cut the materials. The dies are positioned over the materials and, by means of a press, cut through one or more layers. With leather, cutting is usually done one at a time so that varying imperfections may be avoided. Manmades, on the other hand, may be cut in layers because they are uniformly produced in the factories. Where leather is cut by individual craftspeople to make certain that material use is optimized, man-mades may be cut by means of automated cutting systems that significantly speed up the process.

Fitting or Stitching. The largest number of individual operations are performed in the "fitting" room where all of the individual parts are sewn together. For example, the vamp lining is attached to the vamp, the quarter lining applied to the quarter, the quarter is sewn to the vamp, and so forth. As many as 60 individual procedures are accomplished at this stage, including stitch marking, which helps to accurately position both the upper and the other components; skiving, to reduce the thickness of leather where needed; doubling, the placement of fabric interlining

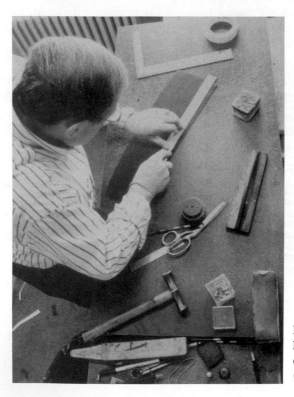

Figure 14-7 A craftsperson hand cuts the leather to produce high-quality shoes. (Courtesy of Cole-Haan)

between the upper and lining to improve comfort; eyeletting, punching holes through which the laces will be inserted; and stitching, which may be either functional or decorative or a combination of both.

Lasting. In the lasting room, the fitted upper is pulled over the last in a series of operations that makes the upper conform to the shape of the last. It is at this point that the final upper takes the shape of the shoe. A number of different lasting techniques are used, depending on such factors as the quality of the shoe and its function and appearance, with each procedure basically involving the closing of the heel area first, then the toe section, and finally closing up the sides.

The most popular lasting techniques include:

- Goodyear Welt in which the upper and sole are joined to secure a firm attachment and a smooth insole. The construction is unique in the formation of two seams in the attachment of the shoe bottom. The first is a hidden chain-stitched inseam that holds the welt, or narrow strip of leather, upper, lining, and insole together; and the second is a lock-stitched outseam by which the outsole is attached. It is considered one of the finer methods of lasting.
- Mackay lasting is achieved by tacking, stapling, or cementing the upper over an insole that is visible on the inside of the shoe and then attaching the outsole with a chain-stitched seam.
- Littleway, a method in which the sole is stitched directly to the upper.
- Cementing involves the use of adhesives rather than stitching to attach the sole to the upper.

Assemblage of Remaining Components. While the upper is being assembled and lasted, various components such as counters, stiffening

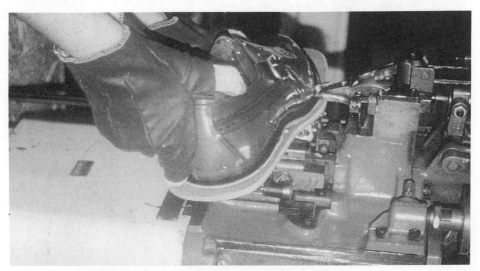

Figure 14-8 Operator stitching shoe components together.

Figure 14-9A A manufacturing plant. (Courtesy Allen Edmonds Shoes)

Figure 14-9B Lasts, the forms over which shoes are constructed. (Courtesy Allen Edmonds Shoes)

Figure 14-9C Assembled shoe uppers. (Courtesy Allen Edmonds Shoes)

Figure 14-9D Shoe uppers with inner components. (Courtesy Allen Edmonds Shoes)

Figure 14-9E Upper and sole being joined by welt method. (Courtesy Allen Edmonds Shoes) ▼

▲

Figure 14-9F Heels to be attached to shoes. (Courtesy Allen Edmonds Shoes)

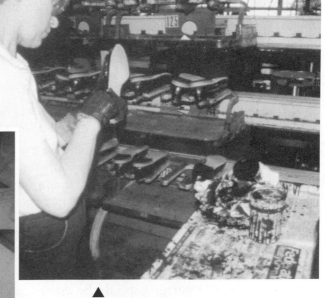

▲

Figure 14-9G Sole and heel edges are dyed to match leather. (Courtesy Allen Edmonds Shoes)

◄

Figure 14-9H The attachment of a tassel adds fashion flair. (Courtesy Allen Edmonds Shoes)

materials used to strengthen the back part of the shoe; sock linings, which cover any stitching during sole attachment; outsoles, the ones that are visible to the eye; shanks, steel pieces that are inserted into the arch of the shoe for support; and heels are being assembled.

Each of these components is needed during a specific time in the production process; therefore, timing is important to make certain that these items are ready when needed.

Bottoming. In an area called the bottoming room, the lasted upper receives shanks and fillers and is prepared for the outsole to be permanently attached to the upper of the shoe. Then heels are nailed through the insole for strength, essentially completing the shoe.

Finishing. Before the shoe is sent to the packing room to be shipped to the retailers, various final operations, collectively called finishing, take place. Among those typically used are buffing the bottoms with fine sandpaper to produce a velvety, smooth feel; polishing with wax to enhance the luster of the leather; treeing, which is placing the shoe on the form used in construction to make certain that it was properly shaped; spraying with a lustrous solution that bonds the fibers of the upper material and preserves and protects the finish; lacing and ornament attachment; and inspection to make certain that the finished product meets the company's standards.

After the product is considered ready for delivery to the customer, it is boxed and sent either to a warehouse for storage or directly to the purchaser.

CARING FOR FOOTWEAR

With the cost of shoes and boots continually increasing, a number of simple rules should be followed to extend their usefulness. Included are:

1. They should be rotated in the wardrobe. Although the foot naturally perspires and leather absorbs the moisture, time is needed for drying out.
2. "Trees," preferably made of cedar, should be used to help the shoes dry to their original shapes.
3. Leather footwear should never be stored near a heat source because this will dry the leather too quickly. Natural drying is best for the product.
4. New footwear should be polished before the first wearing, which not only will protect it but will make future polishing easier.
5. Polishing should be done with the application of small circles of paste or cream, followed by brushing, then by polishing with a fine, soft cloth.
6. Heels and soles should be regularly checked to make certain that they are not worn down past the point of repair.

JUDGING THE FIT

The first attraction to the shoe or boot is generally style, color, or fabric. It is proper fit, however, that is necessary to bring comfort to the wearer.

Figure 14-10
Shoe-care products. (Courtesy of Cole-Haan)

To make certain that the fit is appropriate, these rules should be followed:

1. Feet should be measured in the standing position; if one is larger than the other, the larger foot should be used to determine size.
2. Measurement should be made from the heel to the ball of the foot, not the toe, to assure the best fit.
3. The thickness of the hosiery should be considered during measurement because thick socks will increase the size. It is always best to wear the same hosiery during the try-on time that will be worn with the shoe.
4. The time of the day the shoe is fitted should be considered because the foot swells later in the day.
5. The toes should be wiggled to make certain that there is between ¼ and ½ inch between the longest toe and the front of the shoe.
6. Both shoes should be tried to assess fit because, often, one is larger than the other.
7. A few steps should be taken to judge slipping and comfort.
8. If the shoe pinches the foot or feels loose, another size should be tried.

STYLES

Although men's, women's, and children's footwear is available in many styles, the popularity of each is based on the fashions of the time. They range anywhere from those that are used for physical fitness activities to those that are used for formal occasions. The following list shows various styles that are traditional favorites as well as some that seem to appear and disappear according to the dictates of the fashion world.

Aerobics A term used to describe footwear that is used for walking, running, or any moving exercise. These are generally lightweight, leather or fabric constructed, designed to absorb impact to the feet, and have nonskid bottoms.

Bal A classic closed-tie shoe that is generally available in wingtip design, straight tip, saddle (where two contrasting colored leather uppers are used), and plain front.

Basketball sneaker Available with either high or low sides and in leather or canvas, its traditional appearance has been enhanced in a number of ways, including unusual color and design decorations and "pumps" that are used to increase height.

Blucher An open-tie style in which the lace stays open at the bottom of the eyelets. It is primarily worn with casual attire.

Boot A shoe that is extended anywhere above the ankle to the thigh. Initially designed for warmth and heavy-duty activity, it has been adopted by the fashion world and now accompanies any type of clothing.

Brogue A heavy oxford with decorative stitching.

Buckskins A blucher shoe made of sueded leather, available in white, tan, and fashion colors.

Clog A shoe with a heavy platform sole that is made of wood or cork.

Deck shoe A moccasin that uses lacing through the top and sides of the shoe, has nonskid soles, and is made of canvas or leather. Once relegated to use on boats, it is now a favorite for casual wear.

D'Orsay A women's pump with low-cut sides.

Espadrille A square-throated, closed-back shoe with a fabric upper and a woven hemp bottom.

Figure 14-11 The basketball sneaker is worn on and off the court. (Courtesy of MFA)

Figure 14-12 A Johnston & Murphy Nubuc blucher. (Courtesy of MFA)

Ghillie　A low-cut women's shoe that laces across the foot and onto the ankles.

Huarache　A Mexican flat shoe that uses strips of leather woven together to form the upper.

Loafer　A term used to describe any slip-on. It is similar to the traditional moccasin except that it has a sturdier heel and sole.

Mary Jane　A name for a shoe that uses a strap across the instep and has a rounded front.

Moccasin　A shoe construction whereby a single piece of leather is used for the upper, extending all the way under the foot. Generally, attached soles are made of harder leather. It is closed with heavy seaming that is often sewn by hand.

Mule　A backless slipper.

Oxford　A low shoe that features laces over the instep.

Pump　Low-cut shoe with seamless head-to-toe design.

Saddles　Shoes that feature a piece of leather extending from the shank over the throat of the vamp and upward to the quarter on both sides. It often uses a material that contrasts with the rest of the shoe.

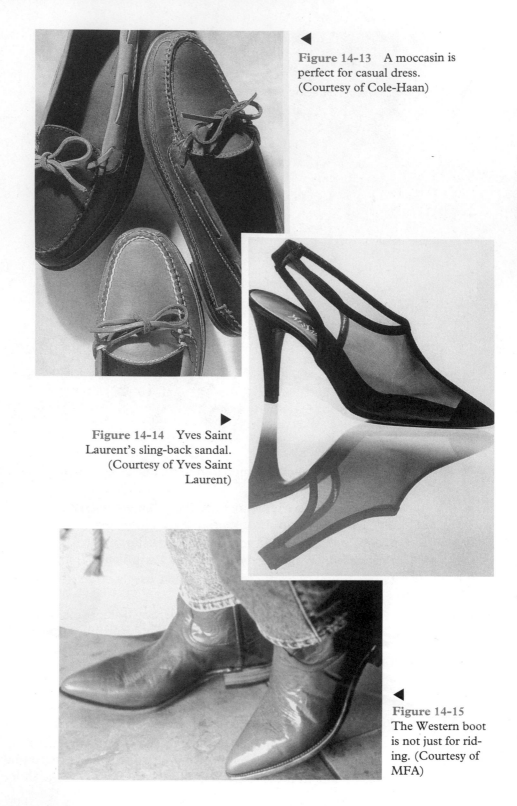

Figure 14-13 A moccasin is perfect for casual dress. (Courtesy of Cole-Haan)

Figure 14-14 Yves Saint Laurent's sling-back sandal. (Courtesy of Yves Saint Laurent)

Figure 14-15 The Western boot is not just for riding. (Courtesy of MFA)

Sandal One of the oldest forms of footwear that traditionally features a sole with straps.

Sling back A pump with a strap across the back.

Slipper A shoe worn at home.

Sneaker A canvas or leather shoe that was originally worn for sports activities but has been adapted for street wear. Its styles involve lacing across the instep and it comes in various heights.

Spectator A term used to describe a shoe with two contrasting colors that usually has a wooden or stacked heel.

Thong A sandal that uses a piece of material to slip between two toes.

Wedgie A shoe that uses a heel that extends from the back of the shoe to the ball.

Western boot A calf-high boot that has a wooden stacked heel and a pointed toe.

Wingtip An oxford that has a stitched tip shaped like a wing.

HANDBAGS

Once relegated to being only an accessory that was primarily functional, the handbag is now an important part of the fashion business. Not long ago, the industry took its cues from the apparel designers and shoe manufacturers and created products that would enhance or coordinate the designs of both. Today, although clothing design often signals the need for specific types of handbags, this alone is not the motivation for the industry to produce its wares.

The nature of the industry has radically changed from one that was unheralded in terms of designer names to today's environment in which designer labels are as important as they are to apparel. During the 1970s, much attention was focused on the handbag when the Cardin and Dior signatures started to appear on the bags themselves and not merely on the inside labels. It was a time when the famous LV logo was displayed on a vinyl collection and customers flocked to purchase them at prices that began at $200.

Recognizing the importance of the designer label, handbag manufacturers who once were more concerned with styling than making their names recognizable to the consumer entered into licensing agreements. Capitalizing on the world's best known apparel designers such as Liz Claiborne, Anne Klein, and others have helped expand the industry even more.

Many lines are now featured in separate stores or special departments within stores, borrowing from the manner in which apparel has been successfully merchandised. For example, Coach, manufacturers of fine leather handbags, operates its own retail boutiques and is merchandised in individual departments in stores such as Macy's and Bloomingdale's. Other lines such as Louis Vuitton and Fendi also command individual departments in these same stores.

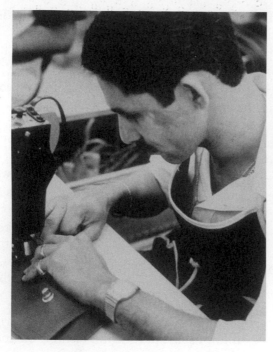

Figure 14-16 Here fine handbags are constructed by hand. (Courtesy of Cole-Haan)

New York City serves as the central point of the industry, with more than 50 percent of the companies based there. Although American production accounts for a significant amount of business, imports at all price points continue to compete for the consumer dollar. Inexpensive bags from places like Hong Kong and South Korea and costly ones bearing such names as Fendi and Gucci offer fierce competition to the domestic market.

COMPONENT PARTS OF THE HANDBAG

Using as few as three or four parts or as many as 30, the most important components are the frame, the body over which the design is constructed; gussets, side panels to allow for expansion; lining, which covers the construction stitches or glues for a neater look; handles of varying lengths and materials; and closures such as buckles, zippers, locks, clasps, snaps, and drawstrings.

The outer materials used to cover the construction include leather, which still dominates the market, vinyl, plastic, fabrics that range from canvas for casual wear to brocades for evening use, lucite, straw, and metallics.

Ornamentation may be in the form of metallic logos such as the one used to identify the Chanel collection, synthetic stones, appliques, flowers, beads, fringe, or tassels.

CONSTRUCTION

As in the case of other fashion merchandise, the designer initiates the process with a design on paper. Then, a sample is prepared in a material

such as muslin or felt and is fitted with any closures or ornamentation. After the decision has been made to go ahead with production, patterns of all of the parts are developed.

The patterns are then used to cut the individual pieces. In the case of leather, each part is individually cut so that the craftspeople can carefully avoid scars and markings inherent in the leather. The actual cutting may be accomplished with a sharp knife or by means of dies that stamp out the pieces in cookie-cutter fashion. For fabric handbags, dies may be used to cut many pieces at a time, thus reducing the cost of construction.

The pieces are then assembled by machine or by hand and made ready for the stiffening materials that will be inserted between the body of the bag and the lining to provide support; stays, plastic strips that will hold the body in shape; or fillers, often made of foam, which give the product a softer feel.

The body of the bag is then fitted to the frame and made ready to receive the handles, closures, and ornamentation.

After the bag has been completed, it is inspected and made ready for shipment to the stores. Some bags are individually boxed, whereas others are bulk packed, the determining considerations being price, quality, and material.

STYLES

As in the case of other fashion accessories, styles fall in and out of favor, with some remaining available as staples.

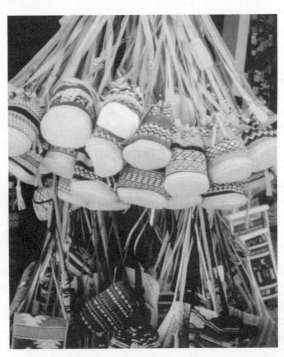

Figure 14-17 Drawstring fabric handbags.

Some of the more popular handbag styles include:

Box A square- or rectangular-shaped bag made of lucite, metal, or wood or a material that covers a rigid underside.

Clutch A bag that is free of handles and must be held or "clutched" by the wearer. Many manufacturers provide long chain or narrow leather concealed straps that may be used to carry the bag on the shoulder.

Drawstring A frameless bag that uses a drawstring as its closure.

Envelope A flat, rectangular-shaped bag that has a flap closure. As in the case of the clutch, it may be fitted with concealed handles or straps for use on the shoulder.

Feedbag Sometimes referred to as a duffle, it is a large bag that is shaped like a horse's feedbag and is carried on the shoulder.

Satchel Based on the design of a doctor's medical bag, the satchel has a flared, flat, wide bottom and is accented by two handles.

Shoulderbag Any bag that has a long strap for the carrier.

Tote Featuring an open top and two strap handles for carrying, its design is based on the shopping bag.

BELTS

No longer relegated to being used merely as a functional device, the belt now stands on its own merits as a fashion accessory. The industry is primarily centered in New York City and is made up mainly of small producers who serve the needs of two types of customers. They either create their own designs that augment the styles of the apparel market and sell to the retailers or they provide manufacturers with belts to adorn dresses, sportswear, and ensembles.

This market, as that of handbags and shoes and other accessories, has reached a new status level with the entry of designers who have made their reputations via the apparel route. Logos and signatures of such names as Gucci, Claiborne, Anne Klein, and others have helped bring the belt into fashion prominence.

CONSTRUCTION

Belts are made of a variety of materials that include leather, fabrics, metals, vinyls, and elastic. Their construction is based on the materials used.

In the case of leather, each piece is cut to the desired length or width either by hand or a strap-cutting machine. If the belt requires a shaped design, as in the case of a contour model, a die might be developed and used in place of the traditional machine that makes straight cuts. As in the case of other leather products, caution during cutting must be exercised to avoid blemishes in the leather.

Those belts that are to be backed are done so either by means of a walking-foot machine that sews the two pieces together or by gluing.

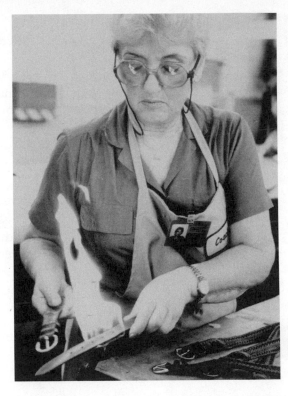

Figure 14-18 A craftsperson hand finishing a belt. (Courtesy of Cole-Haan)

The basic fabric belts are constructed in the same manner, except that many materials may be stacked and cut by means of dies, thus reducing construction costs.

After the body of the belt has been completed, decorative ornamentation such as stitching is applied. Holes, where needed, are then punched, and buckles are inserted and sewn or glued.

Today's fashion world calls for many belts that use nailheads, stones, metallics, and other adornments for leather belts as well as a variety of novelty belts that are fabric, lucite, metal, and vinyl-based. Their designs might be ethnic, such as the American Indian variety, which uses silver and silverlike materials that are augmented with real or synthetic turquoise stones; bejeweled and laden with a variety of colored stones; or anything that captures the imagination of the designer.

In the case of the cinch belt, which tightly conforms to the body with the use of elasticized materials, or the chainlink metallic, which uses a number of interlocking pieces, construction is simpler than the traditional leather variety. The cinch belt merely requires cutting the elasticized material, sewing its edges, and using snaps or other fasteners for closures. Chainlink types require fastening one link to another to form the desired length and using the excess links to interlock for the fastener. Sashes are the simplest types of belts to produce because they do not require any buckle or formal closure, but only require sewing the edges.

Figure 14-19 Belts with a Native American design.

STYLES

Some of those styles that regularly serve traditional needs and others that often follow specific fashion trends include the following:

Cinch Used to accentuate the waistline, it is generally made of an elastisized material and fitted with a buckle or snap closure.

Contour A belt that is shaped to fit the contour or form of the figure.

Cummerbund A wide fabric belt that resembles a sash. It is usually wide in the front and narrower in the back like the type used by men for evening wear.

Link Chains or metallic pieces interlock forming the belt. They are made expandable by constructing with elastic.

Rope A corded model that is tied around the body.

Sash A fabric that is wrapped around the waist.

Self Any style belt that is made of the same material as the garment that it accessorizes.

REVIEW QUESTIONS

1. Discuss the role played by apparel designers in the manufacture of shoes.
2. Explain why shoe merchandising is more difficult than that of any other fashion product.

3. Which three major pieces comprise the formation of the shoe?

4. Define the term *designer last,* and how it is generally developed.

5. Why must the "last" be transformed into a pattern before production can begin?

6. Where are the largest number of individual operations performed in shoe construction?

7. In what way does the Goodyear Welt method of "lasting" differ from the Mackay technique?

8. How are heels fastened to the shoes to assure strength?

9. Why is shoe rotation suggested to extend the life of the shoe?

10. Briefly describe the differences between the "bal" and the "blucher."

11. Describe the appearance of the "saddle" shoe.

12. Which designer names in the seventies helped bring new prominence to the handbag industry with their logos on the bags' exteriors?

13. Why are gussets used in handbag construction?

14. What is meant by the term "clutch" bag? How do some manufacturers augment the style and make them usable in another way?

15. What material is used in the "cinch" belt to make it conform to the waist?

EXERCISES

1. Select a shoe that you are ready to discard and disassemble it into its various components. Mount each piece on a board and identify it with its technical name.

 Using the visual aid you have constructed, prepare a brief talk outlining the construction of the shoe and the purposes served by each of the components you are displaying.

2. Write to a major shoe manufacturer (their names are readily available in advertisements featuring their lines) requesting photographs of the styles they produce. In an oral or written presentation, each picture should be accompanied by the types of apparel with which the shoe is worn.

3. From fashion periodicals such as *Elle, Vogue,* and *Harper's Bazaar,* clip photographs of handbags that are being featured for this season. Each photograph should be mounted on a display board and described in terms of its material and use.

4. Collect as many different belts as you can from family and friends. Each one should be used in an oral report that describes its materials, ornamentation, and uses.

CHAPTER 15

JEWELRY AND WATCHES

LEARNING OBJECTIVES

After reading this chapter, the student should be able to:

1. Discuss the various reasons why jewelry is worn.

2. Trace the history of jewelry from ancient times to the present.

3. Describe many of the processes that are used in the manufacture of jewelry.

4. List and explain many of the important types of of jewelry.

5. Explain the differences among the numerous settings used in precious and fashion jewelry.

6. Discuss the history of watches and describe the types of timepieces used today.

INTRODUCTION

When the crowned head of the British Empire presides over a royal festivity, her jeweled tiara helps set her apart from other participants; at a ceremonial rite, the Indian chieftain's squash blossom necklace, resplendent in silver and turquoise, often captures the attention of the observer; and at the fabulous French runway shows, the inventive jewelry enhances the innovative apparel.

From archaeological excavations, we have learned that jewels have been favored by humans since as early as 20,000 B.C. Long before precious and semiprecious metals and stones were used in jewelry design

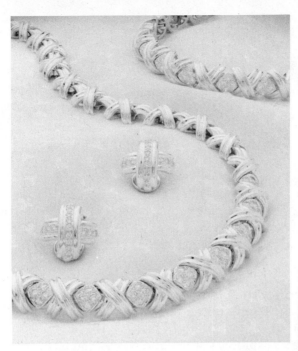

Figure 15-1 This necklace is from Tiffany & Co.'s Signature Series, a collection of classic 18-karat gold jewelry for women. (Courtesy of Tiffany & Co.)

and production, other materials such as shells, ivory, and wood were crafted into imaginative ornamentation.

Today, jewelry comes from every corner of the world in assortments that range from the rarest and costliest to the five-and-dime varieties. Stores like Tiffany and Cartier cater to the rich and famous with precious treasures that can cost hundreds of thousands of dollars, whereas at the other end of the spectrum, the second-hand shops are replete with large collections of baubles, bangles, and beads that suit every shopper's pocketbook and need.

Internationally renowned designers such as Yves Saint Laurent, Chanel, Karl Lagerfeld, and Donna Karan, who initially concentrated on apparel, ultimately entered the jewelry arena and created masterpieces that ingeniously augmented the costumes worn on the runway. Others such as Elsa Peretti captured the attention of the fashion world with inventive jewelry designs that have remained popular over time.

In comparison with jewelry, watches are newcomers. The earliest varieties first appeared in the late 1700s. Although watches are certainly functional products, a look at the elaborate designs of many timepieces immediately reveals a fashion presence. With bejeweled entries that run as high as $100,000 or more and Rolexes and Patek Philippes that often cost more than $10,000, more than telling time is on the mind of the wearers.

At the other end of the scale, a reliable Timex can satisfy a functional need for as little as $30 and, for even less, counterfeits and copies of the

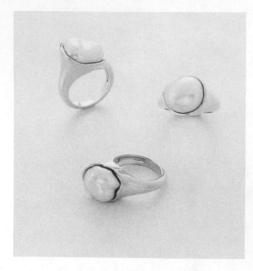

Figure 15-2 Elsa Peretti 18-karat gold and pearl rings are designed exclusively for Tiffany & Co. (Courtesy of Tiffany & Co.)

upscale signatures can easily be purchased at fairs and flea markets. As with jewelry, the offerings are vast, the styles varied, and the costs are at every price point.

This chapter explores jewelry and watches in terms of their functions, historical perspectives, styles, and manufacturing processes. The materials used in their manufacture were explored earlier in Chapter Ten, "Metals and Stones."

JEWELRY

Many people think of jewelry as an enhancement that merely plays a subordinate, aesthetic role to fashion apparel. Although adornment is, in fact, the major purpose of jewelry, it is not its only purpose. The decorative belt buckle not only provides a fashion statement, but it serves a functional purpose. The ornate pin, while playing a fashion role, also serves as a fastener.

Jewelry has also served more sinister purposes. In medieval times, rings with hidden compartments have been pictured as vehicles in which deadly poisons were stored.

As symbolic gestures, various designs have had their places in history. In the mid-seventeenth century in England, funeral rings were worn to commemorate the deaths of the aristocracy. Today, antique shops sell these rings not for mourning purposes, but purely for their artistic nature.

No piece of jewelry has more symbolic meaning than the rings that identify a betrothment and marriage. For generations, women have displayed their engagement rings with pride that defies comparison with any other accessory. The wedding ring, from the simplest band of gold to the most elaborate jewel-encrusted varieties, indicates membership in a select institution.

Figure 15-3 Copies of expensive watches are sold at flea markets.

Even religion continues to play an important role in jewelry. The Star of David has been crafted in both realistic and stylized versions in materials that range from precious metals to plastic, wood, and stone. The cross remains a big seller and is often used as a fashion piece. Madonna, for example, sometimes incorporates large crucifixes into her performance costumes.

Pins have routinely identified people's affiliation with fraternal orders, rings have been served to commemorate achievements such as graduation from educational institutions, and all kinds of ornamentation have been used for magical and mystical rites.

Although jewelry plays an important role in denoting status, underscoring symbolic meaning, connoting magic, and providing utilitarian function, its use as ornamentation makes it one of the major components of the fashion industry.

A HISTORICAL OVERVIEW

Jewelry has had a meaningful presence in every culture since the beginning of time. From the most primitive designs that used nothing more than common materials to the intricately detailed intrinsic works that used precious metals and stones, jewelry has made its mark in every era.

In all parts of the world, archaeologists have uncovered caches of precious rings, pendants, bracelets, and necklaces of gold and stones that were produced by techniques that we still use today.

Some of the earliest finds came from Mesopotamia, a region between the borders of Syria and Iran. The Philadelphia Museum houses some of

Figure 15-4 The engagement ring symbolizes betrothment.

the treasures from that region that feature hammered gold and the semi-precious lapis lazuli stones. Museum shops all over the world feature reproductions of those models, and artists today still draw on these designs to create updated precious and costume versions. The people who inhabited the Mesopotamian region were called Summarians and they produced jewelry in many styles. Most notable were leaf designs, abstract flowers, animals, and the symbols that were to become known as the signs of the zodiac.

At about the same time the Summarians were developing their designs, Egypt was producing remarkable jewelry. Early metallic engraving and embossing were used in Egyptian designs as were a wealth of stones such as lapis, turquoise, and carnelian. The many gold mines of Egypt offered a wealth of precious metal in which the craftspeople could toil. The jewelry of ancient Egypt featured animal-headed gods and goddesses, the eye, the papyrus blossom, and the ankh.

In approximately 700 B.C. Greece, simple jewelry designs were introduced. The offerings were mainly gold or silver or a natural alloy of both precious metals known as electrum. The objects were mainly cast or made of woven chains. The most popular items of ancient Greece were earrings. The designs featured animal heads and human and mythological figures. Later in the Greek era, pendants, pins, bracelets, and rings also came into prominence. In addition to the gold varieties, an enameling technique was developed that permitted color to be added to the jeweler's creations.

The Far East has contributed a great deal to modern-day jewelry. Although some of the treasures from that part of the world date back to 1000 B.C., it was not until the seventh century that jewelry of that region made its mark. Initially, hair ornaments, rings, and bracelets were made

Figure 15-5 Arms full of bracelets make a fashion statement. (Courtesy of Karl Lagerfeld)

by soldering and hammering. The great period of Chinese jewelry was created from A.D. 960 to 1279. Hair ornaments remained the major adornments and were crafted from both gold and silver. The forte of the period was workmanship rather than valuable materials, although jade was prominent in many of the creations. Jade has remained the mainstay of Chinese jewelry.

Rounding out the Far East offerings were those that had their origins in India. Since the 1700s, enormous amounts of real and intimation stones were the centerpieces of the designs. Superstition was often the basis of these styles, which have not undergone changes since they first appeared. When metals were significantly involved, they were generally unpolished, leaving the impact of the pieces to the stones they encased. Aside from the traditional necklaces, bracelets, and other items, Indian jewelry concentrated on nose ornaments and toe rings, atypical of the offerings of other cultures.

Beginning in the early A.D. 300s, European jewelry creation was centered in Byzantium, Turkey, a sophisticated urban center. High standards and expert workmanship were commonplace, with architectural design at the forefront of the styles. Tremendous pendants were held by intricately detailed chains, and colorful enameling played an important part in the creations.

It was trade with the Orient during the thirteenth and fourteenth centuries that provided Italian craftspeople from Genoa and Venice with materials that would become the basis for elaborate jewels. Gold, silver, and bronze were used to house fabulous diamonds, rubies, and sapphires in necklaces.

During the Renaissance period of the fifteenth and sixteenth centuries, elaborate versions of religious symbols were commonplace.

Figure 15-6 This pendant features the "ankh" sign, meaning life. The original, from which it was taken, dates back to 1500 B.C. in Egypt.

Figure 15-7 The goddess Hathor was the inspiration for this Egyptian pin.

Figure 15-8 The kétos, or sea monster, used in the design of this pin, is a Greek mythological figure.

Figure 15-9 Renaissance jewel earrings were inspired by a motif on a robe worn by Pope Alexander I.

Stylized crosses and other biblical symbols were evident in pendants. Base metals were replaced with gold and silver, and precious stones took a prominent place in jewelry design. The compositions of the time included vast numbers of pictorial subjects such as classical figures. Portraits of rulers and popes were painstakingly carved into intricate designs.

The lavishness of Baroque jewelry came into prominence in the seventeenth century. Grand, ornamental designs that reflected the art of the period were evident in jewelry. During this time, faceting was used to increase the brilliance of the stones, and diamonds overwhelmingly dominated the scene. The precious metals were now only used to encase the stones, and the larger the stones, the more important the pieces. Intricate design gave way to a preference for bigger and bigger stones.

The eighteenth century saw the introduction of the Rococo style in Europe that underplayed the lavishness of the Baroque signature. The designs were asymmetrically balanced in mostly pastel colors. Even though the Rococo designs were lighter in feeling, they, too, were somewhat elaborate.

At the end of the nineteenth century, neoclassicism, with regard for simple designs of materials like steel, was a relief from the more ostentatious varieties that had come before it. It was the basis for much of the contemporary design we find in today's jewelry offerings.

During Victorian England in the nineteenth century, new technology led to a turn in jewelry production. Rather than using only precious metals, electroplating base metals with thin layers of gold and silver made jewelry an affordable item. Lockets and brooches were popular, and themes of hearts and clasped hands were symbolic of the time. It was a period when jewelry became available for the masses.

The twentieth century afforded wearers Art Noveau and Art Deco designs. The former's themes were often concentrated on lilies, water, butterflies, peacocks, and women with long, flowing hair. The latter avoided the subjects of nature that were evident in Art Noveau pieces in favor of pieces that used geometric patterns.

No history of jewelry design would be complete without the study of native jewelry. In both Africa and America, native craftspeople made their marks with specific designs.

African jewelry was prominent in Europe in the eighteenth and nineteenth centuries as a result of trade. Gold was either cast or hammered and made into ornamental disks, masks, and human forms. Ivory played an important role in African design, where it was combined with brass and copper.

Native American jewelry, or Indian jewelry as it is commonly called, has a significant place in the industry. Each tribe contributes a specific

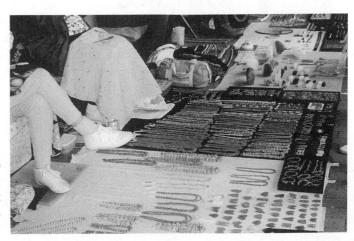

Figure 15-10
Native American jewelry at a street fair in Santa Fe, New Mexico.

style that represents its own culture. These include bangle bracelets, necklaces, earrings, brooches, rings, and belt buckles that combine metals with stones. Some of the more typical Native American designs are squash blossoms, which are necklaces of hollow silver beads embellished with turquoise, and conchas, oval silver pieces that are strung together for belts.

Most popular are the Navajo designs that emphasize heavy silver in symmetrical patterns; Zuni, a more delicate style using stones that are inlaid into metal; Hopi, which features a popular technique that joins two layers of metal and cuts a design in the top layer to expose the one beneath; and Santo Domingo, which primarily focuses on beadwork.

Each historical period has brought a distinct dimension to jewelry design. Today's industry draws from these various eras and either reproduces designs as they were originally created or translates the patterns into creations that fit today's life-styles.

PRODUCTION TECHNIQUES

After the design has been conceived and sketched, it is ready to be transformed into a piece of jewelry. Through the ages, various techniques have been used for this transformation, including hand crafting, die striking, and casting. Variations of these techniques come at the hands of knowledgeable craftspeople who use their own expertise and ingenuity to create both precious and fashion or costume jewelry.

In Chapter Ten, "Metals and Stones," the basic terminology related to these materials has been explored. Those techniques such as annealing, forging, embossing, and engraving are prominently used in the manipulation and formation of the materials used to form jewelry.

Some of the machine and hand production techniques include:

Fusing By liquefying metal under intense heat, two pieces may be joined without the use of any adhering material. The carefully controlled temperature and amount of heat used contributes to the success of the fusing.

Soldering The soldering process requires the use of a separate metal that has a lower melting point. The solder must be of the same color and strength of the two metals to be joined so that it will be unde-

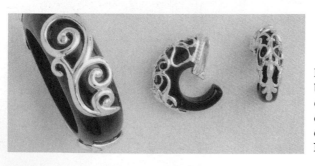

Figure 15-11 Resin bangle bracelet and earrings are enhanced with a metal design that was achieved by casting. (Courtesy of Neiman Marcus)

Figure 15-12 The shape of this enamel pin was achieved by hand cutting.

tectable on examination. The two pieces to be joined may be held in place by means of wire, steel pins, soldering blocks, or plaster, depending on the type of solder to be used and the size of the piece.

Drawing wire Many types of jewelry use metals that have been drawn into wires so that they can be used to form different designs. The drawing involves the taking of heavy-gauge wire and reducing it to the desired thickness. The thicker wire is forced through a device called a drawplate, which has larger holes on one side and smaller on the other. The thick wire is forced through the wide opening and drawn with pressure until it leaves the other side with its reduced thickness.

Rolling metal Through the use of a rolling mill, an ingot or heavy piece of metal is transformed into either sheets or wires of any desired thickness.

Metal bending Metal is often bent by means of square-nosed pliers to achieve specific curves or angles. If the piece of metal is very wide, a machine called a brake is used to bend the sheet.

Repousse Metal can be formed by this important method. Unlike bending, which merely turns angles or curves, repousse consists of working a flat piece of metal with hammers into a hollow, three-dimensional shape.

Cutting The cutting process may be achieved with shears that cut through the metal; sawing, when a precise cut must be made; drilling holes, when metal must be cut away; or carving, where the metal may be manipulated through the use of chisels.

Hammering When a variety of textures is required, different types of hammers may be used to create the desired effect.

Die-striking When a number of identical pieces must be produced, the metal is shaped with the use of a mold or form. They are placed between the dies and squeezed into shape by means of a hydraulic press at extreme pressures that sometimes reach 25 tons per square

inch. This production technique results in extremely strong, high-quality settings that are used for rings.

Casting This process involves making a cast or mold into which molten metals are forced. The mold is then immersed into cold water where it eventually breaks, leaving the newly cast metal in the desired shape. The piece is then cleaned and polished before it is used in the finished product.

Hand manufacturing When unusual designs, limited numbers, or intricate designs are desired, hand manufacturing is used. It involves one or more procedures already described such as sawing, drawing, hammering, or soldering.

STONE SETTINGS

Rings, pins, bracelets, and other jewelry pieces often combine metals and stones. The setting used for a stone is dependent on the value of the stone, its security, and the ultimate price of the finished piece.

There are many different types of jewelry settings. Some of those most frequently used include the following:

The *Tiffany setting* is typically used for stones that are to be prominently displayed without the intrusion of too much metal. It uses four or six prongs or projections in V-shaped openings that press against the stone and secure it in place. It is the most popular setting for diamond engagement rings.

The *buttercup head setting* also uses the prong configuration. It has six prongs that rise from a scalloped base and resemble a flower bud. These forms are generally used for pendants and earrings.

The *illusion head* is used to give the impression that the stone it holds is larger than its actual size. It uses a metal border that features a design or texture that surrounds the prongs. This patterned design creates the illusion of a larger stone.

When a number of tightly arranged stones are used to form a closed symmetrical pattern, a *cluster setting* is the choice. Generally, six stones are used to surround one in the center, which may be larger than the oth-

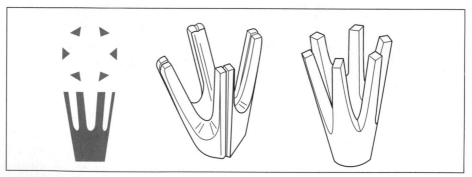

Figure 15-13 Two Tiffany settings, four-prong and six-prong.

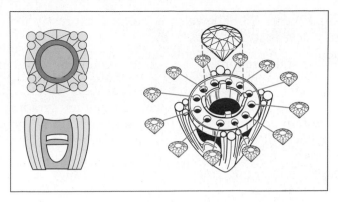

Figure 15-14 Illusion settings.

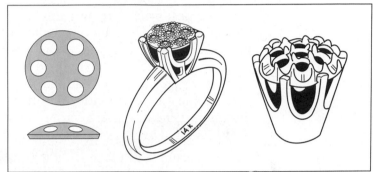

Figure 15-15 Cluster settings.

ers or the same size. For variation, two or more tiers of settings might be stacked one on the other to give the piece a more dramatic effect.

The *pavé setting* has extensive blank areas that are tooled into little beadlike surfaces that surround a number of small stones. The area is literally paved with stones and, when featured in combination with the metallic beads, gives the surface a brilliant effect.

In the *channel setting,* the stones are lined up next to each other with no metal between them and set into grooves or channels.

The *bezel setting* holds a stone in place by a rim of metal that goes around its entire perimeter. It is sometimes called a flush setting.

In inexpensive rings and other jewelry ornaments, *paste settings* are routinely used. The stones, rather than being held in place by metallic prongs or other projections, are actually glued into the setting. The disadvantage of this type of setting is that the stones often become dislodged and fall out.

JEWELRY STYLES

Precious and costume jewelry come in any number of styles. Each serves a functional or decorative purpose. The popularity of a given style at a particular time depends on the materials used in its manufacture, the dictates of the fashion world, and whether or not it is considered standard,

traditional wear. Some jewelry is created expressly for either men or women, whereas some serves both.

The following list represents various jewelry styles:

Rings Bands that are worn on fingers, rings come in many materials and designs. They range from the traditional varieties that are of special significance such as marriage, engagement, graduation, or signets that contain crests or initials to the more decorative types such as dinner or cocktail rings that feature an assemblage of precious or semiprecious stones in dramatic arrangements. Often, when fashion is favorably focused on rings, several of them may be worn on the hand at one time.

Bracelets Ornaments that encircle the arm or wrist, they come in the bangle types, which slip over the hand and onto the wrist, or the flexible varieties, which are constructed of metal links or chain. Charms that offer special meaning to the wearer are sometimes added to the chain or link bracelets. To make the bangle bracelet an easier fit on the arm or wrist, hinges are added to the design. The most expensive bracelets feature diamonds and other precious stones. Contemporary designers generally use a variety of materials such as plastic, brass, wood, colored beads, or glass in bracelet designs.

Necklaces Available in a number of different lengths and materials, they are worn as decorations around the neck. Traditional precious necklaces may be constructed of diamonds, rubies, emeralds, sapphires, pearls, gold, or silver. The costume or fashion varieties are available in semiprecious stones, metal alloys, beads, or other materials. The closest fitting type is the *choker,* which sits snugly atop the collarbone. It might be single or multistranded. Multistranded necklaces that hug the

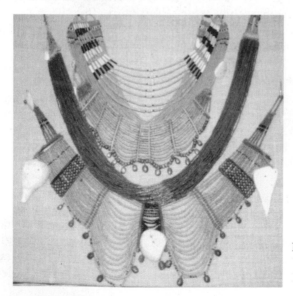

Figure 15-16A Multistrand beaded necklace. (Courtesy of Larkin)

Figure 15-16B Rope necklaces.

base of the neck are called *bibs*. Longer lengths are called *matinee neck-laces* and range from 22 to 24 inches long, whereas even longer ones are called *opera lengths* and range from 30 to 32 inches. *Ropes* are necklaces that are as much as 45 inches long and may be wrapped around the neck to give the impression of more than one necklace.

Brooches Ornaments with pin backings are called brooches. They come in many sizes, styles, and materials. Typical variations include *lapel pins,* which are used as decorative ornamentation on suit lapels, and *stick pins,* which are usually elongated decorative types.

Earrings The three major classifications of earrings are categorized according to the manner in which they are affixed to the ears. *Clip-ons* and *screwbacks* grip the ears, whereas the *pierced* variety use posts that pass through the earlobe and are held in place by means of small screws. The designs range from the types that fit against the earlobes and are known as button or ball earrings to those that extend from the lobes and are called drop earrings. This latter design often features hoops in many different sizes or extra long styles that are called chandeliers because they sometimes resemble miniature, ornate lighting fixtures.

During the late 1980s, the popularity of earrings increased as more and more men began wearing them. Those men who favored this form of jewelry generally chose one earring, but in the 1990s, an increasing number of men began to wear earrings in pairs.

Earring jackets Some earrings are made with holes in their centers so that small studs may be inserted into them. These studs are often small diamonds or other precious and semiprecious stones that may be changed to suit different needs.

Barettes These are hair ornaments that have clasps into which hair may be secured. They can be used either alone to accent a ponytail hair design or in pairs when braids are worn.

Ankle bracelets Sometimes called slave bracelets, they are usually thin chains that are worn on one ankle.

Charms Pendants that come in a variety of forms and are made of metals, often impregnated with stones, depict a variety of images. They include animals, hearts, initials, and religious symbols. The charms are generally suspended from a bracelet.

Cuff links Used with French cuffs, they are designed as cuff closures in place of buttons. The base of the shirt sleeve is produced with an opening through which the links are passed and fastened.

Tie clips These devices clip onto the tie and hold it in place. A variation is the *tie tack*, which is a small device with a post that passes through the shirt and tie and is held secure with a screw backing.

Tiara A head ornament that resembles a crown. It is usually jeweled and worn as an accent to a formal gown. The tiara is a version of the crowns worn by royalty.

Shirt studs In place of the standard buttons that fasten the shirt's opening, formal shirts are usually designed with openings into which

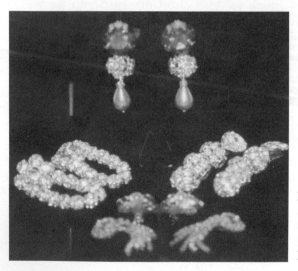

Figure 15-17 Ornate earrings and necklace enhance this Yves Saint Laurent couture design. (Courtesy of Yves Saint Laurent)

Figure 15-18 Men's cuff links, ring, and tennis bracelet from I. B. Goodman, Le Mans collection. (Courtesy Men's Fashion Association)

studs are inserted. These closures come in a variety of materials such as black jet, jade, rhinestones, and other decorative elements. The appearance of the shirt may be quickly altered with the change of studs.

Watchbands Serving both functional and decorative needs, watchbands come in many different styles and materials. For sportswear, the band might be made of leather, fabric, or steel links. Dressier watches often use precious and semiprecious stones as well as gold and silver in a wide range of designs.

Other jewelry types include *lockets,* which are often heart shaped and may be opened for the insertion of a loved one's photograph; *clasps,* which serve as decorative closings on bracelets and necklaces; *ornamental headbands; slides,* ornaments that are worn on chains that slide up or down adjusting the neck opening; and *hair sticks* that hold ornamental flowers in the hair.

WATCHES

Although we tend to think of watches as functional devices, examination of the many timepieces sold around the world indicates that decorative adornment is as important as keeping time. One of the earliest watches that is still in existence is one designed for the Empress Josephine in the early 1800s. Although the watch kept time, its extravagant setting in 18-karat gold, enhanced with pearls and emeralds, gave the impression that its significance as a bracelet was greater than its functional ability.

The watch was reserved for European royalty and those in the upper social classes. It was not until the early 1900s that watches were appreciated and worn by average citizens.

Figure 15-19 The Baume & Mercier chronograph is the perfect timepiece for today's man. (Courtesy of MFA)

A HISTORICAL OVERVIEW

Aside from the limited numbers of watches that were specially made for the aristocracy, watches did not achieve acceptance until the mid-1800s. During that time, Swiss companies began to produce timepieces that were initially produced for use by German naval officers in Berlin. In addition to satisfying the needs of this small group, some of the companies tried to market their watches for the general public. The immediate reaction was disinterest.

During the American colonial period, those who wore watches brought them from England. In the early 1800s, the importation of watches from England was restricted because of the Jefferson embargo. Luther Goddard was an American watchmaker who decided to use this opportunity to begin a watch business of his own. At the start, he produced large quantities of watches with success, but his business was ruined by the lifting of the importing ban. By 1830, English watches were flooding the American market. It was during this time that the first large-scale, important watch-producing American business was born.

Originally known by a series of other names, eventually it was called the Waltham Watch Company, only to be renamed several more times. After numerous reorganizations and mergers, the American Watch Company was formed. A financier, Royal Robbins, invested a great deal of money in the company and directed its success. Robbins recognized the need for inexpensive watches to serve the military during the Civil War and was able to satisfy its needs. This, coupled with another round of high tariffs on European watches, gave the company the market it needed to maintain a successful business. In 1925, the company changed its name back to the Waltham Watch Company. The company ultimate-

ly produced 34 million watches in the United States before it closed its doors in 1957. Today, the name Waltham is still used, but only as a trade name on a Swiss watch.

Watch making is now a world-wide industry. At the high end of the scale are the masterpieces made by Swiss craftspeople. At the other end are poorly crafted imitations, available for a few dollars.

TYPES OF WATCHES

Beginning with the earliest watches, which required keys to wind the mechanism to the quartz variety, which is void of a principal mainspring, the industry today produces several types of mechanisms. They are classified as mechanical, electronic, digital, and quartz.

Mechanical watches Although these date back several hundred years, they have survived the many new inventions of the watch industry. Inexpensive varieties use the pin-pallet technique, which involves metal rubbing against metal. These mechanisms are easily detectable by the loud noises or ticks that they make. Although they are modestly priced, they generally lose their ability to keep accurate time after about a year. Their popularity has waned with the introduction of newer techniques that afford the wearer an inexpensive timepiece with better accuracy.

For precision, mechanical watches use jeweled movements. The most popular movements have 17 jewels, although as few as seven jewels are used for less expensive watches and as many as 24 jewels are found in special timepieces. The mechanism involves the drilling of tiny holes into which jewels are inserted to act as friction points. The jewels originally used were rubies or sapphires. Today, most jewels used in watches are synthetics. The use of jeweled movements eliminated the noise associated with pin levers and produced watches that would serve the wearer many years.

The mechanical watches made in Switzerland are considered the world's finest. They are the ultimate timekeepers. Even when subjected to a great deal of physical strain and extreme temperature changes, their accuracy is rated at 99.98 percent, a level unachievable with any other mechanical instrument.

Electronic watches The mechanical watch was a successful product for watchmakers all over the world. As production reached enormous proportions in the early 1950s, a renowned French watchmaker, Fred Lip, announced an invention to the industry that could seriously affect future production of mechanical watches.

In June 1953, at the behest of the British Horological Society, Mr. Lip was invited to deliver a lecture to the Royal Society of the Arts on his use of a tiny electronic power cell for watches. By 1956, an American organization, the Hamilton Watch Company, was the first to put electronic watches into production.

Figure 15-20 A Bulova quartz watch.
(Courtesy of Bulova)

Instead of the mainspring barrel which is used in the mechanical watch, a power cell is used that can last for about a year. A variation of this design was introduced in 1960 that involved the use of a tuning fork combined with an electronic circuit to produce an even more efficient timepiece. The Swiss were barely interested in the electronic devices, so Max Henzel, an electronics engineer who was determined to make this new invention a success, went to America to find a company that would be interested in this type of watch making. Bulova refined the new movement and called its product the Accutron.

The advantage of the electronic watch is the elimination of the ticking sound, which is replaced with a mild hum; its ability to keep better time than the jewel movements; and, because of fewer parts in its assemblage, it is more serviceable.

Digital watches Instead of the moving parts that are prevalent in the mechanical and electronic entries, a new development revolutionized the industry. By using solid-state components, except for the use of a button, mechanical parts were eliminated. Instead of hands that moved over numbers of markings to indicate time, the digital watch displayed numbers that indicated the time in hours and minutes whenever the button was pushed.

Swiss manufacturers, fearful of losing their place in the industry, soon began to enter into contractual arrangements with American producers of solid-state components so that they could enter this new phase of technology.

In a matter of a few years, the watch industry boomed. For as little as $15, anyone could own a reliable timepiece. In 1982, Swatch entered the market with inexpensive, fashionable watches and quickly captured an enormous share of the watch industry.

Figure 15-21 The Swatch watch is wearable and readable under water. (Courtesy of MFA)

Quartz watches With the major changes in technology, the Swiss decided to move full speed ahead in this new era of watch production. They established a number of organizations, the main one being Centre Electronique Horloger, known as CEH, to produce a quartz wrist watch. At this point, a quartz clock had been popularly produced, but it had to be made smaller for use in wrist watches. In 1967, C.E.H. produced a miniature version of the quartz clock, the quartz wrist watch. Its capability as a timepiece was amazing as its accuracy was ten times greater than that of conventional watches. Although the Swiss thought they had exclusively captured the quartz market, the Japanese were busy perfecting their own quartz entry. The first Japanese company to produce the new watches was Seiko, which marketed its wares all over the world.

The use of quartz crystals enables manufacturers to produce watches that are extremely thin and attractive and keep time that is accurate to two or three minutes after a year.

The Japanese quickly rose to the forefront in watch production. With their image of high quality cameras already gaining worldwide acceptance, the task to foster themselves as quality watch makers was simple. After a few years, the Swiss caught their breath and also became a major player in the quartz industry. American companies didn't quite market their crop of these watches properly. They believed that with each new advance in technology, people would abandon their old watches for a new model. Unlike other products which lose their popularity when new ones come along, watch wearers expect a great deal of long-term wear from their timepieces. This marketing miscalculation discouraged them from producing top-quality watches, and caused them to lose as a major player in quartz watch production.

Micro-circuitry has expanded the watch into a product that keeps more than just time. While the display of days and dates are commonplace in these timepieces, some now have the ability to store and retrieve such information as telephone numbers and birthdays.

REVIEW QUESTIONS

1. How long ago did people use jewelry as part of their dress?
2. Does jewelry serve any purpose other than use as an adornment?
3. Discuss some of the symbolic purposes served by jewelry.
4. Describe the types of jewelry that were discovered in the Mesopotamian region between Syria and Iran.
5. What were the designs of the jewels made in 700 B.C. Greece?
6. In addition to gold and silver, what major precious ingredient is found in Chinese jewelry?
7. Describe the type of jewelry that was popular during the Renaissance period of the fifteenth and sixteenth centuries.
8. Differentiate between *Baroque* and *Rococo* style jewels.
9. During what period was the locket considered an important piece of jewelry?
10. Describe the the styles and types of Native American jewelry.
11. Distinguish between soldering and fusing of materials.
12. In what manner do jewelers make thick wires into thinner gauges?
13. Discuss the casting technique used in jewelry production.
14. Describe the Tiffany settings used to hold stones.
15. When do jewelers use paste settings?
16. How do matinee-length necklaces differ from opera-length?
17. What is an earring jacket?
18. When did watches achieve acceptance for purposes other than military use?
19. What is meant by the term 17-jewel movement?
20. Describe some of the capabilities of quartz watches other than displaying time.

EXERCISES

1. Draw the outline of the upper torso of a female human form and sketch and identify the various lengths of necklaces that may be worn by this figure.
2. Collect four newspaper or magazine advertisements that feature different types of watches. Mount each on a board and describe its features and benefits to the consumer.

CHAPTER 16

GLOVES, HATS, HOSIERY, AND SCARVES

LEARNING OBJECTIVES

After reading this chapter, the student should be able to:

1. Describe the various types of gloves available to consumers.

2. List and explain the stages of construction in the manufacture of gloves.

3. Recognize and describe various types of hats that have been fashion favorites.

4. Explain how hosiery is constructed.

5. Discuss how apparel designers made an impact on the scarf industry.

INTRODUCTION

A man, woman, or child bundled up in the cold might be seen wearing gloves, hats, hosiery, and scarves that immediately imply function over fashion. Although that certainly may be the case, it is not the only reason for such wearable accessories. A look at the runways in Paris reveals exciting millinery that was created with the same passion as the clothes that are being shown. Hosiery, too, need not be lackluster. The once-practical hosiery for evening wear has been replaced with designs that are intricately detailed. A glimpse of the prices will readily show that these are not merely minor enhancements, but items that have been crafted with fashion in mind. The Hermes signature scarf, with its several hundred dollar price tag, carries as much fashion status as a designer dress.

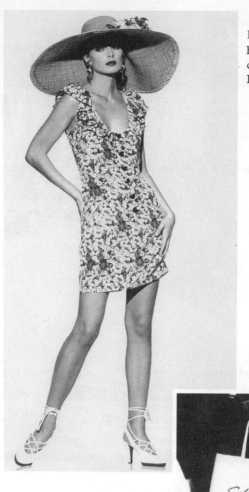

Figure 16-1 The Yves Saint Laurent hat is as important as the dress he designed. (Courtesy of Yves Saint Laurent)

Figure 16-2 Detailed hosiery has become an important fashion element. (Courtesy of DuPont)

No longer relegated to the hidden corners of retail emporiums, these accessories are visually merchandised front and forward, and are bringing significant profits to their creators and merchandisers.

The roster of designers who, on their own or through licensing agreements, affix their labels to these tidbits of fashion continues to grow. Today, the signature scarf collections bear such designer names as Anne Klein, Ralph Lauren, Yves Saint Laurent, and Pierre Cardin. The outrageous hosiery designs of Emilio Cavallini have gained recognition throughout the world and have placed the product in a class with other creative accessories.

Of course, one need not spend extravagantly to enjoy the pleasures of these items. Gloves, hats, hosiery, and scarves are available at prices to fit everyone's pocketbook. Although they might not carry the prestige afforded by the upscale variety, the assortments are varied, inventive, and fashion worthy.

In this chapter, each of the accessories is examined in detail to describe its methods of construction, the wealth of available styles, the materials used in production, and the purposes it serves.

GLOVES

A look at historical fashion indicates that gloves were important accessories for men and women of the royal courts, beginning with the sixteenth century. In the 1800s, women of the Victorian era chose an assortment of gloves for all occasions. A look back to the 1920s and 1930s shows an increase in the use of the product, and its popularity increased to the mid-1970s. At that point, the glove was no longer considered the obligatory companion for apparel, and women, except on the colder days, shed them.

During the 1980s, the glove industry once again took a somewhat prominent place in the fashion world. Intricately knitted and crocheted designs joined the ranks of the leathers. To give the market an ever greater boost, many designers such as Anne Klein and Bill Blass affixed their signatures to glove collections.

COMPONENT PARTS OF THE GLOVE

The number of individual parts used in the construction of gloves range from one, for those that are knitted, to four, for leathers or woven materials. In the case of the knitted type, the entire glove consists of one piece, made either by machine or hand.

The purpose of the four-piece construction is that it allows for comfort and proper fit. Knits are inherently comfortable because they stretch and easily conform to the wearer's hands.

The *trank* is the rectangular silhouette or shape that constitutes the front and back portions of the glove. To provide room for the fingers,

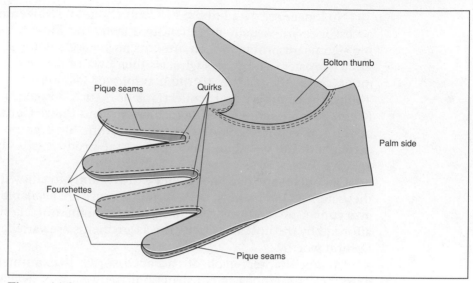

Figure 16-3 This diagram shows the component parts of a glove.

narrow oblong pieces known as *fourchettes* are cut. The materials used for these inserts may be made of the same material as the trank or a different one to provide interest to the design or comfort to the wearer. Sporty gloves sometimes use knitted fourchettes as inserts. To give extra freedom of movement for the fingers, small triangular sections known as *quirks,* are used. The quirks are made of the same material as the trank. The final part is the *thumb.* Basically, there are two types of thumbs used in glove production. One type is the *bolton,* which is bulky and provides freedom of movement for the wearer. Men's dress and sport gloves usually use this thumb, as do ladies' casual gloves. The *quirk thumb* is actually a two-piece component. It allows for a snugger fit and is generally the chosen style for women's dressy gloves.

An additional part is the lining. Some gloves are unlined, as in the case of many knits, whereas others use a wide range of materials. Fur or wool may be the material of choice when warmth is the concern; silk or rayon may be used for sleek, dressier gloves. Linings may be of the skeleton type where only the trank is covered, or full where the entire glove is lined.

GLOVE CONSTRUCTION

In the case of leather glove making, the initial operation involves *taxing.* This is the examination and marking of the skins to determine how many pairs may be cut. The best leather gloves come from skins that have been dampened and stretched to assure proper fit. Once this has been determined, the cutter is ready to produce the trank. In better quality leather gloves, the procedure used is called *table cutting.* This means the craftsperson dampens the leather, pulls it over the edge of a table, and

determines the correct shape before cutting the trank by hand. The skill of the cutter assures that the cut will provide maximum flexibility for the wearer. In less expensive leather glove construction, *pull-down cutting* is used instead of table cutting. This procedure does not use hand cutting or careful manipulation of each piece of leather. It involves using a die or outline to form the trank, cookie-cutter style. Once the tranks have been cut, they are piled, one on top of the other, so that the fingers may be slit and thumb holes cut by steel dies.

Assembling of the various parts may be accomplished using a number of different seaming techniques. The method selected depends on the cost of the finished product and the desired appearance.

The least expensive seam used in glove construction is called the *inseam*. In this operation, the seams are sewn together on the inside of the glove and then turned inside-out. There is no visible seaming when this operation is used. The opposite technique to inseaming is the *outseam*. In this construction, the stitching is done along the edges of the material, exposing the seaming and the raw edges of the glove. In the case of *overseam* assemblage, the raw edges of the materials are seen, with the stitches lapping over them. This effect is used for more casual gloves. When sleek fit and comfort are required, *pique* seaming is the choice. It is the costliest of the seaming methods. It involves the use of a special machine that sews one edge of material over the other, both on the front and back, thus exposing only one raw edge. A variation of this method is known as *half-pique*. In gloves constructed by using this technique, only the seams on the back are overlapped, the remaining ones using the inseam or outseam closure.

In some glove construction, a final step is used called *pointing,* which involves the application of stitching on the back of the glove. After all of these pieces have been assembled, the gloves are placed on forms and pressed before shipment to the stores.

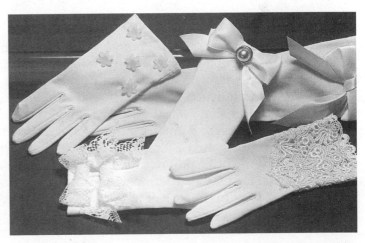

Figure 16-4
Gloves produced with the inseam method. (Courtesy of Caroline Amato Inc.)

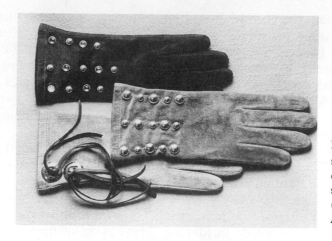

Figure 16-5 The pique seam, used in these designs, is the costliest seaming construction. (Courtesy of Caroline Amato Inc.)

Woven fabric gloves use the same stages of construction as leathers, except it is not necessary to table cut them because the fabrics are uniform in terms of appearance and quality.

Knitted gloves require very little assembling, because the entire product is constructed of one piece. The only sewing that is necessary is that which closes the tips of the fingers.

GLOVE LENGTHS

Women's gloves come in a variety of lengths ranging from the shortest, which ends just at the wrist, to the longest, which covers most of the arm. The lengths are measured in terms of *buttons*, with each button measurement accounting for one inch, starting at the base of the thumb. One-button gloves are the shortest and reach to the wrist, two buttons cover the wrist, four buttons end somewhere between the end of the wrist and the middle of the arm, eight buttons end at the middle arm, twelve buttons end at the elbow, and sixteen buttons reach almost to the shoulder.

GLOVE SIZES

The specific size ranges of gloves depends initially on the materials used. For those that are knitted, manufacturers need not be concerned with the demands of precise fit. Even in the case of woven fabrics, there is a certain degree of elasticity that eliminates careful sizing.

Men's knitted and woven fabric models usually come in sizes S, M, L, and XL. Women's glove sizes are even more restricted, with the majority of knits often as "one size fits all." The wovens that have a little less flexibility might be produced in an S, M, L range and A for smaller hands and B for larger. Children's sizes are also determined based on the stretch factor.

In the case of leather, sleek fit necessitates a more exacting size range. Men's and women's models progress at ¼-inch intervals. For men, the standard sizes measure from 7 to 10, with women's sizes available from 5

½ to 8. Today, with the growing number of large- and tall-size shops, the gloves found there exceed the normal run of sizes. Children's glove sizes use age as a factor, as do children's apparel products. The formula for size is half the age of the child. The four-year-old, for example, would wear a size 2, whereas the one-year-old would require a zero. The total range begins at 0 and runs through 7.

CARE OF GLOVES

The manner in which one cares for gloves will extend both appearance and function. The type of care is, of course, dependent on the materials used and method of construction.

First, when gloves are placed on the hands and ultimately removed, it must be done with care. The tugging on a glove will often stretch it out of shape. The hands must be gently inserted into the gloves and also gently taken out. Gloves, especially leather and vinyl types, should be completely aired after each wearing.

Many of today's glove manufacturers use combinations of man-made fibers in knitted constructions that simplify their care. They are often machine washable and retain their shape no matter how little attention is paid to care. Children's gloves, often mistreated, are produced of these fibers so that they can be laundered many times without the need for special attention.

At the other end of the spectrum is leather gloves. Some require professional dry cleaning, whereas others may be laundered by the consumer. Attention to the care label will reveal how the product should be cared for. For the washable variety, those made of smooth leather are best laundered while on the hand. A solution of mild, soapy water should be used and, when clean, they should be rinsed, removed from the hand, and patted dry on a towel, which will absorb the excess moisture. Bulkier, hand-washable leathers are generally washed off-the-hand and finished in the same manner as the smooth variety. To guarantee suppleness, the leather, once dried, should be gently massaged. Some manufacturers recommend that, after washing, the gloves should be placed on plastic forms for drying so that the original shape will be maintained.

Woven fabric varieties usually follow the same procedures as leathers.

STYLES

There are only a few basic glove styles. The visual differentiation comes from the fabrics and decorative trims that are used.

Mitten The body of this glove separates only the thumb from the rest of the fingers. It is made of many materials and comes in lined and unlined versions. Mittens are particularly easy for children to wear because they require only the thumb to be inserted separately.

Shorty It is a two-button glove that reaches the wearer's wrist. In leather or woven fabric models, there is generally a side or center open-

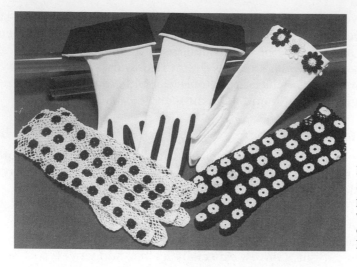

Figure 16-6
Summer gloves complete the fashion wardrobe. (Courtesy of Caroline Amato Inc.)

ing for easier use. In knitted models, the natural stretch of the yarns eliminates the need for the wrist opening.

Driving glove Copied from the gloves worn by race car drivers, this design has small ventilating holes that provide comfort and additional flexibility for the wearer. They are generally made of soft leather, suede, or fabrics, sometimes with knitted palms that allow for a secure grip of the automobile steering wheel.

Gauntlet A glove that uses a triangular insert, starting at the wrist.

Mousquetaire A longer-length glove, used for evening wear, that ranges from eight to sixteen buttons. Characteristic of this design is a vertical opening above the wrist that enables the wearer to slip her fingers in and out of the glove without its complete removal.

Slip-on A glove that ends at the wrist or slightly higher on the arm that does not have any fasteners or slit openings.

HATS

When the film industry chooses ancient Egypt or Rome as its setting for a movie, we are treated to a wealth of millinery that the leaders of those periods wore as part of their costumes. Throughout history, most eras demanded that the hat be part of their appropriate dress. One would hardly attend the opening day races at Ascot, in Great Britain, without the benefit of a "timely chapeau." The theatrical classic *My Fair Lady* features Audrey Hepburn and the other ladies in fantastic millinery creations.

Although the hat industry has had its ups and downs since the turn of the twentieth century, there were times when millinery was considered a most important part of the fashion industry. In Paris, where haute couture has always reigned, the early decades of the 1900s housed hundreds of milliners. Each performed his or her craft with the same painstaking care as the creators of custom apparel. Today, with hats not nearly as vis-

ible as in those golden years, Paris still boasts more than 60 milliners creating original masterpieces that sell for as much as $500. Names like Jean Barthet, the dean of French milliners, Josette Desnus, and Olivier Chanan are as renowned in creative millinery circles as are their couture apparel counterparts LaCroix and Saint Laurent.

Hats in the American scene, much like those in France, have also been placed in a lesser role than they once enjoyed. In fact, during the middle of the twentieth century, until the 1970s, hats were relegated to few wearers. Men who once had a selection of felt hats in their wardrobes to complement their business attire went hatless. Women, who amassed millinery wardrobes to suit different occasions and needs, also joined their male counterparts and opted to show their coiffures rather than cover them.

Except for the obligatory requirements of religious rites and ceremonies, weddings, funerals, and special situations or when the winds of mother nature warned one to cover up, the hat was dead!

Not to be discouraged by the insignificant role now played by headwear, some companies held fast and began to see the return of the once-favored accessory. During the 1970s, those still in business were either producing special occasion millinery or head warmers for women and felt hats for business attire, caps for sportswear, and knitted models for warmth for men.

Of particular comfort to those who believed that men would eventually return to wearing hats, the new breed of successful young executives opted for wearing hats. Although this was a limited market, a phenomenon surfaced in the late 1980s that made a specific hat style the standard

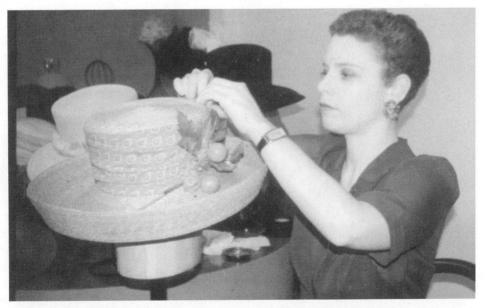

Figure 16-7 Milliner putting finishing touches to a hat. (Courtesy of Lola)

uniform for men of all ages. The youth of America in the middle and secondary schools, the collegiate set, the sportsman spending his leisure time, and those well into their later years began to wear what continues to gain momentum in the 1990s, the baseball cap. Stores have appeared all over the country that sport colorful caps featuring college and professional athletic teams, names of cities and states, and designs and logos of different events.

On the women's front, a host of hats have started to resurface in the 1990s from the types that echo the styles of different periods to those that are primarily worn as protection from the elements.

A glimpse at millinery departments in stores, newspaper ads, and hats as accompaniments to apparel in runway shows indicates that this accessory may still have real value in the world of fashion.

HAT CONSTRUCTION

The construction of any hat is based on the price of the finished product, the materials used for the body, the decorative trimmings, and the ultimate appearance.

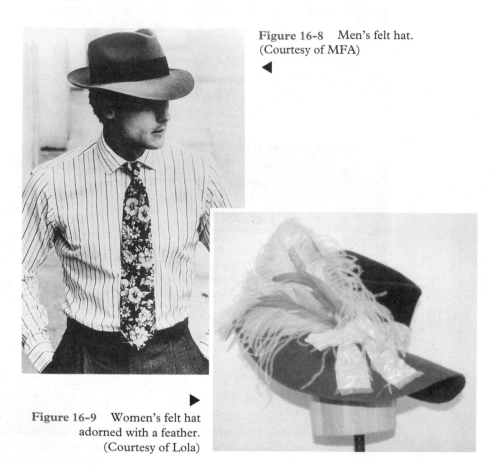

Figure 16-8 Men's felt hat. (Courtesy of MFA)
◀

▶

Figure 16-9 Women's felt hat adorned with a feather. (Courtesy of Lola)

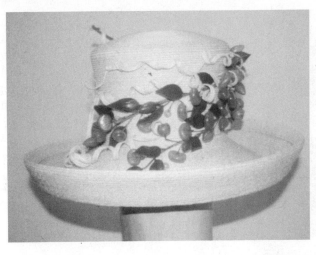

Figure 16-10 Straw is the most extensively used material for summer millinery. (Courtesy of Lola)

Inexpensive hats are primarily machine made, whereas the finer, costlier ones require several hand operations.

Before any production can take place, the designer sketches a style and translates it into a sample. Each design is made up of the body of the hat and the ornamentation with which it is enhanced.

After the model has been evaluated, it is ready for production. Hats that command prices in the $500 range are often one-of-a-kind pieces, which are expressly made for private customers and are totally hand crafted.

Felt hats, the mainstay for men and available in many women's styles, are made by shaping the fabric over "cones." After repeated steaming under pressure, the body of the hat, known as the "crown," and the "brim" are formed. After additional steaming and ironing, the brim is ready to be trimmed to the desired width. For inexpensive models, wool or man-made felts are used, whereas the more expensive varieties use fur felt.

Straw is another industry standard for both men's and women's styles. Some straws are made of woven mats that are shaped on wooden forms called blocks. Each block is constructed to resemble a particular style. The straw material is then steamed on the block until it takes the shape of the form. After it has dried, the item might be fortified with a stiffened material "buckram," which helps the hat retain its shape.

Another method of straw construction involves sewing narrow strips of straw, one overlapping the other, until the appropriate shape is achieved. This method is known as plaiting and is accomplished by machine. The plaited material is then shaped on a block and stiffened for shape retention.

Other materials and styles require different construction techniques. In the case of soft fabrics such as velvets or velours, used when an unstructured model is desired, the procedure is much like that used in making a garment. The operator cuts the material to the desired size and shape, drapes it, and sews it into a "soft" style.

Figure 16-11 Knit hats are winter favorites. (Courtesy of Lola)

Knitting and crocheting are also used for hat construction and may be produced by hand or machine.

HAT SIZES

Men's hat sizes increase in ⅛-inch intervals and range in size from 6¾ to 7¾. When less-structured models are produced such as caps and berets, they are usually available in S, M, L, and XL. The baseball cap generally comes in one size, but is fitted with a band across the back that may be adjusted to fit any head.

Women's hats are generally offered in a range from 21½ to 23½. Many also come in the S, M, L range, especially when the styles are less fitted.

Younger children's models usually coincide with their ages. Infants wear sizes that range from newborn to two. Older children's versions are generally produced in S, M, L.

CARE OF HATS

The nature and amount of care is determined by the style of the hat and the materials used. Felt and straw models should be kept in boxes and stuffed with tissue paper to help shape retention. The box should be sufficiently large to allow for air space and enough room not to crush the style out of shape. At the end of a season, it is best to have this type of hat professionally cleaned and "reblocked" back to the original shape.

Knitted and other soft hats may be stored on shelves. Some might be freshened through laundering, whereas others might require profession-

al cleaning, as in the case of suede caps. The labels often explain the appropriate care.

STYLES

There are many different models that have been in fashion at one time or another. Some are exclusively for one gender, whereas others may be worn by either sex. The following is representative of the available styles:

Baseball cap A rounded, fitted cap that is constructed of several "gores" or triangular inserts and finished with a peak at the front. They are available in colors that are indicative of specific professional or collegiate teams. Variations of the baseball cap are produced in suede. It is a one-size-fits-all style that has an adjustable band in the back.

Beanie A brimless model that is made of triangular gores and is typically worn for college initiations or "pledging" purposes.

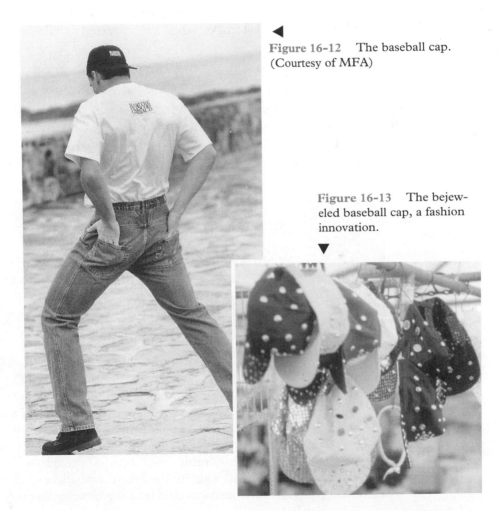

◀

Figure 16-12 The baseball cap. (Courtesy of MFA)

Figure 16-13 The bejeweled baseball cap, a fashion innovation.

▼

Beret A soft, unstructured style that was made popular by the French. It is worn by men, women, and children and comes in a variety of materials.

Cowboy A felt hat that is the standard for western ranch hands. It has a high crown and broad brim and is sometimes called a ten-gallon hat.

Sherlock Holmes The crown is made of gores, with the front and back replete with peaked, stiffened brims. The most common are made of tweed woolens. The name comes from a British detective who wore it in numerous films.

Derby A stiff felt hat that has a rounded crown and narrow rolled brim. It is sometimes called a bowler.

Fedora A soft felt hat with a creased crown. It is also called a Homburg.

Panama A straw hat that has a high crown with a center crease. It uses the finest straw that has been created through plaiting.

Pillbox A small, round, brimless structured woman's hat. It was one of millinery's greatest rages when popularized by President Kennedy's wife, Jackie.

Bonnet A brimmed hat with a ribbon that ties under the chin.

Cloche A high-crown, close-fitting hat with a narrow brim.

Gaucho A flat-crowned felt hat that usually has a rolled, wide brim. A cord, originating from inside the crown, fastens under the chin.

Alpine Man's soft felt hat with a brim that is turned up on one side. It is also called a Tyrolean.

Figure 16-14 The cowboy hat is the perfect accent for western attire.

Figure 16-15 A standard derby.
(Courtesy of MFA)

Turban A soft constructed headpiece that is made of draped fabric that fits around the head.

Top hat A formal man's hat, usually made of silk, that has a very tall crown and rolled brim.

Tam O' Shanter A Scottish hat with a round, flat top that is finished with a tassel at the top.

Breton A woman's hat with a small evenly rolled brim.

Cartwheel A woman's hat that is large and has a wide, circular brim.

Sailor A low-crowned hat with a stiff brim.

Nehru A soft, brimless hat that has a creased crown.

Garden party Wide-brimmed, floppy straw hat that is embellished with ribbons and flowers.

Ski cap A knitted hat that usually has a wide, turned-back cuff and is adorned with a pompom on the top.

Picture A large hat with a floppy brim that frames the face.

Slouch A soft hat with a center crease and a brim that is turned down. It is often shown as a water repellent rain hat.

Toque A woman's small, brimless hat.

Hood A head covering that is usually attached to a coat or jacket and is made of a piece of cloth.

Profile A woman's hat that features a brim that is up on one side and down on the other.

Fez A high, cylindrically shaped crown with a tassel at the top.

HOSIERY

When DuPont introduced nylon as the miracle fiber of the twentieth century, the hosiery producers capitalized on it and it soon became one of the largest segments of the accessories industry. Although leg coverings date back to ancient times, it was not until the sixteenth century that it was adopted by ladies of the court as enhancements for proper dress. From that time until DuPont's discovery, the materials used for hosiery construction were primarily cotton and silk.

The leg coverings used were stockings for dresses and skirts and socks for casual attire. The stockings were produced either flat and sewn together with a seam or on circular knitting machines that did not require seaming. They came in a limited number of colors. Some were plain, whereas others featured embroidered designs at the ankle.

To prevent stocking slippage, women wore garters to hold the hosiery in place. In the 1960s, machinery was perfected that would produce *pantyhose,* a one-piece configuration that combined stockings with a panty and eliminated the need for women to wear garters. The new product became so popular that by the 1980s, it significantly outsold regular stockings.

Later developments made pantyhose even more desirable than when it was first introduced. Manufacturers began to construct the panty por-

Figure 16-16 Women's hosiery has become an important fashion accent.

tion of the product with materials such as Spandex that helped to control any excess "bulges" and also provided support for the wearer.

Today, many retailers severely restrict their stocking inventories, whereas some do not bother to offer them at all.

In addition to pantyhose, *knee-high* stockings are offered for use under pants. They reach just below the knee and, for outward appearance, it seems as though full stockings or pantyhose are being worn. They are popular because they are less restrictive than the others and cost a good deal less.

In addition to stockings and pantyhose, women began to enjoy socks when they embraced the pant as an alternative to the skirt. Socks of every length became popular, with the major craze belonging to the teenagers who worshipped the singing idol Frank Sinatra and wore *bobby socks* to his concerts. That style featured a short sock that had a band that folded over the top. Today, women's socks come in many lengths and materials and are favorites among females of every age. With the less rigorous demands of more formal dress, the sock serves many purposes. It is not only fashionable, but it offers greater warmth than fine hosiery.

Men, like women, wore stockings as far back as the 1600s. They were usually silken, came to the knee, and were held up by garters. They were necessary accompaniments to knickers that were worn at the time. When the man's pant leg was lengthened, stockings were produced in shorter lengths. The material of choice for fine gentlemen was silk, which could be seen when the man was seated and the leg was partially exposed.

Today, men wear socks in place of the formal hosiery. They are available in various lengths, materials, patterns, and styles to complement every type of apparel.

The men's and women's hosiery industry of today has significantly expanded. The product is so important as a fashion accent that the industry, once dominated by "less-than-household names," now includes offerings by designers who have made their reputations on fashion apparel. Primarily through licensing agreements, names like Ralph Lauren, Calvin Klein, Bill Blass, Anne Klein, Christian Dior, and Liz Claiborne grace the products. The market has become so popular that department and specialty stores have expanded their spaces to house all of the varieties of the hosiery industry, and new specialty stores have started to appear that exclusively limit their merchandise assortments to hosiery. Some, such as the Sock Shop, a company originated in London, sells only socks.

HOSIERY CONSTRUCTION

All types of hosiery are knitted. It is only the fibers and methods of knitting that differ from one type to another. Although modern technology has enabled hosiery to be produced faster and better than ever before, the methods of construction are much like those produced in the early years.

Figure 16-17 A jacquard geometric design adds interest to men's socks by Mondo di Manco. (Courtesy of MFA)

Stockings that use the *full-fashioned* construction are produced in flat form, in the desired size and shape. A back seam is then stitched to finish the assemblage. The product is dyed, placed on a form, and heat set for shape retention. *Seamless* hosiery uses a one-piece construction that forms the hosiery by use of circular knitting machines. The product is made according to the desired size and shape. It, like the full-fashioned type, is dyed and heat set.

Pantyhose is constructed in two ways. One way may use individual stockings and a panty, which are ultimately stitched together to form the product. Some manufacturers create pantyhose as one-piece constructions on special machines. In both cases, the items are dyed and heat set.

Socks construction follows the same stages as stockings and panty hose. They are knitted on circular machines, either in a natural color that must be bleached to better accept later dyeing or, if a pattern is desired, different colored yarns are knitted together, eliminating later coloring.

MATERIALS

The majority of "dress" hosiery is produced in some form of nylon. Although the fiber has been regularly enhanced through various techniques that add elasticity, texturing, less shine, other visible and functional characteristics, and sometimes bears more exotic names such as Enkasheer, it is still nylon.

Nylon hosiery also takes on different appearances depending on the weight of the yarn and the number of loops knitted per inch. *Denier* applies to the fineness of the yarn, and *gauge* to the closeness of the knit.

Socks are made of a variety of fibers such as cotton, wool, cashmere, acrylic, polyester, and nylon. To prevent slippage, an elastic band might

be inserted at the top of the sock or a "ribbed" construction might be used above the ankle. To give the appearance of a luxury product and provide function and comfort to the wearer, two or more yarns may be used in the construction.

One of the most important features of hosiery is color. The industry takes its cue from the apparel markets and produces varieties of hues that enhance the wearer's garments. Thus, even the colors that are considered to be neutral have subtle differences that change from season to season.

SIZES

Men's hosiery generally comes in a standard size that fits all sizes from 10 to 13. These sizes correspond to shoe sizes that range from 8½ to 12. With the significant stretch in men's hosiery fibers, there is little need for other sizes. In some cases, producers will manufacturer smaller and larger sizes.

Women's socks also use a single size, as do men's, because most women can be accommodated with the one-size-fits-all concept. In the case of pantyhose, size is generally determined by the wearer's height and weight. They usually range from size A for women whose heights are somewhere between 4 feet 11 inches and 5 feet 3 inches and whose weights range from 95 to 125 pounds, to size F for the heaviest and tallest figures that include heights of 5'1" to 5'7" and go to weights beginning at 155 and end at 170 pounds. Sizes B, C, D, and E fall somewhere between the measurements of A and F. Most companies include a size chart on the package to assure proper size selection. In cases of inexpensive pantyhose, a one-size-fits-all measurement is used.

For the tiniest figures, some manufacturers tailor their pantyhose in petite sizes, whereas larger sized women are treated to queen sizes.

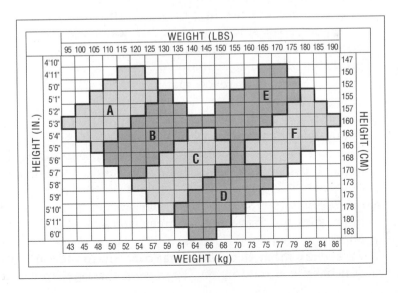

Figure 16-18 Size range chart for women's hosiery.

Children's hosiery comes in a variety of sizes. Newborns to age one usually wear sizes that range from 4 to 5½; older children wear sizes that run up to 8½. Preteen and young teenage girls wear a range that begins at 9 and concludes at 11. Preteen boys and young teenage boys usually wear from 9½ to 13. Some children's manufacturers are using S, M, and L for their hosiery.

CARE OF HOSIERY

One of the problems with fine nylon hosiery is that it can be easily damaged if improperly handled when placed on the leg. The procedure should move the hosiery up the leg carefully, making certain that neither a jagged fingernail nor ring injures the yarn. If not handled with caution, a "pull" or "run" will produce damage even before the item has been worn.

Stockings, pantyhose, and socks should be laundered after each wearing. Nylon hosiery should be washed in mild soap and warm water. Although hand laundering is preferred, a washing machine may be used if it can be operated on a gentle cycle. Socks may be machine washed unless otherwise indicated on the label. They, too, should be cleaned on the gentle cycle with mild soap and warm water. For white athletic socks, which often are stained during wear, warmer water and stronger detergents may be used.

STYLES

Today's hosiery manufacturers offer many styles for both dressy and casual attire.

Pantyhose Hosiery that combines stockings and a panty and covers the body from the toes to the waist. They come in seamed or seamless styles.

Stockings Hosiery that comes in pairs and reaches from the toes to the thigh. To prevent sagging, they are worn with garters or garter belts. Like pantyhose, stockings are either seamed in the back or seamless.

Tights The same as the pantyhose concept, except that the product is produced of an opaque material.

Anklets Socks that reach just above the ankle and may be ribbed, plain, or cuffed.

Crew socks Socks that use heavy ribbing in the design and reach about four or five inches above the ankle.

Tennis socks A style that just covers the foot and ends beneath the ankle. It usually has elastic around the body, and an ornamental pom-pom that peeks over the sneaker with which it is worn.

Knee-highs A type of hosiery that reaches above the calf. Men wear finer types for dresswear, whereas women use them primarily under pants.

Tube socks Shapeless socks that conform to the foot and are worn for athletics.

Many hosiery manufacturers produce stockings or pantyhose in different variations for purposes that might be decorative or functional. The following are terms used to describe certain style pantyhose:

Control top A pantyhose that features a yarn such as Spandex in the panty portion of the design.

Sandalfoot Hosiery that eliminates heel or toe reinforcement. It is worn with sandals and avoids the unsightly portion of hosiery that is present in regular stockings or pantyhose.

Textures Stockings or pantyhose that use fancy patterns in their designs.

Demitoe A stocking or pantyhose with an abbreviated reinforcement at the toe.

Support A term used to describe hosiery that uses Spandex along with another fiber, usually nylon, for better control.

Mesh Hosiery that uses knitted fabric that resembles mesh.

SCARVES

Many countries have had scarves as part of their dress for centuries. Spain, for example, introduced the *mantilla,* a lace version that is worn over the head. It was popularized in America during the Kennedy reign in the White House when it was the choice of Jackie Kennedy as a head covering worn to church. The British, French, and Chinese each had their own versions that have remained popular within their own borders

Figure 16-19 Here an Anne Klein silk scarf is worn as a prominent accessory. (Courtesy of Anne Klein for the Vera Companies)

as well as in other places. These large scarves were not the only styles favored by the people. Smaller versions, oblong shapes, and others were favorites.

Scarves, as we use them today, are both functional and decorative. On a stormy winter day, there is nothing quite as warming as the woolen muffler that prevents the wind from making the body feel colder. At the other extreme, the large silk square is ever present, displaying the name of a famous fashion designer and telling the world that it is as treasured as the apparel it augments.

American fashion emporiums began to feature silk squares of all sizes in the 1950s. Those of modest price points bore the creative motifs and signature of the designer Vera, and the ones at the highest prices were silk imports from Europe that were signed by Gucci and Hermes. Since that period, fashion designers have joined the bandwagon, opening their own scarves divisions or lending their names, via licensing agreements, to accessories manufacturers.

The industry continues to grow, as evidenced by the sizes of the scarves departments in department and specialty stores.

SCARVES CONSTRUCTION

Unlike shoes, handbags, and other more intricately produced accessories, scarves are simple to make. Natural fibers such as silk, wool, and

Figure 16-20 This large scarf is draped over one shoulder for a dramatic accent. (Courtesy of Perry Ellis for the Vera Companies)

cotton, and a host of man-mades serve as the basis of the scarf. Some are individually silkscreened to create a design that parallels a painting or work of art, whereas others are cut from rolls of fabric that have been printed, or dyed solid colors before being cut and sewn.

The motifs range from typical paisleys and flowered prints to geometrics. The edges of the costly varieties are hand rolled, whereas the mass-produced, inexpensive types have their edges finished by machine.

They may be made into squares, rectangles, oblongs, and triangles, depending on their final use. Sequins, beads, fringe, and other trimmings are used to enhance some of the designs.

Akin to the scarf is the tie. Generally worn by men but, on occasion, women have been seen wearing their own versions, ties are separately discussed in Chapter Twelve, "Men's Clothing."

CARE OF SCARVES

Like any other fabric accessory, care should be given according to the fibers used in the construction. Silk scarves that are costly should be professionally dry cleaned to assure continuous pleasure, as should the woolen varieties. Those made of cotton, linen, or launderable man-mades may be washed according to the directions on the hang tags. Since many types are worn directly around the neck, the naturals oils from the hair and body tend to soil them. In these cases, regular cleaning is recommended.

Stoles, oblong, oversized scarves, are often made of fur. For those types, the same care should be given to them as any fur garment, including cold storage during the summer months.

STYLES

As do other accessories, scarves come in a variety of styles.

Ascot A piece of material that comes to two points and is worn one over the other around the neck. Often, it is held in place with a decorative stickpin.

Shawl A large piece of cloth in a rectangular or triangular shape that covers the neck and shoulders and is worn over a dress, suit, or coat. It is sometimes accentuated with fringe.

Mantilla Taken from the head covering of Spanish ladies, it is a lace scarf that has either straight or scalloped edges.

Cowboy scarf A square that is folded into a triangular shape that is worn with the point to the front and is knotted in the back.

Muffler A knitted or woven oblong-shaped scarf that is worn around the neck to provide warmth.

Stole An oversized rectangle that is worn over a suit or dress. It is made of wool or fur.

1. What phenomenon gave a boost to glove sales in the 1980s?
2. What is a trank?
3. Define the term *fourchette* and tell the benefit served by it in glove construction.
4. Name and differentiate between the two major types of thumbs used in making leather or fabric gloves.
5. Distinguish between full and skeleton linings in gloves.
6. Why are the more expensive leather gloves "table cut?"
7. Describe the method used in pique seaming.
8. Through what system are glove lengths measured?
9. How does a mitten differ from a traditional glove?
10. Over what type of form is the felt hat shaped?
11. Describe the process of plaiting used in the construction of straw millinery.
12. At what size intervals do men's hats progress?
13. What is a "pillbox," and who popularized it in America?
14. What is the distinguishing feature of a bonnet?
15. How did DuPont help to revolutionize the hosiery industry?
16. Explain the style "pantyhose."
17. In what way has Spandex helped in the sale of pantyhose?
18. How is seamless hosiery constructed?
19. Differentiate between the terms *denier* and *gauge*.
20. What is a mantilla?

EXERCISES

1. Remove five different glove photographs from fashion magazines and label each one in terms of its style and component parts. Suggest the type of outfit with which each might be worn.
2. Visit a department store's hosiery department and take note of the different size classifications used on the package. From the knowledge gained, prepare a "graph" that explains the proper size for each wearer.
3. Visit a men's or women's hat department and prepare a report on the types of hats offered for sale. Ask the manager for permission to photograph the assortment for a school project. Each hat should be labeled as to its style.

GLOSSARY

accessories—Articles that are worn with or carried to enhance apparel.

acetate—A man-made fiber that has a luxurious feel, drapes extremely well, drys quickly, and is resistant to shrinkage.

acid dye—Excellent for achieving bright colors, but is not fast to washing.

acrylic—Soft, warm-like, lightweight fiber that has considerable strength.

active sportswear—Articles of clothing that are intended for use in such sports as golf and tennis, and are also worn for casual occasions.

advertising—The nonpersonal presentation of the facts about products and services.

A-line—A style where the skirt portion of the dress barely hugs the waistline, skims the hips, and flares at the hemline.

alloy—A combination of two or more metals.

alpaca—A specialty hair fiber of the wool family.

alternation rhythm—In design, where two objects alternate in the pattern.

analine leather—A product that features the natural characteristics of the leather, obtained through the use of transparent dyes.

analogous color scheme—A combination that features two adjacent colors on the color wheel.

anchors—The major, largest retailers, usually department stores, in a mall.

anklets—Socks that reach just above the ankle.

annealing—The process of heating metals to make them more workable.

antiquing—The application of chemicals to darken metal to give it an antique or old appearance.

antistatic—A textile finish that eliminates clinging of materials due to static.

appliqués—Small fabric or leather pieces that are sewn onto garments for enhancement purposes.

assistant buyer—A mid-management retailing employee who assists the buyer with purchasing responsibilities.

asymmetrical balance—Informal balance used in design.

athletic size—A size range in men's wear that features narrower waists and broader chest sizes.

baggies—Loose-fitting pants that achieve their fullness from the gathers at the waistline and tight fit at the ankles.

baguette—Small rectangular stones that are used to flank larger stones in a setting.

bal—A classic closed-tie shoe that is generally produced in a wing-tip, straight-tip, or saddle design.

balance—In design, the assignment of equal, visual weight on either side of an imaginary axis.

bolero—A short jacket that features curved bottom sides at its hemline.

bolton thumb—A separate thumb of a glove that allows for freedom of movement.

baroque jewelry—The most ornate type of jewelry.

barrel cuff—A shirt sleeve closure that has one or two button fasteners.

base metals—Inexpensive metals that are combined in alloys with precious metals.

basic dye—A type of dye that easily produces bright shades, is generally colorfast to washing and light, and resistant to crocking (color won't come off due to friction).

batch work—A system where several people can perform more than one operation in the production of a "batch" of products.

bating—The removal of chemicals during the leather tanning process.

bateau—A neckline that is open, wide, and close to the neck; it is often called a boat neckline.

beatnik look—A term used to describe the informal, casual dress of the young of the mid-fifties that featured leotards, form-fitting pants, and oversized shirts.

bell-bottoms—Narrowly fitted at the hipline, they flare beginning at the knee extending to the shoes.

beret—A soft, unconstructed hat.

bermudas—Shorts that end somewhere around the knees.

bertha collar—A large collar that resembles a cape which extends from the neck and covers the shoulders.

better sportswear—A merchandise classification that falls between popular priced lines and bridge collections.

bezel setting—A flush setting used in jewelry where a stone is held in place by a rim of metal that goes around its entire perimeter.

bias cut—A design that uses fabric that is cut on a 45-degree angle to permit better drapability.

bleaching—The removal of color through means of chemicals.

blouson—A loose-fitting style that uses elastic or a drawstring at the waist to form gathers.

blucher—An open-tie shoe style in which the lace stays open at the bottom of the eyelets.

bonding—The adhering of two fabrics together.

bonnet—A hat that ties under the chin.

bottoming—In shoe construction, the lasted upper receives the shanks and fillers and is prepared for the outsole to be permanently attached to the upper of the shoe.

bouclé—A knitted fabric that features a rough surface enhanced by small knots in the fiber.

bouffant silhouette—A full-skirted design that is often accentuated with the use of petticoats.

boutiques—Small retail shops that feature narrow assortments of higher priced women's apparel and accessories.

braces—Suspenders that hold pants in place.

branches—Smaller units of department stores that feature a representative selection of the merchandise sold in the main or flagship store.

breton—A woman's hat with a small evenly rolled brim.

bridge lines—A term used to describe women's clothing that is priced just below the designer collections.

brilliant cut—Sometimes referred to as a full or round cut, it imparts the greatest amount of the stone's "fire."

brooch—A term used in jewelry for an ornamental pin.

broadcast media—The communication outlets of radio and television.

broadcloth—A fine cotton fabric that is produced with the plain weave.

brogue—A heavy oxford shoe with decorative stitching.

buckram—A fabric that is used as a stiffening interlining.

budget lines—The least expensive merchandise lines of apparel.

buttercup setting—Used primarily for pendants and earrings, these settings use a six-prong configuration that rises from a scalloped base and resembles a flower bud.

button length—A measurement used to describe glove lengths.

buying plan—An outline that buyers use for future purchases.

buyer—In retailing, the individual responsible for purchasing merchandise.

cabochon cut—A smooth rounded surface that is usually found on translucent stones.

calendering—An ironing process that increases luster on fabrics.

cambric—A fine linen that is used for handkerchiefs.

canine family—A family of animals that is mainly represented by the fox.

cap sleeve—A short cape design that covers the shoulders.

carat—A measurement used to indicate the size of stones.

cardigan—A style that features a sweater that buttons down the front and is void of a collar.

carding—A process that involves the straightening of fibers.

Caribbean Basin Initiative—A program under which tariffs are not imposed upon certain nations when their goods are sold to the United States.

casting—A process used to make jewelry in which liquefied metals are poured into forms.

catalog—A publication that features merchandise and is used to sell to individuals via the mail or telephone.

cat family—A family of animals including lynx and leopard.

chambray—A plain weave cotton fabric that uses a set of white and colored yarns.

Chambre Syndicale de la Couture Parisienne—A French trade organization that represents the major couturiers and performs such duties as the regulation of times new collections are shown.

chains—Two or more retail units that are centrally owned and operated.

channel setting—A setting in which stones are lined up next to each other with no metal between them.

chasing—Tapping a design into a metal surface.

chemise—A dress silhouette that employs the tubular look, is straightlined and void of a waistline.

chesterfield—A coat or jacket that features a velvet collar.

chic—Fashionable, stylish.

chiffon—A sheer fabric that has a floating quality in motion.

choir boy—A large, rounded collar that ends in two points and features two bands of fabric that are tied into a bow.

chrome dye—A method used for dyeing leather.

cinch—A type of elastisized belt that snugly fits the waist.

classic—A term used to describe a style that is always a fashion staple.

cloche—A close-fitting woman's hat.

clog—A shoe with a heavy platform sole that is made of wood or cork.

cluster setting—An arrangement of stones that are used to form a closed symmetrical pattern; usually there is one center stone that is surrounded by six stones.

clutch—A small handbag that is void of handles or straps.

colorfast—A term used to describe a fabric that will not lose its color when laundered.

colorist—An individual who selects the specific colors to be used in textile production.

collection—A term used to describe the entire merchandise offering of a designer.

color sealing—A process which uses a finish to prevent colors from running during laundering.

color theory—A concept that shows how colors might be best used in combinations.

color wheel—A theory that arranges colors adjacent to each other on a wheel and shows their relationships to each other.

combination advertising—Incorporation of a promotional and institutional message in an advertisement.

combing—A process used in textiles that aligns and straightens fibers and enhances luster.

commission—A percentage paid to the seller of merchandise.

comparison shoppers—Individuals who work for retailers and compare prices of their merchandise with their competitors.

complementary color scheme—An arrangement that uses two colors that are directly opposite each other on the color wheel.

composite stone—A stone that features two or more stones that are glued together.

computer cutting—The cutting of fabrics with the aid of the computer.

computerized digitizer—In pattern grading, a system that automatically upgrades or downgrades a pattern.

conservative styles—Fashions that are basic and void of the trappings found in highly styled designs.

consignment selling—An arrangement that offers goods to a retailer and the right to return those that are unsold. It is often used in the fur and precious jewelry industries.

continentals—A trouser style in which the waist is an extension of the narrow pantleg with the absence of belt loops.

contour—Usually refers to a belt that is shaped to the contour or form of the body.

contractor—A company that performs some operations for the manufacturer of fashion merchandise.

continuous line rhythm—A continuous line of a pattern or trim, for example, leads the viewer's eye throughout the design.

converter—The individual or company that applies finishes to fibers and fabrics.

corundum—A group of stones that includes ruby and sapphire.

cost analysis—An investigation of all of the expenses involved in the manufacture and marketing of a product.

counterfeits—Copies of items that imitate the originals.

couturier—A French term for designer.

cover letter—The letter that is sent along with a resume.

covert—A closely woven, lightweight woolen twill fabric that is used for topcoats, suits, and sportswear.

cowl—A collar that is cut on the bias or diagonal to permit either front or back draping.

crash—A coarse linen fabric that is used for suits, jackets, and trousers.

crepe—A fabric that has a crinkly effect.

crepe de chine—A lustrous light crepe with a soft rippled effect.

crocheting—The production of fabric through means of hooks.

crown—The top of a stone.

cross dyeing—A technique that allows for two or more colors to be applied to fabrics.

culet—The lowest part of a stone.

culottes—Short pants that give the impression of a skirt.

cultured pearls—Pearls that are produced by the placement of an irritant in the oyster.

cummerbund—A sash that ties around the waist.

custom-made clothing—Garments that are made specifically to one's measurements.

cutting ticket—A term used to describe the minimum number of ordered garments before a style will be manufactured.

customer servicer—An individual who handles customer complaints.

damask—A patterned fabric produced on the jacquard loom.

delustering—A finish that removes the shine from fabric.

denier—The fineness of the yarn.

derby—A stiff felt hat that has a rounded crown and narrow rolled brim.

designer—The creator of a product.

design elements—They are color, materials, silhouette, details, and trim.

designer inspiration—What motivations caused the designer to create the collection. It might be a film, famous person, etc.

design principles—They are balance, proportion, emphasis, rhythm, and harmony.

die-cutting—A method of cutting that uses a "cookie-cutter" device.

digital watch—A timepiece that uses solid-state components and displays the actual time whenever a button is pushed.

direct advertising—The method of reaching potential customers with catalogs that are mailed directly to them.

direct dye—A dye that has poor fastness to laundering as well as light penetration, and generally requires dry cleaning.

direct mail—Catalogs, pamphlets, and brochures that are mailed directly to the potential purchaser.

dirndl—A type of skirt that is gathered at the waistline.

disperse dye—Fast to crocking and perspiration.

display—The visual presentation of merchandise.

distressed leather—A material that has markings that have been intentionally done to create a specific appearance.

divisional merchandise manager— A member of a retail management team with responsibility for overseeing a wide merchandise classification.

dobby weave—A construction technique that produces a very small pattern such as the one in bird's eye pique.

dolman—A type of sleeve that features a wide armhole that tapers to a narrow wrist closing.

domestic production—A term used to describe manufacturing that takes place in the United States.

Donegal—A woolen tweed fabric that is characterized by randomly woven multicolored yarns.

d'orsay—A woman's shoe style that is a pump with low-cut sides.

doublets—A stone that is actually a combination of two stones.

drawing—A term used in jewelry production where metals are "drawn" or transformed into narrow wires.

duffel coat—A ¾ length coat that uses toggles as closures.

duty—A tariff or tax levied on certain imported merchandise.

duty-free—Merchandise imported from other countries on which no tariff or taxes are levied.

dyeing—A method for coloring materials.

earring jackets—Earrings with small holes in the center into which small stones may be inserted.

electronic watch—A timepiece that uses a power cell instead of a mainspring.

electroplating—Applying a very thin coat of precious metal over a base metal with the use of electricity.

embossing—Stamping a design on fabric, leather, or metal.

emerald cut—A type of cut used on stones that produces facets that are similar to miniature "steps."

emphasis—A design principle that is a style's main focus.

empire—A high waistline that is placed directly under a woman's bosom.

engraving—A decorating technique whereby a design is scratched into metal.

enhancement—Items such as buttons or flowers that are used to improve the appearance of a garment.

envelope—A type of handbag that resembles a mailing envelope that is void of handles or straps.

espadrille—A square-throated, closed-back shoe with a fabric upper and a woven hemp bottom.

etching—A decorative process that uses acid to achieve a design on metal.

European cut—A men's wear silhouette that emphasizes the waistline and accentuates the shoulders.

facets—Faces that are cut into stones to increase brilliance.

fad—A short-lived fashion.

fashion—A style that is popular for a particular period of time.

fashion clinic—A format used to inform consumers about fashion appropriateness for different occasions.

fashion coordinator—An individual who works in a major retail operation who has the responsibility for assessing fashion direction.

fashion cycle—The stages through which a fashion passes.

fashion director—Someone with the responsibility for assessing the direction of fashion for the retailer; a term often used synonymously with fashion coordinator.

fashion forecaster—A person who predicts which styles will be popular in the future.

fashion industry components—They include designers, manufacturers, retailers, advertisers, and promoters.

fashion periodicals—Trade journals such as *WWD* that are directed to those in the industry.

fat liquoring—The replacement of oils in leather that are lost during processing.

faux pearls—Imitation pearls.

fashion write—Someone in the world of fashion who reports on the styles of the times.

fedora—A soft felt hat with a creased crown, sometimes called a Homburg.

feedbag—An oversized handbag that has a drawstring closure.

felt—Fabric that has been produced through the use of steam and pressure.

fez—A hat with a high, cylindrically shaped crown with a tassel on the top.

filament—A very long fiber such as silk or any of the man-mades produced with the use of a spinnerette.

filling—Crosswise yarns.

findings—A term used to describe functional garment enhancements such as buttons and zippers.

finish—An application that is applied to fabric or leather to improve appearance or performance.

fit models—Individuals on whom garment samples are adjusted to achieve the proper fit.

flagship—The main store of a department store organization.

flame retarding—A chemical finish that is used to retard fire.

flannel—A soft fabric, most often made of wool.

flea markets—Sales arena where merchandise is sold at bargain prices.

fleshing—The removal of flesh from the hides of animals in leather production.

floats—A term used in the satin weave that tells the number of warps that are passed over by the filling yarns before interlacing; it produces a shiny surface.

flocking—A decorative finish in which dimensional designs are created by adhering loose fibers to pre-glued surfaces.

florentining—Engraving a metal surface with a series of fine scratch marks.

formal balance—A term, often referred to as symmetrical balance, that produces a mirror-image design.

fourchettes—Narrow inserts that are placed between the fingers in gloves.

franchises—Individually owned units of a retail organization.

French cuff—A sleeve closure that features a double cuff with openings for cuff links.

full-fashioned—A term used in knitting where the material is produced as a flat form and closed with seams.

full grain—Leather that features the full thickness of the hide or skin.

fulling—A finish on woolens that increases the density of the fabric.

fur fibers—The short, downlike fibers of fur pelts that provide warmth.

fusing—The adhering of one material to another.

gabardine—A durable, tightly woven worsted fabric that has a hard finish.

garment center—A term used to describe the place where clothing manufacturers are located.

garment dyeing—The coloring of a garment after it has been constructed.

gauge—A term that refers to the closeness of the knit.

gauntlet—A type of glove that flares above the wrist.

georgette—A very sheer, gauzelike fabric.

ghillie—A low-cut women's shoe that laces across the foot and onto the ankle.

ginning—The separation of the seeds from the cotton fiber.

girdle—A term used to describe the widest part or edge of a stone.

glazing—Spraying the fur with water or chemicals and then carefully pressing them to add luster.

gold filled—A term used to describe thin sheets of gold that have been rolled and adhered to a base metal.

goodyear welt—A shoe construction that uses a separate strip to join the sole and upper portions.

gores—Triangular strips of fabric used in garment construction.

gray goods—Unfinished fabrics as they come from the loom.

guard hairs—The longer hairs of a pelt.

hackling—A process used to align flax fibers.

hair fibers—The specialty fibers such as cashmere and vicuna that belong to the wool family.

half sizes—A designation given to large women's clothing that is shortwaisted.

halter—A neckline that fastens around the back of the neck.

"hand" of fiber—The feel of the fiber.

hard goods—Merchandise such as appliances and furniture.

harmony—A principle of design that addresses the proper relationships of the other principles such as emphasis, proportion, and balance.

haute couture—A French term that refers to creations that bear the signature of high-fashion, original designs.

heat transfer printing—A method that transfers a pattern that has been printed on paper and onto fabric by means of heat and pressure.

hemp—A coarse, brittle fiber.

herringbone—A diagonal design that is produced with twill weave.

hides—Skins of large animals.

hip huggers—A pant with a waistline that is dropped and fitted across the hips.

honan—A fine quality silk.

hot pants—Very short shorts.

hot item—Merchandise that sells very well.

hue—A term used to describe the name of the color.

huarache—A woven, leather shoe that originated in Mexico.

inclusion-free—A term used to describe a stone that is blemish-free under 10 power magnification.

industrial periodicals—Magazines and newspapers that are directed at a particular trade or industry.

informal balance—A design that is "weighted" on both sides of an imaginary line with different objects; it is also known as asymmetrical balance.

in-house production—A term used to describe a facility that belongs to a manufacturer in which all production takes place.

in-house video—Video that is shown on the store's selling floors.

inseam—A method of joining glove parts where the seams are on the inside of the product.

inspiration—The events, people, or circumstances that motivate designers to create specific designs.

institutional advertising—A type of advertising that promotes a store's good will or image.

intensity—The degree of saturation in color.

Ivy League—A style that features such details as half-belts on trouser backs and button-down collars.

jabot—A ruffled or pleated extra piece of fabric that is featured at the neckline.

jacquard weave—A method of fabric construction that produces intricate designs.

jersey—A fine knitted fabric.

jeweled movement—In mechanical watches, tiny jewels are used as friction points.

jewel neckline—A high, rounded neckline that is void of any collar.

jobber—Another word for wholesaler.

jodhpurs—Riding pants.

joint venture—A business arrangement that involves a partnership of two companies.

jumper—A sleeveless dress under which blouses or sweaters are worn.

juniors—A size range that features a fit for short-waisted women.

jute—A medium quality vegetable fiber with a rigid feel.

karat—A term used to express the amount of gold in jewelry.

keyhole—A neckline that resembles a keyhole.

kicking—In fur processing, furs are beaten against each other to restore oils.

kiosks—Stands in the center of the aisles of shopping centers.

knee-high—Hosiery that ends at the knee.

knickers—Short pants that are gathered just below the knee and feature a band or elastic that hugs the leg.

knitting—A method of producing fabrics with the use of two or more needles.

knock-off—A copy of an original design.

lapels—Decorative facings on coats and jackets.

lapidary—A person who cuts and sets gemstones.

last—The form over which shoes are constructed.

lawn—The sheerest, finest linen.

leather—The skin of the animal with the hair removed.

leathering—The insertion of strips between fur skins to lessen bulkiness.

leg-of-mutton—A sleeve popularized during the Gibson Girl era that uses gathers or folds at the shoulder.

letting-out—A method of fur construction that is used to elongate the skins of an animal.

licensing—An arrangement where a well-known designer permits another company to use his or her name on products.

link belt—A belt that is made up of metallic pieces.

loafer—A casual shoe that has no laces.

logo—A symbol used to identify a product's maker; the Ralph Lauren polo pony is an example of a fashion-oriented logo.

loom—The machine on which yarns are woven into fabrics.

malleable—A term used to describe metals that are easily workable.

mandarin—A high neckline that features two narrow bands of material.

man-made fiber—A fiber that is made in the laboratory from chemicals.

manufacturer's representative—An individual who sells a producer's lines for a commission.

manufacturer's warehouse outlets—Sales arenas that sell the producer's leftover merchandise.

mantilla—A lace shawl worn over the head.

market consultant—An individual such as a resident buyer or fashion forecaster who helps retailers with buying plans and decisions.

market week—The period of time in which buyers come to the wholesale markets to purchase the new season's offerings.

marquis—A stone cut that comes to two points.

maryjane—A shoe that features a strap across the instep and a rounded front.

matinee necklace—Longer length necklaces that measure from 22 to 24 inches.

maxi—A floor-length skirt or dress.

men's furnishings—Products such as shirts, ties, and socks.

mercerization—To increase luster, fabrics are immersed in a solution of sodium hydroxide for a few minutes; strength is also improved through the process.

merchandise confinement—When a line is sold exclusively to one merchant in a trading area.

merino—A sheep that produces fine woolen fibers.

middy—A blouse that features a large square collar in the back.

modacrylic—A man-made fiber.

model stock—An inventory that contains the appropriate assortment to satisfy the potential customer's needs.

Moh's scale of hardness—A scale that lists the hardness of stones.

moiréing—A process that implants a watermarked design on fabric by means of rollers.

monochromatic color scheme—A color arrangement that is based on one color.

mousquetaire—The longest length glove.

mule—A backless shoe.

muslin—A term used for a fabric pattern of a design.

napa—The surface of a soft leather hide that has a shiny smooth or pebbly surface.

napping—A finish that raises the fibers on fabrics.

natural fiber—An animal- or vegetable-based fiber.

natural shoulder—A shoulder of a garment that is void of any padding.

natural stones—Stones that are either mined or come from the seas such as pearls.

neutral colors—Black and white are neutrals.

nubuck—A leather that is slightly buffed until it takes on a fine nap that appears smoother than suede.

nylon—A man-made fiber with exceptional strength that launders easily.

off-price—Merchandise that is purchased by retailers from manufacturers at less than the original wholesale price.

off-pricer—A store retailer who purchases for less and sells for less than the traditional stores.

off-shore production—Manufacturing that is accomplished in foreign lands.

olefin—A man-made fiber with extreme strength that will dry quickly and is resistant to mildew and perspiration.

opera length—The longest length necklace.

outside contractor—A firm that performs some stages of production for manufacturers.

outseam—A method used to assemble the parts of the glove that features the stitching on the outside.

oval cut—The newest cutting of stones that is a variation of the brilliant or round cut.

overseam—A glove stitching procedure that places the stitches over the raw seams of the product.

Panama—A straw hat with a high crown and center crease.

pantyhose—Hosiery that combines stockings with a panty and covers the body from the toes to the waist.

pantsuit—A style used to describe a woman's jacket and matching trousers.

parasol—An umbrella.

paste setting—A very inexpensive jewelry setting that uses glue to cement the stone into place.

pattern—A design or motif.

pave setting—A setting with extensive blank areas that are tooled into little beadlike surfaces that surround a number of small stones.

pear shape—A stone cut that is rounded at the top and comes to a point at the bottom.

pedal pushers—Pants that end at the knees.

pelts—Undressed skins with the fur intact.

peplum—An extra piece of material that extends from the waist of a skirt or dress.

permanent press—A finish that resists creasing.

personal shopper—A retail employee who personally services the customer by either preselecting merchandise or accompaniment through the store to help with selections.

petites—A size that is proportioned to fit the shorter, slimmer female figure.

petticoats—Underskirts that are worn to give a fuller look to skirts and dresses.

pickling—The use of salt and brine in leather processing to attract and tie up excess moisture.

piece dyeing—A technique where the fabric is dyed after it is woven or knitted and before it is made into garments.

pile weave—A construction method used in textiles that produces a fabric with a raised surface.

pillbox—A small, round, brimless, structured woman's hat.

pique seam—A technique used to assemble the parts of a glove that involves sewing one edge over the other.

plain weave—The interlacing of one set of yarns at right angles.

plissé—A fabric that is finished to give an uneven, raised surface.

plucking—The removal of the guard hairs from pelts.

point—A term used in describing the weight of a stone; there are 100 points to a carat.

point d'esprit—A finish that adds flocked dots to netting.

pointing—The decorative stitching found on the backs of some gloves.

polyester—A man-made fiber that resists wrinkling and launders easily.

pongee—A light- or medium-weight Chinese silk fabric made from tussah silk.

poplin—A very finely ribbed cotton fabric.

portly—A men's wear size that has the same dimensions as regular, but with a wider waist.

pouf—A full skirt that is gathered at the hemline.

power center—A retail shopping environment that features high volume stores as its attractions.

precious metals—Metals with intrinsic value such as gold and silver.

precious stones—Diamonds, rubies, emeralds, sapphires, and natural pearls.

preliminary sketch—An artist's rendering of a design before it is made into a sample.

preshrinking—A textile finish that minimizes the amount of shrinking due to laundering.

press kit—Folders that are distributed for publicity purposes; they usually contain written materials and photographs or drawings.

press release—A statement that is sent to all media in hopes that they will give it some publicity.

pret-a-porter—A French term for ready-to-wear.

price point—The level at which the major portion of a line is priced.

primary colors—Red, yellow, and blue are the primary colors from which all others may be produced.

princess—A silhouette that uses gores to form the shape.

print media—Media such as newspapers, magazines, and direct mail.

private label—A line that a retailer has developed for itself that cannot be found in any other store.

production manager—An individual who has the overall responsibility to oversee the manufacturing process.

production schedule—A timetable noting the various dates of each stage of production.

progression rhythm—A design principle that incorporates motifs that progress in size.

promotional advertising—Advertising that concentrates on the sale of specific merchandise.

promotional campaign—A special endeavor by a company to promote a special event.

proportion—The relationship between the size of objects and the space provided for their showing.

publicist—An individual who has the responsibility to get a company's name or product out to the media.

pump—A woman's shoe that is low-cut with seamless head-to-toe design.

quality control—A system that examines merchandise to ensure that it meets certain standards.

quartz watch—A timepiece that has accuracy 10 times greater than that of the conventional watch.

quirks—Tiny triangular inserts in gloves at the base of the fingers.

quirk thumb—A thumb attachment that has an additional piece called a quirk.

quota—Limit established by government to prevent unfair competition from foreign producers.

raglan—A sleeve that extends from the neckline of the garment and drops over the shoulder in one piece.

ramie—A coarse vegetable fiber.

rayon—A man-made fiber that is soft, easy to dye, and has extreme versatility.

redingote—A dress with a matching coat.

reeling—The unwinding of the silk fiber from the cocoon.

regional mall—A major shopping center that serves a large trading area.

regular sizes—A designation for sizes that fit the average male.

reorder—Merchandise that is ordered over and over again.

reporting services—Agencies that report on the fashion industry.

resident buying office—A company that assists retailers with their purchases.

resources—Places from buyers purchase their merchandise.

retting—A rotting process that is necessary to separate the flax from the stalk.

rhythm—A design principle that assists the movement of the eye from one element to another.

rhythmic radiation—A design principle that radiates from a central point.

rhythmic repetition—A design principle that uses the same element over and over again in a pattern.

rococo—An ornate type of design.

rodent family—A family of animals that includes chinchilla, rabbit, nutria, and muskrat.

rolled gold plate—Very thin sheets of gold that have been adhered to a base metal.

roller printing—A method of fabric decoration in which a pattern is etched on a roller and is then transferred onto the material.

runway presentation—A fashion show format that uses a runway to bring models close to the viewing audience.

safari jacket—A silhouette that features epaulets as the shoulder design, four patch pockets, and a belt that is tied around the waist.

sample garment—A finished piece of merchandise that is shown to prospective buyers for ordering.

sample sale—A method of disposing of unwanted merchandise samples by designers and manufacturers.

sandal—One of the oldest forms of footwear that features a sole with straps.

sandalfoot—A type of hosiery that eliminates heal or toe reinforcement.

sash—A narrow, oblong length of fabric that is tied around the waist.

sateen—A material that is woven with the satin weave that uses floats to give it sheen.

satin weave—A weave that uses floats to enhance the shine of fabrics.

schreinerizing—A process that produces a finish on fabrics that is soft in luster and soft to the touch.

sclerometer—A system to measure the hardness of stones.

screen printing—A process in which color is fed onto a screen and then penetrated into the fabric; a design is then produced when some areas receive dye and others are prevented from receiving the dye by a blocking out on the screen.

seasons—A term used to describe the different number of collections produced in a year.

secondary colors—They are orange, violet, and green.

seersucker—A crinkled, bumpy fabric whose texture is achieved during production rather than with finishes.

self belt—A belt that is made of the same fabric as the garment it enhances.

semiprecious stones—Inexpensive, natural stones.

serge—A wool fabric that is twill woven and extremely durable.

sericin—A sticky substance that is part of the silk fiber.

sericulture—The production of cocoons for their silk filament.

Seventh Avenue—New York's garment center.

shantung—A soft, lustrous fabric with sparse, irregular ridges in the texture.

shearing—A process that uniformly cuts pile woven fabrics.

Shetland—A soft, raised fabric made from wool from the sheep in the Shetland Islands in Scotland.

silhouette—The shape of a garment.

simulant—A look-alike of a natural stone.

singeing—A finish that burns off the hairs of a fabric to make it smoother.

single cut—A variation of the round or brilliant cut that features fewer facets.

sizing—A stiffening finish used on fabrics.

skin-on-skin construction—Inexpensive fur construction where one skin is sewn below the next until the desired length is reached.

sling back—A pump that features a strap across the back.

sloppy joes—The name given to oversized sweaters of the 1940s.

solution dyeing—A process wherein the color is added to the chemical solution when fibers are produced into filaments.

spandex—A lightweight, man-made fiber that has the ability to stretch 500 percent without breaking.

special event—A promotion that is run just one time.

specialized department store—A major retailer that limits the merchandise selection to one classification such as apparel.

specialty stores—Retail operations that restrict their merchandise offerings.

spectator—A shoe that features two colors of leather.

spinneret—The device that resembles a shower head that is used to produce man-made filaments.

spinning—The process in which fibers are twisted together to form yarn.

spinoff—A term used to describe a specialty store that belongs to a department store.

split—Leather that has had its top layer removed.

split-skin construction—A method of fur construction that slices the plump male skin (usually mink) down the center and then "lets out" each piece for elongation purposes.

splitting—Slicing leather into several layers.

squash blossom—An ornamental necklace made by Native Americans.

staple fibers—Short fibers.

sterling silver—A metal alloy that is 925 parts silver and 75 parts copper.

stock dyeing—The coloring of the fiber before production into yarn.

studs—Small ornamental inserts used as shirt fasteners.

style—The shape of the garment or accessory.

subspecialty stores—Retail operations that carry only a very narrow classification of merchandise such as ties.

suede—A leather material that is napped to raise the surface.

surah—A soft silk fabric with a pronounced diagonal rib.

surplice—A neckline that features two pieces of fabric in which one crosses over the other.

symmetrical balance—Formal arrangement where both sides of a design are identical.

synthetic stone—A manufactured stone that is made to imitate one that is natural.

table—The top part of a stone.

table cutting—A term used in glove manufacturing where each glove is cut one at a time.

taffeta—A crisp fabric that "rustles" as it moves.

tanning—A process used to preserve leather before it is made into products.

target market—An audience that has the most potential as product purchasers.

tariff—A tax levied on some imported merchandise.

tariff schedule—A listing of the different taxes levied on imports.

terrycloth—A looped, cotton fabric that is extremely absorbent.

thong—A shoe that has a piece of material that is worn between two toes.

tiara—A jeweled crown.

tiffany setting—A setting for stones that are to be prominently displayed without the intrusion of too much metal.

toggling—During the drying of leather, toggles or clips are used to stretch the leather and keep its shape.

topcoat—A lightweight overcoat.

top hat—A high hat worn by men for formal wear.

toque—A women's small, brimless hat.

tote—A large handbag with two handles and an open top.

trade associations—Organizations that represent specific industries and provide information that is beneficial to its membership.

trade publication—A periodical that is directed to a specific industry.

trade show—A sales event where producers show their lines to prospective buyers.

traditional cut—A term used in men's wear to describe suits and jackets that feature fuller proportions.

trank—The body of a glove.

trapeze—A dress or skirt that exaggerates the A-line shape.

trench coat—A style that features military detailing such as epaulets and brass buttons on a double-breasted construction.

trimmings—Decorative and functional embellishments.

triplet—A stone that is made of three pieces with an artificial or simulant in the center.

trolley carts—The wagons seen in garment centers on which merchandise is transported.

trumpet—A skirt that is fitted at the hips and flares out below the knees.

trunk show—A sales promotion used by some designers in which their collections are taken from store to store to be shown to customers.

tube socks—Hosiery without shape.

tunic—A sleeveless or sleeved garment that extends to the thigh and is worn over a skirt.

tussah—Fine quality silk.

twig—A specialty store that belongs to a department store that is also called a spinoff.

twill weave—A durable weave that produces a diagonal line.

unconstructed style—A loosely fitted garment that is usually unlined.

undressed pelts—Skins of animals that have not been finished.

ungulate family—An animal family that features tightly curled skins such as Persian lamb.

upper—The top portion of a shoe.

upscale merchandise—Costly merchandise.

vacuum drying—A process used in leather to remove moisture from the skins.

value—A term that refers to the lightness or darkness of a color.

vat dye—A dye that has excellent fastness to sunlight, washing, and perspiration.

velour—Dimensional fabrics that are pile produced.

velvet—A pile fabric with a rich, uniform surface.

vents—The openings in the back of a jacket.

vertical malls—Retail sales arenas that are built upward.

vicuña—A costly hair fiber.

visual merchandising—Design and enhancement of the display and selling areas of a company.

wardrobe consultant—An individual trained to assist customers with appropriate dress.

warp—Vertical yarns that give strength to the weave.

warp knitting—A process wherein yarns are looped around a single needle to form loops that are vertically attached to other loops.

water repellent—A finish that helps fabrics shed water.

weasel family—An animal family that includes mink, sable, and ermine.

weaving—The interlacing of two or more sets of yarns at right angles.

wedgie—A shoe that features a heel that extends from the back of the shoe to the ball.

weft knitting—A process wherein knitted goods have been produced horizontally.

wholesalers—Companies that buy from manufacturers and sell to retailers.

wing tip—An oxford shoe that has a stitched tip shaped like a wing.

woolens—Soft wool fabrics.

worsteds—Wool fabrics that feature a hard surface.

yarn dyeing—A process where color is added after fibers are spun into yarn.

INDEX

monochromatic, 68
 split complementaries, 68
 triads, 69
coloring leather, 198-199
composite stones, 248-249
 doublets, 248-249
 triplets, 248-249
computerized pattern grading, 96
consignment selling, 228-229
costing a product, 82-86
 distribution expenses, 86
 materials, 82-83
 production labor, 84-85
 transportation, 85-86
 trimmings, 83-84
cotton, 155-158
Cotton Incorporated, 147, 187
couturier, 7
couturiere, 7
crocheting, 179
cuffs, women's, 277
cultured pearls, 246-247
cutting tickets, 87

D

delustering, 184
department stores, 104-106
Designer Collective, 309
designer elements, 66-72
 color, 67-69
 details, 72
 materials, 69-71
 silhouettes, 71-72
 trimmings, 72
design principles, 72-76
 balance, 73-74
 emphasis, 75
 harmony, 75-76
 proportion, 74-75
 rhythm, 75
details, 72
details, menswear, 303-307
details, women's, 275-279
development of line's concept, 61-65

diamonds, 241-243
direct marketers, 108-109
discounters, 110-111
display, 143
distribution of products, 99-100
domestic regional markets, 11
downtown shopping districts, 113-114
dresses, 256, 326
duty, 91-92
dyeing techniques, 179-181
 cross, 180
 garment, 180
 piece, 180
 solution, 179-180
 stock, 180
dye types, 181-182
 acid, 181
 basic, 181
 chrome, 181
 direct, 181
 disperse, 181
 fiber reactive, 181
 napthol, 182

E

emeralds, 243-244
embossing, 184
ermine, 221
European fashion capitals, 11-13

F

fabric construction, 175-179
fabric finishes, 179-186
 appearance enhancers, 183-185
 dye selection, 181-182
 dye techniques, 179-181
 functional finishes, 186
 printing processes, 182-183
faceted stone's parts, 250
fad, 7
Far East markets, 14
fashion, 6
fashion advertisers and